CW00516498

# CURIOUS VISIONS OF MODERNITY

David L. Martin

# CURIOUS VISIONS OF MODERNITY

Enchantment, Magic, and
the Sacred

THE MIT PRESS   CAMBRIDGE, MASSACHUSETTS   LONDON, ENGLAND

For information about special quantity discounts,
please email special_sales@mitpress.mit.edu

This book was set in Garamond Premier Pro
and Helvetica Neue Pro by The MIT Press. Printed
and bound in Spain.

Library of Congress Cataloging-in-Publication Data
Martin, David L., 1971–
Curious visions of modernity : enchantment, magic,
and the sacred / David L. Martin.
    p. cm.
Includes bibliographical references and index.
ISBN 978-0-262-01606-3 (hardcover : alk. paper)
1. Knowledge, Theory of. I. Title.
BD181.M37 2012
121—dc22

2011002085

10  9  8  7  6  5  4  3  2  1

To my father Peter James Martin
And in memory of Mike Hurrell
Who both taught me the value of
good storytelling.

# Contents

# A NOTE TO THE CURIOUS: ON READING THIS BOOK

In many ways the book you hold in your hand is an experiment in writing. It attempts to position itself against a way of thinking, conceiving, and knowing of the world that sees the world as an object of rational study. But it necessarily attempts this task from within the folds of that which it is writing against: the rationality of modernity. In doing so it threatens repeatedly to fold in on itself. It necessarily employs the language of the academy; it necessarily does so using the conventions of how such language should appear; it necessarily conforms to the legal and institutional strictures which codify the modern academy as the gate-keeper of this "enlightened" rationality. Yet at every turn it attempts to resist these impulses.

In writing this book I have attempted to admit and prioritize those things usually deemed "improper" to, or unworthy of, academic study by giving as much room as possible to the fragment, the narrative, the excursion, the fleeting glance, the sympathy, and the resonance. I have resisted the urge to lock the curiosities which loosely form the content of this book into relation-ships of cause and effect, or to stamp them with a single narrative which binds them together as a coherent story, preferring instead that you, the reader, may make your own associations between the objects I have gathered within these pages.

In attempting this task I have structured the book much like a cabinet; the kind we will encounter in the princely collections of Renaissance Europe. Such cabinets do not function as definitive statements or encyclopedias, but rather they take sustenance from what each collector brings to them in the unpacking. So although this book necessarily engages in the kinds of refer-encing which would mark it as "academic," I have tried to limit my use of specific theoretical works (in particular) to a valuable few; and then, as much as not, I have tried to be guided by the "spirit" of these works and their authors, rather than slavishly following the letter of the law or explicating endless definitions. I do this in an effort to leave the necessary room to allow each reader to bring to the text their own interpretations, their own inflections, and their own discursive wanderings. In this regard I have been guided at every turn by the words of Walter Benjamin when he said: "I have nothing to say; only show."

Finally, I must mention the function of the Notes section or "excursions," as I have called them. Here you will find commentaries, caveats, alternative readings, hidden conversations, as well as blind alleyways. They represent normal academic citations, guides to the researcher, as well as challenges to the narrative disclosed in the main text. They are like the drawers of a cabinet whose opening and closing refreshes the collection anew.

## ACKNOWLEDGMENTS

For many years now, I have been something of an academic collector, watching out for the fragments and broken pieces of early modern visual culture discarded and scattered by the vagaries of historical discourse. In this venture I have had the great fortune to take instruction from skilled teachers and follow the lead of inspiring guides, while all the while being buoyed by the camaraderie and infectious enthusiasm of those select few like-minded collectors that I have encountered along the way. Gathering my fragments together like so many treasured curiosities, I have found that several of them speak to me at the level of biography; their recollection tracing the friendships and academic influences of the past decade. While such curiosities have served me well as a researcher and a teacher, to my enduring distress their ability to summon those biographies to mind is something that goes largely unbeknownst to the people to whom these biographies refer. This book would not be possible without the generosity and influence of each of them.

This project began its life in Melbourne where, for a time, exceptional people seemed to be doing exceptional things and I was lucky enough to drift into their orbit. To Kirsty Major and Patrick Wolfe, both of whom are sorely missed and underthanked teachers. To Phillip Darby for innumerable opportunities to teach without rein or tether, and for embodying the kind of intellectual generosity and theatricality so dreadfully at risk of being purged from today's academy. To Kaz Ross for being there to share the sparkle of heterotopic anomalies, and to Adam Driver for a friendship and collaborative spark that has kept the world alive with wonder. And of course to Michael Dutton, my teacher, supervisor, and more recently most welcoming colleague and wonderfully supportive friend. His influence is stamped across this book. There are few people whose daily barrage of ideas could be as dazzling or sustained.

In the production of this book I owe a specific debt of gratitude to Bobbie Oliver of Curtin University for alerting me to the crimes visited upon Yagan of the Noongar peoples of Western Australia; Adam Shoemaker of ANU for making his unpublished manuscript on Australian currency and heads of state available to me; and Mark Meadow of UCSB for allowing me to publish the Microcosms illustrations. To the first true readers of this text, John Hutnyk of Goldsmiths and Mick Taussig of Columbia University, unlike rosé wine, I hope this has matured with time. And finally to the two anonymous readers for the MIT Press:

your, at times, unbridled enthusiasm and excitement for this project allowed me the most selfish of pleasures—to *enjoy* the process of reengaging with its substance, details, and purpose. Doing justice to the sheer wealth of your knowingness will take more than one book; for that I am truly grateful.

Some musings on statues, embodiment, and defacement were taken from this study to form the basis of my short piece "Of Monuments and Masks: Historiography in the Time of Curiosity's Ruin," *Postcolonial Studies* 10 (3) (September 2007): 311–320, © The Institute of Postcolonial Studies. This material is reprinted by permission of Taylor and Francis Ltd (http://www.tandf.co.uk/journals), on behalf of The Institute of Postcolonial Studies, Melbourne, Australia.

Curiously, in finding a Melbourne (or at least many Melbournians) relocated in London there are, already, the stirrings of new biographies and the excitement of new collections to be had. For their support and advice I am indebted to: Sanjay Seth, Rajyashree Pandey, Huw Hallam, Anthony Gardener, and Ben Smith. Thanks also to John Cash, Ramaswami Harindranath, and Karina Smith for being supportive friends and journal colleagues from afar.

To Roger Conover for confirming that collection is indeed something that strikes to the very heart of who we are. His is one that categorically dispels the comforting gap between who we say we are and what we actually stand for. His influence on me will be there when this book is cracked and moldering.

There is little an acknowledgments section can do to offset the world of debt owed to family, friends, and partners, but I hope I can make a first dent. To my parents for showing me the world; to the Hurrell family for four wonderful years of support in that world; to the Woods family for worlds yet to come; to my brother for a childhood of collection and play at world's end; and finally, to Angela, for the worlds we will create together ... thank you all.

# Introduction

——

The program of Enlightenment was the disenchantment of
the world; the dissolution of myths and the substitution
of knowledge for fancy.

Max Horkheimer and Theodor W. Adorno, *Dialectic of Enlightenment*

## Entombed Enchantment: Historiography and the Heterogeneous

In our time, history is that which transforms *documents* into
*monuments*. In that area where, in the past, history deciphered
the traces left by men, it now deploys a mass of elements
that have to be grouped, made relevant, placed in relation to one
another to form totalities. There was a time when archaeology,
as a discipline devoted to silent monuments, inert traces,
objects without context, and things left by the past, aspired to
the condition of history, and attained meaning only through
the restitution of a historical discourse; it might be said, to play
on words a little, that in our time history aspires to the condition
of archaeology, to the intrinsic description of monuments.

Michel Foucault, *The Archaeology of Knowledge*

This book grew out of a very personal dilemma: how to write about an idiosyncratic collection of modern discursive "curiosities" that for one reason or another had taken my fancy over the course of several years. Gathered primarily from my travels through art history, the history of science and, in recent years, critical and postcolonial theory, these curiosities seemed to share a common relationship to the discourses and regimes of vision; discourses that have increasingly come to be seen as characterizing and galvanizing our very understanding of Western modernity. Individually, each of these curiosities shone as a treasured item disclosing to me, their collector, a near-magical ability to reveal and illuminate something lingering there in the very structures of Western scientific knowledge; something like a shadow of forgotten ways of knowing and being, haunting the homogenized and transparent surfaces of a scientific modernity triumphantly proclaiming its own "Enlightenment."

Whether appearing as strange historical antecedents to otherwise familiar modern forms of knowledge production (like the wondrous and singular objects in Renaissance curiosity cabinets), or taking the guise of modern modes of veneration supposedly outdated by scientific rationality (such as the mimetic qualities of the cenotaph), there was something about each of these curiosities that beckoned enticingly, holding out the allure of a more nuanced understanding of the structures of modern, post-Enlightenment rationality. Something appeared to be lying there in the slippages and ruptures of the otherwise seemingly smooth epistemological surfaces of this scientific rationality that threatened to reveal a gulf of ambivalence and unreason, if only my curiosities could be made to speak.

But try as I might, it seemed that the act of writing to the elusive nature of these curiosities was to destroy the very thing which had drawn me to each in the first place: their heterogeneity; their ability to defy taxonomic description; their ability to resist, if not the written word, then certainly the binding logic that would see them cohere as a clearly definable "argument." Every time I attempted to proffer one of my curiosities as *this* specific historical antecedent or *that* modern sacred, the modes of theoretical expression or historical analysis at my disposal seemed only to turn each curiosity to stone. Stripped of the magic that had once enchanted them, my treasured modern curiosities came to appear as little more than ruined monuments; monuments rapidly being reduced to dust by the very tools of theoretical abstraction and scientific transparency that I was hoping to undermine.

This is the dilemma from which this book was conceived: the tools of critical analysis were, in fact, the very things I needed to critique. The historical archive that had thrown up my heterogeneous curiosities was the very thing that was encasing those curiosities in stone, making monuments of them,

abstracting and disenchanting them so that they could be compared, contrasted, qualified, quantified, systematized, and temporalized—in a word: homogenized. The task that presented itself to me was one of reclamation: not of further historical details to place at the feet of modern historiography but, rather, of that certain indescribable thing—that heterogeneity—which lay encased within the crumbling monument that scientific rationality had made of the curiosity. What this book presents, therefore, is a specific "archaeology"; an "archaeology" of the visual, aimed precisely at redressing this modern proclivity toward the production of monuments.

<center>• • • • •</center>

In a description of the psychological structure of fascism, Georges Bataille opposed a fundamentally bourgeois, "productive" constituent of society, whose most significant trait was its "tendential homogeneity," with a nonhomogeneous, nonproductive element of society he described as *heterogeneous*.[1] Referring primarily to a division between those in possession of the means of production and those excluded from such means, interestingly enough, Bataille extended the reach of this description to include the very structures of thought and knowledge production of society itself. In this regard, scientific knowledge, by its very nature, was allied to the homogeneous elements of society: "compelled to note the existence of irreducible facts ... the object of science is to establish the homogeneity of phenomena."[2] Such were the circumstances of scientific knowledge production for Bataille that he declared those heterogeneous elements of knowledge to be subject to a *de facto* censorship; a censorship he likened to the description proffered by psychoanalysis concerning the exclusion of the unconscious from the conscious ego. Among those things excluded in this fashion, Bataille listed first and foremost the "restricted heterogeneous" elements of taboo and mana. Beyond these properly sacred things, Bataille also deemed heterogeneous everything resulting from "unproductive" expenditure: violence, excess, delirium, and madness—these were the elements of heterogeneity that surfaced in persons or mobs when the laws of homogeneous society were broken.

Although couched in the terms of an "intentionality" that would see science as being open to the vagaries of individual manipulation—the word "censorship" suggesting it to be little more than a bourgeois tool for the active, personalized exclusion of the heterogeneous from homogeneous society—Bataille's work offers us the beginnings of a description of knowledge most apt for my present task. Since Bataille was convinced that science represented the dominant mode of knowledge production for homogeneous society, then it is possible for us to suggest that the exclusion of the heterogeneous is part of the very *raison d'être* of that knowledge. Yet whereas Bataille might wish to suggest

that this "desire" to exclude the heterogeneous is an active means by which the bourgeoisie maintain their control over the means of production, I would prefer to see this so-called "desire" operate at the level of discourse, as a general condition of knowledge. In this regard, we can liken this discursive "desire" to Heidegger's wider epistemological deployment of Husserl's phenomenological understanding of perspective; Heidegger suggests that every effort at knowledge production is necessarily accompanied by a simultaneous and unavoidable act of concealment.[3] In this manner, the production of knowledge is, from the very outset, but one side of a coin; the flip side of which consists of a process of masking and unknowing.

Inherent to the discourses of post-Enlightenment rationality, then, is a homogenizing tendency which is inscribed in the very structures of scientific knowledge production at the level of discourse. From this position we may proffer the claim that within the very discursive folds of scientific knowledge production there exists a series of repressed heterogeneous elements, covered and concealed by the supposedly transparent knowledge claims of post-Enlightenment thought. To continue with Bataille's psychoanalytic analogy, we may further suggest that such repression is never fully complete. Thus, although scientific rationality would come to define its knowledge claims against a series of heterogeneous elements decried as mere superstitious irrationality (which itself was a brutally enforced homogenizing strategy), and proclaim its transparent surfaces to be free of the taint of the heterogeneous, such was not the case. For there, lurking in the very structures of Western knowledge itself, was the one thing rationality so desperately sought to expunge; repressed but not erased by the rationality of science. Only occasionally are we made aware of this repressed heterogeneity and the part our histories and sciences play in its repression, and then only through its periodic incursion into the homogeneous discourses of rationality. This book seeks to trace what Bataille might call the "vengeful incursions of the sacred."

. . . . .

In a book on political change in postsocialist Europe, Katherine Verdery makes the somewhat suggestive claim that "statues are dead people cast in bronze."[4] Ever since reading this statement I have been captivated by the chilling thought that within each statue, like a living soul made corporeal, lies the captive body of the person the statue is said to represent; our museums, parks, and city squares being veritable mortuaries of tortured and imprisoned flesh. Not only can it be said that this somewhat macabre image takes its very suggestiveness from one of the most enduring recurrences in modern times of the heterogeneous (namely, the mimetic ability of an object to stand in for the thing it is said to represent), but it also can be viewed as the perfect analogy for the

theoretical problem this book is set to redress. In this instance, however, the imprisoned flesh of the dead body is that of a repressed heterogeneity; its bronze encasing is the discourse of history or, more precisely, a way of writing history which, to paraphrase Michel Foucault, is devoted to the production of silent monuments.

It is for this reason that my approach to the heterogeneous will be an "archaeological" one, by which I chiefly mean the unearthing of the discursive structures of scientific rationality through the tracing of specific genealogies. In this regard, I am taking my lead from Michel de Certeau's reading (some would say, slight misreading) of Foucault's use of the term, as expounded in *The Order of Things* and *The Archaeology of Knowledge*.[5] Both authors explicitly pursue the genealogies that constitute their specific "archaeologies" from within the folds of discourse and without recourse to the generative logic of a knowing subjectivity, and thus, so too will I. Where I see the primary point of departure between these two authors on this matter, however, is in de Certeau's refusal to predicate an archaeological detachment from the inert mass of past discourses to which such an archaeology applies. Not as strident as Foucault in his call for the comprehensiveness of those historical ruptures dividing discrete *epistemes*, de Certeau saw in Foucault's work an unsettling new pertinence to the past precisely in its ability to linger in the otherwise seemingly inert document/monuments of historical analysis. Much like Bataille's penchant for psychoanalytic analogy, de Certeau expresses this difference thus: "Beneath the cultural displacements there survive original wounds and organizing impulsions [*poussées organisatrices*] still discernable in the thoughts that have forgotten them."[6]

Taking inspiration from this statement, it can be said that the present book represents the first step in an archaeology of the "original wound" that was the homogenization of knowledge production otherwise known as the Enlightenment; that near-heretical abandonment of the written texts of God in favor of the "visions" of humankind. Toward this end, three separate genealogies will be traced of what I consider to be the most distinct and historically immediate fields of modern visual culture: the collection, the body, and spaces; though, as we shall see, each has a tendency to fold into the other.

## Visions of Modernity: An Introduction

The act of reading ruins and fractured objects needs some deliberately twisted linguistic devices that figuratively resemble the ruined space itself.
..................................................................................................
Vladislav Todorov, *Red Square, Black Square*

In a book that, to this day, never ceases to dazzle me with its almost magically conceived academic sleights of hand, Hillel Schwartz suggests that to write an introduction is to prophesy *post hoc*.[7] And taking my lead from this statement, I can guarantee that this book *will* see the world renewed, in chapter 1, through the act of collecting the curious and wondrous objects of Creation; *will* have visions of tortured and broken flesh rising from the dissecting tables of anatomy theaters to stalk the discourses of medical knowledge in chapter 2; and *will* witness the spilling forth of a "pictorializing" geometry from the gilt frames of Renaissance panel paintings as a means of raising and venerating a panoptic god in chapter 3. But in many ways, these are things that have already taken place; they are, to paraphrase Walter Benjamin, the prescient dreams in which every epoch comes to see the epoch that is to succeed it.[8] They are, in effect, my curious visions of modernity.

This is a book about vision. It is a book about the dawning of an age of modern scientific rationality that staked the worth of its knowledge claims on a transparency supposedly guaranteed by the visual. It is a book about the perceived ability of this scientific visuality to expunge all traces of difference, of heterogeneity, and of the sacred from its self-proclaimed "enlightened" discourses. It is a book about the visual disenchantment of modernity. And it is a book about the ultimate failure of these claims.

Thus, in many ways, this book is about much more than the persistent modern uncritical elevation of the visual. It is also a book about history and its ability to make monuments of people, places, and things. It is a book about the modern historiographic proclivity toward making such monuments magically disappear as if they had never existed. It is a book concerned with the repressed heterogeneity of modernity, and with finding alternative ways of writing about such heterogeneity without contributing to that very repression. In short, it is a book concerned with writing back against a way of making history which makes ruins of the past futures "envisaged" by the curious forebears of modernity.

# Collection

---

**1**

I found in the image of the Rood called the Rood of Grace, the which
heretofore hath been held in great veneration of people, certain
engines and old wire, with old rotten sticks in the back of the same,
that did cause the eyes of the same to move and stare in the head
thereof like unto a living thing; and also the nether lip in like wise to
move as though it should speak; which, so famed was not a little
strange to me and others that was present at the plucking down of the
same. ... [I] did convey the said image unto Maidstone this present
Thursday, then being the market day, and in the chief of the market
time, did show it openly unto all the people there being present, to see
the false, crafty, and subtle handling thereof, to the dishonor of God,
and illusion of said people.

Agent of Thomas Cromwell reporting on the disassembling of the
Cistercian abbey at Boxley, Kent, 1538

First, the collecting of a most perfect and general library, wherein
whatsoever the wit of man hath heretofore committed to books
of worth ... may be made contributory to your wisdom. Next, a
spacious, wonderful garden, wherein whatsoever plant the sun of
divers climate, or the earth out of divers moulds, either wild or
by the culture of man brought forth, may be ... set and cherished:
this garden to be built about with rooms to stable in all the rare
beasts and to cage in all the rare birds; with two lakes adjoining,
the one of fresh water the other of salt, for like variety of fishes.
And so you have in small compass a model of the universal
nature made private. The third, a goodly huge cabinet, wherein
whatsoever the hand of man by exquisite art or engine has
made rare in stuff, form or motion; whatsoever singularity, chance
and the shuffle of things hath produced; whatsoever Nature has
wrought in things that want life and may be kept; shall be sorted
and included. The fourth such a still-house, so furnished with
mills, instruments, furnaces and vessels as may be a place fit for
the philosopher's stone.

Francis Bacon, *Gesta Grayorum* (1594)

## Unpacking the Collection

"Every passion borders on the chaotic, but the collector's passion borders on the chaos of memories"; so Walter Benjamin characterizes the temperament of the book collector, who, surveying their collection, is struck by a "spring tide of memories" that surges up within them.[1] It is only through the habit of recalling the memories of chance discoveries, protracted searches, and hard-fought negotiations that something akin to order can be made out of the otherwise accustomed confusion of items within a collection. Benjamin's collection, therefore, requires a constant "recollection" or "unpacking" to make order out of the chaos of individual memories and books; an order that Benjamin himself describes as "a balancing act of extreme precariousness."[2] This dialectical tension between the poles of order and chaos that characterizes the collector's life is one that is firmly destroyed by the fixity and historicizing tendencies of the catalog, which stands as the antithetical counterpart to the enchantment of the collection.

It is precisely this notion of enchantment that lies at the center of Benjamin's collection: the collector's relationship to books is one that does not emphasize the functional or utilitarian value of the individual volumes, but rather prioritizes their talismanic qualities. Like a modern-day oracle, the book collector is possessed of an ability to see dreamily right through the covers of their books into the distant past, and bring that past back forward into the world of the collector. In this way, the collector comes to acquire the magical charm of a child at play who is able, through the games of naming, rummaging, and acquiring, to "accomplish the renewal of existence in a hundred unfailing ways."[3] Collection, then, proceeds from the wonderment of locking individual items within an arcane circle in which the attributes of the object (its craftsmanship, origin, and provenance) add up to a "magic encyclopedia" whose quintessence is the present fate of the item as the collector's own possession. This re-collection (through a divinatory recollection) of the books within a collector's library has the effect of renewing the qualities of those books housed within; replenishing their ability to marshal, harness, and conjure up the past as a renewal of the collector's own world. Thus, the passion of the collector for new acquisitions, and the opportunity that the new acquisition affords for recollection (and hence re-collection), is nothing short of the manifest desire to create worlds:

> To renew the old world—that is the collector's deepest desire when he is driven to acquire new things, and that is why a collector of older books is closer to the wellspring of collecting than the acquirer of luxury editions.[4]

Benjamin's collector is possessed not only of this passion for renewing worlds but also of a well-honed tactical instinct: cities, towns, and landscapes reveal themselves through the objects they offer up to the collector's zeal. Monuments, landmarks, and shops become the sites a collector inhabits as they "capture" a city by passing through it. The act of recollection/re-collection that characterizes a library is therefore an intimately personal one for Benjamin; one that loses its meaning (its memories, its strategic holdings, and its ability to renew the world) as it loses its personal owner. Yet it is only at this moment of transmissibility, when meaning is lost as it passes from one owner to another (or, better yet, from one owner to no other—that is, upon the collection's dispersal), that we, the outsider, get the first inkling of how the magic of that particular collection may have been ordered, and its powers nourished. As Benjamin himself puts it: "only in extinction is the collector comprehended."[5]

Susan Stewart has similarly characterized collection as an exercise of "context building." Comparing the life of the collection to that of the souvenir, Stewart suggests that the collection does not displace attention to the past (as the souvenir is prone to doing) so much as marshal the past to authenticate itself. In this regard, Stewart's collection is not far from the spirit of Benjamin's; the collection being concerned not so much with "the restoration of a context of origin, but rather the creation of a new context, a context standing in a metaphorical, rather than contiguous, relation to the world of the everyday."[6] It is this creative, and at times playful, re-creation of contexts through the act of collection that allows Stewart ultimately to see in the collection the construction of a hermetic world: "to have a collection is to have both the minimum and the complete number of elements necessary for an autonomous world—a world which is both full and singular, which has banished repetition and achieved authority."[7]

·····

In 1995 the University of California, Santa Barbara, hosted an exhibition entitled "Microcosms: Objects and Knowledge (a University Collects)." The presiding rationale of this exhibition, which was codirected by Mark Meadow and Bruce Robertson, was the exploration of the material economy of knowledge associated with the "multifarious things of the world that we collect and analyze in the contemporary university."[8] Whether the sources of knowledge production themselves, the storehouses of that knowledge, or the means of their dissemination, the objects housed in a modern university can be as diverse as the instruments of an engineering faculty, the specimens of a zoological collection, the personal mementos of individual field trips, right through to the plastic fruit used as teaching aids in language classes.[9] Given the pedagogic significance of this vast array of objects, the initial impulse of the "Microcosms"

project was to address the surprising absence of scholarship regarding the epistemological status of modern university collections, as well as to establish policy directions for their continued maintenance, use, and deployment.

From its very inception, however, this initial objective of "Microcosms" was tempered by the stark realization that just as scholarly attention was finally being turned toward this area of analysis, the promises of new technology seemed to indicate that "knowledge would now most easily be examined, produced and reproduced electronically."[10] In the words of the two curators, the underlying suggestion here was that technologies of electronic knowledge production would mark the "imminent end to a phenomenon that began with the 16th-century Curiosity Cabinet: that of collecting material objects as a means for comprehending the world."[11] What was at stake then (or at least perceived to be at stake) was nearly five hundred years of a material economy of knowledge that had coexisted with, and nurtured, the more familiar textual knowledge production of the Western academy.

In the light of this early "realization," the rationale of the exhibition became, in many ways, one of recuperation. Hence, it was suggested that "Microcosms" might enable the revitalization of contemporary understandings of university material collections through the use of sixteenth-century modes of ordering objects. In doing so, it would also hold out the promise of offering much-needed analysis on the relationship between such strategies of ordering and those inherent in the emerging technologies of the late twentieth century. "Microcosms" was thus seen to highlight "interesting parallels ... between the associative process by which knowledge was generated in the curiosity cabinet in the 16th century and the web-crawling, net-surfng [sic] habits of internet use in the late 20th century."[12] Far from necessarily sounding the death knell of university collections, then, the Internet, with its surprisingly analogous penchant for the heterogeneous ordering of objects, could provide precisely the heterotopic space that would enable an invigorated understanding of the material collections that formed the basis of the academy's proprietary claims to knowledge production. Precisely at a time when museological reforms were questioning the worth of certain types of collection deemed inherently "colonial," "Microcosms" held out the promise of radically different ways of structuring, presenting, and reinvigorating such collections; ways that would specifically address the meaning and importance of material objects to the everyday practices of knowledge production within the academy.

Proceeding from the belief that one of the most productive ways of theorizing about contemporary collections was to investigate their historical and epistemological origins in the sixteenth century, the "Microcosms" exhibition consisted of two discrete exhibits. The first was a "working" curiosity cabinet in which the material objects of the university were arranged according to sixteenth-

and seventeenth-century associations; the second was an equivalent space in the form of a modern museum, presenting much the same objects but in a contemporary setting.[13]

The fundamental logic of the first exhibit was expressed in the following words of its two curators: "in our Curiosity Cabinet, we were more interested in exploring the habits of the mind that would have been employed by a visitor to such a curiosity cabinet, than in the intrinsic value of historically 'authentic' objects."[14] To this end, the "Microcosms" cabinet called upon the heterogeneity of its sixteenth- and seventeenth-century predecessors to make explicit the viewer's role in the construction of knowledge. This was achieved by transforming the familiar into the strange through the use of unaccustomed contexts, sympathetic structural associations, and the prioritization of the anomalous object.

Upon entering the first exhibit, the visitor was confronted with three *tableaux* designed to introduce different ways of seeing and ordering the otherwise heterogeneous collection of objects that characterized the curiosity cabinets of the late Renaissance. The first of these *tableaux* consisted of a stuffed caribou head mounted directly above a curved piece of Plexiglas acrylic designed to test wave formations (figure 1.1). Intended to capture a sense of the interrelatedness of the Renaissance notions of *naturalia* and *artificialia*, this pairing was designed to help attune the visitor to the compositional resemblances that exist between dissimilar objects.[15] Thus the first object represents a living creature made into an artifact, while the second represents an artificial substance modeled on nature: the two objects in conjunction displaying specific resemblances of form based on their ability to oscillate between the two poles of *naturalia* and *artificialia*.

The second *tableau* consisted of a seventeenth-century still-life painting depicting a bowl of fruit alongside a similar arrangement of plastic fruit selected from the university's French department (figure 1.2). Intended to prompt the viewer into questioning the inherent "truth value" of particular objects of material knowledge production, this *tableau* highlighted the way that within the context of a curiosity cabinet, the modern divisions between "high art" and "kitsch," two-dimensional representation and three-dimensional realism, would not hold; "naturalism" and "authenticity" were not guarantors of meaning.

The final set of items, before the viewer reached the curiosity cabinet itself, consisted of a pinecone and a pineapple set alongside the hide of a pangolin (figure 1.3). The lesson offered here was that the formal comparison of seemingly unrelated objects can be revealing of hidden resonances and similitudes: upon closer inspection, the spines of the pinecone seem to mirror the protective spines of the pangolin, thereby betraying an association between these two living beings now lost to modern notions of taxonomic order and collection.[16]

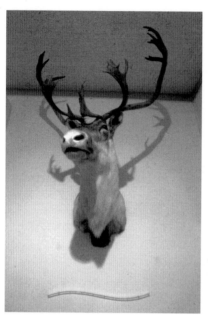 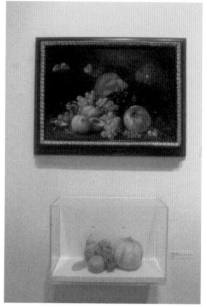

**1.1**

*Caribou Head and Plexiglas Waveform*, from "Microcosms: Objects of Knowledge (A University Collects)," University Art Museum, University of California Santa Barbara, Mark Meadow and Bruce Robertson, curators, 1995. Photo: Mark A. Meadow.

**1.2**

*Still Life by Mahu and French Plastic Fruit*, from "Microcosms: Objects of Knowledge (A University Collects)," University Art Museum, University of California Santa Barbara, Mark Meadow and Bruce Robertson, curators, 1995. Photo: Mark A. Meadow.

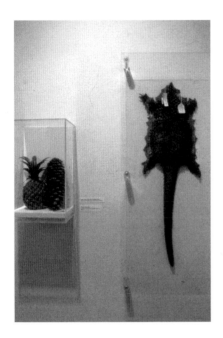

**1.3**
*Pangolin, Pinecone and Pineapple*, from
"Microcosms: Objects of Knowledge (A University
Collects)," University Art Museum, University
of California Santa Barbara, Mark Meadow and
Bruce Robertson, curators, 1995. Photo: Mark
A. Meadow.

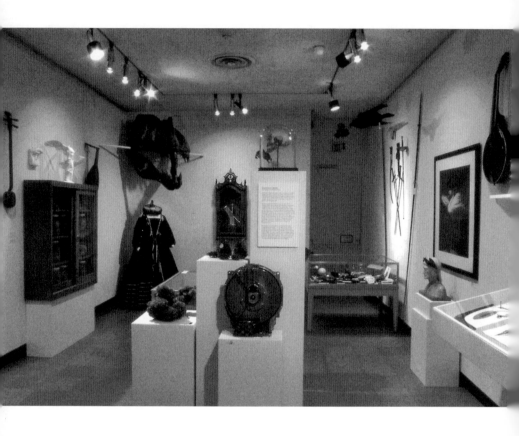

**1.4**

*Curiosity Cabinet,* from "Microcosms: Objects of
Knowledge (A University Collects)," University
Art Museum, University of California Santa Barbara,
Mark Meadow and Bruce Robertson, curators,
1995. Photo: Mark A. Meadow.

Turning the corner into the "cabinet" itself, visitors would then find themselves amid the clutter of heterogeneous objects grouped, not in pairs as in the first section, but rather in arrangements without any obvious order whatsoever, thereby leading to an infinite number of possible associations being drawn between exhibited items (figure 1.4). Following the specific lessons learned from the three previous *tableaux*, the viewer of the "Microcosms" cabinet was set free to make associations and distinctions between these objects as they saw fit. What were once familiar objects of everyday knowledge production within the academy now either clashed or resonated with unfamiliar objects in a way that spoke of nothing so much as the importance of modern typologies and classifications in giving meaning to the physical use of such objects.

It was precisely the "familiar" order of the modern museum that formed the basis of the second exhibit of the "Microcosms" exhibition: across campus, in a "modernist white box," similar objects to those displayed in the re-created curiosity cabinet were arranged in a museum setting, thereby "emphasizing issues of categorization, (over-) labeling and the paradigmatic object."[17] In the light of their previous experiences within the curiosity cabinet, this return to more recognizable systems of classification and ordering was intended to produce critical responses in visitors who now found themselves unable to make the playful and insightful associations between disparate objects under the sheer didactic weight of those typologies that characterize the modern museum. According to its curators, the radical disjuncture produced upon returning to this museum space also allowed visitors to see how modern practices of ordering and displaying objects were productive of paradigmatic or normative, rather than singular or anomalous, accounts.

The success of the "Microcosms" exhibition led to the further extension of the project beyond the boundaries of this initial venture. Attracting wide scholarly attention, the project rapidly transformed into a series of annual international conferences and workshops all predicated upon the fundamental principles extolled by the original exhibition: to use ordering techniques previously deemed archaic and outdated as a method of invigorating understandings of the everyday function of material objects in knowledge production, while at the same time providing invaluable critiques of the didactic nature of modern taxonomic classification. Two such further initiatives, each the subject of workshops held in 1999, were the re-creation of yet another curiosity cabinet, this time based on the famous description of an ideal cabinet by Samuel Quiccheberg in his *Inscriptiones vel tituli theatri amplissimi* of 1565, and the mapping of Giulio Camillo's Renaissance mnemotechnical device, the *theatrum mundi*, onto understandings of the Internet. The importance of the first workshop was stated thus: "the primacy of the Quiccheberg treatise allows

us explicitly to explore institutional origins, [while] the near perfect match between Quiccheberg's suggested range of collectibles and the contents of the modern university collections underscores the continuity of the historical tradition."[18] As for the Camillo workshop, his system of ordering the contents of the macrocosm in small cabinets, each with a corresponding symbolic representation that acted as a guide to the cabinet's contents, was read by the "Microcosms" project as nothing short of the "invention of hypertext 400 years before Vannevar Bush."[19]

·····

The "Microcosms" project is one of a growing number of museological forays into the early modern period of the sixteenth and seventeenth centuries; forays driven by reasons other than merely harvesting the past for historically "authentic" materials to display in the contemporary museum. No doubt in response to the sheer weight of critical attention that museum culture attracted in the final decades of the twentieth century, which focused precisely on the "colonial" nature of its acquisitions and its modes of inscribing objects within taxonomic hierarchies, museums now seem to be increasingly turning an eye to the "reenchantment" of their historical collections.[20] The general nineteenth- and early-twentieth-century disdain for the perceived excesses of baroque art, which extended to the curiosity cabinet's "moribund" prioritization of the monstrous or anomalous object, has now all but done a complete about-face.[21] For it is precisely the curiosity cabinet's prioritization of the heterogeneous object that is now seen as such a valuable conceptual asset in the reordering and restructuring of museum collections today. In fact it would not be unreasonable to suggest that the curiosity cabinet, as a marker of singularity and alternative ways of structuring collections, has become something of a contemporary museological trope.[22]

We can see these strategies of "reenchantment" at work in the recent turn to online exhibitions by numerous galleries and museums. Emerging from the same rationale that prompted the curators of "Microcosms" to extend the logic of the curiosity cabinet into the supposedly heterotopic space of the Internet, it has become somewhat commonplace to find museums organizing their historical collections as so-called "virtual cabinets." In the winter of 2002, the J. Paul Getty Museum in Los Angeles hosted an online exhibition entitled "Devices of Wonder: From the World in a Box to Images on a Screen," which did precisely that.[23] Compiled of objects from the museum's own material collection, the "Devices of Wonder" exhibition encouraged the (young) virtual visitor to "discover the surprising and seductive ancestors of modern cinema, cyborgs, computers and other optical devices."[24]

A similar sense of "enchantment" can be seen in the introductory remarks on an exhibition entitled "The Public's Treasures: A Cabinet of Curiosities,"

held over the summer months of 2002 at the New York Public Library. The catalog description betrays a desire on the part of its organizers to appeal to the wondrous and fabulous qualities of the objects on display:

> Ranging from the sought-after to the serendipitous, the eccentric to the exotic, the playful to the prurient, and the commendable to the condemnable, *A Cabinet of Curiosities* contains many items of a sort that would have been familiar to those who created the original cabinets, and many more that they could never have imagined.[25]

The language employed in both instances is telling of a shift from the flat utilitarian or pedagogic descriptions of a few decades ago, toward a prioritization of the sensual and tactile nature of the objects in question. Particularly with the New York Public Library's exhibition, this "dusting off" of the past so that its material culture acquires a "seductive" quality is achieved by the framing of such objects within a binary of the incongruous ("the playful to the prurient"; "the commendable to the condemnable," et cetera), which, if nothing else, ensures that these items could never be seen as mundane: the past being configured as the playground of a youthful spirit reveling in the wonderment of objects presented as strange ancestors to more familiar modern forms.

What is interesting about this appeal to the wonderment of the heterogeneous nature of the curiosity cabinets as a method of invigorating modern museum collections is the manner in which it is achieved, or rather approached. For the most part, this "enchantment" is sought merely through the repeal of more familiar taxonomic hierarchies, as if it was precisely the absence of a modern ordering system that guaranteed the epistemological status of the sixteenth-century regime of curiosity, and its claims to encyclopedic knowledge, in the first place. Enchantment comes to be defined as an absence: the absence of the modern.

We can see this logic at work even in the "Microcosms" exhibition, where the re-creation of a curiosity cabinet was inseparable from the apparatus of the modern museum that was seen as its necessary counterpart. In spite of its nuanced understanding of how the Renaissance notions of similitude and resemblance could disrupt the neat modern divisions between natural and artificial, living and dead, being and representation, or genuine and authentic, "Microcosms" equally denied the veracity of such Renaissance modes of knowledge production and ordering as being anything other than the absence of modern taxonomies. The effect of this was that "Microcosms" tended to subsume the regime of curiosity within a teleological history that effectively began back in the fifteenth century and continues unbroken to this day. The narrative is familiar enough: the curiosity cabinets were the direct precursors of the modern museum; the history of collection registers a shift from the

private encyclopedic cabinets of the Renaissance to the public, systematic, and rational modern museum—this is shown nowhere more clearly than in the fact that so many modern European museums were formed from the objects taken from dissolved cabinets.[26] What is surprising about this narrative is just how enduring it can be.

The ease with which the subtitle of the "Devices of Wonders" exhibition ("From the World in a Box to Images on a Screen") slips from the "array of fanciful eye-machines" of the past to the instruments of modern cinematography suggests nothing so much as the short (and straight) distance between modern optical technologies and their "seductive ancestors."[27] A similar trajectory is plotted in the "Public's Treasures" exhibition, this time specifically regarding the notion of "curiosity." The catalog states that "perhaps the collections of the original cabinets of wonder and our own are linked more closely by the curiosity displayed by those who collected, catalogued, exhibited and studied them—and those who continue to do so."[28] The "curiosity" that was productive of late Renaissance microcosmic collections of the macrocosm in the quest for a divinely sanctioned universal knowledge is hereby collapsed and equated with the idle wonderings of the modern museum-goer.

This overt denial of the historical specificity of "curiosity" was also evident even in the words of the two curators of the "Microcosms" exhibition. As previously mentioned, Robertson and Meadow suggested that re-creating a curiosity cabinet afforded the chance of "exploring the mind that would have been employed by a visitor to such a ... cabinet."[29] The implicit logic here is that the "curiosity" of the Renaissance can be "known" to us today, merely through the assemblage of physical objects in an arrangement lacking in modern taxonomic hierarchies.

Of course this historical continuum was there right from the outset of the "Microcosms" exhibition when its curators suggested that the promises of a new electronic age would herald the "imminent end of a phenomenon that began with the 16th-century Curiosity Cabinet: that of collecting material objects as a means for comprehending the world."[30] To suggest this was to proceed from the belief that the collection of material objects has remained much the same in meaning and significance throughout the last four centuries. Further instances of this projection can be found in the seamless mapping of Quiccheberg's sixteenth-century *Inscriptiones* onto the modern university's material collections, or Camillo's *theatrum mundi* onto the Internet itself. Even if we were to concede the somewhat dubious characterization of the modern university as the site of a universal knowledge production, to equate Quiccheberg's guide to constructing a Renaissance encyclopedic collection with the material objects accumulated within the modern university seems an epistemologically fraught exercise.

What is surprising in this regard is the sheer obstinacy of this narrative in the face of the exhibition's otherwise highly productive approach to the discursive nature of early modern knowledge formations. The disruptive effects on the perceived "naturalness" of modern typologies by the prioritization of the alternative ordering systems of resemblance and similitude, as seen in the initial three *tableaux* of the exhibition's curiosity cabinet, although entirely reliant on the museum exhibit that followed, was "Microcosms" at its critical best. Here was contemporary museology respecting the epistemological boundaries that separate the discursive formations of modern knowledge production and its ordering from that of its historical predecessors; here was contemporary museology acknowledging that just because specific items that were once found in Renaissance curiosity cabinets became the founding objects of the modern museum does not mean that those objects, or the practices that surrounded them, took the same meaning in each formation. In short, here was the inkling of a critical methodology that might have differentiated "Microcosms" from the museum practices that we were witness to in the "Devices of Wonder" and "Public's Treasures" exhibitions. Unfortunately, their similarities outweighed their differences.

·····

Regarding the task of "unpacking collection"—that is, of unpacking the various modes in which collection is practiced and theorized—Walter Benjamin's book collector proves to be an invaluable guide. For there is something in the "tactical" instincts and "oracle-like" prescience of Benjamin's collector that points to something entirely absent from our three modern curatorial efforts at reenchanting museum collections. Whether it was the evocation of a timeless sense of "curiosity" in "The Public's Treasures," or the ability of those "fanciful eye-machines" of the "Devices of Wonder," to "seduce" us with their supposed "wonder*ment*," or even the more nuanced invocation in "Microcosms" of resemblance and similitude to get us closer to the "mind" of the Renaissance collector, what was missing from each of these strategies was precisely the "magic" that makes enchantment "work."

Seeking enchantment through the absence of modern typologies and systems of ordering merely defines the heterogeneous in terms of a lack; it suggests nothing of the excesses of the aberrant; nothing of the sacredness of wonder; and nothing, really, of the "curiosity" that led to the creation of the world in miniature through the prioritization of the singular and the monstrous. All it manages to achieve is the homogenization of the heterogeneous, imprinting the logic of the modern world onto the past. And this lies in sharp contrast to the spirit of Benjamin's collector; a spirit which suggests that the task of "unpacking collection" should be full of the childlike charms of *renewing* the world. The "magic" that makes the "enchantment" of a collection work is in the

recollection, and hence re-collection, of those prized and significant objects that mark a collection as complete, not in the writing of catalogs, nor in the writing of a "history of absence," which merely effaces the fluidity of collection.

Here is the task that I wish to set before us. Rather than plot yet another history of collection—which invariably means writing yet another history of the modern museum—what I wish to undertake here is a genealogy of collection that takes wonderment and curiosity as more than just rhetorical devices or adjectival flourishes, and more than just the quaintly misguided forerunners of a "scientific" rationality that was awaiting an opportune moment to bloom. Instead, curiosity and wonderment will be taken as epistemologically discrete discursive functions with their own internal logic for the structuring and ordering of knowledge, their own practices of knowledge production, and their own relationships to representation and visual display. In short, I wish to undertake an "archaeology" of collection.

With Benjamin's book collector as my guide, I want to unpack *my* collection of the history of collection; peer *through* the covers of the texts of museum studies, and engage in a *recollection* of the regimes of wonderment and curiosity that modernity so triumphantly sought to expunge from its "enlightened" surfaces.

## Visions of Wonderment: Overcoming the Logic of the Treasure Hoard

As well as relics, churches also kept and put on show other objects, including natural curiosities and above all offerings: altars, chalices, ciboria, chasubles, candelabras and tapestries sometimes retain even today the names of their donors, while certain pictures even include the faces of them and their families. Funeral monuments, stained-glass windows, jubes and historiated capitals should all be added to the list, and doubtless other items too. Thus, besides being places of worship, each church also constituted a permanent exhibition of dozens of objects. This, however, is so familiar a subject that it needs no further elaboration.

Krzysztof Pomian, *Collectors and Curiosities*

Insofar as the significance of items collected and assembled within the medieval church is invariably reported in terms of their preciousness, their value, and their worth, I tend to agree with Pomian's otherwise abrupt evaluation: this is a subject with little need for elaboration.[31] Yet whereas Pomian's dismissal of this task is based upon his belief that such literature is, essentially, too complete to make any novel additions or detailed finds, I am more inclined to dismiss the task as one that necessarily obfuscates our ability to see beyond the secular economies of collection.

Economic history has done the history of collection a disservice. It has superimposed the idea of the "treasure hoard," with its accumulation of objects

for their material or (at best) symbolic worth across all forms of collection. The effect of this has been the preeminence of the notion of a collection's "value," even in matters of religious, intellectual, or ritual significance.

Projecting the logic of the treasure hoard upon the history of collection has two consequences. First, rather than presenting a problem to the logic of the hoard, the item crafted out of *non*-precious materials is provided with a "worth" or "value," even if it is a social, archaeological, or mythic one, so that it may sit with other treasures in commanding an exorbitant price. Hence we are told that in 1595, the Republic of Venice gave the massive sum of thirty thousand ducats for a piece of horn reported to have been from a unicorn.[32] Second, when the logic of the treasure hoard ascribes such a value to an object, this item loses its intrinsic qualities; the fables and legends that surround it are dispelled, and its curative or magical powers are lost—we forget the sound logic underpinning the Grand Inquisitor Torquemada's decision never to venture out without the protective aid of a unicorn horn, or that nearly until the cessation of the French monarchy a sliver of just such a horn would be placed in the drinking cup of the king to ward against the poison of would-be assassins.[33]

With regard to the church collections that Pomian was so loath to explore, we can see the logic of the treasure hoard binding together those items deemed worthy enough (or of enough "worth") to warrant a mention: the gold chalices, the sumptuous tapestries, and the embossed funeral monuments. According to this narrative, all of these, if not in their day then certainly in later eras, belonged to a circuit of valuable and precious items, which continue to make them the worthy subject of histories of collection today. What is interesting about Pomian's description of the items collected within the medieval church is the perfunctory nature of the first two categories he mentions: relics and natural curiosities. Either he deems them "unworthy" of being included in histories of church collections in the first place, or he believes that these two categories have been "valued" quite adequately by other authors already. This is not something necessarily specific to Pomian's account of the history of collection, as we can see it at work in David Murray's description of the objects that found their way into church collections and the reasons for them being gathered there in the first place:

> The acquisition of articles prompted by piety or superstition was no doubt on a different footing from collecting for the purposes of instruction or study, but it stimulated the taste for collecting, and secured the preservation of numerous interesting objects. The treasuries of many foreign churches still contain some of the finest existing examples of ancient art, and many of those beautiful and valuable objects which now adorn our great museums at one time belonged to churches.[34]

Note the almost incidental relationship between the items that are valued because they are "fine," "beautiful," and "valuable" (and hence worthy of collection by museums today) and what prompted their inclusion in the church in the first place: piety and superstition. There is a distinct disjuncture here between the "value" of these items and their function within the medieval church.

When relics do merit inclusion in the histories of church collection, it is invariably the gold-plated, gem-encrusted surfaces of their reliquaries that command attention, not the actual sacred fragments that are housed within.[35] The general medieval practice of labeling reliquaries with the details of the donors of specific valuable gems or stones is merely taken as a further indication of the significance of these precious materials within an earthly and temporal economy as "treasure." The church may have been "the poor man's first museum," yet it was also, according to this narrative, the repository for an earthly wealth and power; relics and their reliquaries being the means to further this end through their drawing power at the offertory.[36]

Yet if we discard the logic of the treasure hoard and search instead for how these relics and their reliquaries might have functioned, not within a temporal economy but within a liturgical and sacred economy largely devoid of such sovereign claims, we can come to see how early church collections operated within a very different register from the economy of the hoard: the regime of wonderment. Studying the relationship between sacred objects and the methods of their visualization and display within the medieval church provides an insight into how "wonder" operated as more than just the "misguided" rationale for the collection of precious and non-precious materials. I wish to characterize the regime of wonderment (like the regime of curiosity that followed it, and the regime of Enlightenment that followed that) as an historically specific discursive formation, with its own set of knowledge claims, its own methods for the production and ordering of knowledge, and its own subject positions, *even though the specifics of these may not—and perhaps should not—ever be fully grasped*. Proceeding in this fashion enables us to see why it is that most modern efforts at museological "enchantment" through the adoption of either "pre-" or "early modern" notions of collection are destined to failure, as it exposes the way that such strategies are little more than the projection of modern discourses (discourses like the treasure hoard) back onto the past. The effect of this is that the "magic" that enabled the reliquary to transfigure its beholder with a divine light, or the princely ruler to command the heavens and the earth from within their *studiolo* or cabinet, is shattered by the modern typologies that heralded the death of such "superstition" during the Enlightenment.

## Of *Lux* and *Lumen*: Reflections on the Sacred

Thus, when—out of my delight in the beauty of the house of God—the loveliness of the many-colored gems has called me away from external cares, and worthy meditation has induced me to reflect, transferring that which is material to that which is immaterial, on the diversity of the sacred virtues: then it seems to me that I see myself dwelling, as it were, in some strange region of the universe which neither exists entirely in the slime of the earth nor entirely in the purity of Heaven; and that, by the grace of God, I can be transported from this inferior to that higher world in an analogical manner.

Suger, Abbot of Saint-Denis

The place of the relic within the medieval church marked the site where the earthly intersected with the divine; as such the relic was of paramount significance to the liturgical proceedings of the church, and constituted the primacy of all that was collected there. The preeminence of the relic among all forms of collection proceeded from the rationale that the saint or martyr in heaven was actually present at the site of his or her bodily remains, thereby effecting a conflation of the altar and the tomb.[37] The relic, as a fragment of the saintly body, transcended the anonymity of mere human remains, as it was seen to be full of the life of these "very special dead."[38] The fourth-century theologian Gregory of Nyssa stated this association most eloquently when he suggested:

> Those who behold them [relics] embrace, as it were, the living body itself in its full flower, they bring eye, mouth, ear, all their senses into play, and then, shedding tears of reverence and passion, they address to the martyr their prayer of intercession as though he were hale and present.[39]

Thus the "living" saint or martyr was fully present in the fragments of their bodily remains and, because of this, possessed the ability to bridge the divide between heaven and earth, enabling them to be called upon to intercede on behalf of the devout; protecting them in their travels and curing them of their ailments. For this reason, the discovery of relics all but demanded that the pious pilgrimage to them in order to receive their blessings. Further to this, even those objects that had merely been in "contact" with this living presence or *praesentia* could now be said to manifest the actual presence of the saint, thereby constituting relics in their own right.[40] The fullness of such *praesentia*, in both bodily fragments and "contact" relics, ensured that by the Middle Ages the geographical distribution of such relics was released from the "accident" of place that was the original location of the saint's martyrdom. Rather than diminish the power of the relic, however, the discovery of new relics, or even their transference from one community or church to another, was seen as the result

of God's will and mercy, thereby adding to their "preciousness." Thus, the collection of body fragments and contact relics marked these early forms of medieval collection with an aura of the sacred.

How such relics functioned within the liturgical and sacramental practices of the medieval church is illustrative not only of why the church was an avid collector of saintly relics, but also why it amassed collections of beautifully ornate reliquaries, altarpieces, candelabra, and even natural marvels. By focusing on the liturgical practices surrounding these objects, we can also get a sense of how they were utilized to inculcate the viewer into an elaborate visual assemblage of sacredness, and how this in turn helped produce a world rich in wonder. I wish to suggest, therefore, that far from representing the mere accumulation of wealth, the collections of the church operated within a wider discursive framework that was geared toward ends quite removed from such sovereign or worldly concerns. I do not wish to claim that the gold- and gem- encrusted surfaces of these objects were viewed as "invaluable," far from it in fact.[41] Rather, I wish to suggest that their preciousness was a manifestation of their ability to function within a discourse of the sacred, whose primary purpose was to effect communion with God. Toward this end, the description offered by Stephen Bann of the presentation or, more accurately, "demonstration" of Saint Thomas à Becket's cranial reliquary in Canterbury Cathedral is highly revealing.

With no fewer than four sacred sites to the cult of Becket (the site of his martyrdom, the crypt, the Trinity chapel where he partook of his first Eucharist, and the corona of the same chapel which housed the cranial reliquary), Canterbury Cathedral was a major pilgrimage site during the twelfth, thirteenth, and fourteenth centuries.[42] The chief cultic object was the cranial relic, which was contained within a magnificently ornate reliquary, encrusted with precious stones. As part of its daily function as a cultic object, no less than the prior or head of the associated monastic order would, with great solemnity, point out each adorning jewel of the reliquary by touching it with a rod, or *radius*; adding its French name, its worth, and the name of the donor (the principal gems often being the gifts of kings) in what was a highly ritualized procedure.[43] It seems that to be a pilgrim at Canterbury Cathedral was to be a participant in an elaborate performance, which focused not only on the sacred object of the relic, but also upon the ornately decorated reliquary that housed it. To this we could also add those other objects used in the sacramental proceedings of the medieval church: the richly adorned chalices, goblets, and altarpieces, as well as the very structure of the cathedral itself. For what we are actually witnessing here, in the elaborate display of the cultic object and its reliquary at Canterbury Cathedral, is part of a sophisticated marshaling of all forms of representation, visual ordering, and aesthetic experience toward a common end: communion with the sacred. This intricate assemblage of litur-

gical practice, material collection, visual experience, and pious subject positions I wish to describe as a regime of wonderment: a complex discursive formation centered on the collection of precious and beautiful things.[44]

There are scant few indications of the discursive nature of this regime of wonderment as illustrative as that of the twelfth-century treatise on the abbey of Saint-Denis, by Abbot Suger. The at times ecstatic delight and pleasure expressed by Suger as he recalls the wondrous beauty of the objects housed within the abbey are some of the most powerful expressions of medieval piety available to us today. Believing that the house of God must also be the house of beautiful and pleasing things, Suger was possessed of a Benjamin-like "tactical instinct" for the collection and display of all manner of rare and precious items. His descriptions of the Saint-Denis possessions suggest that the cathedral was home to an assortment of wondrous items including a rock and crystal goblet formerly of Solomon's Temple, a piece of white agate upon which was impressed the likeness of the Queen of Sheba, a unicorn horn and numerous gems, gold chalices and goblets (figure 1.5).[45] The pleasure that Suger derived from viewing the rich ornamentation of these precious items was nothing so much as an indication of their beauty, and this beauty was in turn a manifestation of their ability to act as vehicles and vectors for the power of the sacred: pleasure being an integral part of the medieval discourse of piety.

Medieval aesthetics consisted of a theory of ideal proportion, as well as a more spontaneous and sensual appreciation of light and color: the latter being of particular importance to an understanding of this pious "pleasure."[46] The aesthetic beauty of the objects housed within the medieval or Gothic cathedral was in no way incidental. Rather, such beauty was a manifestation of an invisible yet present sacredness, transmitted and amplified through the luminosity of objects intricately crafted from brilliant materials, especially transparent materials such as stained-glass windows and gems.[47] The medieval sense of aesthetic beauty occurred, then, precisely at that moment of its encounter with the sacred: what made an object beautiful, and hence worthy of collection, in the eyes of Abbot Suger, was precisely its ability to propel, uplift, or "throw" one into communion with the invisible and sacred light of God or the luminosity of his martyred saints. We can see this plainly at work in Suger's description of the properties of reliquary gems (quoted above): what at first seems to be an expression of a mere sensual pleasure or intellectual contemplation of the supernatural was, in fact, an experience of a "mystical *joie de vivre*": an ecstatic transfiguration that literally lifted the subject out of the earthly realm.[48]

This sense of wonderment was not produced merely through church reliquaries; rather, every aesthetic experience of the church conspired toward this end. Painting was considered to lend didactic weight to liturgical proceedings by beautifying the house of God, while at the same time making scriptures

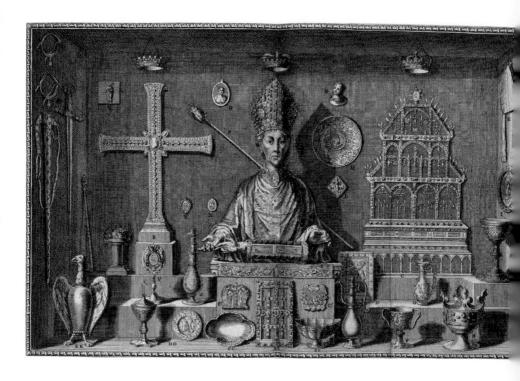

**1.5**

"Treasures of Saint-Denis," from Michel Félibien,
*Histoire de l'abbaye de Saint-Denis* (Paris,1706),
plate IV. Beinecke Rare Book and Manuscript
Library, Yale University. Representing an early
"Enlightened" survey of extant treasures at the time
of publication, Félibien nonetheless remains our
best pictorial guide to the wondrous objects housed
at Saint-Denis.

more accessible to the common people by bringing the lives of the saints to their minds. As such it constituted a "literature of laity."[49] Architecture combined the aesthetics of light and color with the theory of ideal proportion, so that every aspect of the Gothic cathedral—from the height of its vaults, the breadth of its nave, the position of its altars, windows, portals and shrines, to its very location within the surrounding landscape—conspired toward an aesthetic whole. Constructed not as an empty vessel waiting to be filled, but as the ideally proportioned conduit for the light of God, the Gothic cathedral transformed the house of God into a "foyer of grace."[50] It is here that we see the significance of the stained-glass window of the Gothic cathedral as "a relay or a place of transit through which the eye must pass to reach its goal," which was of course communion with the light of God.[51] Suger often commented on the "sapphire glass" of the windows at Saint-Denis in a way which saw them as essentially equivalent to gems in their function of beautifying the house of God through the transmission of divine light.[52]

Finally, the medieval church also possessed all manner of "marvelous" artifacts dating from the biblical past, or from the realms of God's wondrous creation: giants were mentioned in Holy Writ and their bones could often be seen decorating medieval churches, while colossal eggs, tusks, or claws brought back from the Crusades were also common. A prized possession of the abbey of Saint-Denis was the claw of a griffin presented to Charlemagne in the year 807 by the king of Persia.[53] The housing of such rare and fabulous objects within the medieval church impressed upon the collection not the mark of natural-historical inquiry, nor even historical erudition, but rather a sense of wonder. Acting like a fulcrum or a bridge, the marvelous artifact help propel the pious into divine contemplation of the sacred realm, at the same time as it marked the earthly realm with a numinous, immaterial quality; saturating the world in wonder.

· · · · ·

If we return to the description of the "performance" of Becket's cranial reliquary at Canterbury, there seems to be a discrepancy between the narrative I have just enunciated, regarding the medieval church being a discursive site for the production of a sacred wonderment, and the priority given to elucidating the monetary "worth," and the donor, of each gem encrusted in the reliquary's surface. To claim the origin of any one particular gem as being from the hand of a king or princely ruler, and to then state its worth, seems to suggest the presence of all too temporal concerns. However, although this seems to be the logic of the treasure hoard in operation, Suger himself would suggest otherwise in his description of the restoration of the "Golden Altar" at Saint-Denis (where the remains of the abbey's patron saint resided):

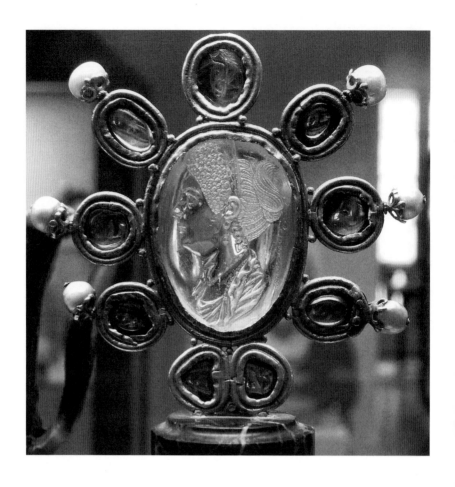

**1.6**

Crest jewel of the former "Escrin de Charlemagne,"
Cabinet des Médailles, Bibliothèque Nationale,
Paris (Photo: Sailko). The only surviving segment
of the gem-laden altarpiece known as the
"Screen of Charlemagne"; it can be seen in the
background of the Félibien plate (figure 1.5).

we have put [into the front panel of the altar], according to our estimate, about forty-two marks of gold; a multifarious wealth of precious gems, hyacinths, rubies, sapphires, emeralds, and topazes, and also an array of different large pearls. ... You could see how kings, princes and many outstanding men, following our example, took the rings off the fingers of their hands and ordered, out of love for the Holy Martyrs, that the gold, stones and precious pearls of the rings be put into the panel. Similarly archbishops and bishops deposited there the very rings of their investiture as though in a place of safety and offered them devoutly to God and His Saints.[54]

Within the sacred space of the medieval abbey church of Saint-Denis, the symbols of temporal power (precious rings and gems) were literally *transferred* to the altar, the crucifix, and the reliquaries of Saint-Denis, and were thereby *transmuted* into another form of power—the light manifest in sacred objects.[55] This was not merely the imposition of one form of sovereign power over another: the church claiming worldly dominance over both subject peoples and kings alike.[56] Rather it should be seen as the transformation of a secular and temporal power into a divine and sacred form of *aesthetic experience*, through the intrinsic "magical" nature or power of "precious" things.

Thus, whether it was the relic with its powers to cure the sick or protect the weak, the precious mineral or stone that could transmit and amplify the pleasing and beauteous luminosity of the sacred, or the natural rarity dating from an antediluvian or biblical past, the medieval church became a repository for all manner of artifacts, cherished for their marvelous or miraculous qualities. The gathering of such wondrous objects together within the architectural assemblage of the medieval church, where all constituent parts spoke of divine proportions, had the effect of producing a discursive site for the ordering of both sacred and earthly knowledge, and the marshaling of vision, representation, and aesthetics. The regime of wonderment was predicated upon the idea of collection: a collection of complex relays and circuits between light, beauty, and divinity that had the power to "throw" subjects into communion with God. Within this setting, then, collection was replete with miraculous associations, being nothing so much as an active engagement with the sacred.

. . . . .

Could there be a more accurate portrayal of Benjamin's collector than the twelfth-century figure of Abbot Suger of Saint-Denis? Suger's passion for beautiful things was not an idle delight or sensual pleasure in material wealth; rather, what made an object worthy of collection was its ability to transform and transcend the earthly. In "reflecting" upon the brilliant splendor of the luminous gold and transparent gemstones within his collection, Suger transformed "that which is material to that which is immaterial," thereby reenchanting the world through communion with the wonder of the heavenly realm of the

invisible. Is this not precisely the talismanic quality of the books in Benjamin's collection in action? Can we not see, in Suger's near-ecstatic transfiguration, the renewal of the collector's world through recollection?

It is as if the oracle-like ability of Benjamin's book collector has been at work here, making the covers of history books transparent so that the past may be telescoped into the present, refreshing and renewing *our* world, which has all but forgotten what it means to collect. For in many ways, Suger's Benjaminesque passion for collection shows us what is so plainly missing from modern efforts at reenchanting the collection: that certain *praesentia* which animates the objects within a collection, allowing them to transform worlds when they are brought together through their recollection. Far from being merely the absence of modern typologies, what "enchants" a collection is actually a presence, the presence of the sacred.

## The Rainbow Madonna: The Transparency of Scientific Knowledge

On the morning of 17 December 1996, a client at the Seminole Finance Corporation of Clearwater, Florida, noticed a strange phenomenon on the building's façade: large panes of reflective glass had become discolored, creating a three-story-high shape that bore a striking resemblance to images of the Virgin Mary. Iridescent shades of color formed a "Rainbow Madonna" with a covered head slightly tilted to one side, eyes gazing downward toward the asphalt parking lot of the corporation. Within two hours of the sighting, this parking lot was filled with curious onlookers who had come from throughout Tampa Bay, armed with video cameras and rosary beads. ... Over the course of the next few days, stories of the apparition ran in newspapers across the globe. ... Meanwhile, in Cincinnati, Ohio, a visionary named Rita Ring announced that she was receiving messages from the Mary appearing in Clearwater.

Manuel A. Vásquez and Marie F. Marquardt

The appearance of a shadowy "rainbow" likeness of the Virgin Mary in the reflective glass surface of the building façade of a financial corporation in Clearwater, Florida, is part of a spate of miraculous modern manifestations of the Madonna. Vásquez and Marquardt suggest that in the final two decades of the twentieth century more sightings of the Madonna occurred than had occurred between 1830 and 1930, otherwise euphemistically known as the "great century of Marian apparitions."[57] Within the first six months, estimates had placed the number of visitors to the Florida site as being well over one and a half million.[58] On any one day the parking lot outside the building would be full of devout or merely curious people jostling to catch a glimpse of the "miracle of Clearwater," while in front of the glass building façade, offerings of flowers, candles, and other gifts in honor of the Virgin would be placed. One

"eyewitness" report suggested that "People of all different ages, races, nationalities and beliefs daily come to pray before Mary. The crowds are orderly, friendly, and loving. There has been no negative reaction to this apparition."[59]

In July 1998 the building was leased to an Ohio-based Catholic group, the Shepherd of Christ Ministries, with the intention of turning it into a religious center with accompanying bookstore. The group erected a statue of Jesus in the parking lot and conducted evening prayer services. In an effort to raise money to help finance the running of the center, tiles were sold with the names of donors printed on them.

In the early months of 2004 vandals smashed the upper three panes of glass with the image of the Madonna's head on them, thereby creating a momentary renewal of media interest in the site. James Randi, editor of the self-proclaimed James Randi Educational Foundation, the JREF, stated in the March 2004 edition of his online newsletter, *Swift* (which he describes as an "educational resource on the paranormal, pseudoscientific and the supernatural"), that he, in the "excellent company of Richard Dawkins and members of the Atheists Alliance International group," went to Clearwater determined to get to the bottom of the Rainbow Madonna mystery.[60] After jostling their way through vendors selling "every sort of souvenir, prayer card, candle, medal, and charm," Randi and his companions took samples of the ground water there for "scientific analysis."[61] The results of these tests indicated that the water was heavy in metallic oxides, which, when sprayed onto the reflective glass surface of the building by a broken water sprinkler (now capped), had left a thin film of minerals, thereby producing the fuzzy, rainbow-like patterns on the glass. That people had seen the Madonna in these blurry streaks was mere coincidence. Scientific analysis complete, Randi was convinced that his initial skepticism had been proved correct. With a measure of triumphant commiseration he offered the following solution to the problem of the defaced Madonna:

> The weeping and wailing that went on caused quite a fuss among the faithful in Clearwater, but I have the perfect solution. New glass panes have now been put in. Simply remove the cap from the broken pipe, and restore the sprinkler system for a couple of weeks until the chemical deposit has been made again. It's that simple. Anyone can make a virgin.[62]

Anyone can make a Virgin, indeed! But can the postmodern reenchant the sacred?

. . . . .

Transparency is the catch-cry of scientific rationality. It is the unfettered gaze that demands that objects reveal themselves to knowledge, as they stand, fixed and permanent, in a world laid bare before an observing rational subject. It is

**1.7**
Rainbow Madonna. Photo: Guss Wilder / Tampa
Bay Skeptics.

CHAPTER 1

the act of science seeing through the heterogeneous, disarming its excesses and curbing its imaginative reach. Transparency is the guarantor of a rationality that peers through the sacred to find only superstition or sham.

The Rainbow Madonna, while in no real manner truly dispelled by the revelation of its mineral oxide composition, nonetheless seems to ring hollow as an expression or manifestation of a modern sacred. Perhaps the irony of its location allows us to ponder just a little too long on the seemingly "postmodern" playfulness of its quotidian manifestation; or perhaps it is our cynicism that the specter of the treasure hoard may be at work behind the bookstore or souvenir trinkets for sale; or perhaps lurking there at the back of our minds are Zygmunt Bauman's knowing words that globalization itself is a "magical incantation,"[63] or maybe it is the striking resonance with the notion of transparency (*Clear*water, rainbow, refraction, glass) that makes it hard to differentiate between the faith of those who go to see this modern Marian manifestation and those who would see it "for what it really is."

It is not that I am suggesting that the medieval church was a site totally devoid of sovereign claims; that the offertory was in no way connected to a temporal economy of earthly financial gain (though I do wonder what our histories of the church would look like if this logic were not so obvious, or *transparent*, to us). However, the "completeness" of the medieval church as a discursive site for the production of pious subjectivities in commune with the sacred does seem to sit in sharp contrast to the multiplicity of registers at work in Clearwater. Rather than being a site of wonderment, or even transgression, the "goings-on" in the parking lot of the Seminole Finance Corporation represent the simultaneous erasure of the heterogeneous and the sacred, as well as what appears to be a longing for a lost past, replete with such wonderment. Even the act of vandalism that destroyed the Marian apparition seems to reside more in the realm of modern transparency—"seeing it for what it is"— than in any meaningful act of desecration: smashing Mary seems to have *dissipated* her power, not *enhanced* it, as we would otherwise expect of a transgressive act.[64]

There is something very interesting and illuminating in this shift in the epistemological status of transparency: once the guarantor of transcendence, it is now the vehicle through which such transcendence is disciplined.

## The "Enlightenment" of Curiosity: Dispelling the Enchantment of Collection

Your letter has drawn me from the solitude in which I had shut myself up for nearly nine months, and from which I found it hard to stir. You will not guess what I have been about. I will tell you for such things do not happen every day. I have been making a list of from two to

three hundred radical words of the Russian language, and I have had them translated into as many languages and jargons as I could find. Their number exceeds already the second hundred. Every day I took one of these words and wrote it out in all the languages which I could collect. This has taught me that Celtic is like the Ostiakian: that what means sky in one language means cloud, fog, vault, in others; that the word God in certain dialects means Good, the Highest, in others, sun or fire. ... I asked Professor Pallas to come to me, and after making an honest confession of my sin, we agreed to publish these collections, and thus make them useful to those who like to occupy themselves with the forsaken toys of others.

Letter from Catherine the Great, dated 9 May 1785

Although Catherine's collection of words constitutes the kind of "typology" that marks her as a collector of an Enlightenment or "classical" age of comparative philology, there resided in the Romanov court a strong spirit of collection which had its discursive roots in the Renaissance; this spirit being one of curiosity.[65] Less than a century earlier, Peter the Great undertook his first journey to Europe and was seized by this spirit of curiosity, which manifested itself in his desire to furnish a princely *Kunstkammer* with all manner of rarities from both art and nature. On 24 April 1697 he wrote from Libau to his apothecary in Moscow: "Here I have seen a great marvel which at home they used to say was a lie: a man here has in his apothecary's shop in a jar of spirits a salamander which I took out and held in my own hands."[66] Peter's itinerary for this trip reads like a catalog of Europe's famous collections, the young Russian monarch being particularly taken by the Elector of Saxony's *Kunstkammer*, and the anatomy theater at Leiden. Possessed, now, of an unceasing thirst for encyclopedic collection, Peter charged his overseas agents with the task of gathering objects for his own cabinet of curiosities.[67] Existing purchasing accounts from the various envoys of the Romanov court give us an indication as to the types of curiosities Peter sought for his royal collection: "Bought at Amsterdam from the merchant Bartholomew Vorhagen, a marine animal, a 'Korkodil,' also a fish called Swertfish for his Highness the Tsar's personal household."[68] Like many of his European courtly counterparts, Peter had a particular proclivity for the collection of anomalous or monstrous rarities of nature. Quite apart from his collection of preserved animals, ethnographic rarities, and anatomical specimens (which included the pickled head of his wife's one-time lover, William Mons), Peter's *Kunstkammer* was also home to a "collection" of living curiosities: a young hermaphrodite (who later escaped from the *Kunstkammer*) and the "monster" Foma, a peasant boy from Irkutsk with "clawed" feet and hands. Foma's fate was intimately bound to the cabinet—serving as a guide to the *Kunstkammer* in life, upon his death Foma was stuffed and exhibited in the collection.[69] Although it is startling to modern sensibilities, Peter's

*Kunstkammer* marked him as a man of learning; curiosity being the driving force behind the Russian monarch's will to collect, as well as the overriding logic that gave such collections their epistemological meaning.

We will return to the contents of the curiosity cabinets later. In the meantime I wish to stick, at least momentarily, with Catherine and her collection of words. For although Catherine's collection places her well within an age of Enlightenment, in many ways the curiosity of the Romanov court lingers on in her early "scientific" enterprise. The solitary pleasure she derived from the task of collecting, as well as her own description of her collection as a "toy," recall the Renaissance princely predilection for a monastic, yet "playful," meditation among the artifacts assembled within the curiosity cabinet. Further to this, the compilation and publication of her encyclopedia of words recalls that one overriding logic which set the regime of curiosity sweeping across Renaissance Europe during the second half of the sixteenth century in the first place: the humanist *textual* project of assembling the Book of the World. There are few catalogs, bibliographies, or encyclopedias that do not have intellectual antecedents in this "reclamative" project, which saw all of nature as a readable text, and collection as the means for producing encyclopedic textual knowledge. So although the Enlightenment may be remembered as the age of the great encyclopedic projects of d'Alembert and Diderot's seventeen-volume *Encyclopédie* (1751), it was with the humanist project of assembling the textual evidence of divine creation into a Book of the World that such universal totality was first sought: collection during the sixteenth and seventeenth centuries being defined in terms of a regime of curiosity.[70] In fact, during the Renaissance one of the most highly sought-after, yet also one of the most potentially heretical, forms of collection was the bibliography itself, as if the possession of names and words alone came closest to the possession of secret knowledge.[71] By the middle of the eighteenth century, however, the encyclopedic project had become a repository merely for atheistic, scientific "truths"; curiosity having all but lost its proprietary claims to the act of collection and knowledge production.

Perhaps there is no easier way of plotting the shift that occurred in the epistemological status of the regime of curiosity—or, for that matter, the status of the objects that appeared in these cabinets between the time of Peter and Catherine the Great—than to start with my own collection of words, or rather, a single word. Unlike Catherine, however, I do not wish to plot the meaning of this word as it appears in different languages; rather, I merely wish to select two different instances of it, as it appeared in two separate dictionaries: Antoine Furetière's *Dictionnaire universel* (1690) and *Dictionnaire de l'Académie Françoise* (1717). Although they are separated by less than thirty years, this in fact constitutes a gulf of great significance. Furetière:

CURIOUS, He who wishes to know and learn everything. Every man is *curious* (*curieux*) to know his own fate. ...

The rarities which are collected or remarked by the *enthusiast* (*curieux*) are also described as *curiosities* (*curieux*), that is, rare, or contain many singular things, unknown to many. The secret is *curious* (*curieux*). This experiment, this comment, is *curious* (*curieux*). This man's museum is most *curious* (*curieux*), full of *curiosities* (*choses curieuses*).

The *curious sciences* (*sciences curieuses*) are those which are known only to a few, and have particular secrets, such as Chemistry, and a part of Optics, where extraordinary sights are produced by means of mirrors and glasses; also several sciences, said to reveal the future, such as Astrology, Chiromancy, Geomancy and even Cabbala, Magic, etc.

CURIOSITY, Desire, eagerness to see, learn about new, secret, rare and curious things. *Curiosity* (*curiosité*) can be both good and bad. He was punished for his *inquisitiveness* (*curiosité*). He has benefited from his *curiosity* (*curiosité*).

The Académie:

CURIOUS, He or she who is most eager and is at great pains to learn, see, possess new, rare and excellent things. Very curious *(curieux)*. Extremely curious (*curieux*). Eager (*curieux*) to know. ...

As a substantive, it designates someone who takes pleasure in collecting rare and *curious* objects or who is very knowledgeable about them. An *enthusiast's* (*curieux*) museum, he mixes daily with *those who have an inquiring mind* (*les curieux*).

CURIOSITY, Eagerness, desire, anxiousness to see, learn, posses rare, singular, new things. ... *Inquisitiveness* (*curiosité impertinente*), foolish curiosity (*curiosité*). Forbidden curiosity (*curiosité*). He has very little curiosity (*curiosité*). Too much curiosity (*curiosité*). ...

In particular, it is used for an over-zealousness to know the secrets and affairs of others. He is such a *busybody* (*sa curiosité le porte à*) that he opens every letter that he comes across. The desire to know the secrets of one's friends against their will is a sign of *inquisitiveness* (*trop de curiosité*).[72]

While the initial meaning of the term "curious" barely differs between these two accounts, note the way that Furetière's understanding of the term extends to the nature of certain objects deemed not only rare but possessed of "secret" properties. This is further reinforced by his characterization, as "curious," of a group of what could only be described as hermetic sciences (including chemistry and optics). The tenor of the entry from the *Dictionnaire de l'Académie Françoise* is quite different, however, as it suggests that the term "curious" should be applied only to the inquisitiveness of the amateur "enthusiast"; curiosity thereby being relegated to something trivial and unworthy of serious scholars.

With regard to the term "curiosity" the differences are decidedly more marked: Furetière shows evenhandedness in his approach, declaring the possibility for "curiosity" to be enlightening or misguiding; while the Académie is almost exclusively negative in its assessments of "curiosity's" worth (anxious, foolish, too much, too little ... forbidden!).

Something has happened in the thirty-odd years separating these two descriptions that has had a profound effect on how "curiosity" was viewed and functioned in relation to knowledge formation. Once seen as a productive force for the procurement of encyclopedic knowledge, curiosity has subsequently become little more than a disruptive influence on what is now deemed the primary task of knowledge production: the collection and collation of descriptive hierarchies and typologies (like Catherine's comparative collection of words). Thus, the emerging classical *episteme* of the Enlightenment would radically change how it was that knowledge was constituted and arranged, prioritizing the binary relationship between fixed and measurable elements over the fluid and moving signifiers of a Renaissance universal totality; the normative over the anomalous; analysis over analogy; and the democratic transparency of knowledge *production* over the "closeted" and aristocratic *interpretation* of knowledge.[73] The age of curiosity, which in many ways represented the ultimate expansion and extension of all elements of the medieval world, would finally come to be collapsed into the flat tables of difference of this classical age of science.[74]

. . . . .

While I do not wish to take this (largely Foucauldian) narrative concerning the changing epistemological status of curiosity to task, I do wish to suggest that something more is going on here than merely a clean rupture between two otherwise discrete *epistemes*. For there seems to lurk in the disapproving and moralizing tone of the description of curiosity offered by the Académie Françoise the specter of something disturbing and forbidden. Not something merely left behind as "outdated," "ineffectual," or "nonsensical," curiosity seems to have carried with it the taint of something imprudent, if not dangerous; that is, something deserving of eradication. Ultimately I wish to suggest that the distance we can perceive between the regime of curiosity on the one hand, and the emerging classical *episteme* on the other, is something that was both actively sought and actively maintained *at the level of discourse*. This is not something I wish to leave to the vagaries of an ahistorical individual will; my intention here is to suggest that within the very discursive practices of Enlightenment and post-Enlightenment (or modern) rationality resides a logic predicated upon the active expurgation of the heterogeneous. It is for precisely this reason that I have commenced this discussion not with curiosity's generation, but with its

demise. With Benjamin as my guide, unpacking *my* collection (about collection) is not the unfolding of a narrative of the linear history of collection, but rather an engagement with the magic and enchantment of Benjamin's book collector; an enchantment under siege in a modern age of scientific rationality.

·····

The general disdain for the forms of collection produced and nurtured by a regime of curiosity was in no way confined to this classical *episteme* of the seventeenth and eighteenth centuries. In fact, the recent museological efforts at reenchanting the modern museum (which form the point of departure for this present discussion of the discourses of collection) represent one of the few serious attempts at reclaiming curiosity from the derision that befell it in the eighteenth century.[75] Prior to these efforts, the logic underpinning the Renaissance cataloging of the world through the collection of rare and anomalous objects was dealt with by twentieth-century authors in remarkably similar ways to that of the *Dictionnaire de l'Académie Françoise*: curiosity was not only something best forgotten, it was something worthy of condemnation. Two distinct modern historiographical strategies have been employed toward these ends: one of recuperation (historical forgetting), the other of reprisal (historical condemnation).

Modernity's penchant for teleologies, particularly when it comes to the writing of its own histories, represents a type of knowing erasure: something akin to Heidegger's notion of concealment through historical revelation. Curiosity, in this regard, has represented a worrying ancestor for the history of science, making it the subject of innumerable recuperative efforts, invariably designed either to proclaim individual collectors as having been in possession of a "scientific" spirit before their time, or to suggest that certain historical collections should be seen as the forerunners of specialized modern museums. Of course, certain individuals prove easier to champion than others, as do certain collections. The cabinets of the emerging Dutch and Italian bourgeoisie have attracted particular attention in this regard. It is easier to divine the origin of natural history museums in their New World collections of flora and fauna than it is to recuperate the more disparate assemblages of medals, art, automatons, rocks, and optical devices of the aristocratic *Kunstkammern*. However, "divine" is an appropriate word here, as these recuperative histories often prove to be little more than modern historians trying to save their beloved Renaissance collectors from themselves, and from the discourses that made their supposed "scientific" predisposition available to us in the first place.

Giuseppe Olmi's efforts at championing Ulisse Aldrovandi, the late-sixteenth-century keeper of one of the most famous curiosity cabinets in all of Europe, is illustrative of this desire to save science from its "curious" beginnings.[76] Olmi's desire to see Aldrovandi's collection elevated to the status of one of

Europe's first natural history museums necessitates the prioritization of the (decidedly modern) scientific-didactic function of Aldrovandi's cabinet over its symbolic or cosmological significance. Aldrovandi's cabinet is described as being a public museum rather than a private *studiolo*, a space of scientific learning and not one of idle contemplation, and a collection prioritizing *naturalia* over *artificialia*—all of which *were* characteristics of early Enlightenment natural history museums.[77] In order to maintain this position, however, Olmi has to deal with a series of congruencies between Aldrovandi's cabinet and standard Renaissance cabinet features. He does this (largely) through the imposition of a modern subject position onto the figure of Aldrovandi, the result of which is a string of apologetic gestures. Thus, in response to the sheer number of monstrous specimens in Aldrovandi's cabinet (which would be at odds with the normalizing typologies of a classical or modern *episteme*), Olmi implies that Aldrovandi, as an astute man of science, realized that popular taste dictated the inclusion of these items.[78] Yet, as we will shortly see, the epistemological status of the monstrous was in no way incidental to Renaissance cosmology: what marked Aldrovandi as a Renaissance "man of science" was precisely his inclusion of the anomalous object; to suggest that it was merely a "knowing" tactic is to suggest that Aldrovandi occupied a position outside of discourse. Olmi utilizes this same "knowingness" to explain the lack of a recognizable modern order to the objects appearing in Aldrovandi's cabinet: "The imposed order was not one believed to exist in nature itself, but one calculated to appeal to the eye of the visitor."[79] The implication here is that modern taxonomies are an accurate reflection of nature, and that Aldrovandi was merely pandering to popular trends when he decided to "unorder" his collection.

Not something we should just dismiss as poor or uncritical scholarship, the concerted historiographical effort to declare certain Renaissance collectors "modern" needs to be interrogated further, for it has the scent of politics about it. What we are dealing with here is more than just an act of scholarly legerdemain, as the end result of these incessant forays into the past to lock Renaissance individuals into a "history of science" is the active diminishment of curiosity's claims to the history of ideas, and to the history of modern science. The individuals or accomplishments that we praise have been stripped away from the generative force of curiosity; whatever is left has generally been condemned as blind alleyways or just openly dismissed as nothing more than superstitious unreasoning.

This leads us to the second characteristic of modern historiography: historical condemnation. More than just an effect of the previously mentioned twentieth-century disregard for the perceived excesses of baroque art, this condemnation has seen to it that, until quite recently, the curiosity cabinets of the

Renaissance have received an inordinate amount of scholarly derision. What seems to confound modern authors so much in their efforts to trace the origins of modern scientific museums in the curiosity cabinets is the structural logic or "order of things" that underpins the arrangement of objects found within them (or rather, as they see it, the complete lack of logic underpinning the formation of such collections). Thus, it is not uncommon to find authors expressing open contempt for these collections and their "confused" owners. For instance, F. H. Taylor informs us that the *Kunstkammern* of the Protestant North demonstrated the disorder and uncertainty of the Germanic princes: "The strange, the wonderful, the curious, the rare were more and more welcomed by the credulous with each passing day."[80] But perhaps the most eloquently caustic of such modern commentators was Niels von Holst when he stated:

> It is necessary to mention briefly the German *Kunstkammer* (cabinet of curiosities), an expression that conjures up the image of a "Faustian" universality in collections, something peculiar to that sombrely reflective age, the late sixteenth century. At the same time when Shakespeare was writing *Hamlet*, his contemporaries were assembling all kinds of objects in a "Theatrum Mundi." Here there were early scientific and pre-scientific stirrings ... [yet] the *Kunstkammer* also served as an arsenal of alchemy and housed materials with magical powers. ... One of the Hapsburgs saw in his crystals revelations of the power of the Almighty, even the reflection of the Godhead itself.[81]

Von Holst's description of the *Kunstkammern* is at the very least dismissive, if not highly condescending, though it must be said that this condescension is not merely aimed at the encyclopedic form that Renaissance collections took. After all, this was an "understandable" enough impulse indulged in by the early modern museum. Rather, von Holst's disdain, like Taylor's comment regarding the credulity of the Germanic princes, was aimed at the perceived saturnine and disordered minds of those struck by the uncritical spirit of curiosity; a spirit which (mis-)led them to prize their "trinkets" of fossilized sharks' teeth and unicorn horns in the first place. In a gesture betraying the imaginative inadequacies of modern scientific transparency more than anything else, von Holst triumphantly announces these unicorn horns to be nothing more than walrus tusks.[82]

Yet if von Holst represents a modern dismissal of the regime of curiosity, particularly from the perspective of art history and museology, then in his words we can also find the overriding reason for this dismissal, one that hardly differs from the eighteenth-century accounts looked at previously. If Shakespeare was truly a "Renaissance man," it was because he was a man of erudition, not superstition; on the other hand, Rudolf II (the Hapsburg in question here) represents all that is worthy of derision (it is speculated that the Holy Roman

Emperor grew increasingly mad as he spent his days contemplating his strange, secret treasure instead of attending to affairs of state).[83] What proves so unfathomable to the modern eye is not so much the collection of rare or monstrous artifacts, but rather what these artifacts represented in the confines of the curiosity cabinet: a means for the nonearthly procurement of an earthly knowledge and power. Curiosity, then, with its decidedly unmodern synthesis of magic and erudition, represents all that is anathema to the transparency of modernity. In many ways modernity is much more tolerant of the regime of wonderment than it is of curiosity: when, in the guise of organized religion, the sacred is contained as something separate to modernity, something "other." What is so disturbing and intolerable about curiosity, however, is the realization that the heterogeneous is anything but "other."

·····

Returning to an age of wonderment where textual knowledge, aesthetics, and representation conspired toward commune with the sacred, we find in the fifth century the great Latin doctor of the church, St. Augustine of Hippo, decrying curiosity as a source of mortal danger, suspecting it of turning philosophers away from faith by encouraging them to consort with demons.[84] Not long after this, the seriousness of this mortal peril prompted the seventh-century scholar Isidore of Seville to impose a series of interdicts:

> Have no curiosity for those things which lie hidden. Abstain from seeking out those which are far and distant from human senses. Leave to one side, like a secret, anything which the Holy Scriptures has not caused you to learn. Seek not beyond that which is written, question not the holy teachings. Do not desire to know that which is forbidden to know. Curiosity is a dangerous presumption. Curiosity is a harmful science. It leads to heresy. It embroils the mind in sacrilegious fables.[85]

As we turn now toward the task of "unpacking" the curiosity cabinets and elaborating upon how the discourses underpinning curiosity infused collection with the sacred duty of assembling the Book of the World, we would do well to remember the lessons learned from the regime of wonderment. Curiosity was in no way merely the absence of the modern. However, to a large degree Isidore was right: curiosity necessitated a form of collection that *was* dangerous, which did at times border on the heretical, and which did espouse secret and forbidden knowledge. For the curiosity cabinets were not the storehouses of the mad; rather they were the birthplace of the first truly modern subjectivity: the knowing subject. That modernity's response to curiosity resembles and resonates so well with the fears of medieval scholars speaks, first, to the significance of the Renaissance *episteme* as a different "order of things"; and, second, to the realization that from curious things came modern forms.

## The Fox, the Fake, and the Firmament

I end the description of the stones from the Holy Land with a stone contained in this museum, taken from Lake Garda, next to the castle of Sirmione in the diocese of Verona. This stone opens into two halves. In one half, one can see a cross, formed by nature's hand in exactly the same way as a skilful sculptor would have done: it consists of two crossed pieces of rounded wood, petrified in the stone. It could be believed that God has left the memory of the Most Holy Passion he suffered for mankind in the heart of the mountains.

Ludovico Moscardo, *Note ovvero memorie del Museo di Ludivico Moscardo ...* , Padua, 1656[86]

But we men discover all that is hidden in the mountains by signs and outward correspondences; and it is thus that we find out all the properties of herbs and all that is in stones. ... There is nothing in the depths of the sea, nothing in the heights of the firmament that man is not capable of discovering. There is no mountain so vast that it can hide from the gaze of man what is in it; it is revealed to him by corresponding signs.

Paracelsus, *Archidoxis magica*[87]

Before an understanding of the dangerous and heretical nature of curiosity can be arrived at, the discursive nature of curiosity itself needs to be addressed. For it was in the discourses of Renaissance cosmology—of the microcosm and the macrocosm; in the Renaissance modes of representation—of resemblance and similitude; and in the Renaissance textual strategies of humanism—of the veneration of fragments; that we find curiosity's power to renew the world through the ultimate act of collection: the assemblage of the universal Book of the World. To possess this "book," this divine cabinet, was to grasp and understand the sacred, to behold creation itself.

The Renaissance was witness to the greatest archaeological exercise ever undertaken: humanism. With its prioritization of the art, literature, and sciences of antiquity, humanism, in many ways, constituted a vast mode of collection. Predicated on the literal unearthing of the fragments of antiquity and the translation of vague antiquarian and philosophical concerns into specific intellectual projects, humanism was to a large extent dependent upon the possession of material objects, including coins, codices, statues, medals, building fragments, fossils, and stones.[88] Just one indication of the importance of these ancient fragments to the cultural and artistic achievements of the Renaissance can be seen in the way that the discovery of individual pieces of sculpture, like the Belvedere torso, provided Renaissance artists with an oft-copied model of bodily proportion and beauty, as well as fueling interest in the portrayal of "naturalistic" anatomical detail in both painterly and sculptural compositional forms.[89]

However, apart from these direct artistic influences, the intellectual monuments of humanism tended to be the reclaimed encyclopedic projects of the ancient authors, and as such were generally textual in nature and universalizing in approach. For instance, the rediscovery and translation of Pliny the Elder's *Natural History* became an important source of inspiration to Renaissance scholars like Ulisse Aldrovandi, driving them to produce vast compendia or inventories of all the known forms of life.[90] At the same time Giorgio Vasari was compiling his *Lives of the Artists*, detailing the work and accomplishments of artists from the time of the renewal of the arts in the fourteenth century to his own day. Similar projects were undertaken in almost all fields of Renaissance academic endeavor: from natural history to anatomy, cartography to cosmology, no aspect of Renaissance intellectual life went unshaped in some way by the humanist project of antiquity's reclamation.[91] At the heart of these intellectual ventures lay the confrontation of ideas and objects, making the act of collection a central concern of the learned and curious discourses of early modern Europe.[92]

The Renaissance was also bequeathed an understanding of collection as a metaphor of creation from the medieval age of wonderment. As we have already seen, during the Middle Ages objects were valued and collected for their marvelous qualities or for their ability to transmit and reflect the miraculous work of the martyrs and saints, thereby establishing an inextricable link between collection, aesthetics, cognition, and wonderment. We can see this interrelatedness at work in the development of language: *mir*, the root of *mirabilia* (marvelous, wondrous) and *mirari* (to wonder) is also where we get the word mirror from—the mirror being a popular medieval metaphor for divine wisdom and contemplative knowledge.[93] This was coupled with the most persistent of cosmological associations between the perfection of the heavenly realm, the planets and the spheres (the macrocosm) and its symbolic reflection in the body and attributes of man (as in most Christian hierarchies of being, it was "man") and the earthly realm (the microcosm) in the great Christian metaphor of "the mirror of nature."[94] The correspondence between the macrocosm of divine creation and the microcosm of people and things meant that an appreciation of material objects was not merely a worldly vice, but rather could lead to a more mystical, imaginative, and fundamentally religious experience.[95] The metaphor of the "mirror of nature" was one that lent Renaissance scholars the impetus to celebrate divine creation through the acquisition of universal knowledge.

Thus, Renaissance cosmography perfectly wed itself with a humanist understanding of collection-as-reclamation to produce a divinely inspired notion of collection as Christian "duty." It is at these crossroads that we see one

of the major significances of the curiosity cabinets: as the celebration of divine creation through universal comprehension. Yet the Renaissance scholar was keenly aware of the inadequacies (or incompleteness) of contemporary knowledge, particularly in an age of colonial and mercantile expansion. That the pagan culture of antiquity was held to be a superior epoch worthy of emulation suggested nothing so much as the general "crisis" of knowledge that had befallen humanity with the expulsion of Adam from the Garden of Eden. The seventeenth-century German physician Johann Daniel Major, in a short treatise on the *Kunstkammern*, elaborated upon the nature of this "crisis" and the manner in which it might be redressed. Adam's fall had erased the "slate of memory" of humanity, resulting in the loss of "understanding or desire for truth and knowledge about all things of beauty in nature."[96] Major suggested that the task that faced the Renaissance scholar was the restoration of Edenic wisdom: "at least / now that the slate is clean / so far as still possible for us / something can be written upon it anew."[97] According to Major, curiosity represented a bridge back in time to the blissful state of knowledge prior to the fall of humanity's ancestors; the collections of the *Kunstkammern* becoming a metaphor for the mind's reclamation of Edenic wisdom.[98]

Yet the problem still remained of how it was that such knowledge of God's divine creation could be gained; of how it was that creation would be recognizable to the dutiful scholar if "the slate of memory" had been wiped clean of its ability to judge, to know, and to name. This, of course, had been compounded by the confusion of tongues at Babel, where the transparency of the relationship between things and words that had allowed Adam to name all of creation had been destroyed as punishment for humanity's vanity.[99] Not only had humanity lost its ancient knowledge of creation, it had also lost its primary ability to compile that knowledge. To appreciate how Renaissance scholars resolved this impasse we need to turn to Foucault's understanding of the hermeneutics and semiology of the Renaissance *episteme*. For what we find is that the acquisition of knowledge consisted almost exclusively of a task of *interpreting* the hidden signs or traces of God's act of creation that, like a signature, were written into all things. Although God had punished humanity for the transgression of its ancient ancestors, God had created the world to be known; the task that confronted the Renaissance scholar was an understanding of the *resemblances* and *similitudes* that bound all things and beings together in an endless series of hidden and secret relationships: the Renaissance scholar becoming, above all, a semiotician.

It was resemblance that, for Foucault, lay at the heart of Renaissance epistemology, guiding the interpretation of texts. The play of symbols made possible the knowledge of things both visible and invisible by controlling their

representation: "The universe was folded in upon itself: the earth echoing the sky, faces seeing themselves echoed in the stars, and the plants holding within their stems the secrets that were of use to man."[100] The world and all things were thus conceived as being endlessly related in hidden and secret ways, bound by an order of similitudes in constant circulation, replenishing and making the world anew through the sameness of its constituent parts.[101]

The theory of resemblances thus told the Renaissance scholar how the things and beings of the world were related in their sameness, and therefore opened the possibility that they might be known in this sameness. However, it did not suggest where and how these resemblances might be recognized. For this the scholar had to turn to the visible marks left on the surface of things to ascertain the invisible analogies and sympathies held within:

> It is not God's will that what he creates for man's benefit and what he has given us should remain hidden. ... And even though he has hidden certain things, he has allowed nothing to remain without exterior and visible signs in the form of special marks—just as a man who has buried treasure marks the spot that he might find it again.[102]

Thus there were no resemblances without signatures; the world of similitude, therefore, could only ever be a world of signs.[103] We can see the nature of these signs at work in the description by the mid-seventeenth-century collector Ludovico Moscardo of a literal sign of Christ's Passion in the form of a cross, imprinted within the very structure of a stone from the Holy Land (quoted above). The system of signatures or signs thus reversed the relationship of the visible to the invisible, covering the world with a vast expanse of blazons, characters, ciphers, words, and hieroglyphs that revealed the nature of the resemblances they signified insofar as they themselves were recognizable by the nature of their resemblance to what they signified. As Foucault himself suggests: "Every resemblance receives a signature; but this signature is no more than an intermediary form of the same resemblance. ... The form making a sign and the form being signalized are [both] resemblances."[104] Unlike the binary form that signs would take with what they signified in the flat tables of the Enlightenment and Modernity, during the Renaissance the sign floated freely in an endless series of resemblances and sympathies, the result of which was that these resemblances needed continual deciphering as they slid from one form of resemblance to the next. Foucault therefore characterizes Renaissance knowledge as plethoric because it was limitless, yet poverty-stricken as it condemned itself to never knowing anything other than the same thing: the repetition and sameness of all things through a system of resemblances.

. . . . .

This is an uncharacteristically finite dismissal by Foucault, one which I need to contextualize in terms of this book's own "archaeological" efforts. Perhaps the most important outcome of tracing genealogies of modern visual practices to their so-called premodern forms is precisely the ability to disrupt the abruptness of such pre- and post- categorization: genealogies have the tendency to discover the pre- in the post-, thereby muddying our sanitized and comforting distinctions between them. But more than this, such archaeologies also allow us the space to resist the urge to dismiss the binding logic of something which is now "other" to our understanding, construction, and ordering of the world, purely because it is "other." Implicit in this project has always been my belief— and here I put myself in opposition to Foucault—that scientific rationality was born, not in an epistemologically poverty-stricken age, but rather in an age of nuanced understandings and open possibilities. These would soon enough be ironed flat by the coming of the binary associations of modern rationality, but for now what I wish to convey with this present section on Foucault's understanding of the Renaissance *episteme* is a sense of the fluidity and adaptability of the knowledge claims that were made possible in an age of curiosity.

· · · · ·

In a system of knowledge where the scholar must come to know the resemblances and sympathies binding creation through the decipherment of the signs left on all things, which in turn were themselves no more than similitudes, to know must be to interpret: "to find a way from the visible mark to that which is being said by it and which, without that mark, would lie like unspoken speech, dormant within things."[105] And interpretation is above all a textual project; the space inhabited by these signs and resemblances (nature) becomes like a vast open book, the Book of the World, bristling with written signs, every page full of strange figures intertwined like a text, repeating themselves but in different orders. In this way language partakes in the universal dissemination of similitudes and signatures, being itself something that must be studied as a thing of nature; philology having the same epistemological arrangements and structures as natural history. Although deprived of its original transparency that enabled Adam to name the plants and animals merely by reading their mark, language still carried within it various resemblances and similitudes that would allow the patient scholar to see the hidden nature of things through the decipherment or interpretation of words.[106] It is here that the legacy of the Ancients proved so important. If once there was no difference between the visible marks that God had stamped upon the surface of the earth so that we might know the inner secrets of creation, and the legible words of the Scriptures, then the commentaries of the Ancients upon the text of the world provided us, already, with one interpretation of these similitudes, which the

Renaissance scholar need do little more than gather up in abundance (provided one could read, that is, interpret, the signs left in the language of the text).[107] It is here that we can start to see the enormity and significance of the humanist project of collecting together the textual work of the Ancients for an understanding of a Christian Book of the World; antiquity's pagan status was beside the point: the encyclopedic undertakings of the Ancients were nothing short of the first interpretations of a Christian world.

.....

If we return briefly to the curiosity cabinet and literary works of Ulisse Aldrovandi (whom we encountered earlier with regard to Giuseppe Olmi's efforts to pronounce him the first modern natural historian), we can see how the Renaissance *episteme*'s interpretive knowledge structures worked in relation to a world conceived as an endless series of resemblances and similitudes. Aldrovandi's cabinet was the literal (and literary, we could say) Book of the World from which the Bolognese scholar attempted to revive Pliny the Elder's project of cataloging all the creatures of God's creation. Published in 1637 as part of an ongoing thirteen-volume encyclopedia of natural history, Aldrovandi's third quadruped volume, the *De quadrupedibus digitatis viviparis*, contains within it a twenty-eight-folio-page description of the fox. Since it commences with an illustration of the fox's skeletal structure in a section entitled "Anatomica," we could be excused for seeing Olmi's point: this has the initial appearance of an Enlightenment comparative-scientific text. But if we continue through the section headings, this initial response quickly recedes: after short entries on Names, Habits, Voice, and Food, we find sections on Antipathies and Sympathies ("a fox will often bury itself in the mud with only its tail showing, shaped like a bird's neck; an irresistible avian decoy designed to lure prey"), Physiognomy, Epithets ("crafty," "sly," "cunning," and "deceitful"), Emblems and Symbols (the depiction of a fox sneering at two hounds; the motto: "security without fear"), Fables, Hieroglyphics, Proverbs ("a fox takes no bribes"), Allegories, Morals, Omens ("it is bad luck to encounter a fox on the path"), and Symbolic Images, to name but a few.[108]

Buffon, one of the great Enlightenment natural historians of the eighteenth century, was to express his astonishment at the eclectic mix of observation, quotation, fable, heraldry, and mythology represented in Renaissance natural history volumes like Aldrovandi's: "Let it be judged after that what proportion of natural history is to be found in such a hotch-potch of writing. There is no description here, only fable."[109] As Foucault points out, this was precisely the point: it was all *legenda*—things to be read. As with his contemporaries like Conrad Gestner, for Aldrovandi, natural history was a discipline forged in the library with bibliographic tools rather than direct experience: in Gestner's

*Historia animalium* (1551–1558), for instance, over eighty different authorities are quoted in the section on the fox alone, most of which were ancient authorities.[110] The point is that Aldrovandi was no better or worse an observer than Buffon, neither was he more or less credulous; his observation was merely directed toward different epistemological ends: "Aldrovandi was meticulously contemplating a nature which was from top to bottom written."[111]

. . . . .

The natural history of the fox alerts us to many of the concerns of Foucault's Renaissance *episteme*; concerns which ultimately allow us a greater insight into the purpose and functioning of the curiosity cabinets. Like most humanist projects, the bibliographic nature of Aldrovandi's natural history marked it as a "commentary," an arrangement or collection of texts with a mind to their interpretation. Whether it was a commentary on the Scriptures, on the Ancients, on fables and legends, or on travelers' tales, the act of commentary marked the proper function of knowledge, not in observation or demonstration, but in interpretation. In a system of dissociated signs circulating freely in an endless repetition of resemblances and similitudes, the act of interpretation was an "active" one requiring constant attention and repetition. In fact, it was precisely in the repetition of interpretation, of the rearrangement of commentaries, that understanding and insight could be gained. Thus, during the Renaissance, the writing of commentaries was an act of collection, an act that invited further reorganizations of that collection, not the preclusion of them, which in many ways is what modern acts of writing tend to do. Modernity's binary relationship between signs and their signifiers has tended to conflate the act of writing with the logic of the catalog: tying down ideas and meanings in definitive forms. In this regard, the modern commentary errs toward assessment and opposition, not the invitation to re-collection.

The point I wish to make here is that if nature is the *text* to be interpreted through the act of writing commentaries on it, then the curiosity cabinet is the *con-text* through which this task can be attempted. Reading the text of nature through the signatures and signs inscribed upon its fragments (which are themselves in circulation as so many resemblances and similitudes), the Renaissance scholar, within the confines of his or her curiosity cabinet, was interpreting the commentaries that objects themselves offered up to the scholar through their particular arrangement. In this regard the arrangement of a collection acted as a material form of writing. This also explains why modern authors have been so confounded by the curiosity cabinets' supposed lack of order. Far from being a lack, this absence of a strict hierarchy of materials separating and ordering the various objects within a collection was nothing so much as attention to the vital cognitive act that accompanied the "use" of a cabinet:

interpretation. It was in the successive act of arrangement, or—as Benjamin would suggest—in the *unpacking* of the collection, that illumination could be found. This also explains why so few catalogs of curiosity cabinets were produced by their owners during the life of the cabinet: the "living" cabinet, like the knowledge it so aptly represented was, to paraphrase Foucault, a thing of sand. It was the *context* from which one could interpret and track the flow and movements of these resemblances and similitudes. When catalogs of cabinets were produced, they usually accompanied the dismantling of the cabinet. During the Enlightenment, the catalog would come into its own as the preeminent form of scientific knowledge production, but in the age of curiosity, the catalog sounded the death knell of collection. It is interesting to note, in this regard, that the modern attention accorded to Samuel Quiccheberg's *Inscriptiones* (which forms the basis of arrangement of the university's material objects as a cabinet in the "Microcosms" project) tells us more about our own desires to stamp order and hierarchy across the curiosity cabinets than it does about any general strategy Renaissance scholars may have employed in their approach to assembling a cabinet. Quiccheberg's *Inscriptiones* never acted as the blueprint for an actual cabinet; rather, it was more likely to have acted as a commentary on the cabinets: a written interpretation of the act of interpreting through material collection.

No two cabinets were the same, nor did they need to be. For curiosity to act as a bridge to Edenic wisdom, it was the play of resemblances, sympathies, and similitudes that was in need of interpretation, not every instance of creation. Unlike the flat tables of Enlightenment science, the curiosity cabinet's claims to universal knowledge did not proceed from the possession and cataloging of *every* signature of God's act of creation. Rather, through the similitudes of analogy that allow the microcosm to reflect the machinations of the macrocosm, the curiosity cabinet as a microcosmic form of collection signified, as Susan Stewart would put it, "both the minimum and the complete number of elements necessary for an autonomous world."[112] That Aldrovandi's collection may have had more natural history specimens then Ludovico Moscardo's cabinet full of statues and stones merely represents the different starting contexts from which it was possible to construct an "autonomous world."

· · · · ·

The deformity of "Foma the monster," the peasant boy from Irkutsk, caught the curious eye of Peter the Great, thereby sealing his fate as a sign among many in the Russian monarch's *Kunstkammer*. Yet the unfortunate life of Foma as a living curiosity stood on the brink of an epistemological divide that would see the monstrous fade as a prodigious sign of nature's wrath, only to be eclipsed in an age of medical pathology as a fancy or a "sport"; falling between the categories on the flat tables of nature's classification.

During the sixteenth century the monster was seen as a calamitous sign; a prodigy with apocalyptic associations: "They presaged world reformation, the overthrow of the wicked, and the vindication of God's elect."[113] By the middle of that century, monstrous children and animals were dragged into town to be paraded as ill omens, the people bracing themselves for the coming of hard times. That by century's end the monster had all but lost its autonomy, dissolved its links with earthquakes, and ruptured its connectivity between the natural and the supernatural, speaks of the power of Enlightenment science to normalize the heterogeneous.

In reference to the twin effect of malaise and seduction accompanying the modern sideshow "freak," Georges Bataille suggested: "if one can speak of a *dialectic of forms*, it is evident that it is essential to take into account deviations for which nature—even if they are most often determined to be against nature—is incontestably responsible."[114] Yet in an age where portents were signs, and signs were related not in binaries but to a world of associations by their resemblances, sympathies, and *antipathies*, the monstrous was prized not for the twin values of horror and delight, but rather for the insight it afforded into the divinity of Bataille's nature: "What the collector sought, therefore, were not common or typical items, but rare, exotic and extraordinary testaments to a world subject to divine caprice."[115] The deformity that forever condemned Foma to Peter's *Kunstkammer* was the sign of nature erring, which as an *antipathy* told the Renaissance scholar as much about creation as a hundred *sympathies*. The aberration was the exception to the rule, which in turn allowed for more specific interpretations of that rule, hence the proliferation of the strange, the marvelous, and the anomalous within nearly every cabinet across Europe.[116]

By way of concluding this section, the monstrous neatly brings us to a problem that is so prevalent in the dismissive nature of modern scientific transparency: the fake or fraudulent object. Particularly with regard to the histories of the curiosity cabinets, every instance of the heterogeneous is probed for the truth that lies within it, which I would suggest is nothing so much as the search for the binary relationship each object has with that which it stands for. In this age of scientific transparency we would see the magic of the unicorn horn dispelled by its revelation as a walrus tusk; the prized bezoar is revealed to be mere dross (an intestinal stone from large animals), and the mermaid nothing more than a dugong or the torso of a monkey stitched onto the tail of a fish. To the modern eye, the curiosity cabinet's penchant for the rare and monstrous item lent itself to the excessive abuse of forgeries: "In 1685, a wolf was killed, stuffed, bearded, and masked to resemble a burgomaster whose reincarnation the wolf was supposed to be. This was then placed in the local curiosity cabinet

as visual proof of the existence of werewolves."[117] Yet in an age of curiosity, where the sign can (and has to) form multiple associations with the objects it resembles and has sympathies with, the notion of exposing the forgery "for what it is" becomes somewhat of a hollow exercise as it fails to appreciate the epistemological weight of the copy during the Renaissance. Within an *interpretive* system of knowledge where certainty is guaranteed by an object's sympathies and resonances with the "unknowable" act of creation, the copy or forgery was, like the bibliography or catalog, merely a commentary among others. To put it another way: in a cabinet, which is itself a microcosmic copy of the macrocosm, every item is a copy: the question of origins is epistemologically vacuous. When the task of the scholar was to get objects to speak of the truth that was hidden within them, a truth that only the object itself fully "knew," illumination came through the act of unpacking the microcosmic collection, of arranging the words of the text of creation so that one might interpret the signatures inscribed within all things. In this setting, the fake often pointed to higher truths.

## The Renewal of Worlds: The "Knowing" Prince and the Cult of the Machine

The next day he would look at his jewels and precious stones, of which he has a marvelous quantity of great value, some engraved in various ways and some not. He takes great pleasure and delight in looking at those and in discussing their various powers and excellencies. ... I am told that he has such a wealth and variety of things that if he wanted to look at each of them in turn it would take him a whole month and he could then start afresh, and they would again give him pleasure since a whole month had now passed since he saw them last.

Filarete (c. 1400–1469) describing the pastimes of Piero de' Medici

The Emperor [Rudolf II] is a lover of stones, not simply in order that he may thereby augment his dignity and majesty, but so that in them the excellence of God may be contemplated, the ineffable might of Him who is seen to press the beauty of the whole into such exiguous bodies and include them in the power of all other created things.

Anselm Boethius de Boodt, *Gemmarum et lapidium historia*, 1609

Lorenzo Ghiberti, one of the most celebrated sculptors of the early Renaissance, related the story of the mid-fourteenth-century discovery of an ancient statue of Venus in the city of Siena during the excavation of a building site. The citizens, seeing this discovery as a great omen, erected the statue in the town square in honor of the skill and craftsmanship of their ancestors. Later, the city entered a period of extreme financial need. This ill luck was attributed to the influence

of the statue, whereupon it was taken down from its mounting, smashed, and its fragments were buried across the Florentine border, where it was hoped it would inflict its sinister influence upon the traditional rivals of the Sienese.[118]

. . . . .

In January 1545, in a gallery of the palace at Fontainebleau, Benvenuto Cellini faced his most trying moment. Commissioned by the French monarch François I to sculpt a series of silver statues, Cellini had managed to complete only the statue of Jupiter in time for the king's visit. In order to conceal this omission and avoid the resentful ire of Madame d'Estampes, who had taken a dislike to the artist, Cellini employed an ingenious conceit: he concealed four hardwood balls in the mounting block of the statue, "arranged so skillfully that even a child could move the Jupiter back and forth or from side to side without expending any effort whatsoever."[119] Madame d'Estampes had arranged for the king to arrive in the evening, so that Cellini's work would appear dull compared to her beloved ancient statuary. But upon François's arrival, Cellini lit a candle held in Jupiter's hand, casting the statue in a radiant light, then motioned to his assistant, Ascanio, who, in Cellini's words, "slid the beautiful Jupiter forward ever so gently, and because I had constructed the device that enabled this motion quite ingeniously, that slight movement of the statue made it appear as if it was alive. All eyes abandoned the ancient art in the room, turning immediately and with great pleasure to my work."[120] François waved Madame's efforts to detract from Cellini's work aside: "Whoever wished to disadvantage this man has done him a great service. ... High praise is thus accorded our Benvenuto; his works do not merely rival those of the ancients, but surpass them."[121]

. . . . .

These two stories on statues, like the two epigraphs on the princely regard for precious gems preceding them, are concerned with the innate properties of things. The first is a story of the magical powers associated with ancient sculpture; the second is a story about the magical life-imitating qualities of the machine. Together, all four of these fragments represent qualities worthy of collection in a curiosity cabinet, as all four are illustrative of the Renaissance hierarchy of materials, which bound things and beings together in relationships of resemblance and similitude stretching from the creations of nature to the tinkerings of humanity, from *naturalia* to *artificialia*. As such, all four present themselves to us as instances of the blurring between magic and erudition that lay at the heart of the curiosity cabinet's claims to Edenic wisdom. And further to this, all four hold within them that *praesentia* that eludes the transparency of modern museological efforts to reenchant collection.

Because of this, I want to view these four fragments as bookmarks to my own collection of things that, when assembled, represent my particular approach

to the magic of the curiosity cabinets: a magic that modern authors have been quick to decry as nothing more than foolish superstition. As I have already suggested, there is something in the urgency and malice characterizing these modern histories of the curiosity cabinet that seems to point to an ambivalence regarding the nature of magic and erudition in the age of *modernity*. Curiosity seems to hold a special, disturbing power that not even the regime of wonderment seems to hold in the eyes of modern scientific rationality. Yet in order to explore this heterogeneity, which modernity so keenly sought to expunge as "other" from its proclaimed transparent surfaces, we need first to explore the nature of this magic that underpinned the regime of curiosity; a magic that the Enlightenment attempted to flatten out in its tables and catalogs, and modernity, in turn, desired to expel from between the categories of those tables. It is to this end that my four fragments will be employed.

With Foucault as our guide, we were able to see how the Renaissance *episteme* ordered and refined knowledge in ways that marked the curiosity cabinets as physical "interpretations" of the textual nature of creation. Remarkably akin to Benjamin's book collector, we saw how the cabinets provided illumination through the constant "unpacking" of their collections. The task I now wish to see completed is the end effect of this unpacking; that is, I wish to see what was deemed so dangerous about curiosity that led Isidore of Seville to place so many interdicts upon it. Essentially, I wish to plot the implications of the magical acquisition of this Edenic wisdom. For it is here that we will gain our greatest insight into the insecurities of modernity's approach to the collection of the heterogeneous.

·····

Perhaps the clearest guide to the functioning of the curiosity cabinets comes to us through the practices of princely collectors like Rudolf II and Piero de' Medici. Yet how do we make sense of their particular penchant for, among other things, glyptics (the cutting, engraving, and study of gems)? Thomas Kaufmann sees in Rudolf's vast *Kunstkammer* a form of *representatio*: a symbolic statement of imperial self-determination. Kaufmann suggests that Rudolf's *Kunstkammer* acted as the center of formal diplomatic functions of the Hapsburg court, Rudolf having spoken in and through his *Kunstkammer* by displaying either his magnanimity in the gifts he would send to other courts, or his magnificence in the collection he kept: "In an age of princely collections, Rudolf had a *Kunstkammer* that was worthy of his rank as Holy Roman Emperor, as first among European rulers: he was first among collectors."[122] Yet no matter how accurate or productive a claim this may be, it denies that anything lay behind Rudolf's love of gems, except for a somewhat romantic, slightly tortured, contemplation of temporal power. If we are ever to see anything more

than just eccentricity or madness in these pastimes of the princely rulers of Europe, then the topic deemed so nonsensical by most modern commentators on the cabinets needs to be broached: the subject of their magical properties.

If we recall Foucault's characterization of the "proper function" of knowledge during the Renaissance *episteme* as one of interpretation, we get a sense of how magic and erudition were essentially one and the same in an age of curiosity. If to know is to interpret (to find a way from the visible mark to that which is being said by it), then *eruditio* becomes a form of *divinatio*, both being part of the same hermeneutics: "Divination is not a rival form of knowledge; it is part of the main body of knowledge itself."[123] If knowledge consisted of the reciprocal cross-referencing of signs and similitudes, then magic would necessarily be inherent to this way of knowing.[124]

The point that needs to be stressed here is not that magic was an accepted mode of knowledge in an age tolerant of these things but, rather, that magic was *the* mode of knowledge.[125] In the confines of the curiosity cabinet, the act of acquiring knowledge consisted of reading and interpreting the signs inscribed in the being of all things. Yet given the nature of resemblance and similitude, to interpret was nothing short of an act of divination, the sacred text of the world being a particular "reading" of the relationship between signs and the act of creation that they signified. Whereas Enlightenment science would define an object as an empty vessel awaiting the natural historian's inscription of meaning in the form of its classification (the fixed relationship of an object to a space in a two-dimensional table), to the Renaissance scholar the object already "knew" itself, insofar as it bore the mark of creation within it (a *praesentia,* if you will). What remained to be done was its collection and recollection/re-collection so as to divine its significance and resemblance to a macrocosmic whole.

Far from being the product of madness, then, Rudolf's incessant attention to his gems was nothing short of his desire for knowledge, a knowledge that one acquired through an act of divination. In this regard, von Holst's acerbic comments have actually hit upon the secret of Rudolf's love of glyptics: "One of the Hapsburgs saw in his crystals revelations of the power of the Almighty, even the reflection of the Godhead itself."[126] This is precisely the point. If we take seriously Foucault's account of the discursive structures of Renaissance knowledge, then the indignation of modern critics like von Holst becomes curiously revealing, as what they are railing against is the idea that the princely collector was a masterly semiotechnician; magic being the end effect of a world where signs are not locked into one-to-one relationships with what they signify.[127]

Yet if this Foucauldian narrative gives us an idea of how curiosity cabinets enabled the production—or, as I now should say, the *divination*—of certain

knowledge claims, then it still remains to be seen just how these cabinets were actually used, and what the effect of their use was. This is not an insignificant question, as in it we will find an answer to the fears that prompted Isidore of Seville to place his series of interdicts upon curiosity. To inquire into the use of the cabinet, then, is to inquire how curiosity came to be seen as so heretical. Clearly the answer is not as simple as suggesting that as repositories of magical things the cabinets were *inherently* heretical: theirs was a magic, after all, in the service of divine celebration. No, what proved so heretical was their ability to produce a heretical subjectivity: the knowing subject.

As previously mentioned, Samuel Quiccheberg's *Inscriptiones vel tituli theatri amplissimi* of 1565 is generally taken to be the first museological tract.[128] However, rather than seeing the *Inscriptiones* as a guide to how to establish and order a curiosity cabinet, we can see in this account a reference to how they were "used." On three separate occasions the *Inscriptiones* refer to Giulio Camillo's mnemotechnical device the *theatrum mundi*, and explicitly to the Munich *Kunstkammer* of Duke Albrecht V by the title *Theatrum* or *Theatrum Sapentiae*, both of which are taken to be open references to Camillo's construction.[129] *Theatrum* was a general term connoting a compendium or a complete compilation on a particular theme, but Camillo's *theatrum* was a physically built space, constructed at the court of François I about ten years before Benvenuto Cellini produced his moving statue of Jupiter for the French monarch. Camillo's *theatrum* was the physical embodiment of a medieval mnemotechnic skill, used to train and extend the memory. Commonly referred to as the "art of memory," this aid to both devotion and oration consisted of populating various loci (places easily grasped by the memory—a village or house) with minutely specific *imagines* (masks or simulacra of the thing to be memorized).[130] As a technique of textual recitation, all that the scholar needed to do was "unpack" their text by walking through their memorized loci, describing the objects housed within.

Camillo's *theatrum mundi* transformed the immaterial spaces and images of "the art of memory" into a physical "theater of memory," which was designed to produce, at a glance, an understanding of the entire universe. A contemporary description of it exists which is revealing of this significance:

> He calls this theatre of his by many names, saying now that it is a built or constructed mind and soul, and now that it is a windowed one. He pretends that all things that the human mind can conceive and which we cannot see with the corporeal eye, after being collected together by diligent meditation may be expressed by certain corporeal signs in such a way that the beholder may at once perceive with his eyes everything that is otherwise hidden in the depths of the human mind. And it is because of this corporeal looking that he calls it a theatre.[131]

The semicircular stage of the *theatrum mundi* had all the cognitive qualities of a Renaissance *Kunstkammer* in that it consisted of seven tiers, bisected by seven rows, each containing closed cabinets housing objects representing the contents of the universe. On the door of each cabinet was an emblem whose sympathies or antipathies to the objects housed within held the key to ordering and understanding this world in miniature. In this setting, Camillo claimed, the microcosm (the Renaissance scholar) could fully understand and fully know the macrocosm (creation) by interpreting the signatures and correspondences of the talismanic imagery inscribed on the cabinet doors. Should the philosopher deem it necessary, any number of cupboards could be opened to reveal drawers, which in turn were full of objects/memories. Within the confines of Camillo's *theatrum mundi*, then, the individual's memory became "a mystical tool for grasping the relationships of the world and reuniting man with God."[132]

From the specifics of Camillo's *theatrum mundi*, built (significantly) at the court of one of the most powerful monarchs of the sixteenth century, to the underlying epistemological mechanics of knowledge production represented by the more general "theater of the world" of the princely *Kunstkammern* of the Protestant North or the curiosity cabinets of the Catholic South, the idea of unpacking a collection was a powerful one indeed. The curiosity cabinet as a "theater of the world" presented physical objects whose associations to the macrocosm could be divined and articulated through their visible surface signatures, and which, when taken as a totality, represented a cosmology of all creation *which included within it the position of the subject for whom this view had been constituted*. Seen in this manner, the curiosity cabinet, with its collection of anomalous and monstrous rarities, its precious stones, ancient statuary, and mechanical devices, becomes a magical theater for the production of "knowing" subjectivities: positioned at the center of the represented macrocosm, the collector becomes the microcosmic privileged point, saturated with universal analogies and sympathies. Herein lay the epistemological scandal of the curiosity cabinet. The acquisition of Edenic wisdom (the ability to name and hence to know creation) through the magical memory theater of the curiosity cabinet represented nothing short of deposing Adam as the knowing subject; this in turn was a claim to the divinity of the individual. Painted upon the ceiling of the curiosity cabinet of Athanasius Kircher (the great Jesuit philologist) was the following inscription: "Whosoever perceives the chain that binds the world below to the world above will know the mysteries of nature and achieve miracles."[133]

Recalling Kaufmann's words that Rudolf, as first among princes, was first among collectors, we can now see the magic of this association: Rudolf's micro-

cosmic possession of the world was an expression of his greater mastery over the macrocosm; mastery derived from his position as a knowing subject.

·····

A curious addendum to this narrative, one that most historians of science are keen to ignore, is that the mechanistic philosophy of Cartesian thought actually saw to the persistence of the curiosity cabinets as a mode of ordering the world, well into the age of the Enlightenment. John Locke (in echo of Johann Daniel Major) linked the imprinting of characters on the *tabula rasa* of the human mind to the filling of a cabinet. Francis Bacon conceived of natural history as though it were the collection of a *Kunstkammer*, extolling the virtues of maintaining a "goodly huge cabinet" along with a collection of rare beasts in a "spacious and wonderful" garden (see chapter epigraph for full quotation). And Descartes himself maintained that except for their size he could see "no difference between machines built by artisans and objects created by nature alone"; these words indicating that he, like other philosophers of nature, had been impressed by the curiosity cabinets, which "for three generations had been using [their] mute images to depict the transition from natural formations to art forms."[134]

This last comment by Descartes is quite revealing, as it suggests that the gentle transition of natural forms to human creations that was such a mainstay of the curiosity cabinets (seen in the shifting relationships between *naturalia* and *artificialia)* helped to promote one of the most powerful schools of thought of the early Enlightenment period: mechanistic philosophy. With the waning of belief in an interventionist God, mechanistic philosophy came to see the universe as a powerful, practical, and elegantly contrived machine, with God as its divine mechanic; the omnipotent *mechanikos*. The curiosity cabinets became one of a number of important sites where God the mechanic might come to be known and, in particular, *emulated*. Particularly in the warmer climates of the Catholic South, the Renaissance fascination for grotto art exploded in a spate of garden designs by the likes of Bernard Palissy and Salomon de Caus. Deemed one of the first empiricists by the history of science, Palissy was also an heretical follower of alchemy; his garden designs were replete with grotto and rock *gallerie*, which he conceived of as anthropomorphic "wombs," where metals became more highly developed as though in an underground laboratory.[135] De Caus made the link to the curiosity cabinets even more explicit: his most ambitious grotto design included a series of moving sculptures depicting mythological scenes, behind which lay underground workshops, laboratories, and a space for a curiosity cabinet.

Returning to the two previously discussed stories regarding the innate properties of statues, we can see how the Renaissance "hierarchy of materials" came to be so closely allied with the esoteric nature of mechanistic philosophy.

Lorenzo Ghiberti's tale of the medieval belief in the fearsomely powerful attributes of ancient statuary betrays the origins of the Renaissance conception that the art of antiquity could mediate between the formations wrought by nature (fossils) and the objects crafted by artisans (sculpture): during the early Renaissance, ancient statuary was thought to be generated in the ground itself.[136] The story of Cellini's Jupiter, on the other hand, represents an early instance of what would come to define the ultimate collusion between the esoteric arts of mechanistic philosophy and the magic of the curiosity cabinet: the emulation of divine creation through the synthesis of life. As we have already seen, one of the defining features of the curiosity cabinets was their collection of hybrid and liminal objects suspended between art and nature, living and dead. However, an equally strong impulse was the consignment of living things to death and the bringing of dead things to back to life. In this manner, "the collector was never far from the realm of necromancy."[137] From the collection of *Schüttelkasten* (small boxes housing mechanical insects and reptiles which move when shaken) to the life-size clockwork mechanical automata, the creation of life through movement was one of the most enduring forms of magic of the curiosity cabinets; one that ultimately became predicated upon the notion of a mechanized nature at play.

Within a Cartesian-inspired natural history, the aberrant or monstrous creation was stripped of its Renaissance associations with omens and portents, to be seen instead as something of a playful "joke" of nature.[138] Nature was to be seen as a playful demiurge; the curiosity cabinet as the ideal place to observe this nature at play, as well as the ideal place to limit and give direction to it.[139] The automata of the curiosity cabinets represented, then, the emulation of that playful impulse which was associated with divine creation. It is for this reason that the automata, almost without exception, were fashioned as dolls or toys, designed to delight rather than perform some "useful" task. And herein lay yet another scandal of the curiosity cabinets: not only did they represent a magical means to encyclopedic wisdom; through them the knowing subject could now emulate the playful demiurge. Whosoever was in possession of the secrets of a curiosity cabinet was, indeed, a dangerous philosopher.

·····

Reading Filarete's account of the Medici collections (quoted above), we can almost imagine the aged, arthritic Piero meticulously "unpacking" the curious rarities, the bronze medallions and the precious gems of his collection; going through each item in turn, mumbling something about their "excellencies and powers," only to return to the start of the collection to cherish each of them again. But just as we were wise not to dismiss Rudolf's efforts at divining the secrets of creation in his gems as something merely whimsical, so too we should

be careful not to dismiss the collector's passion for re-collection. The following comments were made in 1494, the year that the Medici collections were dispersed:

> In Apulia, at night, there were three suns in the middle of the sky but cloudy all about them and with horrible thunder and lightning; in the territory of Arezzo, for many days infinite numbers of armed men on great horses passed through the air, with a terrible noise of trumpets and drums; in many places in Italy holy images and statues sweated openly; many monstrous men and other animals were born everywhere.[140]

The curiosity cabinet, in many ways, represents the quintessence of Benjamin's own passion for collection: Rudolf II, Ulisse Aldrovandi, Piero de' Medici, and Peter the Great all being exemplary (book) collectors, for their passion truly did lie in the chaos of memories, the re-collection of texts, and the playful renewal of worlds. And like Benjamin's book collector, we can see in the habits of these "curious" collectors the power of re-collection, and the need to nourish and nurture a collection.

## Postscript: From Collection to Exhibition

The dates serve to remind us that a wonder-cabinet is not a museum, not even a vague or half-formed gesture toward one. Its relation to the later forms of collection is a discontinuous one, even when the objects displayed were themselves preserved and carried over. ... The museum as an institution rises from the ruins of such collections, like country houses built from the dismantled stonework of dissolved monasteries; it organizes the wonder-cabinet by breaking it down—that is to say, by analyzing it, regrouping the random and the strange into recognizable categories that are systematic, discrete and exemplary.

Steven Mullaney, "Strange Things, Gross Terms"

The Renaissance world of freely circulating signs was a world infused with magical associations; associations that allowed the regime of curiosity to invent worlds, divine encyclopedic knowledge, and portend the first truly modern subjectivity. At precisely the moment when this world was being flattened out into the transparent binary relationships of scientific rationality, the Enlightenment was indulging in one final act of heresy: the conjuring of the modern, knowing, individuated subject in the closeted confines of the curiosity cabinet.

The curiosity cabinet's ability to renew the world through the unpacking of its collection became, then, the vehicle through which the world would witness the demise of the magic that infused, as well as necessitated, the act of collection. From this moment on, collection would be a transparent affair condemned to

a binary relationship of things and what they signified, which was nothing so much as an effort to cover the tracks of modernity's heretical birth. Like a naughty child hiding its disobedience, modernity would actively deny the heresy it committed. It would gather objects and people together in vast storehouses, arranging so many things as if on display for the benefit of just one gaze. Proclaiming their worth to a rational scientific knowledge, modernity would refute the superstitions of an object's *praesentia*, claiming instead that what lay behind the sign was the "value" of the hoard; the value of commodity.

Yet always there lurked in collection the specter of the heterogeneous, the simultaneous fear and hope that the magic of collection might once again be unfettered, and that modernity would be relieved of its burden of guilt.

# Bodies

---

**2**

During the siege of Florence Niccolò Capponi, a famous citizen, died at
Castelnuovo della Garfagnana [18 October 1520], on his return from
Genoa, where he had been ambassador for the republic to the emperor.
They sent in great haste to Silvio [Cosini of Fiesole] to make a death
mask, to be copied into marble, and he did a very fine one in wax.
At this time Silvio was living at Pisa with all his family, and was a
member of the company of the Misericordia, who there accompany
condemned men on their way to execution, and being sacristan,
a most strange idea occurred to him. One night he took the body of a
man who had been hanged the preceding day out of its grave, and
after dissecting it in the interests of art, being fanciful and perhaps
believing in charms and such follies, he flayed the body and made
himself a leather jerkin of skin, supposing it to possess some great
virtue, and wore it for some time over his shirt without anyone
knowing of the matter. But one day he confessed all to a good father,
and following the priest's injunctions, he took off the jerkin and
put it back in the grave. I might relate many similar stories of him,
but I do not because they do not concern our history.

Giorgio Vasari, *The Lives of the Painters, Sculptors and Architects*

The origin of this strange belief is illustrated by the practice of
uncivilized people of the present day. Some of the aborigines
of Queensland carefully flay their slain foes, and preserve the
skin with the hairy scalp and even the finger nails attached.
They look upon it as a powerful medicine, and cover their patients
with it as with a blanket.

David Murray, *Museums: Their History and Their Use*

## Scientific Prestidigitations: The "Collection" and Repatriation of Yagan

The remains of Aborigines are not "relics" just because white people claim them to be. Like other humans in the world, the remains of our dead are for the families and the people of the deceased to deal with according to our culture.

....................................................................................................................................................

Michael Mansell, Aboriginal lawyer and activist

In September of 1833, ensign Robert Dale left Australian shores for London in possession of the smoked head of Yagan, a warrior and early resistance leader of the Noongar peoples of southwest Western Australia, a region surrounding the then-fledgling Swan River colony. Dale's express intent was to sell the head of this once feared warrior as a "medical curio" to the highest bidder. Upon his arrival in London, however, Dale found it difficult to convince either phrenologists or anatomists of its worth, and eventually ended up striking a deal with surgeon, antiquarian, and London socialite Thomas Pettigrew, who leased the exclusive right to "use" the head for a full calendar year. Pettigrew, who had studied anatomy under Johann Friedrich Blumenbach and was well known for throwing parties in which he would conduct autopsies on Egyptian mummies for the entertainment of his guests, displayed the head in his parlor before a panoramic view of King George Sound, drawn from sketches made by Dale.[1] An evening's entertainment at Pettigrew's Savile Row abode would not be complete without the purchase of a small pamphlet, which included phrenological observations of the head that neatly accorded with the white settler description of Yagan when he was still alive: "there are indications of an impatient, irritable, and violent temper; of a domineering and overbearing character."[2] In October 1835, Pettigrew returned the head to Dale, who had subsequently moved to Liverpool. From this time onward, the fate and whereabouts of Yagan's head became lost to his peoples, until recently.

On 20 May 1997, Aboriginal political leader and Noongar spokesman Ken Colbung arrived at Heathrow Airport in an attempt to exert political pressure on the British government for the immediate exhumation and repatriation of Yagan's head. Since the early 1980s various Noongar groups had sought the location of their ancestor's head so that it might be reunited with its body and homeland. It was not until December 1993, however, that the head's exact location was determined, and Colbung was entrusted with the task of bringing Yagan back. Upon disembarking from the plane, Colbung is reported to have challenged the then British Home Secretary, Jack Straw, to a spear fight.[3] The impetus for these actions, and the gravity of the task at hand, were echoed in Colbung's words:

It is Aboriginal belief that because Yagan's skeletal remains are incomplete his spirit is earthbound. The uniting of his head and torso will immediately set his spirit free to continue its eternal journey.

Yagan's head had been buried in plot 296, section 16, of the Everton cemetery where it had been interred along with a Peruvian mummy and the tattooed head of a Maori, all of which had been on display in the Liverpool City Museum until 1964, when their advanced state of decay necessitated their being removed from exhibit.[4] Yet exhuming these remains was proving to be a complex legal affair, as sometime after 1964 twenty stillborn children from a local hospital had also been buried in the same plot. The Burial Act of 1857 required that the next of kin of these children grant their consent before any of the remains could be disturbed; and such consent was not forthcoming. In 1995 Colbung's request that the Act be repealed because of the significance of Yagan's remains to both his descendants, and to Australia's history in general, proved unsuccessful.

Colbung's visit to the United Kingdom did, however, help garner support for Yagan's repatriation. An extensive electromagnetic survey of the grave was conducted, thereby pinpointing the precise location of Yagan's head in relation to the other bodies interred there. Colbung pushed for exhumation before the one hundred and sixty-fourth anniversary of Yagan's death on 11 July, but on 15 July he departed London empty-handed.

In Colbung's absence, and without his knowledge, Yagan's head was successfully exhumed by tunneling vertically down through an adjacent grave, and horizontally across without disturbing the bodies of the children that lay above. Yagan's head remained for a month in yet another museum, where its identity was confirmed from descriptions of the skull (and the fractures caused by the fatal gunshot wound) recorded by Charles Pettigrew. Finally, on 31 August it was presented to a Noongar delegation that included Ken Colbung and other community leaders. Controversy was to surround this repatriation ceremony, as it was reported that Colbung had linked the return of Yagan's head with the death of Diana, Princess of Wales, who had died that same day:

That is how nature goes. Nature is a carrier of all good things and all bad things. Because the Poms did the wrong thing they have to suffer. They have to learn too, to live with it as we did and that is how nature goes.[5]

· · · · ·

The repatriation of Yagan's head is part of a wider controversy affecting university and museum collections around the world.[6] Yet in many ways, Yagan's story of repatriation is not typical of its kind in that Western science had already given up his remains as being no longer of any use to its narratives of evolution, superiority,

and control. Of course, this has more to do with the decay of human flesh than it does with the decline of these theories in general; many of them live on, embedded behind the façade of science's supposedly transparent knowledge claims. What is interesting in this regard are the apologetic claims of such institutions for not returning human remains. Although the "folly" of phrenology or eugenics may be quickly acknowledged, to claim that indigenous remains still have a place within these scientific storehouses because they are part of a "global heritage" completely denies the method of their acquisition; a method that is not as distanced from the present as we would like to believe.[7] Further to this, there is an alarmingly short distance between the paternalistic tenor of nineteenth-century Empire and present utopian notions of a "global order" or "global capitalism" that underpins concepts like "world heritage." That it is the same Western institutions which are deemed the most appropriate custodians of such heritage seems to go largely unnoticed. That it is the same engines of global capital that help maintain the continued subjugation of indigenous peoples is flatly denied.

Yet in many ways Yagan's case *was* different from most stories of the repatriation of indigenous remains, insofar as Ken Colbung and the Noongar people's interlocutors were not so much the institutional spaces of science, but rather British burial customs. I make note of this, not so much to seek a reprieve for such institutions, but rather to highlight that customs and beliefs about the appropriate handling of the dead are as much part of Western structures of knowledge, including scientific discourses, as they are of non-Western ones.

If the story of Yagan's repatriation is somewhat atypical, then the story of how his head became a medical and anthropological curio in the first place is anything but …

In 1829, Captain James Stirling established the Swan River colony, determined to avoid the bloodshed that had marked the settlements in both New South Wales and Tasmania.[8] Early settlers knew Yagan as a negotiator, often assisting in the distribution of the flour and clothing offered by white settlers as compensation to Noongar people for the use of land. But as settler cattle drove indigenous food sources further off the land, Noongar warriors began taking cattle as reparation, which under British law was theft, resulting in several killings. Yagan warned colony officials that Aboriginal law required that they take a life for each life taken. Then, in December 1831, Yagan and his father Midgegooroo were alleged to have killed the servant of a local farmer in retaliation for the deaths of several Aboriginal men found taking livestock. Further conflicts led to the successive deaths of Yagan's brother Domjuim as well as his father Midgegooroo. Yagan was declared an outlaw, and a bounty of £30 was placed upon his head.

On 11 July 1833, two teenage farmhands, James and William Keats, approached Yagan and his traveling partners, persuading them not to journey to the nearby homestead to collect supplies as an armed party lay in wait there. The Keats brothers suggested Yagan would do well to follow them to a safe distance and accept their offer of food. According to the *Perth Gazette*, what was to follow was nothing short of a "wild and treacherous act." Apparently desperate to leave the colony, but without the means to do so, the young Keats brothers seized their opportunity when Yagan and his men began to take their leave. The elder brother, William, raised his rifle and shot Yagan from behind. The younger brother, James, shot a companion of Yagan's, a man called Heegan. The two brothers attempted to flee, but William was overtaken and speared to death. James escaped over a river and returned with an armed party. Upon their return Heegan was discovered alive, but was killed with another gunshot. Yagan was decapitated and the tribal markings were skinned off his back, the bodies being buried a short distance from where they were killed. Yagan's head was then taken to the nearby homestead, where it was smoked in the hollow of a tree for some three months to preserve it. The entrepreneurial Robert Dale, the first European explorer to cross the Darling Ranges, persuaded the governor to give the head to him as an "anthropological curiosity," and so Yagan's head came to leave his homeland.

·····

There are few images as arresting as a line of human skulls in an ethnographic or anthropological museum. It is a *tableau* that has marked the modern museum with a kind of Hegelian death wish; simultaneously invigorating and haunting the structures of knowledge that circulate around and within it. Yet in light of the previous chapter, we can now say that this ambivalence has little to do with the objects in question, but rather with the historically specific discursive formations that codify, order, and arrange these objects in relation to others. There is nothing "natural" about the order that binds things together in a collection. Because of this, the meaning of a body fragment such as a skull will never enjoy a fixed relationship to the items it is grouped with in any collection. Throughout history the skull has been the sacred relic housed within a pilgrimage shrine, the ingredient from the apothecary's shop to cure madness, the divine blueprint for the proportions of the Gothic cathedral, the *memento mori* of the Protestant humanist, the curio trophy of the white hunter, the proof positive of evolution's veracity and the damning evidence of its vagaries.

The story of Yagan's head (of how it was procured, of how it was displayed, and finally, of how it was discarded) likewise tells us much about how modern discursive formations structure and arrange objects in relation to each other. For instance, it has already been observed that a very definite fiscal economy

underpinned Robert Dale's impetus for taking Yagan's head in the first instance: the lucrative trade in body parts that formed the basis of many a museum's collection.

Further to this, we can see in the parlor tricks of Charles "Mummy" Pettigrew, as he was affectionately known, a worrying conflation of science, entertainment, and specular commerce: he may not have charged admittance for the chance to gawk at human remains at his London parties, but he certainly was not above charging for his phrenological observations in the form of a souvenir pamphlet.

A similar sense of "stagecraft" has always underpinned the way science has been able to make dead matter speak. With regard to the collection of indigenous remains, the effect of such "prestidigitations" has been an alarming conflation of mutilation, retributive justice, science, and governance. We have already seen how the phrenological description of Yagan after he was dead neatly accorded with the sentiments of white settlers while he was alive. Taking the anthropological or medical "curiosity" to London and making it speak of either the "degeneracy" or "savagery" of the person while s/he was alive functioned to legitimize that person's violent death as something equally "natural." The collection of severed heads was thereby neatly expunged of any culpability for those deaths. Turnbull has suggested that phrenology's ability to make skulls speak in this fashion had the further benefit of providing colonial administrators with an irrefutable logic for paternalistic governance in that it legitimated further expropriations of land, culture, and bodies in order to save those people from their own savagery:

> Heads were made to perform a new identity, that of national character or temperament. In the process, moreover, the heads strengthened the claims of the metropolitan anatomists and phrenological entrepreneurs to have produced knowledge capable of bringing order and humanity to the task of governing Britain's savage Australian subjects.[9]

Pettigrew's phrenological observations of Yagan's skull are suggestive in this regard, for in addition to the obvious signs of a "violent and irritable temperament," Pettigrew also detected evidence to suggest that "moral education, or good patriarchal legislation might have averted the tragedy played out in the upper Swan valley."[10]

The links here between retributive justice (killing Aborigines for taking livestock), the acquisition of scientific specimens (mutilating their dead bodies), and paternalistic colonial governance (expropriating their lands and bodies) are disturbing ones indeed.

.....

In her article "Objects of Ethnography," Barbara Kirshenblatt-Gimblett characterizes the ethnographic display in the following way:

> Ethnographic displays are part of a larger history of human display, in which the themes of death, dissection, torture and martyrdom are intermingled.[11]

It is a sentence that for years has captured my imagination as well as disturbed it. Lurking within it is the suggestion that only the thinnest of lines separates the cognitive vivisection of the living ethnographic subject from the actual dissection of that subject's corpse on the anatomist's table. This disturbing slippage is something of a commonplace in stories of people being taken to Europe to be paraded before crowds of onlookers, be they scientific or otherwise. One has only to think of the ease with which the body of Saartjie Baartman, commonly known as "the Hottentot Venus," moved from being the living embodiment of primitive sexuality to anatomical fragments of the same, to appreciate that Kirshenblatt-Gimblett's statement may be more than just "suggestive."[12] Likewise, in the request by Charles Byrne, the "Irish Giant," to be buried at sea in an effort to avoid ending up in the hands of anatomists we can see the fears of a man already sized up and vivisected by the curiosity of science while he was still alive. Byrne's fears proved fully justified: his remains are possessed by the Hunterian Museum in the Royal College of Surgeons, London, to this day.[13] And finally, with the story of Yagan, the "curious" economy of mutilations leading to phrenological pronouncements, and back to more mutilations, cannot help but raise the specter that these slippages are somehow constitutive of the sciences in question.

It is precisely this last point that forms the critical thrust of this chapter: that modern sciences concerned with the living body are actually marked by the presence of the *dead* body *from which that knowledge was constituted.* We can see, in their constant efforts to animate corpses, to speak through skulls, and to conjure the spirit of the living, the ever-present desire of these discourses to transcend their own associations with the dead. And here I do not merely mean that dead bodies form the subject of their inquiries, or that these discourses merely have a metaphorical relationship to death. Rather, I am suggesting that these knowledges are marked both epistemologically and ontologically by their relationship to retributive justice, to torture, to mutilation, and to death—that is, that death is part of what binds and structures them as knowledge.

There are numerous histories of ethnography and ethnographic displays. I am not attempting to add to this body of literature. Rather, following in the same vein as the previous chapter, I shall proceed "archaeologically" through the

scopic regimes of the one discipline that constantly underpins both nineteenth-century anthropology and ethnography in terms of their "performance" and procurement of bodies—medical anatomy. The history of medical anatomy is, in many ways, the history of avoiding the epistemological scandal of "killing" the body by looking inside it (of counteracting the effects of the gaze that invalidates the bodily whole), as well as the subsequent efforts at recuperating that body as a "living" body of knowledge (the transformation of *corpse* into *corpus*). More than just being possessed of a "death gaze" that nullifies the living through a cognitive vivisection, medical anatomy (and, by extension, Western medicine and its cognate disciplines, such as ethnography) is haunted by its epistemological association with the grave.

Furthermore, in keeping with the general thesis that science constantly seeks to expunge the heterogeneous from the face of modernity, I wish to suggest that this animation of dead matter is nothing short of an act of mourning for the sacred—the vital spirit that invigorates the icon. This we can see in science's moribund collection of "relics" and its constant acts of defacement.

### The Three Tasks of Andreas Vesalius: A "Biography" of Anatomy

Because of the outbreak of war I returned from Paris to Louvain where, while out walking … I came upon a dried cadaver … which had been partially burned and roasted over a fire of straw and then bound to a stake. Consequently the bones were entirely bare and held together only by the ligaments. … Observing the body to be dry and nowhere moist or rotten, I took advantage of this unexpected but most welcome opportunity and … climbed the stake and pulled the femur away from the hip bone. Upon my tugging, the scapulae with the arms and hands also came away, although the fingers of one hand and the patellae as well as one foot were missing. After I had surreptitiously brought the legs and arms home in successive trips—leaving the head and trunk behind—I allowed myself to be shut out of the city in the evening so that I might obtain the thorax, which was held securely by a chain. So great was my desire to possess those bones that in the middle of the night, alone and in the midst of all those corpses, I climbed the stake with considerable effort and did not hesitate to snatch away that which I so desired. When I had pulled down the bones I carried them some distance away and concealed them until the following day when I was able to fetch them home bit by bit through another gate of the city.

With considerable effort I obtained the missing hand, foot and two patellae from elsewhere and prepared this skeleton with such speed that I was able to convince everyone that I had brought it from Paris. Thus any suspicion of having made off with the bones was destroyed.

Vesalius, *De humani corporis fabrica*, 1543

There is a certain kind of charm to the gleeful boastings of the young Andreas Vesalius, dodging city officials to finally claim his prize of an armful of moldering bones.[14] Yet it is a charm that quickly fades as we realize that in Vesalius's nightly sojourns we are actually bearing witness to the type of opportunistic curiosity that would fill museum warehouses with countless specimens in the years to come. We can see in Vesalius's insatiable desire for body parts— matched here only by his practicality in obtaining them—the emergence of a "spirit" that would come to define what it meant to be scientific. Armed with a keen eye for experimental observation and a will to put his own "hand to the matter," Vesalius, in an act of historiographical legerdemain, has come to represent the literal embodiment of the so-called "anatomical Renaissance."[15]

It is one thing to claim, as his most recent modern biographer has done, that "Andreas Vesalius is now recognized by most scholars as the founder of modern anatomy."[16] Or that Vesalius was one of a very small number beginning to cast aside the restrictive taboos regarding the opening up of the human body for pedagogic purposes, and thereby can be seen as laying the foundation stones of modern anatomy, "by his factual contributions ... by his method of presentation and by the scientific principle he enunciated as fundamental to research."[17] In this regard Vesalius is universally seen as having "affirmed the educative potential of dissection on the one hand and, on the other, provided a tool for an empirical verification of that anatomical knowledge."[18] It is quite another thing, however, to conflate the body of the man with the body of the science. Yet even the most cursory of glances through O'Malley's biography of Vesalius would be enough to give this impression: that the biography of the man, punctuated as it is with anecdotes from Vesalius's own hand, is somehow assumed to be the history of a burgeoning discipline.

Thus, as we are taken through the exploits of the individual, we are simultaneously being led through those landmarks that constitute the history of anatomy as a science: the construction of the first articulated skeleton (Louvain, 1536); the overthrowing of the time-honored academic "division of labor" by waving aside the barber-surgeon, stepping down from the *cathedra*, and conducting the visceral dissection by his own hand (Padua, 1537); and finally, breaking the deep-seated humanist aversion to textual illustration with the publication of the first, truly anatomical "atlas," the *De humani corporis fabrica libri septem* (Basel, 1543). It is, however, a narrative that is not without its uses.

We have already seen the "spirit" of scientific curiosity manifest in Vesalius's body-snatching escapade in Louvain. More than just a personal anecdote, this episode is taken to mark the advent of a series of observational techniques that codified the body as a site of both representation and knowledge production. Vesalius's collection of body parts was, after all, not without purpose: the

fragments in question were mounted as an articulated skeleton to be employed during lessons in osteology. In this matter we can see the first tentative steps toward an epistemological rupture from the previous regime of medical training that was bereft of such visual prompts or aids. This is not merely to suggest that humanism, in its efforts to emulate the textual practices of the Ancients, was loath to use textual illustration on any subject hallowed by ancient authority (though this was certainly the case).[19] Rather, it is equally suggestive of the lack of representational precedent that would allow pictorial embellishments to elucidate textual meaning. As we shall see with the practice of public dissection, this relationship extended beyond the confines of the text to at least partially dominate the relationship between anatomical knowledge and textual authority in the anatomy theater; the presence of an actual corpse being far from necessary.

· · · · ·

As for the second "task" of Vesalius, I will let his own words act as an introduction:

> My intention could by no means have been fulfilled if, when I was studying medicine in Paris, I had not put my own hand to the matter but had accepted without question the several casual and superficial demonstrations of a few organs presented to me and my fellow students in one or two public dissections by unskilled barbers. So perfunctory was the presentation of anatomy there where we first saw medicine re-born that I, experienced by several dissections of brutes under the direction of the never-to-be-sufficiently-praised Jacobus Sylvius, at the third dissection at which I was ever present and at the urging of my fellow students and teachers, conducted it publicly and more completely than was usually the case. When I conducted it a second time—the barbers having been waved aside—I attempted to display the muscles of the arms as well as to make a more accurate dissection of the viscera, for, except for eight abdominal muscles shamelessly mangled and in the wrong order, no other muscle or any bone, much less an accurate series of nerves, veins, or arteries was ever demonstrated to me by anyone.[20]

The first recorded dissections of the human body post antiquity were executed in the early fourteenth century at the university of Bologna as part of the training of new physicians. The earliest existing university statutes relating to these anatomical demonstrations date back to 1405, and are revealing of highly structured and regulated proceedings that took the form of an anatomical lesson with an accompanying dispute. The strict protocols that governed the attendance of students, the procurement of the cadaver, and what text was to be recited, tend to indicate that these lessons were undertaken for more than just their pedagogic function.[21] The ceremonial nature of these public anatomies seems well characterized by Heckscher's description of them as "the fêtes of the universities."[22] With a near-theatrical solemnity the presiding *praelector* would read, or recite from memory, a Latin anatomical text (usually

Galen or one of his "commentators") from the vantage point of the elevated *cathedra*, pausing only to add commentary if deemed necessary. Below, in closer proximity to the cadaver, the *ostensor* would indicate or demonstrate to the audience, with the use of a cane or *radius*, the relevant parts of the anatomy on the dissected corpse, often repeating the words spoken by the *praelector* or translating them into the vernacular.[23] The actual dissection of the corpse would be carried out by a butcher or barber-surgeon, with little or no Latin training, indicating that such exercises were at the very least deemed menial, if not completely marginal to the pursuit of academic knowledge. Glenn Harcourt states it thus: "As a resolutely manual operation, the actual conduct of a dissection simply lay outside the proper exercise of the professorial office."[24]

In this scene, authority resided with the figure of the *praelector*, or more precisely with the *text* from which the lesson was being conducted. The function of the cadaver was to receive rather than transmit knowledge; it was the passive recipient of an ancient textual knowledge spoken *ex cathedra*.[25] The relationship between this authority and the dissected body was fundamentally ostensive: the role of the *ostensor* being to demonstrate or verify this ancient textual authority in the cadaver itself.[26]

Vesalius was scathingly critical of this division between those who actually conducted the dissection and those professors who sat, "like jackdaws aloft in their high chair, with egregious arrogance croaking things they have never investigated but merely committed to memory from the books of others."[27] Frustrated with the barber-surgeon's inability to describe what it was he had just dissected, yet galled by the physician's inability to put his hand to the matter, Vesalius was dismissive of the entire exercise: "every thing is wrongly taught in the schools, and days are wasted in ridiculous questions so that in such confusion less is presented to the spectators than a butcher in his stall could teach a physician."[28]

Skilled with the surgeon's blade, and proclaiming himself to be the custodian of an inquisitive spirit based on direct observation, Vesalius would come to challenge not only the academic hierarchy of his day, but a thousand years of academic tradition in doing so. In his firebrand performances over the bodies of numerous dissected corpses, Vesalius would openly challenge his teachers and colleagues as to the ancient descriptions of the inner structure of the body. This scandalous behavior led his former Parisian mentor, Jacobus Sylvius, to publish a public denunciation of Vesalius's claims entitled "A Refutation of the calumnies of a certain madman."[29] But, for our purposes, what is of interest here is the epistemological scandal that Vesalius's actions connote. By dispensing with the roles of the dissector and the *ostensor*, and performing those functions himself, Vesalius was displaying a proximity to the body that had been absent

from the knowledge claims of anatomy for centuries. Vesalius's relationship to the body was no longer ostensive, but rather demonstrative: the body now becoming a site from which knowledge was derived. Luke Wilson has suggested that with this new proximity of bodies, anatomical knowledge necessarily became performative in nature. What was on display here was both the body of the cadaver and the body of Vesalius showing the body of the cadaver: "the static spectacle of the authority of the text has been superseded by the dynamic performance of an identifiable performer who, both in his own corporeal particularity and in his physical contiguity with the cadaver, finds himself fundamentally not unlike the body whose structure he performs."[30] The strict hierarchy between living and dead that had once been maintained through academic ritual now became quite blurred as anatomist and cadaver oscillated between being the subject of an anatomist's gaze and being the agent of knowledge claims about the body.

Vesalius's second "task" complete, anatomy would fully develop this performative aspect of the gaze, turning the staid affairs of the academic demonstration into "grand" or "public anatomies," where hundreds of curious laypersons would flock to see the spectacle of the human body dissected. But for now it is enough to leave Vesalius as the one (so historians of science would have us believe) who transformed the textual and descriptive anatomy of the Ancients into the performative and investigative "science" of modernity.

For Vesalius's final "task," I will again let his own words act as an introduction:

> Now I must recall the judgment of certain men who strongly condemn the presentation of anatomy to students, not merely by words but also, no matter how exquisitely executed, by pictorial delineation of the parts of the human body, maintaining that it is necessary for these things to be learned by careful direct observation of the parts themselves, as if I had inserted illustrations—very correct ones, and would that the illustrations of the parts were never spoiled by the printers—on the text so that the student relying on them might refrain from dissecting cadavers; whereas, on the contrary, I, with Galen, have encouraged the candidates of medicine in every way to undertake dissection with their own hands. ...
>
> Nevertheless, how greatly pictures assist the understanding of these matters and place them more exactly before the eyes than even the most precise language, no student of geometry and other mathematical disciplines can fail to understand. Furthermore, the illustrations of the human parts will greatly delight those for whom there is not always a supply of human bodies for dissection.[31]

Perhaps more than any other single achievement it is the publication of the first anatomical atlas, the *De humani corporis fabrica libri septem*, which

has occasioned such a conflation between the man and his science. As one author so categorically puts it: "Anatomy became a scientific discipline with the publication in 1543 of Andreas Vesalius' *Fabrica* [*sic*]."[32] Published in the same year as Copernicus's *De revolutionibus orbium coelestium* (clearly a year of significant portent for scientific achievement), Vesalius's anatomical atlas is deemed so constitutive of modern anatomy because of the enduring legacy of its iconic osteological and myological illustrations. There are very few modern visualizations of the human body, particularly the open human body, that do not have representational antecedents in the hauntingly "animate" skeletons and *écorchés* (or "musclemen") of Vesalius's work. This is not merely to suggest, as was certainly the case, that the *De fabrica* illustrations were copied, reproduced, and emulated for years to come. Rather, what is suggested by this claim is that these illustrations represented a radically different way of conceiving of the body as they heralded a new regime of representation, one that defined knowledge as both descriptive, and the result of direct observation.

It has already been noted that humanist resistance to textual illustration was based upon a lack of representational norms that would allow such illustration to be elucidative of meaning. In Jacobus Sylvius's broadsheet attacking Vesalius's *De fabrica*, he gives vent to his particular horror at the *De fabrica* woodcuts. His challenge would be simple, but damning, in the age of humanist texts: "Galen would never have resorted to visual aids."[33] We have also already seen how, once the human body had been removed from the hierarchical structure of textually based learning that was predicated upon these humanist texts, it could be reconfigured as a site of knowledge transmission and generation; anatomical knowledge arising from the direct observation of the open human body. Likewise, we can suggest that with the publication of the *De fabrica*, a shift occurred in the epistemological status of the human body as both a site and an object of representation. No longer was the human body a blank page awaiting textual inscription; rather, it was the folio page of the atlas that had become an image-bearing surface for the body's normative re-presentation.

Like the famous sea captains and explorers of his day, with their ever more accurate cartographic representations of the expanding known world, Vesalius's anatomical atlas was to establish the representational norm for subsequent chartings of the hidden recesses of the human body.[34] Suggestive of Vesalius's preeminence among anatomical explorers of his day is the conspicuous absence, in the list of his achievements, of any self-conscious place name on the uncharted map of the human body. Unlike other Renaissance explorers, Vesalius left his name to practically no feature of the human body; his legacy was to be the observational and experimental methods that were to enable others to do so.[35]

## The Life of Infamous Men

Adriaan adriaansz, otherwise known as [Aris] Kindt. Laundry boilermaker born at Leiden in Holland. In his 28th year he was punished for his spite with the rope. On 31 January 1632 by the cryer referred for dissection.

..............................................................................................................................
Amsterdam, *Gemeentelijk Archief*, 294, "Anatomij-Boek"[36]

On 12 May a worthless fellow, Jacob Karrer, who had several times been apprehended in crimes for which he ought to have been executed but had instead been set free through the clemency of the Senate, was seized and proscribed. His wife was cured by the surgeons, but her husband ----- was beheaded, and Master Andreas Vesalius, the very famous physician, dissected him and erected his skeleton.

..............................................................................................................................
Johannes Gast, deacon of St. Martin's, Basel, 1543

These two "biographies" lie in sharp contrast to the biography of Vesalius that came before them. Their brevity and tenor identify their subjects as "lowly lives reduced to ashes in the few phrases that have destroyed them."[37] They constitute what were, for Foucault, "the lives of infamous men"—those fragmentary traces that provide the only indication that these two men ever lived. Foucault never completed his collection of infamous lives, but the preface to this project does exist, and in it he discloses the logic that should bind those entries deemed (un)worthy of acceptance:

> they should belong to those billions of existences which are destined to pass away without a trace; that there should be in their misfortunes, in their passions, in those loves and in those hatreds, something grey and ordinary beside what is usually estimated as worthy of being recounted.[38]

But why create a biography of the infamous, the miserly, the mean and the wicked? Precisely because such a biography becomes the blueprint for all biographies by becoming the story of that one thing which has preserved these fragmentary traces, recorded these fleeting lives, and delivered them to us all these years later: power.

For a long time in Western history, everyday life could accede to discourse only when traversed and transfigured by the fabulous—hagiography being the antecedent to biography in its recording of the lives and miracles of the saints. The lives of Aris Kindt and Jacob Karrer, however, possessed none of those characteristics, whether heroic in deed, or villainously ignoble in kind, that would mark them as *exemplary*, and therefore worthy of immortalization. But their lives are preserved in these fragments because of their encounter with power, without which they would have been destined to pass beneath all dis-

course without ever been spoken of again. As Foucault asks: "would anything at all remain of what they have been, in their violence or their singular misfortune, if they had not, at a given moment, collided with power and provoked its forces?"[39]

As a collection, the "lives of infamous men" allowed Foucault (or would have allowed, had he completed it) to chart a shift in the apparatus of power that transcribed the discourses of the everyday throughout the seventeenth century. The direction of this shift was from the *pardoning* mode of the Christian confession to the mechanism of *registration* of administrative bureaucracy. The objectives of these two modes shared the similarity of bringing everyday life into discourse through a survey of the seemingly unimportant irregularities and disturbances that would constitute the everyday. But whereas the "minuscule wrong of misery and misconduct" was once "conveyed to heaven by the scarcely audible confidence of the avowal," it was now "accumulated on earth in the form of written traces."[40] The confession came to mark the discourses of the everyday as something that might have a secret to disclose when it came under the unmitigated gaze of power; the file and the dossier becoming invaluable instruments of governmentality, technologies of a new disciplinary regime. In effect, it was the advent of a disciplinary mode of power that "lowered the threshold of describable individuality and made this description a means of control and a method of domination."[41] In doing so it converted the history of one's everyday life from a "monument for future memory," to a "document for possible use."[42]

But there is another way in which these "lives of infamous men" might speak to us, for in many ways they point to the discursive nature of all biographies. By identifying power as the one thing that binds these everyday "lives" to discourse, we can by extension say likewise of that other category, the *fabulous exemplar*. It was Pierre Bourdieu who suggested that there was something inherently "fictive" about the unitary expression of life that all biographies attempt to portray.[43] If we conjoin this with Foucault's observations about the discursive nature of authorship (that the author is a "function" of discourse), then the biography of Vesalius-as-the-history-of-anatomy becomes equally inscribed by those discourses of power that have brought it into being.[44] Further to this, the attribution of discourse to the "proper name" of an individual is not the result of that person's creative will or intent, but rather an elaborate ritual that constructs that author in the first place. In this case, modern historiography tends to be afflicted with the desires of hagiography: the ever-present need to trace and record the achievements of its own pantheon of venerated saints. Viewed in this way, it is precisely the elaborate ritual of the public anatomy that brings both Andreas Vesalius as well as Jacob Karrer into discourse at

precisely the same time as anatomist and cadaver. What the "life of infamous men" shows us is that our focus of analysis should rest not with the celebrated biography of anatomy's founding father, but rather with those rituals and institutions that summon such subject-authors into being. And it is the fate of Aris Kindt and Jacob Karrer which shows us where to start in this matter: with the chilling conflation of retributive justice and medical science that brought both of them to the dissector's table.

Having said this, there is something about the fate of both these two men which Foucault would be slightly disapproving of (in terms of their admittance into his "rogues' gallery"). Yet on the other hand, this "something" is precisely the thing that would guarantee their place within it, given that the overriding quality that binds each of these infamous lives together in such a collection is their brush with power. For both men are known to us today in one important way apart from their inscriptions within the ledgers and files of disciplinary power: Aris Kindt is the cadaver portrayed in Rembrandt's *The Anatomy Lesson of Dr. Nicolaas Tulp*, while Jacob Karrer's skeleton exists today in a near-complete form in the Anatomical Institute of the University of Basel. This kind of immortalization runs the risk of both men joining the ranks of the *fabulous exemplar*, but for the meanness of the power that extinguished their lives without providing a lesson to be learned from it.

I have indulged in the "biographical illusion" of "Andreas Vesalius as the founder of modern anatomy" for two reasons. First, it is a convenient way of dispensing with the necessary histories that form the subject of any "archaeology," precisely because this kind of biography-as-history is so familiar to us. The charm I identified surrounding Vesalius's descriptions of early modern scientific thought, and his necrophilic boastings of body snatching, is due largely to the fact that these descriptions resonate so well with our own more contemporary counterparts—I am thinking here of Gunther von Hagens's frequent televisual and museological appearances with plastinated bodies which seem to nakedly reference both the performative and representational aspects of Vesalian anatomy, at the same time as openly apeing both the excesses and the obstinacy of Vesalius's personal (i.e., "scientific") spirit.[45] Second, although it is not my intention to critically evaluate each of those teleological, Eurocentric, or positivistic narratives that underpin the history of science's habitual practice of ancestor worship, indulging in biographies of science is a sure way of bringing these problems of historiography to the fore. The interruption of the "lives of infamous men" allows me now to focus on the more discursive relationships that summoned up the body as an anchoring point of power, knowledge, and representation; relationships that would characterize anatomy as decidedly "modern."

## The Anatomy Lesson of Dr. Nicolaas Tulp

The solemn appearance of the sovereign brought with it something of the consecration, the coronation, the return from victory; even the funeral ceremony took place with all the spectacle of power deployed. Discipline, however, had its own type of ceremony. It was not the triumph, but the review, the "parade," an ostentatious form of the examination. In it the "subjects" were presented as "objects" to the observation of a power that was manifest only by its gaze. They did not receive directly the image of the sovereign power; they only felt its effects—in replica, as it were— on their bodies, which had become precisely legible and docile.

Michel Foucault, *Discipline and Punish*, 1979

The modern medical "examination" presents us with a particularly poignant moment for the history of the gaze and institutional medical discourse alike. For at that instance when the gaze of the physician meets the body of the patient, a variety of knowledge claims and "visual techniques" become conflated to effect a disintegration of the living body so that it may be reintegrated as the inscriptions and traces of the "biographical" file of one's "case history." This gaze which examines, cuts, penetrates, and dissects the living body but leaves it physically unmarked has, through various medical imaging apparatuses, assumed near-talismanic qualities.[46] It is a gaze that summons the patient into being, and tracks that patient throughout life, by the comparison of these traces and inscriptions with a normative description of the "healthy" body.

Yet the description of this normative body that underpins the medical examination has a genealogy of its own; a genealogy that betrays its close association to those cognate disciplines that manifest a less "gentle" form of examination in the guise of the military parade, the police confession, and the march to the scaffold. If the compulsory visibility of the medical "examination" marks it as part of the armature of an embedded, invisible, modern disciplinary power, the source of that knowledge equally points back toward an older display of power that was always exaggerated and spectacular: the exercise of sovereign power.[47] For the very constitution of this normative description of the body proceeded not from the examination of vital, living, *exemplary* bodies, but rather from inert, dissected, criminal bodies. During the seventeenth century, as a modern, scientific description of the human body was being assembled, it was being done from those subjects provided by the scaffold.

Acknowledged as one of Rembrandt's early masterly works, *The Anatomy Lesson of Dr. Nicolaas Tulp* (1632) has been taken to represent a group portrait, the record of a scientific public event, and a moralizing celebration of the rise of a rational bourgeois science, depicted here, still in its infancy.

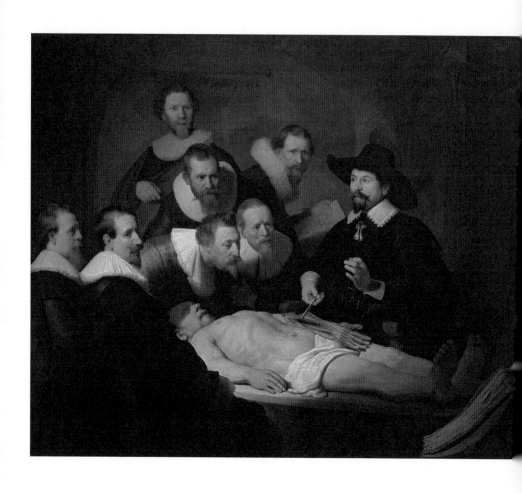

**2.1**

Rembrandt van Rijn, *The Anatomy Lesson of
Dr. Nicolaas Tulp*, 1632, oil on canvas. Royal Picture
Gallery Mauritshuis, The Hague.

Painted on the commission of its occupants, Rembrandt's canvas depicts members of the Amsterdam Guild of Surgeons whose names and identities are known to us from the roll call held in the hand of one of those surgeons.[48] Located immediately to the right of the dramatically lit cadaver is the figure of Dr. Tulp seated in an academic *cathedra*, wearing his hat of office. Dr. Tulp is portrayed in the act of allocution: his left hand (which is the object of at least two energetic gazes) indicates speech, at the same time as it demonstrates the divine instrument that forms the subject of today's lesson—the hand. The closely packed group of surgeons gathers around the body of the cadaver. The inner three surgeons display the observational intensity that would distinguish this new Enlightenment "science" from the textual and bookish affair of ancient anatomical knowledge (portrayed here by the large folio tome cast in shadow at the foot of the corpse). The gazes of the outer three surgeons (ignoring the outermost figure of Jacob Koolvelt, which was added at a later date) are distracted from the corpse, looking out instead at the viewer, indicating the presence of a larger audience witnessing the drama that is unfolding. It is this final point which is crucial to an understanding of Rembrandt's composition, for what we are witnessing here is merely the inner sanctum of an otherwise very public drama at which hundreds of people were present at. On 31 January 1632, Dr. Nicolaas Tulp conducted the second of his annual anatomies in his role as *praelector* of the Guild of Surgeons. Rembrandt's painting commemorates this event.

From the middle of the sixteenth century, when Vesalius was conducting his firebrand performances in Bologna, to the later decades of the eighteenth century, anatomy came to be characterized by a curious mix of science, commerce, and entertainment. Conducted only occasionally each year at the major medical schools of the Catholic South, or the independent surgeons' guilds of the Protestant North, these public anatomies attracted local officials, clergy, traveling dignitaries, foreign medical students, and curious laypeople, bringing honor and prestige to the cities hosting them.[49] Usually lasting four or five days, and conducted in various lessons or "acts," these public anatomies would give audiences a chance to see the complete dissection of a human body in an event not dissimilar to a theatrical performance. From their "triumphant" opening rituals, which consisted of a procession of the anatomist, with his (as they exclusively were) attendants and dignified guests, to the semiprivate feast and torchlit parade held in honor of the master anatomist upon the conclusion of proceedings, a sense of spectacle marked these as important social events.[50] Held in purpose-built wooden amphitheaters constructed within existing buildings—in the Protestant North often in church buildings; the dissecting table curiously taking the place of the altar—and advertised well in advance,

these public anatomies were highly regulated and controlled. Often they would be accompanied by musical performances and, almost without exception, the selling of admission tickets.[51] As Sawday so aptly puts it: "In the anatomy theatres of Europe the bodies of the poor, the condemned and the outcast, were reduced in a public spectacle of partition. To this spectacle paying audiences thronged not merely for enlightenment, but entertainment."[52]

The theatrical nature of these public anatomies brings to mind the performative and pedagogic nature of the scaffold where, before a crowded audience, the vengeance of the wounded sovereign would be literally inscribed into the body of the criminal—with exact cuts and tears of the flesh—in a spectacular display of retributive justice.[53] Foucault's account of the punitive dismemberments of the scaffold bears a remarkable resemblance to the goings-on in anatomy theaters right across Europe.[54] Both spectacles spread rapidly during the sixteenth and seventeenth centuries, sharing not only a similarity of cuts inflicted, but also a similar target of their performance—the criminal body. That the scaffold provided the bodies for such public dissections tends to raise the speculation that these ritual dissections actually belong equally to the same fearsome apparatus of sovereign power that exacted recompense from the broken body of the criminal. It is an association that has not been lost on modern authors: "the anatomist is not simply a disinterested investigator of the natural world; he is fully implicated, as the extension of the law's revenge, in the reassertion of the rights of the sovereign power over the body of the condemned criminal."[55]

If this seems to be overstating the point, one need look no further than the sentiments of the condemned themselves, who frequently were known to express abject fear at the prospect of winding up on the anatomist's table. In Germany, during the seventeenth century, a popular expression came into being, uttered by condemned criminals begging not to be "rolfinked": Dr. Werner Rolfink, founder of the anatomy theater at Jena, performed annual dissections upon those bodies passed on from the scaffold.[56] Moreover, the anatomist himself often became fully implemented in directing the proceedings of the scaffold, collaborating with judges to determine the manner or method of execution that best suited the body's appearance the following day in the anatomy theater.[57] As an indication of the extremes to which this collaboration would go, the fate of a particular Bolognese citizen serves as a telling example. On 30 January 1681, the body of Antonio Bagnoli da Bagni di Lucca became available for dissection: "and it should be remembered that the poor wretch had been condemned for life, but that to satisfy the demands of the scholars, the cardinal legate overruled the decree that had already been passed, and had him condemned to death."[58] The association here between anatomist and jurist is chilling.

Returning to Rembrandt's canvas, we can see in the lifelessly pallid figure of Aris Kindt the record of a life extinguished by the mechanisms of retributive justice. Rembrandt's canvas captures a specific moment in the unfolding of a drama of bodily punishment that commenced at the scaffold, and continues here with the moralizing lesson of the dissection itself: Dr. Tulp is presented as starting his anatomy with the very instrument that sentenced the thief, Aris Kindt, to the gallows in the first place—the hand.[59] It is not to the order of science or pedagogy that this first, most unorthodox of incisions refers; rather, it is "a meaningful episode within a complete drama of retribution."[60] The drama of such proceedings will see its final act in the semiprivate guild feast and torch procession after Kindt's earthly remains have been disposed off. As Barker so eloquently puts it: "To execute, to dismember, to eat. It is difficult to imagine how much more thorough than this an act of corporeal punishment could be."[61]

Yet if the "realism" of Rembrandt's canvas is able to bring to our attention the full horrors of the scaffold that provide the *raison d'être* of this scene, it must also be acknowledged that what Rembrandt is commemorating here is not the body of Aris Kindt, nor the sovereign wound that required his pursuit even beyond death itself, but rather the spirit of a new science of the body and its self-appointed custodians: those enlightened, bourgeois surgeons who confidently catch our gaze all these years later as being decidedly "modern." For just as the body of Aris Kindt marks Rembrandt's canvas as a record of the drama of bodily punishment, these bourgeois anatomists also mark it as a record of the development of a modern "science." What we are witnessing in this historical moment, frozen in the impasto of Rembrandt's brushstrokes, is the emerging claims of "anatomy" over the dissected remains of Aris Kindt, entwined with, yet hoping to distance themselves from, the claims of the sovereign who traditionally laid proprietary rights over the bodies of the condemned.[62] As this fledgling science of the body is making its first discursive enunciations, it is doing so from within the confines of those sovereign discourses of justice, yet it is doing so with an eye to its own preeminence. The figure of Dr. Tulp is the agent of a retributive justice, yet he is also the procurer of surgical information. For at this moment when the criminal body is destroyed by the machinations of sovereign power, it is being created anew in the form of scientific lore.

Medical knowledge derived from anatomies would grow exponentially, circulating claims of a normative "scientific" body through the hundreds of anatomical atlases that would be produced in the years to come. This normative description of the body would become fully entrenched within the institutional practices of governmentality that would see the mobilization of bodies

under the names of hygiene and public health. As such, it would be the ally of a disciplinary mode of power, a biopower, that orders and arranges docile bodies through their visibility and through their being "known" to discourse. The humble medical "examination" comes to possess none of the bodily excess or ostentation that marked the triumphs, coronations, or executions of the sovereign. Rather, examination is the ceremony through which this disciplinary power is both celebrated and reviewed.

Yet we have not quite reached this moment in the scene depicted in Rembrandt's canvas. The "examination" of Aris Kindt does not yet present a body to "the observation of a power that was manifest only by its gaze."[63] Rather, Kindt's bodily destruction marks this "anatomical gaze" as being almost entirely sovereign. What we are left with, then, in Rembrandt's depiction of the solemn ritual of public dissection, are a variety of conflated discursive modes that are equally present at this single historical moment. Soon they will be scattered and redefined by the coming of a "modern" *episteme*, which would order power-knowledge relationships in a very different way, but for now what we can see captured in Rembrandt's canvas is rationality's first tentative claims to a bodily knowledge, and how this, in effect, grew out of an intimate association with bodily destruction. At the same time that the body is being marked as an "anchoring point for a manifestation of power" at the scaffold, so too, in the anatomy theaters of Europe, it is being appropriated as a site of both knowledge production and representation.

## Representing Open Bodies: The Birth of a Scientific Gaze

Human displays teetertotter on a kind of semiotic seesaw, equipoised between the animate and the inanimate, the living and the dead.

...............................................................................

Barbara Kirshenblatt-Gimblett, "Objects of Ethnography," 1991

On more than one occasion my calls for a more discursive analysis of the shift that occurred in anatomical practice at the turn of the sixteenth century has led me to the statement that around this time the body becomes the site of, or anchoring point for, both knowledge production and representation. We have seen how, prior to this time, the body was merely the passive recipient of an ancient textual knowledge spoken *ex cathedra*, and that to dispense with this ancient authority by seeking knowledge of the body through direct observation would have been to dispense with all academic credibility. The Ancients had always rejected the notion that the knowledge derived from dissection could have any investigative utility for the practices of diagnosis, prognosis, or therapy; hence it was always considered a knowledge of "excess."[64] In taking a more

discursive approach to the shift that occurred in the early decades of the six-teenth century, which saw the abandonment of this attitude, I have been able to critique the standard "biographical" histories of science that would see Andreas Vesalius as the lone author of a radically different way of practicing and conceiving of anatomical knowledge. By suggesting that Vesalius was equally a function of the discourses that brought both him and the condemned cadaver into such a hitherto unseen proximity in the eyes of anatomical knowl-edge, we have been able to see how science came to have such a close and vital relationship to the mechanisms of power and retributive justice. It is now time to explore this reconfigured "scientific" body that so readily lent itself to repre-sentation. That is, it is time to investigate the relationship between anatomical practice, representation, and the visual regime of the medical gaze that arose out of a practice of "legitimate killings."

From the outset, the acquisition of knowledge of the inner recesses of the human body through direct observation could have been nothing but a fraught exercise, for it required the disruption, and hence invalidation, of the epistemologically resistant margin of the bodily whole: "a body whose interior is exposed to the eye is felt always to be impaired or damaged."[65] Perhaps the most remarkable attribute of the sixteenth-century practice of dissection was the advent of an associated medical gaze that worked above all by its ability to become unmoored from the specifics of the dissected body. That is to say, direct observation of the hidden recesses of the human body became the prop-erty of the gaze whether the body was splayed open to vision or not. As Wilson suggests, "once the body had been opened to vision, any body can be imagined as so opened."[66] The medical gaze came to acquire the characteristic of the practice that it was discursively linked to: the ability to "anatomize." How this "anatomizing" quality came about can be seen in the associated representations of anatomical practice.

**2.2 (following page)**

Unknown artist, title page of Mondino dei Liuzzi, *Anatomia*, depicting medieval dissection. First published in the collected works of Johannes de Ketham, *Fasciculo de medicina* (1493). Image: Wellcome Library, London.

**2.3 (following page)**

Unknown artist, title page of Andreas Vesalius, *De humani corporis fabrica* (Basel, 1543). Image: Wellcome Library, London.

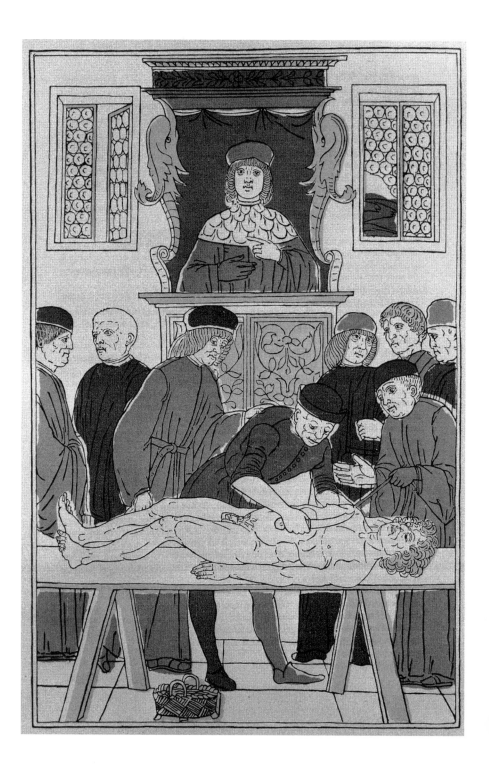

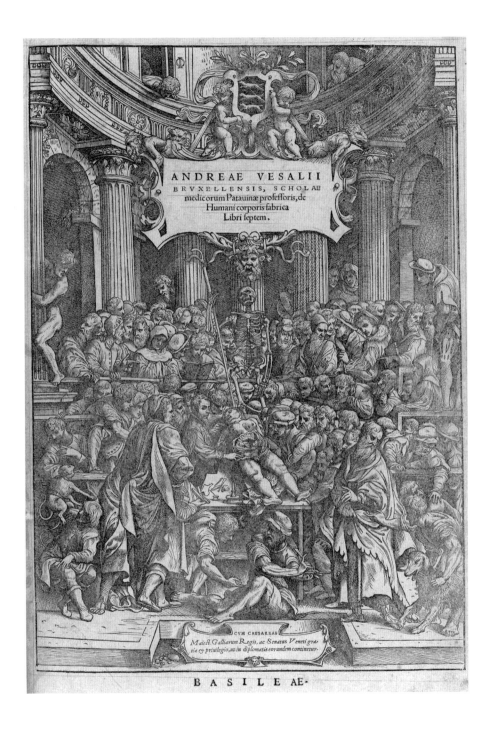

Regarded as one of the most important of all early medical illustrations, the woodcut title page to accompany Mondino dei Liuzzi's anatomical manual, the *Anatomia* (figure 2.2), is one of the few depictions of the hierarchical, textually based practice of human dissection as it was conducted before the time of Vesalius in the sixteenth century. It is a scene that is familiar to us already from Vesalius's scathing descriptions of it.

The composition of the illustration is dominated by a strong vertical hierarchy that is in direct correlation to the academic hierarchy of the proceedings it depicts: our eyes are led upward from the inert corpse laid out on a makeshift table in the foreground, through the figure of the barber-surgeon poised with knife in hand, and culminating in the figure of the anatomy professor seated within an ornate and imposing pulpit or *cathedra*.

The figure closest to the corpse is that of the *prosector*, a base menial or barber, identifiable by his lack of academic garb. Bending over the corpse, he is portrayed here at the moment of initial incision, which, according to the manner prescribed by tradition, proceeds from the sternum to the pubic region.[67] To the immediate right of the *prosector*, occupying a position aside from the central axis of the illustration, is a figure who gestures to the *prosector* with one hand, as well as pointing to that part of the corpse about to be incised with the aid of a *radius*. This is the demonstrator or *ostensor*, whose function it was to mediate between the authority of the *praelector*'s spoken word and the inert, unresponsive frame of the dead body; the *ostensor*'s *radius* directing the eye to the point at which text and body conform.[68] Surrounding these two are some six figures in academic garb, paying little or no attention to the goings-on of the actual dissection. The one exception is the figure directly to the left of the *prosector*, who rests a supportive hand on the barber's back, as if to help steel him against the distasteful act he is about to commit. The otherwise distracted nature of these bystanders, no doubt debating the wisdom of the Ancients, is indicative of the distance between participants and the dissected body that Vesalius was so angered by.

Enveloped by the wings of the ornate wooden *cathedra*, the resplendently robed professor or *praelector* ascends above the chaos of this scene to preside over it with a serenity and poise bordering on otherworldliness. His hands fixed in a common rhetorical gesture of medieval recitation, the *praelector* is depicted mid-lesson; the absence of a text on the *cathedra* indicates that the recitation is being conducted from memory.

If we now turn our attention to the title page of Vesalius's *De fabrica*, we are presented with a very different view of anatomical knowledge, derived here from direct observation (figure 2.3). The first thing to be noted about this illustration is the lack of the spatial hierarchy that dominated the previous scene

and the close proximity of the anatomist to his subject: Vesalius, who is to the immediate left of the open female corpse (looking over his shoulder out at us, the viewer), has stepped down from the privileged position of the *cathedra* and is "putting his hand to the matter." The second thing to note is the theatrical nature of public anatomy, presented here as a dynamic crowded scene, where attendants jostle for position or climb the architectural scaffolding of the amphitheater to secure a better view. In the foreground the dismissed barber-surgeons squabble under the dissecting table over who will sharpen the instruments, while animals are led in to provide comparative anatomies. Two larger-than-life figures dressed in classical robes seem to sanction the affair; one chastising a distracted barber, the other looking on approvingly at Vesalius's skill.

A clear shift has occurred between these two illustrations. The anatomist's new-found proximity to the cadaver produces an intimacy between anatomist and corpse, whose absence was precisely what was on display in the pre-Vesalian woodcut. This is accentuated by the sheer number of the bodies crowding and jostling for attention. The anatomist himself conducts the dissection, and in doing so defines this event as more than just a performance of his own prowess pitted against the elusiveness of the rapidly decaying corpse, as essentially it also becomes the performance of the anatomist's own corporeal body against that of the cadaver. The anatomist, like the corpse, becomes a body subject to view, and is willfully presented as the coherent whole to which the anatomized corpse constantly refers: offering his own body up as a rival to that of the corpse, the anatomist "stands before the audience as a body ontologically undifferentiated from the cadaver beside him."[69]

In a further reinforcement of the intimacy between the anatomist and the corpse, Jonathon Sawday has identified in the *De fabrica* title page woodcut only one figure that looks directly at Vesalius—the dissected cadaver: "What is suggested is a degree of compliance on the part of the corpse. ... It is as though she, herself, sanctioned the performance in which she plays a central part."[70] Although it is specific to the *De fabrica* title page, Sawday's observation will become quite telling when we turn our attention to the Renaissance representational norm of displaying anatomies as "animated" corpses, either in the act of dissecting themselves or displayed as if already dissected but still "alive." These figures point to the incorporation of the corpse within a regime of complicity between anatomist and corpse within the Renaissance anatomy theater.

Far from being a mere a pictorial conceit, this complicity was, I wish to suggest, part of a coding of bodies within the anatomy theater to the demands of an observing subject. Subject to an "anatomizing" gaze, the visual opacity that once defined the anatomist as an agent is stripped away in such close proximity to the cadaver, so that the anatomist's own body also becomes subject to

the mappings of an account of the body that the anatomist is busy demonstrating upon the visually "invalid" open body of the corpse. Control in this scene rests with the knowing, observing audience: the slippage that is generated between anatomist and corpse, animate and inanimate, agent and patient, produces a gaze that marks the living body as a potential corpse, at the same time as it codifies the dead body as a potential body-of-knowledge.

This "cadaverizing" or "anatomizing" gaze was clearly in operation as early as the winter of 1540, when a young German medical student recorded his observations of one of Vesalius's early dissections:

> After dinner, he said, I shall … finish the whole anatomy of the muscles of the body. For tomorrow we shall have another body—I believe they will hang another man upon which I shall demonstrate to you all the veins, arteries, and nerves. For this subject is now too dry and wrinkled.[71]

The (criminal) body that is still alive is here subject to a gaze that anatomizes it before it has even reached the theater. It is precisely this visual codification of the living body as a potential object of anatomization which would come to characterize the medical examination (and all its cognate sciences) to this day: the examination being a mapping of the body-of-knowledge onto the body made visually transparent (hence docile and "patient") by the anatomizing gaze.

A scientific sleight of hand is hereby noticeable; the particularity of any given dissected *corpse* can be hereafter reconstituted as a specific *corpus* of anatomical knowledge. Although derived from an act that necessarily invalidates the bodily whole, the end effects of such visual explorations of the human body were "images" of the body deemed *physiologically* coherent, hence intact, which in turn suggests that the science of anatomy came to be structured analogously to its own accounts of the structure of the human body.[72] In an extension of the logic of complicity that operated between corpse and anatomist, it was the anatomical *corpus*, not dissected bodies, which was being operated on as anatomy constantly sought to update its normative descriptions of itself. As Wilson suggests, anatomy "reapplies to itself its own account of the body, as though somehow it has lost a sense of the difference between them."[73] What is lost in this vacillation between body and bodily knowledge, however, is precisely the certainty as to which is agent and which is patient.

When one turns to the early anatomical illustrations of the sixteenth century, the first thing one is struck by is the hauntingly "animated" quality of the *écorchés* or "musclemen" that adorn the pages of Renaissance anatomical manuals like Vesalius's *De fabrica* (figure 2.4). Lumbering from the anatomy theater under their own volition, the musclemen of the *De fabrica* are portrayed in progressive states of anatomization (figure 2.5). Commencing as essentially

whole but for their skins, right down to skeletal figures stripped completely of their flesh, these musclemen stalk their Arcadian landscape backgrounds with a spirit and liveliness that belie their position as mere "illustrations."[74] Executed by some of the foremost artists of their day, these musclemen have confounded modern commentators with the vitality of their being: "they represent things that no man [*sic*] has ever seen, for, often as a man may have seen a dead body (or parts of it) stripped of its skin and outer layers of muscle, no one has ever seen one that has stood up and made gestures."[75]

The animation and liveliness that underpin the *De fabrica* musclemen neatly illustrate the regime of complicity identified earlier, as it becomes difficult to discriminate between anatomist and corpse as to who is the agent of bodily destruction. Possessed of the type of visual opacity suggestive of agency, the musclemen acquiesce to the requirements of the spectator by displaying their model bodies willingly and without constraint. Subject to the "anatomizing gaze" of the onlooker to which it is a patient, the corpse, in an act of animated compliance that marks it also as an agent, seems to not only sanction its own destruction, but also actually to *desire* it.[76] The ultimate pictorial expression of this can be found in those particular images that represent living figures in the act of dissecting themselves (figure 2.6). These bodies are not only self-supporting, they are self-effacing. Peeling their own skin back so that we may view their internal structure, these figures are so implicated in their own internal scrutiny that the anatomist is no longer needed.[77]

In these figures, then, we begin to see the first stirrings of a power which would come to be known through its actions upon the body, rendering bodily opacity transparent to the inscriptions, records, and traces that follow the subject throughout their life. But more than this, we see in these figures the fantasy of how this form of power will be effected: through a compliance and revelation that will be coded as individual agency.

**2.4 (following page)**
*Écorché*, from Vesalius, *De humani corporis fabrica* (Basel, 1543). Image: Wellcome Library, London.

**2.5 (following page)**
*Écorché*, from Vesalius, *De humani corporis fabrica* (Basel, 1543). Image: Wellcome Library, London.

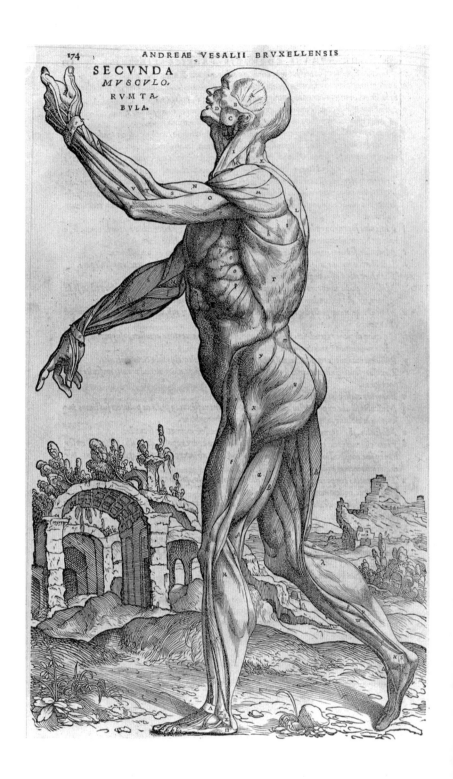

SECVNDA
MVSCVLO.
RVM TA.
BVLA.

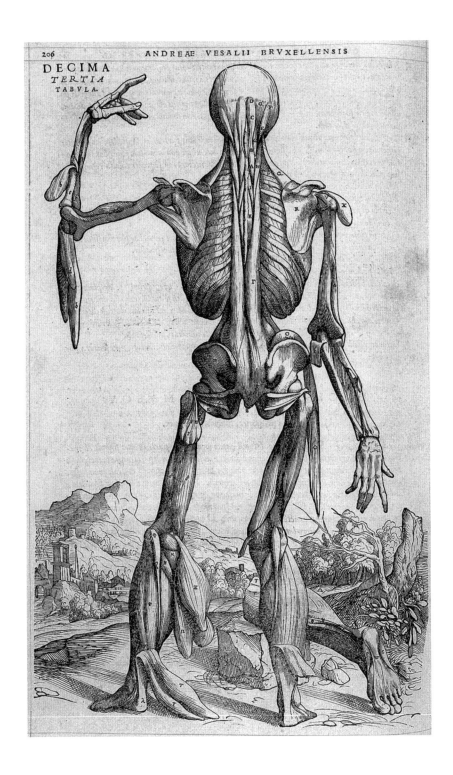

DECIMA
*TERTIA*
TABVLA.

TAB. PRIMERA DEL LIB. TERZERO

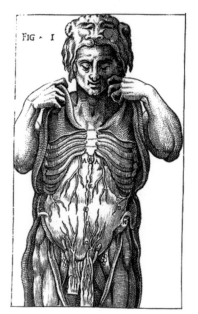
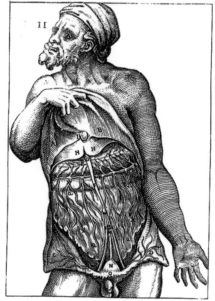

**2.6**

Gaspar Becerra, autodissecting *écorché*,
from Juan Valverde, *Historia de la composicion
del cuerpo humano* (Rome, 1556). Image:
Wellcome Library, London.

## Normative Science and the "Evasiveness" of Anatomical Illustration

Most authors see in the highly ritualized and theatrical performances of the public anatomies the willful harnessing of the rituals of the sovereign in a display of professional preeminence. Francis Barker, for instance, perceives, in the stern, intent bourgeois faces of Rembrandt's *Anatomy Lesson of Dr. Nicolaas Tulp*, the will to appropriate the mechanisms of sovereign vengeance and to rearticulate them; to draw off and reorganize their powerful residues, in order to effect a social and professional autonomy.[78] Keen to distance themselves from the base trade of butchers, barber-surgeons, and executioners whose handling of the dead marked them as socially marginal, this emerging scholarly class of surgeon-anatomists were quick to proclaim themselves the professors of "an intellectual form of knowledge rather than a practical and therapeutic one."[79] More than this, however, these bourgeois anatomists were also keen to separate themselves from the apparatus of the scaffold, which otherwise provided the material of their craft, and chairs in anatomy were established in the major medical schools of the day, in what seems to be a further act of "professionalization."[80] Seen in this manner, the highly ritualized proceedings of the public anatomies become celebrations of the rising office of both anatomy and its enlightened custodians.

This argument has also provided authors with an immediate logic toward deciphering the use of "animated" musclemen in the anatomical atlases of the day. For what other logic can there be in artists presenting anatomical illustrations to a viewer in a way that depicts muscles and tendons flexed as if alive, if not to avoid precisely the association with the dissecting table from which such knowledge comes?[81] The artistic skill required to present anatomical matter as animated and alive, precisely at a time when there was not even a precedent for depicting it as mere dross, tends to point toward an active strategy on the part of author/artists to neutralize the implications of the horror of bodily violation that was practiced in the anatomy theater. In an age when the social position of the physician, much less the anatomist, was by no means assured, artist and scholar have conspired through a representational strategy to effectively reconstruct the violated body as active and alive.[82] Given the almost universal depiction of anatomical knowledge in this fashion, it is little wonder that authors such as Sawday, Harcourt, and Wilson have all seen in these figures an active attempt to "contain" the obvious associations of the scaffold *within* representation itself.

We have already seen how, in the constant slippage between agent and patient, animate and inanimate, that characterized the dominant visual mode of the public anatomies, the particularity of a given dissected corpse could be reconstituted as a specific corpus of anatomical knowledge, through the act of

"demonstration." Given this, the musclemen of the *De fabrica* can be taken to represent the (literal) embodiment of this shift in that what they represent is the evasion of the brutal fact of a particular person's bodily destruction. Likewise, in the act of demonstrating their own internal structure that we previously described as an act of complicity, the musclemen can be neatly explained as yet another attempt to avoid the bloody reality of bodily mutilation. Speaking of the *De fabrica* illustrations, Harcourt categorically states that the effect of depicting anatomical models in such vital and animated poses is that "all the attendant implications of violation, have been effectively suppressed or evaded."[83]

However, to describe these first "modern" depictions of the open body as being mere "representational strategies" is to miss a vital point: that representation is discursively anchored to knowledge production. Vision and representation are not adjuncts to knowledge; rather, they are part of its discursive structure.[84] To read in the animated figures of the *De fabrica* a willful act of containment is to skirt dangerously close to the "authorial intent" that underpins the biographies of science that saw Vesalius as the wellspring of scientific knowledge. It is not that I wish to deny that the bourgeois custodians of this new anatomical knowledge were self-interested or self-promoting. Rather, it is to deny that when the first modern representations of the open body were being depicted as "animated dead," they were the result of a conspiratorial gathering of artists, anatomists, and draftsmen. The sheer breadth of corporeal "animation" as a representational technique seems to point to the realm of the discursive rather than to the will of individuals.

In this regard, I wish to suggest that, if there is an "evasiveness" to be found in the anatomical illustrations of the sixteenth and seventeenth centuries, rather than being the result of individual (or even collective) authorial intent, it should actually be seen as a discursive characteristic of all scientific knowledge, predicated as it is on normative descriptions. The normative description is necessarily contravened by the aberrant or abject, hence there is always a disarming quality to it, the results of which are that the means of scientific knowledge production are constantly effaced or denied. From the very outset, anatomy had always been associated with a particular representational norm that, like the dry, purposeful, and objective language of its accompanying texts, can be seen as simultaneously revealing (of a normative, scientific description) as well as concealing (of the violent means of its production). In effect, it is possible to view all such illustrations as being programmatically scientific at the same time as being practically evasive.[85] This evasive quality is evident today in the way that science's normative descriptions (be they pictorial or otherwise) have a tendency to avoid the implications of the often violent means of its appropriations of body parts or material culture—Yagan's story being a case in point.

To take stock of our argument: we can see, in the vacillations between different forms of agency and subject formation in the anatomy theater, the way that vision, anatomical practice, and representation are quite inseparable in the study of Renaissance anatomy. It makes little sense to talk about the representations of a normative anatomical body without reference to the practice of dissection from which it came, or, for that matter, to the visual coding of the body as a site of knowledge production, which allows for the development of an "anatomizing" gaze. All of these characteristics circulate together as part of the same discursive formation, which, as we have already seen, was intimately linked to the institutions of retributive justice, and particular deployments of power.

Yet even in taking a more discursive approach (or, perhaps, precisely because I have taken a more discursive approach) to the rise of modern scientific anatomy, it should be evident that in the constant slippages between animate and inanimate, agent and patient, living and dead, certain ambivalences come to the fore. I will highlight two of them.

First, on the one hand, we can talk about the programmatic "evasion" that underpins the animation of the *De fabrica* illustrations, or the "evasiveness" of a normative account of the body that erases the particularities of its own constitution. Yet on the other hand, in the practice of anatomy, or even in its representations, there is "excess." The assembling of a normalized account of the anatomical body is necessarily the outcome of a multitude of "legitimate killings." Rather than being a denial or evasion of the dead body, there is a positive celebration or affirmation of, or indulgence in, the handling of it. In his defense of the pedagogic value of anatomical representation, Leonardo da Vinci (in an echo of Vesalius) nonchalantly hints at one form that this excess takes:

> And you who say that it is better to look at an anatomical demonstration than to see these drawings, you would be right, if it were possible to observe all the details shown in these drawings in a single figure, in which, with all your ability, you will not acquire a knowledge of more than a few veins, while in order to obtain a true and perfect knowledge of these, I have dissected more than ten bodies, destroying all the various members. ... And as one single body did not suffice for so long a time, it was necessary to proceed by stages with so many bodies as would render my knowledge complete.[86]

What lends the musclemen of Renaissance anatomical manuals their haunting and disquieting aspect is the excess of killings that marks the (literal) excision of the aberrant from the normative account of the body that they represent. That is, what animates the musclemen of Vesalius's *De fabrica* is the sheer number of corpses consumed in their production. We have also already

encountered another of these excessive indulgences of the flesh in the gleeful boasting and revelry of the young Andreas Vesalius: in so many of his classroom anecdotes there is a sensual delight expressed in the act of "putting one's hand to the matter." It is a delight that was equally shared, once again, by Leonardo:

> And though you should have a love for such things you may perhaps be deterred by natural repugnance, and if this does not prevent you, you may perhaps be deterred by fear of passing the night hours in the company of these corpses, quartered and flayed and horrible to behold. … Concerning which things, whether or not they have all been found in me, the hundred and twenty books which I have composed will give verdict "yes" or "no."[87]

Second, the process of making skulls speak of the savagery of their owners, or the reconstitution of a fragmented and broken body as a coherent body of knowledge, seems to sit somewhat uncomfortably with the language of rationality and normative science. Within anatomy's proclivity toward animating dead matter, or imagining/imaging the living through the dead, there seems to exist the hint of the sacred. Could the basic premise of turning to the study of the dead in order to ascertain information about the living have become so prevalent a mode of scientific investigation, had there not been in the Christian West the ultimate blueprint in the resurrection? And is there not the hint of the more elusive and wondrous charm of imagery in the musclemen of the *De fabrica*: those manifestations of the physical, literally *embodied* in representation?

I now wish to turn to this "power" that animates through dissection, a power that is both excessive and sacral.

### Carnivalesque Anatomy: The Narrative of the Criminal-God

Without this background of feast and ritual it would indeed be difficult to explain why the infliction of pain as a form of punishment should have been so very fanciful throughout the ages.

Edgar Wind, "The Criminal-God"

An eighteenth-century scholar, attending the Bolognese Stadium, explained that public anatomy existed "so that Bologna does not lack its useful shows (*utilia spectacula*) which are attended by many people (*frequens populus*) and by the curious license of masked people (*curiosa personatorum licentia*)."[88] Another chronicler of the public anatomies adds: "This was mostly done at carnival time, being the season best suited to conserve the cadavers, and also to enable the maskers to participate."[89]

We have already encountered the theatrical nature of the public anatomies, in terms of both the stage settings employed and the showmanship displayed; however, there was also a particularly strong association between anatomy and the time of carnival. Almost without exception, modern commentators describe this association as one of convenience, the winter months being best suited to the preservation of the flesh. Yet these two quotations alone, with their references to masked people, are enough to suggest that something more than just happenstance lay behind this association.

If we turn to the university statutes of the Catholic South, or ordinances of the private anatomy guilds of the Protestant North governing the conduct of attendees of the public anatomies, we see various attempts to control and regulate the behavior of crowds. That the 1605 (and 1625) ordinances of the Amsterdam Surgeons' Guild stipulate not only that members of the audience should refrain from laughter and idle chatter, but that the taking of organs such as the heart, the kidneys, and the gallstones was expressly forbidden (incurring a prohibitively high fine of six guilders), tends to point to a degree of potential revelry to be had by those in attendance.[90] In Bologna in 1594 university scholars, in an effort to maintain decorum, refused admittance to anyone who "might enter the anatomy session masked" or remain that way, only to repeal this dictate some twenty-two years later, throwing open the doors to "whoever wishes to hear or see, whether or not they are masked, and whether or not they are armed."[91]

The recurrence of this "curious license of masked people" is a curious one indeed. Ferrari offers the following as another potential explanation for the masked disposition of nonacademic spectators:

In Germany during the first few years of the seventeenth century, the anatomy professor had to warn the spectators "that in particular during the demonstration of the female genitalia, they should contemplate everything with chaste eyes," and historians of medicine tell of spectators wearing disguises at the public anatomies.[92]

The inference here is that there was cause to attend the public anatomies incognito: perhaps it was deemed too licentious and decadent an activity for city officials or clergy to attend without disguise, regardless of how "legitimate" their curiosity may have been? Or perhaps, as part of one's general revelry at the time of carnival, the spectacle of the public anatomy seemed appropriately risqué, being (quite literally) yet another indulgence of the flesh? However, this reading of masked visitors relies on a decidedly romantic reconfiguration of the meaning of the mask in popular folklore, one that would not have been in dominance during the time of the great public anatomies. Mikhail Bakhtin suggests that during the romantic era the mask is

stripped of its original richness and acquires other meanings alien to its primitive nature; now the mask hides something, keeps a secret, deceives. ... The Romantic mask loses almost entirely its regenerating and renewing element and acquires a somber hue. A terrible vacuum, a nothingness lurks behind it.[93]

That the mask, from late antiquity through to the Renaissance, was related to notions of transition, transformation, mockery, and the violation of natural boundaries, rather than hiding the identity of its bearer, seems to point to a very different reading of the associations between masked witnesses, the time of carnival, and the practice of public anatomies. Far from being the result of opportunistic seasonal timing, I wish to suggest that the presence of these "maskers" at the public anatomies during the winter months points to the position of the public anatomy as part of the armature of festival.[94] Further to this, I want to suggest an answer to the one question that is never asked in the literature: why criminal bodies?[95]

The ritual elements of the public anatomy that were used earlier to associate it with the tradition of judicial torture and retributive justice were elegantly summed up in the words of Francis Barker: "To execute, to dismember, to eat. It is difficult to imagine how much more thorough than this an act of corporal punishment could be."[96] The spectacle of the scaffold that provided the body for the anatomy was the first act in a drama that would see a criminal body subsequently mutilated with a strictly controlled level of decorum (Act II), before the torch procession and semiprivate banquet in honor of the anatomists and their guild (Act III). Yet these characteristics of execution, mutilation, and feasting are clearly articulated in the drama of festival and the time of carnival. In some cities the connection was explicit (though perhaps still one of utility): "[public anatomy lessons] were performed on carnival days, given that the anatomy professor had to use the cadaver of the convict executed on the Saturday previous to carnival."[97] The continuance of criminal execution to mark the beginning of carnival existed well into the Renaissance, particularly in Italy and the Catholic South. Given this, it is hard not to see the public anatomy that followed in its wake as being more than just a neutral scientific investigation, and now we can add: as being more than just an extension of the mechanisms of retributive justice. In addition to these two readings, we can also suggest that it was part of the ritual of carnival, with its notions of sacrifice, feasting, societal transformation, and redemption.[98]

Edgar Wind suggests that by the time the criminal is configured as a subject of criminal justice, it has all but lost the powerful associations that it once possessed to the divine king and the ritual of beneficial sacrifice.[99] Prior to this time, in a mimetic act of imitation, the divine king was spared his duty

of sacrificing himself for the benefit of his people, with the sacrifice, instead, of a criminal. Yet the economy of this transaction necessitated that the criminal, by virtue of its inherent powers, be considered as a true and acceptable substitute. This was found to be the case as the criminal, like the divine king who stands above the people, stood apart from the rules of the group. According to Wind, this equation of divine king and criminal becomes intelligible if "Superior Power is understood as a force which is neutral to the distinction between good and evil and thus qualifies the bearer as *taboo*."[100] Part of what ensures the validity of this substitution is the elaborate ritual of lavishing the kingly honors of feasting upon the criminal before the moment of sacrifice. It is these rituals that form the basis of the "world turned upside down" of carnival.

Wind suggests that, particularly with execution practice, we can see the lingering of ancient forms of ritual atonement and sacrifice well into the Middle Ages and the Renaissance, though the meanings of these cosmically significant acts had been largely lost. Hence it was that as the criminal became configured as a victim of legal procedure, the executioner who broke that criminal's body on the wheel "did not know that he was repeating the form of a ritual by which his ancestors had sacrificed a god."[101] Likewise, the executioner's marginal position within society, which was now seen merely as a result of his close proximity to the dead, was once the result of his close proximity and contact with a god; marking him as taboo.

The persistence of these ancient rituals of execution well into the time of the Renaissance is largely dismissed by Wind: "It is probably more a sign of human inertia than of human wickedness that these practices were continued long after they had lost their meaning."[102] What this has the tendency to do, however, is to deny the vibrancy of these forms as preserved in the rituals of carnival with its celebration of the "world turned upside down," or to deny their ability to acquire new meanings. If we proceed discursively, however, then the existence or otherwise of a specific practice in different times does not depend solely on the continuance of its original meaning. Rather, if that meaning is a function of the discourses that bring that practice into being in the first place, then it is more than possible that new meanings can underpin the existence of otherwise similar practices. Thus, just because the executioner no longer knows the significance that the act of breaking a criminal upon the wheel had to his ancestors does not mean that this act had no contemporary significance beyond the utility of killing. New discursive formations are productive of new meanings and significances; invigorating and recoding practice with each discursive shift. And it is precisely this that I want to suggest with regard to the carnivalesque aspects of both Renaissance execution and public anatomy: for although the significance of the criminal-god may have been

all but lost to a late-Renaissance practice of execution, it came to find a likely substitute in the form of the criminal-saint.

## Beyond Iconography: Toward a Reclamation of the Sacred

Control, discipline, even torture of the flesh is, in medieval devotion, not so much a rejection of physicality as the elevation of it—a horrible yet delicious elevation—into a means of access to the divine.

.......................................................................

Caroline Bynum, "The Female Body and Religious Practice in the Later Middle Ages"

In something of an art-historical commonplace, William Heckscher undertakes an exploration of possible pictorial and compositional archetypes that may have acted as representational antecedents to Rembrandt's *Anatomy Lesson of Dr. Nicolaas Tulp*. Although this exercise is possessed of the kinds of positivism that would see representation as being divorced from its institutional practices (thereby contributing to the kinds of histories that, like the history of science, I have already critiqued) it nonetheless provides Heckscher with an interesting point of departure: "Consequently there will be found in the 'Anatomy' a variety of nuances of meaning that will help explain why it is in part a sacrificial scene, in part a ritual scene, and in part a scene of justice."[103]

In the ensuing discussion, Heckscher suggests that when artists started casting around for pictorial archetypes from which to borrow compositional forms, the scenes of Lamentations or Entombments, with their passive body Christ, proved immediately attractive. However, the demands of anatomy for direct action upon the body would give these archetypes a limited utility, with their essentially *untouched* passive bodies. More appropriate patterns of violent interference were to be found instead in the numerous scenes of martyrdoms and in the justice panels of the fifteenth century.[104] Heckscher sees in the depiction of the flayed and dismembered bodies of the saints at the hands of their pagan and Jewish tormentors, or in the portrayal of the tortures and punishments of antiquity, a series of compositional forms that readily lent themselves to the depiction of anatomical illustrations. Thus according to Heckscher, "all that had to be provided to turn a martyrdom into an anatomy was a change in emotional climate."[105]

Take, for instance, the fifteenth-century justice panel by Gerald David depicting the flaying of Sisamnes, the unjust judge, by decree of the Persian king Cambyses (figure 2.7). There are striking compositional similarities to the Rembrandt *Anatomy* (figure 2.1): the proximity of the torturer/anatomist to the body, the use of foreshortening to radically differentiate the subject of

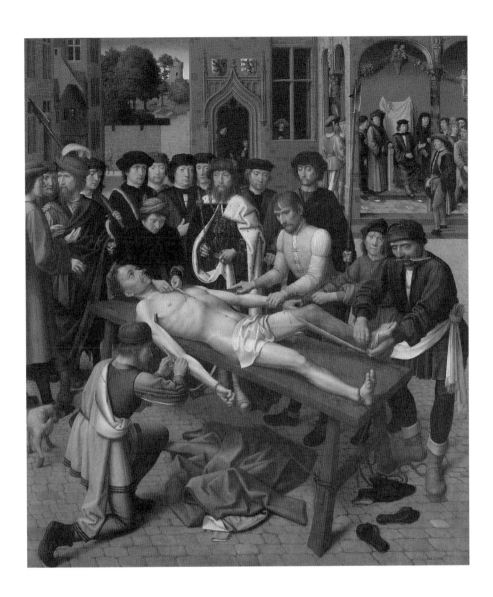

**2.7**

Gerald David, *The Judgment of Cambyses*, 1499,
oil on wood. Stedelijke Musea, Brugge. © Lukas—
Art in Flanders VZW.

**2.8 (following page)**

Gaspar Becerra, *écorché*, from Juan Valverde,
*Historia de la composicion del cuerpo humano*
(Rome, 1556). Image: Wellcome Library, London.

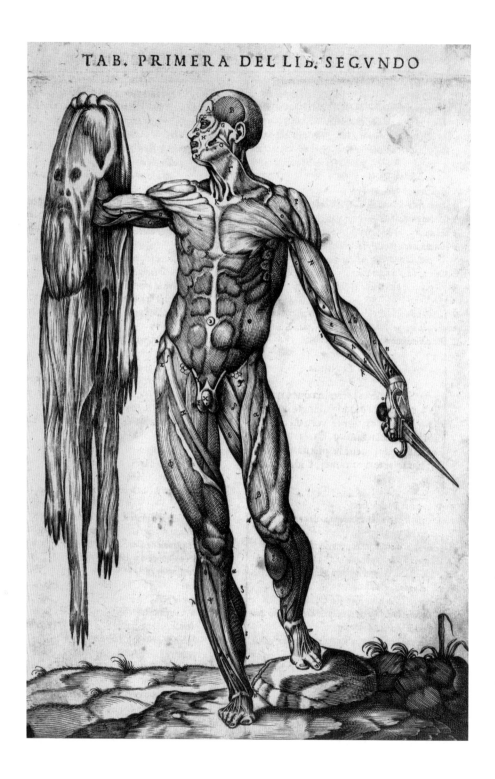

bodily destruction from its agents, et cetera. One could be excused for thinking that David's panel was a direct compositional predecessor to Rembrandt's.

However, subscribing to such a licentious concept of compositional "utility" has the tendency to configure representation as being merely the product of individual author/subjects. The effect of this is the construction of art histories that either chart the movement and popularity of these compositional forms (the history of a "style") or are concerned with the writing of monographs of the "great masters" (those who display a certain technical or stylistic assurance with a particular form). What Heckscher's analysis tends to miss, therefore, is that this compositional resemblance between David's and Rembrandt's respective depictions of bodily destruction is due, I wish to claim, to the lack of discursive distance between the *act* of criminal flaying and scientific anatomies *that brought both practices into being in the first place.*

.....

Nevertheless, I do see something very productive, or at the very least suggestive, in Heckscher's analysis. Not so much in terms of the shift that takes him from representations of anatomies to representations of criminal executions, but rather the shift that takes him from scientific anatomies to martyrdoms *and back again.*

In describing the tortures and dismemberments exacted upon the bodies of early adherents to the Christian faith, Heckscher suggests that these cruelties "must have exercised a strong influence on anatomical representations."[106] We need only turn to one of the most popular anatomical atlases of the day, Juan Valverde's *Historia de la composicion del cuerpo humano* (Rome, 1556), to find pictorial support for Heckscher's claim. In one of the few original woodcuts not plagiarized from Vesalius's *De fabrica*, the artist Gaspar Becerra has depicted an *écorché* brandishing a knife in his left hand, while prominently displaying his flayed skin in the right (figure 2.8).

The significance of the flayed skin motif seems a clear evocation of the martyrdom of St. Bartholomew: Becerra having followed the standard iconographic tradition of depicting the saint holding the instrument of his torture (the butcher's knife) and the cause of his torment (the flayed skin).[107] The link seems almost assured when we compare Becerra's *écorché* with that of Michelangelo's rendition of St. Bartholomew in the *Last Judgment* fresco on the Sistine ceiling (figure 2.9). Presenting the instrument of his torture to the figure of Jesus, the St. Bartholomew of the *Last Judgment* still clutches his flaccid coat of skin in an attitude remarkably similar to Becerra's *écorché*.[108] In the act of casting his skin down toward hell, St. Bartholomew is guaranteed a place in heaven; the skin removed represents sin overcome.

Likewise, in relation to the previous discussion concerning the animated quality of the *De fabrica* illustrations, in which I suggested that the musclemen were bound by a regime of visual complicity where they appeared to be the agents of their own bodily violation, Heckscher's associations between anatomy and martyrdom appear remarkably apt: "It is no mere accident that at the time when the formal anatomies came into the open, the cruelties inflicted upon defenseless *but willing* victims experienced an efflorescence in the arts."[109] It is the *willingness* of the martyr to undergo bodily destruction that strikes such an evocative chord with the musclemen of the *De fabrica*.

What I am suggesting here is not that we should follow Heckscher in his search for iconographic correlations between known images of martyrdoms and specific anatomical illustrations—this, I have already suggested, would be of limited worth to a discursive analysis. Rather, I am suggesting that if we persist with viewing representation and practice as being a function of discourse, then behind Heckscher's art-historical exercise lies the unstated assumption that during the Renaissance there existed a shared association between the act of execution and the act of martyrdom, quite apart from the obvious killing involved. What enables Heckscher to slip between pictorial depictions of martyrdoms and anatomies is not the licentiousness of compositional forms, but rather their shared relationship to a discourse of the sacred as manifest through bodily destruction.

·····

The fifteenth and sixteenth centuries saw a strange conflation of devotional art and the mechanisms of justice in the form of the *tavolette*. Designed as "a kind of visual narcotic to numb the fear and pain of the condemned criminal during the terrible journey to the scaffold," these handheld devotional images would be held before the criminal's eyes as "an antidote to the physical and psychological punishment currently being suffered."[110] Carried by members of the local confraternities, the *tavolette* displayed scenes of the crucifixion and the martyrdom of popular saints, and were intended to lift the criminal up into pious contemplation of the benefits of a penitent death.[111] The choice of which *tavoletta* to use on a particular day was determined by selecting an appropriate martyrdom scene to match the form of execution about to be exacted.

The presence of these *tavolette* indicates that the execution of the Christian criminal here on earth had repercussions for the salvation of the soul in the afterlife: the penitent criminal who embraced the suffering and pain of his or her execution in the stoic and brave manner of the saints would improve his or her chances of salvation.[112] The logic that enabled this conflation of heavenly and temporal justice also underpinned the choice of execution method in the first place, one which was often determined by the symbolic effect it generated

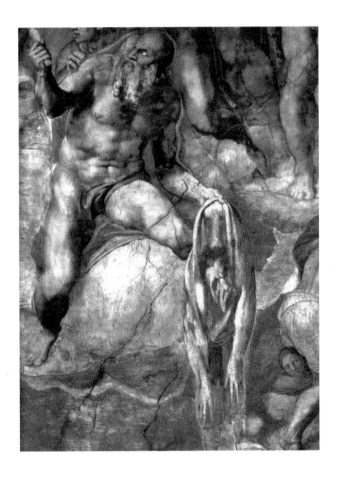

**2.9**

Michelangelo, *St. Bartholomew*, detail of the
*Last Judgment* fresco, Sistine Chapel, Vatican.

in the viewing public: the use of the wheel, the burning brazier, rolling the body in a spiked barrel, and the tearing of the flesh with pincers, were markers of an excess of judicial punishment that ascribed appropriate executions for the crime committed, while selecting executions that echoed the torments of the famous martyrs.[113] This logic extended to the very stagecraft of the scaffold: as members of the local confraternity comforted the condemned with visions of the afterlife, the carefully choreographed position, dress, and even race of the executioner marked this scene as part of a continuing eternal battle between the angels of God and the demons of Satan for possession of the criminal's soul.[114] In this regard it could be said that the aesthetics of the scaffold sanctified and absolved the actions of those perpetrating the violence, at the same time as it attempted to diminish (through accentuating) the enormity of the death about to be experienced; aesthetics and sacrality often revealing their conjoined nature through brutal negation.

Within this sophisticated regime of punishment and sanctity, the body of the criminal, at the moment of its destruction, is emblazoned with significance. Not only is the criminal's body the recipient of a sovereign power that inscribes temporal justice upon its every fiber, it is simultaneously elevated through Christian iconography to the exalted heights of the *fabulous exemplar*: the life that is to be either emulated or shunned. Foucault's "infamous man," the criminal who would be removed from society altogether but for the briefest of entries in the annals of disciplinary power, is yet to be seen in this drama of bodily partition. For although there are the formative moves toward such disciplinary effects (evident already in the atomizing, individuating medical gaze that arose out of the anatomy theaters of the day), the spectacle of the scaffold and the subsequent ritual of the public anatomy are, at this point, still acts imbued with the significance of sacrifice and atonement.

What is remarkable about this account of the conflation of Christian imagery with judicial torture is the manner in which the discourses of the saintly body intersect with that of the criminal *through the process of their bodily partition*. In a way that will have tremendous significance for our understanding of why criminal bodies were deemed appropriate (if not preferable) for the acquisition of scientific knowledge in the anatomy theater, it is the partitioned and mutilated body, whether criminal or saintly, that becomes associated with a register of sanctity.

As we have already seen from the cult of the saints, bodily partition was not the sole preserve of scientific anatomy (although I am about to suggest that anatomy would come to emulate, if not actively try to appropriate, the sacral nature of these partitionings).[115] The story of the nuns of Montefalco is illustrative of existing funerary practices that indulged in the partition of the body for purposes of both preservation and veneration; it is also a story of how

"saintliness" was adjudicated. In 1308, the nuns of Montefalco, Umbria, deemed it necessary to open the body of their abbess, Chiara, who had died "in an odor of sanctity" so that she might be preserved.[116] Conducted by the nuns themselves, the evisceration of the body yielded surprising results:

> On the following evening, after vespers or thereabouts, the said Francesca, Margarita and Lucia and Caterina went to get the heart, which was in the box, as they later told the other nuns. And the said Francesca of Filigno cut open the heart with her own hand, and opening it they found in the heart a cross, or the image of the crucified Christ.[117]

Further evidence of Sister Chiara's sanctity would be found inscribed throughout her body, which, once preserved, was exhibited annually on the eve of the Feast of St. John the Baptist.[118] The story of the nuns of Montefalco shows us that sanctity leaves its telltale marks upon the body, and that dissection secures this sanctity; the procured fragments of such a partitioning thereby displaying the properties of the divine. The difference with martyrdom, however, was that, in a parallel to the apparatus of the scaffold, it was in the very act of breaking and partitioning the body which was significant: partition also being the guarantor of sanctity.

With regard to the criminal body, its partitioning would occasion a trade in body parts to rival the trade in saintly bodies: the fat of the criminal, extracted by the executioner after the deed, when purified could be used as a painkiller; a belt made of the skin of the criminal was a popular remedy for hysteria, as well as being useful for stopping spasms in the hands or feet; while the moss that grew on the skulls of unburied criminals was particularly effective at stopping nosebleeds.[119] Other powers attributed to executed criminals can be found in the English practice of midwives taking babies born on the day of an execution out to the gallows and allowing the hand of the dead criminal to touch the forehead of the child so that it might live a "blessed" or charmed life.[120] The ultimate extension of this logic can be seen in Giorgio Vasari's morbid tale of Silvio Cosini of Fiesole, who fashioned a leather jerkin out of the flayed skin of a criminal, believing it would grant him protective powers.[121] The sheer abundance of these "anthropophagic pharmacologies" derived from criminal bodies suggests, in a faint echo of Edgar Wind's criminal-god, that the criminal, like the saint, was supernaturally inspired; this "inspiration" manifesting as either corrupting or healing powers.[122] But perhaps what we can suggest here, instead, is that it was through the mimetic drama of the scaffold that the sanctity of the criminal was secured; that it was through the exercise of this strange conflation of heavenly and temporal justice, through the brutal destruction of the criminal body in emulation of the saint's own torments, that access to the divine could be had.

It is precisely this sanctity through bodily destruction that, I wish to suggest, underpins the quest for bodily animation within the discourses of medical anatomy, and was played out in the anatomy theaters of Europe. During the nonwinter months anatomy theaters were rarely shut; their doors were often thrown open to the curious appetites of the general public who, for a small fee, would visit such theaters to gaze upon their morbidly wondrous contents. Replete with displays of medical instruments and anatomical specimens, including articulated skeletons (often set in *tableau*), flayed skins, preserved body parts, and stuffed and mounted animals, these theaters functioned in not dissimilar ways to the curiosity cabinets of the day.[123] Marshaled under anatomy's catch phrase of *Nosce te ipsum*, "know thyself," these fragments of criminal bodies were made to speak to the divinity of the act of creation as it was uncovered through the act of systematic bodily destruction.[124] One could attend the anatomy theater to surround oneself with the remains of executed criminals either to contemplate the mortality of human flesh, or to venerate the wisdom of the act of creation as it was manifest in the microcosm of flesh made in the image of God.

We can perhaps get a greater sense of the seemingly contradictory task of acquiring knowledge of the sanctity of the flesh through the study of the criminal if we consider the following inscription by Caspar Barlaeus, which appeared in golden letters above the balcony of the first permanent anatomy theater in Amsterdam in 1639:

Evildoers who, while living, have done damage, are of benefit after their death. Their skins teach us this, even though they have no voices.[125]

Housed within this theater were two flayed skins of the criminals Gielis Calewaert of Haarlem and Suster Luijt; the latter was deemed particularly "holy" to guild members, "because it reminded them of Amsterdam's first public dissection (1550), on the occasion of which they got their nickname "menschenvilders," "flayers of human beings."[126] We have already seen with Michelangelo's depictions of St. Bartholomew on the Sistine ceiling the way that flayed human skin served as both a sign of the torment that guaranteed his virtue and as the embodiment of his earthly sin which, once removed, allowed for, if not assured, beatification. Likewise with Becerra's *écorché*, we see the sanctity of St. Bartholomew's martyrdom mirrored in the guise of a criminal dissected for the medical gaze. More than just a compositional device or strategy to "contain" the morally questionable practice of dissection within representation itself, we can see in Becerra's *écorché* the very goal of anatomy as it was reflected in the devotional and contemplative atmosphere of the anatomy

theater as *cabinet of death*: to quite literally grasp the sacred within the microcosm destroyed. "Putting one's hand to the matter" was nothing short of a mimetic act in emblazoning the body with sanctity by making the criminal—through a sophisticated ritual of imitation that started back at the scaffold—emulate the sacred torments of the saints.

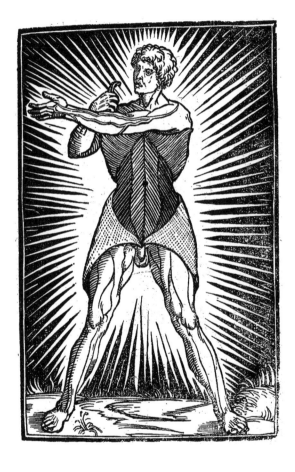

**2.10**
Unknown artist, autodissecting *écorché*, from
Iacopo Berengario da Carpi, *Isagogae breves*
(Venice, 1523). Image: Wellcome Library, London.

In the provocative final pages of Heckscher's analysis of Rembrandt's *Anatomy Lesson of Dr. Nicolaas Tulp*, he suggests the following reading of the public anatomies:

> But in a deeper sense public anatomies were magic precautions taken in order to protect society against the criminal's power to do evil, which the execution alone by no means had managed to annihilate.[127]

We can see in the solemn rituals of public anatomy—in the processions, the prayers for the souls of the condemned in nearby chapels, and the monies spent on proper burials after the dissection has taken its course—the need to deal with such dangerous delays in the appropriate handling of the dead. In this regard these rituals can be seen to serve the dual purpose of the criminal atoning for their sins in life by giving their bodies up to knowledge in death, at the same time as science atones for its profane handling of the dead.[128] The sacrifice of the criminal-god for the atonement of the people springs to mind.

Yet perhaps if we look not so much at the solemnity of the ritual of public anatomy, but rather at its more carnivalesque associations of transformation, then we can see in anatomy's animations something of the logic that motivated Silvio Corsini of Fiesole, a member of a local confraternity, to return to the scaffold to possess the body of the man he had earlier comforted in death, to cut and dissect ("in the interests of art") so as to harness the sacral power of the flesh. And if Becerra's *écorché* does not quite convince us of this pursuit of the sacred through bodily partition, then perhaps the self-dissecting *écorché* from Berengarius's *Isagogae breves* (1523) will (figure 2.10). Standing before the viewer, a criminal has torn his own skin open to reveal the musculature of his body; a divine light radiates from the broken flesh, like the illuminating aura of a saint. The popularity (and appropriateness) of this image is attested to by its repeated use for nearly one hundred and fifty years.

### Conclusion: Dissecting Statues / Invigorating Knowledge

Not only inanimate artifacts but also humans are detachable, fragmentable and replicable in a variety of materials.

Barbara Kirshenblatt-Gimblett, "Objects of Ethnography"

There are ten anatomical figures published in the *De fabrica* that share a similar conceit: "they exist for the eye not as bodies dissected but as fragments of sculpture somehow miraculously able to sustain the act of real anatomical demonstration" (figures 2.11 and 2.12).[129] If the *De fabrica* musclemen have been taken to represent the broken body stumbling forth into a ruined Arcadian

landscape, then these fragment-anatomies are nothing short of the exhumation of the secrets of the inner structure of the human body from Arcadia itself. Depicted as if their extremities "were broken off, rather than severed by the surgeon's knife," these figures have occasioned numerous efforts to identify them as actual pieces of reclaimed classical sculpture: "all of them [are] strongly suggestive of the *Torso Belvedere* and similar pieces."[130]

In a move familiar to us already, Glen Harcourt sees in these figures a "representational strategy that at once belies and elevates the socially problematic practice of physical violation characteristic of the real production of anatomical knowledge."[131] As part of the Renaissance's general "indebtedness" to a reclaimed classical heritage that saw broken and mutilated statues displayed in loggias and *gallerie* without shame or apology, these fragmentary anatomies are seen as a strategic move to codify anatomical investigation as not only sanctioned by the will of the Ancients, but, like mineral fragments removed from the ground, seen as "natural." However, the fractured and broken condition of these reclaimed antique statues also speaks to a very different register.

·····

In a summation of the "economy" of sovereign power and its relationship to the forced recompense of the criminal body through judicial torture, Foucault suggests that

> the body has produced and reproduced the truth of the crime—or rather it constitutes the element which, through a whole set of rituals and trials, confesses that the crime took place, admits that the accused did indeed commit it, shows that he bore it inscribed in himself and on himself, supports the operation of punishment and manifests its effects in the most striking way.[132]

The mechanisms of judicial torture that tear at the flesh do not so much inscribe the power of the sovereign upon the body of the criminal; rather, they cut and burn, break and smash the body of the criminal so as to reveal the truth of the crime that lies already written within the criminal's body. Sovereign power rends the flesh in order to reveal the criminal for what he or she really is.

·····

Robert Musil wistfully observed that there is nothing in this world as invisible as a monument:

> The purpose of most ordinary monuments is to first conjure up a remembrance ... and it is in this, their prime purpose, that monuments always fall short. They repel the very thing that they are supposed to attract. One cannot say that we do not notice them; one would have to say that they "de-notice" us, they elude our perceptual faculties: this is a downright vandalism-inciting quality of theirs![133]

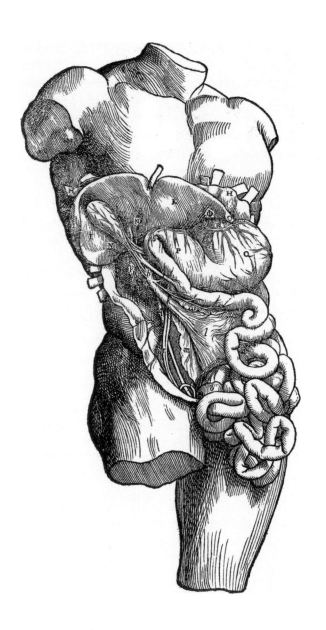

**2.11**

Steven van Calcar, visceral anatomy, from
Vesalius, *De fabrica* (Basel, 1543). Image:
Wellcome Library, London.

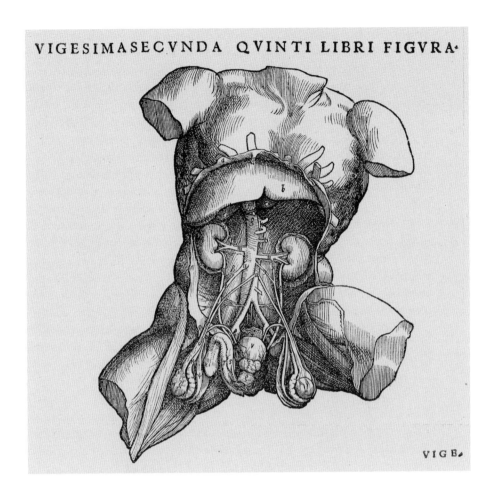

VIGESIMASECVNDA QVINTI LIBRI FIGVRA·

VIG B.

**2.12**
Steven van Calcar, visceral anatomy, from
Vesalius, *De fabrica* (Basel, 1543). Image:
Wellcome Library, London.

To this, Michael Taussig counters with the "contemptible consideration" that some representations have a "strategic, built-in desire to be violated without which they are gapingly incomplete."[134] This willfulness, this animation, this agency on the part of statues that screams out in invisible silence for us, the viewer, to "put our hand to the matter" and intervene on their behalf, achieves its full and proper "brilliant illumination" only through an act of desecration or *defacement*. In a way not dissimilar to the sovereign's power to reveal the truth of the crime that lies within the body of Foucault's criminal, for Taussig, the *negation* of a statue's active ability to *negate* us is something that is housed within its very being: "little effort of imagination is required to understand defacement ... as an act whose uncanny capacity to animate dead matter, by magically fusing the representation with what it represents, is already inscribed in the nature of the statue itself."[135] The act of defacement arouses, within the defaced thing itself, "a strange surplus of negative energy" that activates and animates the broken statue: it is "the broken object that bespeaks of life, precisely because it is broken; it exudes aura and returns our gaze."[136] Defacement is an act that transcends the potentially life-threatening violence inflicted, a violence that the statue all but willed in the first place, releasing instead a potentiality that was always-already within it. Now in a state of *desecration* this "hemorrhaging of presence" shifts the broken statue from Musil's excess of invisibility to an excess of visibility.[137]

·····

In an act of mutilation that went beyond the practical measure of exposing cult images for what they were—mere stone and metal—the early Christian iconoclastic measure of the fourth century AD of affixing the head of a Christian saint on a pagan statue that had been defaced through decapitation, and to subsequently baptize that statue as a "living Christian," speaks to an urgent project not of destruction, but of reclamation.[138] Following Taussig's lead, it would seem that the headless pagan statue, far from being destroyed, has had its "sacredness" invigorated by the act of defacement. It is only through its "conversion" and "healing" that this "hemorrhaging of presence" is ceased.

·····

If we return to the fragment-anatomies of the *De fabrica*, we can see the willfully animated call of Musil's statues for release from their stony prison in the regime of complicity that characterized the sixteenth-century anatomy theater as a place where the corpse not only sanctioned its own defacement, but also actively desired it. The animation that brings the anatomical musclemen to life is mirrored in the ruined landscape through which they stalk: the ruined body is activated by its broken state ("it is the broken body that bespeaks of life"). The anatomy that has so thoroughly destroyed the bodily whole re-creates it as

scientific knowledge. The brutal killing and dissection of the criminal body in the anatomy theater stands for more than just a punishment, or a utilitarian investigation into the structure of the human body: it is, in effect, a call to the conjoined nature of criminal and the saint at the moment of their violent bodily destruction, so that through the act of dissection the profanity of knowledge may be once more deemed sacred.

It is hard to see how this destruction of criminal bodies within these theaters of death cannot be related to the act of defacement. Even if it is only a distant longing for the type of animation that beatified the broken body of the saint, the sensual excess of "putting one's own hand to the matter" seems nothing short of seeking the sacred through an act of its negation. Compared to the nuns of Montefalco, however, these bourgeois scientists cannot help but seem amateurish: fishing around in the broken body, they search in vain for that one identifiable element of the sacred that will animate the body of scientific knowledge. Like the executioner who no longer knows the importance of breaking a criminal on a wheel possessed of thirteen spokes rather than twelve, anatomists would deface endless supplies of criminal bodies in a desperate effort to reactivate the power of the sacred.

The physical presence of the martyred saint, in the bodily relic or in the icon itself, was guaranteed by the act of sacrilege or defacement that invigorated the broken body as sacred in the first place. The fragment-anatomy stands, therefore, not as an act of avoidance, but as a clumsy and hopeful icon that attempts to summon forth the physical presence of the actual bodies that were destroyed in the construction of the image. Perhaps part of the disturbing and haunting quality that these anatomical illustrations hold for the modern viewer is based precisely upon our realization that they were intended as more than just recuperative illustrations of avoidance and atonement: they were active efforts to resuscitate the bodies of the dead so as to invigorate the knowledge of early scientific Enlightenment.

## Postscript: Fragments of Yagan

In consequence of a schism in the sympathetical school of curers, a serious discussion was long maintained "Whether it was necessary that the moss should grow absolutely on the skull of a thief who had hung on the gallows?" The general opinion was that the virtues attributed to skulls belonged only to those which had never been buried, and had lain some time on the ground, or hung on the gibbet or the like.

David Murray, *Museums: Their History and Their Use*

In 1984, Australian sculptor Robert Hitchcock created a life-size bronze of Noongar tribal leader Yagan. Depicted naked with a spear slung over his shoulders, the statue of Yagan stands on Hierisson Island in the Swan River near Perth. In an event that speaks of the mimetic underpinnings of defacement, in 1997 Yagan's bronze likeness was made to recapitulate the events of his original death in 1833. Within a week of Ken Colbung's return to Australia with Yagan's exhumed head, vandals had beheaded the statue. Calls for its restoration were made, and a new head was eventually affixed. This second head was lost within weeks of its restoration. When it was successfully restored a third time, there were calls to cast a new head for the statue based on the actual anatomical details of Yagan's skull.

On 10 July 2010, the eve of the anniversary of the last full day he lived, in a private ceremony attended by Noongar elders, the head of Yagan was finally laid to rest.

# Spaces

---

**3**

This is what happens when you hurry through a maze, the faster you go, the worse you are entangled.

................................................................................................................

Seneca (4 BC–AD 65), *Epistulae Morales* 44

During all the time I spent in Moscow, I made great endeavors to obtain a faithful representation of that town, but could never procure one. There are no painters in that country, and they would receive no consideration there, since there is no understanding of the arts. There are however sculptors and makers of idols, but I never dared to ask any of them to make me a drawing of the town, for they would have me seized at once and delivered me to torture, in the belief that, by asking for such a thing, I must be contemplating treason. …
At that time there was in Moscow a gentleman who, at the siege of Kromy, had received a wound in the leg that had obliged him to remain seated at home. Having a lively passion for drawing, he had among his servants a carver of idols who taught him to draw, and among other things he had executed a view of Moscow with his pen. …
I took the risk of asking him for a view of Moscow. On hearing that, he swore to me that if I had asked for one of his best horses, he would have given it to me more willingly. But considering me to be his best friend, he gave me the drawing on the condition that I swore that I would never say anything about it to a Muscovite or reveal the name of him from whom I had received it. "For," said he, "my life would be in danger if it were known that I had made a drawing of the town of Moscow and had given it to a foreigner. I should be killed as a traitor." I have placed in this book this drawing, done by pen with such exactitude that in truth you have the town before your eyes.

................................................................................................................

Isaac Massa, *Histoire des guerres de la Moscovie* (1601–1610), addressed to Prince Maurice of the Netherlands

## Visions of Modernity: Perspectives on the Sacred

Ecstasies and raptures are the psycho-physical conditions which designate the culmination of mystical activity. At many periods artists endeavored to render not only these conditions themselves but also the visions experienced in that exalted state of perception. What distinguished the Baroque from earlier periods and even the High from the Early Baroque is that the beholder is stimulated to participate actively in the supra-natural manifestations of the mystic art rather than to look at it "from outside." This is meant in a very specific sense, for it is evident that in many works from about 1640 on a dual vision is implied, since the method of representation suggests that the entire image of the saint and his vision is the spectator's supra-natural experience.

Rudolf Wittkower, *Art and Architecture in Italy 1600–1750*[1]

Regarded as the *reductio ad absurdum* of the baroque fascination with *trompe l'œil* illusionistic ceiling painting, the frescoed nave of the church of Sant' Ignazio in Rome represents a deeply uncompromising instance of the single-point system of Western architectural perspective (figure 3.1).

Executed between 1691 and 1694 for the new church of the Collegio Romano, the teaching arm of the Jesuit Order, Fra Andrea Pozzo's *quadratura* is a painterly exposition of the very purpose of the Collegio: the transmission of the word of St. Ignatius to the four corners of the world.[2] Pozzo, who was himself a Jesuit coadjutor brother, has created a visionary scene of transfiguration within the confines of Sant'Ignazio: the light of God can be seen to be transmitted through a celestial Christ transcending from heaven, through the rapturous body of St. Ignatius suspended by angels amid the swirling clouds that have miraculously manifested where the ceiling of the church once was, to then be projected to the four known continents of the earth as a perfect allegory of the missionary work of the Society of Jesus.

Overcoming the restrictions of a non-uniform curved ceiling vault, Pozzo has projected an architectural framework above the height of the nave toward a radiant heaven through a surge of dramatically foreshortened columns with breathtaking bravura. From the floor the observer is unable to see the actual painted surface of the vault: the arches and columns at both ends of the nave seem to stand defiantly upright into space, the ceiling literally having been "opened up" by the skyward thrust of architecture to allow the faithful observer to be witness to the miraculous scene taking place above and within the church.

In order to eliminate all visual traces of the vaulted ceiling in this fashion, thereby giving the scene its dramatic force, Pozzo had to rigorously conform to a concept of a static, monocular spectator transfixed within an elaborate assemblage of single-point perspective.[3] The degree to which this sense of illusion is reliant upon this method of linear geometric perspective is attested to

by Pozzo's placing of a circular marble disk in the floor of the church, representing the ideal *viewing point*; that mathematical reflection of perspective's elusive (and somewhat "mystical") *vanishing point*. It is not until the spectator strays from this ideal viewing position, however, that the true force of Pozzo's illusion becomes apparent: wandering from the marble disk breaks the perspective that maintains the illusion, causing the projected architecture to sway and buckle in a vertiginous manner as if it is about to collapse in on the viewer (figure 3.2). Such is the obstinacy of the illusion, and so convinced is the mind of what it has been viewing, that people walking from the marble disk often feel nauseous or dizzy, many crumpling to their knees, having lost their balance.[4]

In a church of the size and significance of Sant'Ignazio, the question must be asked: why did Andrea Pozzo employ such a rigid and unresponsive system of single-point perspective, seemingly inadequate to the needs of differentially located spectators? It would be easy to dismiss this question on account of the technical difficulties that Pozzo faced in his efforts to project a two-dimensional image onto a curved surface: employing a gridlike net or *velo* suspended at the cornice level, and using a centrally located plumb line to project a cartoon of the composition onto the ceiling, Pozzo, so this response would claim, could not help but construct an image wholly dependent upon a single viewing position.[5] However, to suggest this would be to deny the ingenuity of Pozzo's *quadratura* as well as the wider discursive associations of employing what at first glance merely seems to be a naturalistic, if somewhat mechanical, method of rendering pictorial compositions in two dimensions.

If we turn to Pozzo's own highly popular architectural treatise, the *Perspectiva pictorum et architectorum* (Rome, 1693), we find that the artist himself has marshaled three specific arguments in response to this very same charge (indicating that it was a controversial issue even in his own day).[6] First, Pozzo claims that "all the great masters" had used the single-point system. Although this is seemingly quite an inconsequential argument, Pozzo's appeal to an historical tradition is, I will suggest, highly revealing of the epistemological centrality of geometric perspective to late Renaissance conceptions of knowledge production, subjectivity, and the built environment. Second, Pozzo argues that "since perspective is but a counterfeit of the truth, the artist is not oblig'd to make it appear real when seen from any point, but from one determinant point only," and in doing so criticizes multiple-viewpoint systems in that "they do not look entirely correct from anywhere."[7] And finally, Pozzo insists that the distortion experienced by the strolling observer was "so far from being a fault, that I look upon it as an excellency of the work," as it was his express intent in designing the fresco "to draw all the lines thereof to that true Point,

**3.1**

Andrea Pozzo, *Allegory of the Missionary Work of the Jesuits*, Sant'Ignazio, Rome, 1694.
Photo: Marie-Lan Nguyen.

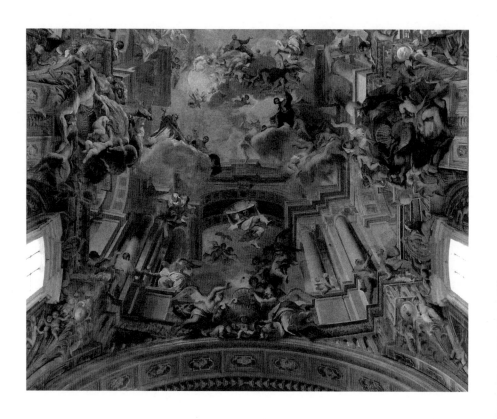

**3.2**
Andrea Pozzo, *Allegory of the Missionary Work of the Jesuits*, Sant'Ignazio, Rome, 1694. Detail showing the illusion faltering. Photo: Bruce McAdam.

the Glory of God."[8] In the case of the nave fresco that "point" is actually the Son of God, who sends light into the heart of St. Ignatius to be transmitted to the most distant regions of the earth.

It would seem that for Pozzo, then, it was the miraculous coalescence of distorted shapes into a coherent revelation that took place when the faithful observer walked onto the viewing point of the marble disk that provided the *raison d'être* of the work. Single-point linear perspective was not only a mechanical technique that could render an illusionistic architectural space; it was also a most able vehicle for a metaphysical enunciation of Jesuit philosophy. Thus a double "movement" occurs with Pozzo's ceiling: illusion is predicated upon a principle of geometric perspective, and it is this illusion reflected back through the system of optical dynamics that enables the correctly positioned, and only the correctly positioned (that is, the "faithful"), observer to be the recipient of a transcendental metaphysic extolling the radiant spiritual work of the Jesuit missionaries. The single, correct viewing position was not just a practical consideration of the work; it was, in fact, integral to an understanding of it.

This is precisely what Rudolf Wittkower is suggesting when he claims that high baroque art represented a "dual vision": the vision of the saint (their moment of ecstasy or transfiguration) becomes the vision of the faithful.[9] More than this, however, the example of Pozzo's ceiling indicates something vitally important to these notions, theories, and practices of Renaissance visualization: more than just a technique for the production of space, linear perspective was equally concerned with the deployment of bodies within space, as well as the inculcation of those bodies within various discourses of knowledge production and meaning. Thus, the visual assemblage of linear perspective represents a site of embodiment: a space for the organization and production of specific knowledge claims and their related subject positions, by representing the relationship between a perceiver and the position of a knowing subject to an external and, in this instance, sacred world.

The case of Pozzo's ceiling allows us, therefore, to make a slight addendum to Wittkower's argument: it is not so much that St. Ignatius's vision is witnessed by an observer as their own mystical vision; rather, it is that the observer is literally "transfigured" by the same light that has transfigured and beatified St. Ignatius: the faithful observer being physically struck to the spot at the same time that they are propelled into pious and reverent contemplation of the sacred work of the Society of Jesus.

.....

**3.3**
Aerial view of Paris from balloon, Exposition
Universelle, 1889. Image: Picture Archive,
Library of Congress.

Paris, 1889: "Capital of the Nineteenth Century." Alexandre Gustave Eiffel's recently constructed engineering marvel soars skyward with a wholly modern self-assuredness, its crisscrossing iron railway-like girder framework representing not only a new industrialized aesthetic but also, quite literally, the high point of modernity's technological and scientific capabilities. But it is not the bold new aesthetic of Eiffel's engineering wonder that is attracting so much attention. Rather, what is proving so irresistible is the commanding view it affords of the greatest spectacle the century has yet seen; a spectacle it was expressly built for: the Exposition Universelle commemorating the outbreak of the French Revolution. As the crowning achievement of modernity's centennial celebration, Eiffel's tower stands before us, as Walter Benjamin would come to describe it, as "an incomparable monument to a new heroic age of technology."[10]

From the vantage point of the world's tallest structure, the spectacle of the 1889 Exposition is laid out in front of us like an enormous map, there to be read like a perfectly detailed site plan, the kind one can find in any number of guidebooks published to commemorate the occasion. Inscribed on this "map," to each of the four "cardinal" points of the compass, extraordinary visions of strange worlds and technological marvels are presented for our contemplation. Gazing southward down the Champs-de-Mars, we are struck by the utopian splendor of the Galerie des Machines: a glass and iron hall with a vault spanning some four hundred feet in width where sightseers can look down from suspended walkways upon "a sea of spinning wheels, clanking hammers, and whirling gears."[11] Part railway station, part *grand magasin*, in its shimmering cathedral-like vault one can see, in the cacophonic chant of its machines hear, and on the price tags attached to all things read, the "festival of emancipation" promised by this centennial exposition; a festival that would stir Benjamin to recall the spirit of Grandville when he suggested: "The World Expositions were places of pilgrimage to the Commodity fetish."[12]

If Eiffel were standing next to us gazing down upon the Galerie des Machines, he would certainly appreciate the "vision": only two years earlier he himself had completed the daring reconstruction of Aristide Boucicaut's Bon Marché. In that instance, the use of iron and glass allowed for open and spacious bays in which large quantities of material goods could be displayed and through which vast crowds could move with ease.[13] Yet in the case of the Galerie des Machines this principle was not only magnified in size by its architect, Ferdinand Dutert, but also glorified in its brilliantly resplendent luminosity: diffuse light streaming through the Galerie's translucent surfaces produced a fairytale "palace of industry."[14] And if we were to linger atop Eiffel's tower until early evening, then this wondrous "vision" of industrial and consumptive desire would be complemented by a dazzling display of illuminated fountains,

**3.4**
Galerie des Machines (interior), Exposition
Universelle, 1889. Image: Picture Archive,
Library of Congress.

each sending rainbows of light, cascading jewels, and flaming liquids into the air; while electric spotlights mounted above our heads would sweep the darkening sky with the promise of infusing everyday life with fabulous qualities.[15] Like most *fin-de-siècle* bourgeois architecture, the Galerie des Machines stood offering itself as a transcendent and universalizing "dream world," enthroning machinic commodity as glittering luxury; opening up a "phantasmagoria into which people entered in order to be distracted."[16]

Yet the utopian world of technology and consumption promised by the Galerie des Machines represents only one of the "visions" offered up to the spectator by this centennial exposition. Turning our gaze westward across the Champs-de-Mars, we behold a very different sight indeed: the minaret of a mosque reaches above a winding street of overhanging latticed windows, whitewashed walls, horseshoe arches, and ornamental "arabesque" tile—this is *la rue du Caire*. Using recycled architectural fragments from demolished buildings of the old quarter of Cairo, this facsimile street spreads out before our eyes as a winding bazaar with dozens of buildings representing, in the words of its designer Delort de Gléon, "various motifs from all *belles époques*" of Cairo's history.[17] Archaeological exactitude was first and foremost on Delort de Gléon's mind when he remarked that his re-created "oriental bazaar" was more authentic than the streets of Cairo itself, in which it had now become all but impossible to find such an old untouched site. However, Delort de Gléon's quest for authenticity also replicated itself in the language of the exposition; the language of commerce. Down on the street below, the fairgoer is tempted by vendors selling pastries and trinkets, jostled by the donkey train carrying people up the length of the street, or perhaps, for a price, charmed by the exotic *danse du ventre* performed by young Egyptian girls. Yet from our vantage point atop Eiffel's tower, the clamor and confusion of the *rue du Caire* presents itself as a moving *tableau*; a "view" to be taken in as a whole.[18]

Turning our gaze now from the thronging crowds of the Champs-de-Mars, northward across the Seine to the Jardins du Trocadéro, we are met with one final, startling vision: before the great arc of the Trocadéro's outstretched arms a vast array of pavilions and exhibition halls have been scattered, constructed in the image of so many different cultures: a Turkish bathhouse, a Cambodian temple, a Sudanese encampment, a Chinese pagoda, and an Algerian coffeehouse. This is Charles Garnier's boldly conceived *L'histoire de l'habitation*. More than just the single *tableau* we witnessed when viewing *la rue du Caire*, Garnier's *L'histoire* appears before us as forty-four individual dwellings, each representing "historical archetypes," composed of what Garnier would describe as "crucial" or "essential" ethnographic elements. Replete with appropriately "typical" decorations and stationed with welcoming indigenous subjects in

"authentic" costumes, these pavilions, so Garnier (in echo of Delort de Gléon) proclaimed, had a quality of exactitude about them such that "the resemblance to truth was truer than truth itself," thereby neatly encapsulating the "spirit" of transparency said to underpin the logic of exposition.[19]

Known in his day as much for his hostility to Eiffel's new tower as for his own lavishly designed Opera House (something that would be rectified only in hindsight), Garnier presented *L'histoire* as a moving theater of organic and "lived" architecture, erected as a counterpoint to the cold, skeletal construction that towered above it. The irony here was that as a didactic lesson intended to show "the slow but inevitable march of humanity through the ages," Garnier's moving panorama—"where all [the world's] habitations parade before us"— could really be properly appreciated only from the vantage point of the tower that he so despised.[20]

From the elevated viewing position of Gustave Eiffel's tower, then, Garnier's *L'histoire de l'habitation* unfolds before our gaze as a world picture: a detailed, living, moving spectacle celebrating "in stone and stucco the civilizing mission of the metropolis and the exotic charm of the territories of the colonial empire."[21] Viewed from such heights, the bustle and clamor, the exotic sights, the swirling sounds and the aromatic smells of the colonial pavilions coalesce into a single "vision"; a vision depicting a maternalistic France in the form of the Trocadéro, arms extended, embracing her colonies. Thus, the emerging world order of universal trade and colonial conquest is here rendered as a "view," something placed before individual subject-observers who are themselves placed before objects on display by a world so ordered in the form of its commodities.[22]

·····

In laying the foundation for his observations regarding a modern order of simulation lacking in referent, and hence hyperreal in character, Jean Baudrillard traces a "procession of simulation" from late Renaissance or early "classical" modes of *imitation*, through industrial modes of *production*, to more recent configurations of a hyperreal *simulation*. The dominant characteristic of early "classical" representation Baudrillard labels as "counterfeit"; the stucco angel being its quintessence: "it's there, in the prowesses of stucco and baroque art, that you read the metaphysic of the counterfeit."[23] Yet for Baudrillard this mode of representation was not merely confined to a physical artistic practice. It was, in effect, a *metaphysic* inasmuch as the very nature of stucco embodied the new ambitions of "classical" culture: those of a *worldly* demiurge—the reduction of all previous diversities to a new level of equivalence.[24] Interesting, in this regard, is Baudrillard's passing reference to the spiritual project of the Jesuits: "there is a strict correlation between the mental obedience of the Jesuits

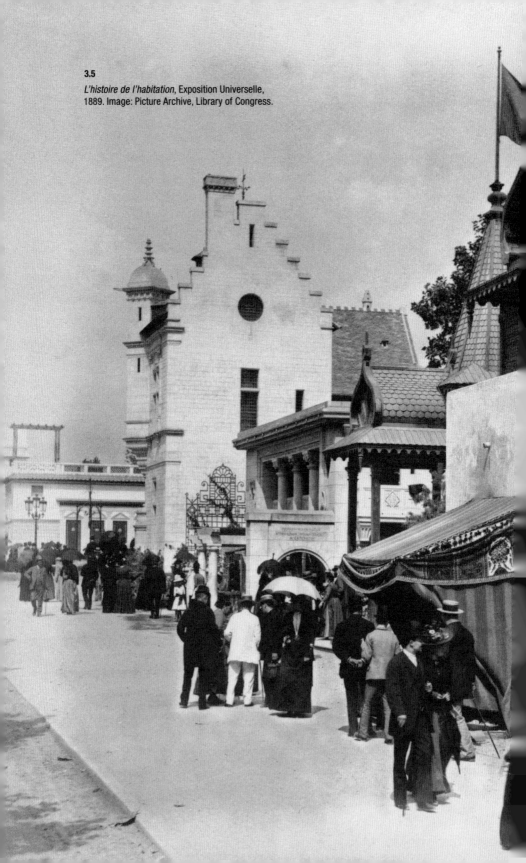

**3.5**
*L'histoire de l'habitation*, Exposition Universelle, 1889. Image: Picture Archive, Library of Congress.

('*perinde ac cadaver*') and the demiurgic ambition to exercise the natural substance of a thing in order to substitute a synthetic one."[25] It was the Jesuit objective of reunifying the post-Reformation world under the aegis of a universalized and homogenized doctrine that Baudrillard saw as so aptly embodied by his stucco angel.

We can see the ultimate extension of Baudrillard's first order of simulation in Andrea Pozzo's wondrous vision of transfiguration, which worked above all by inculcating the viewer into a metaphysical assemblage of Jesuit philosophy through linear perspective. Not only does Pozzo's *quadratura* represent an exemplary instance of "counterfeit" or imitation (perhaps an even more sophisticated one than the stucco angel—the Sant'Ignazio fresco, after all, being able to imitate even stucco itself), it also represents an early instance of this "worldly demiurge" to transform all of nature into a homogeneous exchange; in this case, the Jesuit attempt to unify the furthest extremes of the world under the one true Word.

Where the charm of Pozzo's ceiling truly outshines the stucco angel, however, is in its ability to go one step further than Baudrillard's descriptive analysis, inasmuch as it presents to us the method by which this worldly demiurge actually accomplishes its task: through the physical extension of the spatial practices that form the binding logic of the fresco beyond the confines of the church in which they are presented; a logic predicated on the mobilization of bodies in space, and the presentation and ordering of all things to a subject-observer transfixed by these spatial practices. Thus, although I do not wish to engage fully with Baudrillard's work at this stage, I do wish to point out through him a conspicuous absence not only from his historical trajectory of representation, but also from most other modern theorizations of space and representation: the very physical and embodied nature of these visual regimes— their ability to transfigure; to strike the observer to the spot; to bring them to their knees at the same time as they are propelled from their bodies in pious contemplation.

•••••

It was Benjamin who suggested that "with construction in iron, architecture began to outgrow art; painting did the same in its turn to the dioramas."[26] What strikes me about this statement is the allusion Benjamin makes to what I would call a shared industrial "physiognomy" of the architectural technology of iron and glass on the one hand, and the pictorial reproduction of space of the dioramas on the other. However, Benjamin does not dwell on this shared physiognomy; rather, he is more concerned to see the dioramas in their capacity as forerunners of the modern pictorial turn to mechanical reproducibility, suggesting that photography literally rises out of their ashes: "In 1839 Daguerre's

diorama was burned down. In the same year he announced the invention of the daguerreotype."[27] With this one sentence, Benjamin essentially abandons the pictorial nature of the diorama in favor of its architectural and machinic qualities. It could be said that for Benjamin, more than Daguerre's diorama went up in flames that night in 1839: in effect, painting went up in flames, leaving only the iron girder skeleton of the diorama's mechanical frame behind; a frame whose industrial nature would ultimately provide the architecture of Benjamin's own understanding of the camera and cinematic photography.

In reducing the properties of the diorama to the mechanically reproducible image, Benjamin has prioritized their purely physical or structural similarities to the iron and glass architecture of the arcades. What was so captivating about Benjamin's initial statement regarding the turn both architecture and painting made away from "art" to their modern, industrialized forms, however, was the suggestion that it was the *visual imagery* of the diorama that was related to the *architecture* of the arcades: that is, painting was to the dioramas as architecture was to the arcades. Taken this way, the shared industrial physiognomy of these two structures had less to do with their similar industrial form and more to do with how these forms enabled them both to function in similar ways. And in the case of the dioramas, the way this shared physiognomy manifested itself was in their capacity to represent and reproduce space.

Returning, then, to the fairgrounds of the 1889 Exposition Universelle, we find that one of the most popular exhibits of the day was just such a diorama. Upon entering its spherical structure, viewers would find themselves placed on one of two centralized viewing platforms, surrounded on all sides by a sophisticated panoramic reproduction of Paris. Various artificial lighting devices would simulate the changing times of day so that from these central viewing points, the illusion of overlooking the actual city itself was complete.[28] A common feature of such cityscape dioramas was the incorporation of a final level that actually took the observer outside of the structure to an open-air platform where a direct comparison was encouraged between the pictured view and the view it represented.[29] Standing at the center of the diorama, then, like standing atop the Eiffel Tower, the fairgoer occupied a privileged spatial position: at the center of the fairground, which itself lay at the center of the city, the viewer found themselves surrounded by a picture of the city that lay at the center of an empire—the world having been laid at their feet and before their eyes as a view to be had.

One of the most enduring (and epistemologically damning) insights of Timothy Mitchell's account of Arab visitors to the nineteenth-century world expositions is his retelling of the confusion felt by many such visitors over being unable to tell where the fairground ended and the city itself commenced: Paris

at large being like a further extension of the fair.[30] It is clear that the diorama belonged to this arsenal of exposition practices that formed the armature of Benjamin's dream world of mass consumption, producing and enhancing the phantasmagorical effect of things placed on display before observing subjects. What was interesting about the diorama in this context, however, was its dual function of being not only an example of such a spatial technology, but also itself a representation of space in the form of a world picture.

When considering the veritable academic industry concerned with the theorization of space, or the description of alternative spatial practices and their accompanying subject positions, it is usually to architecture that we turn, and not to painting—the academic allure of Benjamin's arcades having much to do with this, I suspect. What I wish to suggest, however, is that if we take up Benjamin's unclaimed allusion to a shared industrial physiognomy between architecture and painting, and extrapolate its logic, then we can begin to see the importance of the visual for conceptions of space; that is, we can begin to see how our pictorial renditions of the world, far from being mere representations, actually come to underpin and structure the very "architecture" of space.

This, in effect, is the task I wish to place before us in this final chapter: to show the manner in which the spatial ordering of modernity so evident at the world expositions (the world ordered in the form of its commodities before individual subjects) was in fact preceded by certain modes of rendering the world pictorially. In keeping with the general "archaeological" approach of the previous two chapters, I wish to prioritize the discursive specificity of these techniques by tracing the development of a series of modern, scientific "cartographic technologies" for the rendering of the world as a view, which worked above all through the colonization of the heterogeneity of alternative spatial practices.

Further to this, not only do these "cartographic technologies" lend us great insight into this capitalist and imperial ordering of the world, they also show us how such ordering proceeded: through the deployment of bodies in space and through the production of certain visually "pious" subjectivities. Thus, a further aim of this chapter is to place the body back in the picture, so to speak; that is, to prioritize the ontological capacities of modern visual technologies, thereby enabling us to see the preeminence of the pictorial to our theories of both vision and space.

Finally, in tracing the genealogies of modern cartographic techniques for the homogenization of the world as a view, we are brought face to face with a curious vision of modernity indeed, one whose quest for a disembodied, celestial vantage point, and faith in the logic of the vector, speak so clearly to a sense of loss and mourning for the transfiguring power of the sacred.

# Painting the "World Picture": Toward a Genealogy of Cartography

The fundamental event of modernity is the conquest of the world as a picture. ...
Initially the word "picture" makes one think of a copy of something. This would
make the world picture, as it were, a painting of beings as a whole. But "world
picture" means more than this. ... "Picture" means, here, not a mere imitation,
but rather that which sounds in the colloquial expression to be "in the picture"
about something. ... Understood in an essential way, "world picture" does not
mean "picture of the world" but, rather, the world grasped as a picture.

Martin Heidegger, "The Age of the World Picture"

Formed in Spain during the fourteenth century, the Hieronymites were a mo-
nastic order following the teachings of their patron saint Sophronius Eusebius
Hieronymus, called Jerome in English. The order flourished in the sixteenth
century, particularly during the reign of Philip II of Spain; their influence
spread to Italy and Portugal; their properties and possessions grew in both size
and number. Unrivaled in their patronage of the arts, and celebrated for their
generous almsgiving, the Hieronymite order also became active in the evange-
lization of the New World.

Among the possessions of the order was a particular panel painting by
the Flemish artist Joachim Patinir depicting St. Jerome in the wilderness,
removing a thorn from the paw of a lion (figure 3.6).[31] Venerated as a cult
image by the Hieronymite monks of the monastery of St. Lawrence of the
Escorial, this painting, which now resides in the Museo del Prado, has come to
be venerated yet again, this time by art historians, as the incunabulum of an
independent landscape genre.[32] Painted in the second decade of the sixteenth
century, the St. Jerome panel continues to captivate in the way it seems to
stand boldly at the edge of an epistemic divide: its compositional form torn
between an early depiction of a naturalistic view on the one hand, and some-
thing more akin to a topographical study on the other. From this moment on,
European pictorial renditions of the world would branch off in two discrete
directions: landscape painting becoming the pictorial equivalent of our "every-
day" spatial narratives, while scientific cartography would come to define our
modern understandings of space in terms of precise mathematical relation-
ships. But for now, at the beginning of the sixteenth century, we find, in this
one painting, the pictorial rendition of the world poised at a crossroad.

When we turn to the panel itself, what is so striking to the modern viewer
is the painting's unusually high horizon; a structural technique that enables us
to comprehend a much broader segment of the earth's surface than would oth-
erwise be available from the vantage point provided in the foreground. In bold
defiance of the accepted laws of atmospheric perspective, each compositional

**3.6**
Joachim Patinir, *Landscape with St. Jerome*, 1516–1517. Museo Nacional del Prado, Madrid.

element of the panel is displayed in its most characteristic form and in careful detail far into the painting's middle ground and beyond.[33] Even at great distances we are able to perceive small groups of travelers, the eroded surfaces of cliffs, and the brick and thatch of individual buildings. As Walter Gibson suggestively puts it: "It is as if we have been endowed with a preternaturally acute vision that falters only in the farthest regions of the landscape."[34] However, even at these most distant extremes we can still make out the form of faraway mountains and coastal peninsulas. It is as if Patinir has consciously attempted to capture the infinite expanse of the world in one panel.

And this is precisely the art-historical consensus on the matter: at a time when other artists were still subordinating landscape to the sanctified figural compositions of history painting (*istoria*), Patinir was pursuing the aesthetic of the *Weltlandschaft*, or "world landscape." Although it was coined only in the early twentieth century, the nomenclature of *Weltlandschaft* was deemed particularly well suited to these early depictions of landscape unmoored from the constraints of history painting: in essence, what we were being presented with was an effort to capture an encyclopedic panorama of the visible world; a three-dimensional macrocosm represented in two dimensions.[35] Religious motifs and figures may have still been present in Patinir's paintings; though clearly they had been subordinated to the requirements of a world imagined whole, and not the other way around.

Patinir enhanced the effect of the *Weltlandschaft* by populating his landscapes with an abundance of narrative elements; narrative elements that seem to clamor for our attention: peasants at work, travelers journeying to distant monasteries, packs of wild animals hunting, buildings set ablaze, armed horsemen descending on their quarry, and inns of dubious repute. Viewing one of Patinir's landscapes is like watching a story unfold: the eye is enticed and drawn in by these narrative details, our minds are led to wander over the landscape, inviting us into imaginative contemplation of a world of lived experience, just one more twist or turn away. Once again, as Walter Gibson puts it, "in making our way along Patinir's winding roads and rivers, across the fields and valleys, and even over his trackless mountains, we make a kind of vicarious journey."[36] The power of the *Weltlandschaft*, it would seem, is the power of the spatial story, the narrative of everyday life laid before our contemplative gaze.

In contrast to the haste with which art history is inclined to triumphantly proffer historical antecedents to new genres or styles of art, discussion of the aesthetic of the *Weltlandschaft* was accompanied, for many decades, by a rare institutional modesty. What confounded art historians was not so much the lack of potential antecedents for a "naturalistic" autonomous landscape genre but, rather, the inability to explain why it was that when landscape *did* come

into its own, it took the form of the decidedly *unnaturalistic*, disembodied "vision" of the *Weltlandschaft*.[37] If we consult the standard art-historical texts on the matter, the rise of landscape as an independent genre was seen to be predicated upon the Renaissance rediscovery of the pastoral poetry of Virgil, and the writings of Pliny and Vitruvius; their names lending an authority, as well as a theoretical justification, for the existence of landscape independent of *istoria*.[38] The problem for the Renaissance scholarly artist, so this art-historical narrative goes, was that although now possessed of a theory of landscape, no pictorial tradition existed from which the artist could draw. Hence artists like Niccolò dell'Abbate and Dosso Dossi cast their eyes north to the works of the young Flemish artist whom Albrecht Dürer once described as "the good landscape painter": one Joachim Patinir.

This narrative, clearly, tells us little about Patinir's art itself, and more about how Renaissance art-historical scholarship was for so many years captivated by the Italian Renaissance, as opposed to what happened north of the Alps. However, even among scholars of the northern Renaissance, the question of the *Weltlandschaft*'s artistic antecedents was very much a vexed issue. Thus, although a general consensus existed regarding the iconographic influence of Hieronymus Bosch's narrativized pictorial elements on Patinir's painting, the morally didactic nature of Bosch's depictions of a "world in sin" saw him positioned by art history as an "influence," rather than as an "antecedent," of the *Weltlandschaft* aesthetic.[39] Art history may have been relatively quick to ascribe a term to the unusual "vision" of Patinir's world landscape, yet it remained conspicuously silent on the issue of possible stylistic antecedents, in spite of its near-obsessive desires to do otherwise.

There was, of course, a ready answer to this art-historical dilemma, one that was to be found in the very compositional structure of Patinir's landscape paintings themselves. That this answer would go unnoticed for so many decades speaks of the inflexibility of a discipline so stricken by its own teleological projections, and so fettered by its narrow definitions of what constitutes "art," that it was unable to see what lay before it. Thus, if we return to the unusually high horizon line of the *St. Jerome* panel, apart from the sense of a preternaturally acute vision that it induces in the viewer, it also has the effect of producing the appearance of multiple viewpoints when it comes to specific compositional forms: vertical elements like mountains, buildings, and forests appear flush to the picture plane as if viewed from the ground; while horizontal elements like plains and oceans appear as if viewed from an elevated vantage point. Easily dismissed as a lingering medieval naïveté, there was in fact a contemporary practice that displayed precisely these same compositional forms: the topographical studies of early Renaissance cartography.

·····

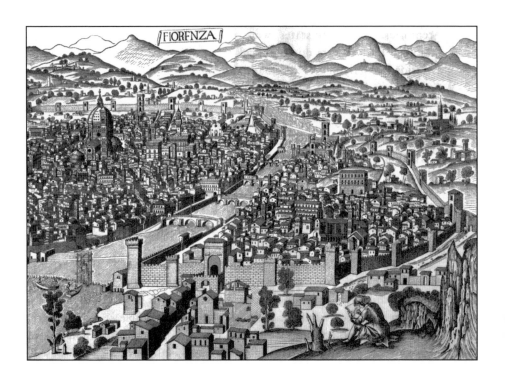

**3.7**
After Francesco Rosselli, *Pianta della catena*
(*Map with Chain*), woodcut, ca. 1470 (segment).
Kupferstichkabinett, Staatliche Museen zu Berlin.

Turning to the topographical view of Florence commonly known as the *Map with Chain* (figure 3.7), we can immediately see the similarities to Patinir's *St. Jerome* panel. Not only does the view of Florence share the same high horizon line (something not so unusual in this instance, as it prefigures the disappearance of the horizon on a cartographic map), it also shares the same compositional juxtaposition of vertical with horizontal elements that saw the most conspicuous details of Patinir's panel rendered in elevation: the walls, buildings, and trees of Florence stand straight upright before our eyes, while the surrounding countryside recedes into depth as if viewed from above. Further to this, however, we can now say of the *St. Jerome* panel that the preternaturally acute vision of the *Weltlandschaft* seems almost entirely an attribute of this early cartographic tradition: like modern maps, the view of Florence does not fade at the extremes; rather, the whole *raison d'être* of the map is to present before the eyes something more than mere vision alone can provide.

There is, of course, one conspicuous absence in the topographical view of Florence, one that acts as a sign of things to come for cartographic depictions of the world. Although we can make out the form of small fishing boats plying their trade on the waterways below, the general wealth of narrative elements that were a hallmark of Patinir's *Weltlandschaft* are now missing; the one exception being the solitary figure of the cartographer in the immediate foreground for whom this view is laid out. The vast sweep of land that was a feature of the *St. Jerome* panel finds its equivalent in the pastoral land surrounding the city of Florence; however, the everyday spatial stories that brought the *Weltlandschaft* alive for the viewer are all but gone here. The eye is no longer allowed to wander and explore the world at large: it is now fixed to a single viewpoint, elevated and distant. Deemed superfluous to the cartographer's task of "capturing" the city as a view, the spatial stories which once brought the depiction of the city alive are hereby written out with the stroke of a pen; only a handful of boats remaining.

Before acquiring its modern meaning as a "view of nature," the term *Landschaft* commonly referred to a geographical space or politicized boundary, similar to the Latin *territorium* or *regio*.[40] Most often in reference to the rural land surrounding a town or city over which that city cast its political influence, the *Landschaft* was precisely what was being depicted in a topographical "view." From about the middle of the 1480s, such topographical views began to appear in printed volumes, one of the most famous being Georg Braun and Franz Hogenberg's oft-imitated *Civitates orbis terrarum* (Cologne, 1587–1617). Such topographical studies were prized by scholars, merchants, and princely rulers alike for their perceived ability to "capture" a place as if one were standing before it.[41] The significance of this metaphor of "conquest" for Renaissance definitions

of spatial knowledge is nowhere more clearly articulated than in the narrative of Isaac Massa and his efforts to procure a "view" of Moscow (chapter epigraph).[42] That Massa's "view" was, first, acquired on pain of death and, second, deemed a worthy gift to help ingratiate himself with Prince Maurice of the Netherlands tells us much about the epistemological status of the topographical view as a "transparent" and truth-giving technology.[43]

In the solitary figure of the cartographer overlooking our view of Florence, then, we can see the beginnings of the cartographic turn away from definitions of space that are "lived" or "practiced" to the flat, geometrically ordered relationships of modern mapping.[44] From his vantage point above the city, the cartographer of Florence can be seen sizing it up, detailing the routes in and out of its walled surrounds, charting the strengths and the weaknesses of its fortifications; preparing it and presenting it, as it were, for "conquest" by a privileged eye. It is with this simple act that depictions of landscape will eventually be relegated to the position of "art" (that modern repository of lost spatial narratives), while the map will come to embody more and more the scientific conquest of space.[45]

·····

Heidegger suggests that the essence of modernity does not so much consist in humanity freeing itself from the bonds of a previous age, but rather that the essence of humanity itself is altogether transformed with the advent of modernity in that "man" becomes the "ground" from which all other things and beings may be known, arranged, and ordered. This manifests itself in what Heidegger somewhat enigmatically calls the "world picture." In many ways this world picture, or the "being in the picture" which it connotes, represents a kind of subjection of the individual to a way of Being which separates and estranges the individual from the objects and beings of the world such that the world must be rendered up, grasped, deployed, and controlled—the need for a kind of "picturing," if you will. A world so rendered to being is a world where technology effects this subjection at the same time as it characterizes this subject— this being in the world; its relationship to things, to beings, and, presumably, to its *self*. More than a mere representation of the world, then, the "world picture" resonates with the phrase "to be in the picture." To grasp the world as a picture is to know the world; a world grasped as a picture is a world where "man" makes dependent upon himself the way he is to stand before beings and things as the objective.

Although Heidegger is adamant that the world picture is not an imitation, a representation, or a *painting* of beings as a whole, it is valuable to consider the place these techniques or technologies for rendering the world as graspable, as a picture, have in the process of this subject(ion) that situates "man" as the ground from which all beings may be known and to which all things are

ordered. Essentially, this is what I wish to suggest: that the ability (perhaps even *need*) to grasp the world as a picture may well be what heralds the modern subject as "new" and "modern," yet it was through "technologies" like the ability to *picture* the world that such subject positions were brought into being.

In many ways, this argument is both an extension of the arguments I proffered regarding the curiosity cabinets (though here projected into the realm of spatiality), as well as a prefiguration of Foucault's arguments regarding the productive nature of the panopticon. As a technology for the mobilization of bodies in space and the inscription upon those bodies of a certain docility through the consistency of their being seen, Foucault's reconfiguration of Bentham's panopticon represents a conflation of knowledge practices, spatiality, and vision to produce certain subject effects. We have already caught a glimpse of this at work with the productive nature of Pozzo's ceiling, where, through a technique for constructing a "naturalistic" picture of the (albeit celestial) world, bodies were deployed in space and pious subject effects were brought to bear by bringing the individual, quite literally, to their knees.

What I now wish to propose is that at the same time as the curiosity cabinet was summoning forth a modern, knowing subject within its closeted confines, the cartographic picturing of the world was doing likewise in its production of a fixed and celestial gaze, and its ordering of the world as something to be grasped as a picture. Moreover, just as the "heresy" of the curiosity cabinet ultimately led to the effacement of the heterogeneity that had once underpinned its knowledge claims, so too the modern map's ability to picture the world was accompanied by an expurgation of the heterogeneity of everyday spatial practices and the implementation of a normative, mathematically rational, and hence "graspable" picture of the world. And it is here that we find the importance of Patinir's *Weltlandschaft*. Standing at the crossroad of an epistemic divide, Patinir's panel paintings represent the historical moment when the heterogeneity of spatial narrations and their picturing of the world are about to be flattened out into the scientific cartographies of modernity; and are about to give way to the homogenizing force of Enlightenment rationality: a divide which would bring the being of "man" into the picture, as the being before which such a world is rendered.

## Moral Geographies / Earthly Technologies: The Magic of Geometric Perspective

Today we are the tired children of their discovery; the magic of perspective illusion is gone, and the "innate" geometry in our eyes and in our paintings is taken for granted.

......................................................................................................................
Samuel Y. Edgerton, *The Renaissance Rediscovery of Linear Perspective*

> In truth one eye cannot look at another without being seen by it,
> because as the eye which beholds receives the form on the
> pupil along a straight line, so also, its own form goes along by
> the same line into the eye which it beholds.
>
> ···········································································
>
> Dante, *Il Convivio*, II, 10

In October 1453, bishop, scholar, mathematician, and diplomat Nicholas of
Cusa sends to the monks of Tegernsee in the Bavarian Alps the treatise he has
promised them, with the following greeting: "Here, then, dearest brothers,
are the explanations I promised you on the faculty of mystic theology."[46] This
volume, which would come to be known as the *De visione Dei, sive De icona*,
though simply called *The Image* or *The Picture* by its author, contained within
its pages a series of "operations" for the monks to perform; operations that
were designed to transform perceptible visual experience into a theory of mys-
tic vision, by "seeding" in each of the participants the possibility of the infinite.[47]
Part "spiritual exercise," part "mathematical experiment," what the monks of
Tegernsee received was nothing short of a spiritual organon for "seeing the in-
visible in the visible"; a manual for leading one "by human paths to divine
things."[48] And for Nicholas of Cusa, this human path to divine things lay in
the certainty of geometry.

The primary "operation" of the *De icona* was presented to the reader as
a "perceptible experimentation" to be conducted with the aid of an "all-seer"
image (*imago omnia videntis*), by which Nicholas of Cusa meant an icon
"whose face is painted with an art so subtle that it seems to look at everything
in the vicinity."[49] The monks were instructed to place the "all-seer" on the
north wall of a room in their abbey; Nicholas of Cusa having sent a painted
copy of one in his own possession so the monks could proceed with the ex-
periment immediately.[50] Then, arranging themselves at equidistant points
around the icon, the monks were to affix their gaze upon the image, noting the
way that it not only returned their individual gazes, but also did so both di-
rectly and seemingly exclusively. The monks were then instructed to move
about the room so that they might test the veracity of this gaze: those who
were to the east of the icon were to move to the south, those to the south were
to move to the west, and so on; all the while keeping their eyes locked to the
gaze of the image. At every step of the way, each monk would perceive the eyes
of the image following him, and "knowing that the image remains fixed and
immobile, he will be astonished at the movement of this immobile gaze."[51]
Equally astonishing, so the treatise says, will be the realization of the sheer
impossibility that as the image moves to affix its gaze on one brother, it will be
doing likewise to any number of other brothers in the room; the icon's gaze

being directed simultaneously toward one place and toward all. Abandoning none of the brothers in the room even when in motion, the gaze of the all-seer acts as the physical "seeding" of the notion of a divine infinite: "He will see that this gaze watches with extreme care over the smallest creature as over the largest and over the totality of the universe."[52]

Within the confines of the abbey at Tegernsee, Nicholas of Cusa was able to marshal a profusion of earthly visual activity toward a theological end. Gazes were cast and returned, bodies were set in motion, and in this way, cognition was transformed from pondering the infinite nature of linear geometry to a theology of the infinite. These "operations," then, functioned as the precursors to the speech acts of Cusan discourse: they marked geometry and mathematics as a way of "seeing"; a call to action; a visual practice that was both a condition of knowledge and a guarantor of its rigor.[53] Arranged as so many equidistant points about the absolute geometric point of the all-seer, each monk was made to experience in his being the absolute nature of the geometric point by tracing the "lines of sight" emanating from the all-seer and from themselves with their very bodies; the monks transform the place of the abbey into a space of action, their bodies narrating a story of the infinite. This narrativization of space is enhanced by the nature of the all-seer, whose presence demands, as it does even in the retelling today, that each monk bring to the room a multitude of different stories regarding the power of the gaze, from acts of pious devotion to tales of the evil eye.

Finally, for Nicholas of Cusa, it was the element of astonishment, or wonder, produced when the image of the all-seer faded from sight as a "realized" geometric infinity (a vanishing point) that propelled the participants of the experiment from human paths to divine things: "deprived of a representable object, astonishment becomes the gesture, at once ethical and poetic, of responding to an excess by turning toward the imperceptible."[54] At that moment of astonishment, the physically perceptible pathway provided by geometry recedes, giving way to an imageless contemplation of the unknown.

· · · · ·

The story of the Cusan "all-seer" image and the experiment that took place around it act as a kind of spatial narrative; one that gives us great insight into the discursive nature of Renaissance conceptions of the visual, particularly with regard to the role that vision played, not only in the act of perception, but also in matters of subject formation, knowledge production, and representation. What we find in its retelling is just how central vision was to the mediation between the heavenly and earthly realms. It was *vision* that distributed bodies in space; it was *vision* that activated the power of the painted image to be not only the recipient but also the *producer* of a gaze; and it was *vision* that allowed

for the worldly narratives and experiences of the monks to be transformed into a mystical understanding of the infinite nature of God. In short, it was the same Renaissance visual discourses that we encountered in both chapters 1 and 2 which can be seen here structuring the events that took place at the abbey of Tegernsee, sweeping aside a thousand years of oral and textual understandings of the universe, proffering instead the "tactile" nature of vision as the most accurate, but also the most pious, way of grasping the world as a picture.

In this regard, the Cusan method took its place within a more generalized Renaissance discourse of visual geometry, more commonly referred to as optics: that branch of Renaissance science that was equally seen as a branch of Faith. As early as the thirteenth century, the Franciscan Roger Bacon (1220–1292) implored painters to study geometry and optics so that they could "make literal, the spiritual sense."[55] For Bacon, optics was the model through which God spread grace throughout the world; understanding the physical laws of optics meaning no less than understanding the very nature of God's divine grace.[56] Ultimately, Bacon saw in geometry and optics the surest means available to Christendom for the recapture of the Holy Lands and the spread of the Word of God to the furthest corners of the earth, something that would come closest to its fruition, as we will shortly see, with the advent of linear perspective some two hundred years later.

Of particular importance to Renaissance artists and theologians alike was the idea of the centric visual ray, an optical concept first expounded during antiquity but later refined and infused with a moral dimension by Christian casuistry during the Middle Ages.[57] Originally this principle stipulated that all but one of the rays making up the visual cone emitted from the eye struck seen objects obliquely, the ensuing refraction diminishing their power to convey visual information. The centric ray, however, struck its target at right angles, and was thus the most distinct ray of all.[58] Roger Bacon updated this theorem in the thirteenth century when the act of vision was deemed a result of light entering the eye, rather than being emitted from it: the centric ray became that ray of divine light striking perpendicular to the optic nerve, thus adding spiritual import. Yet it was not until Leon Battista Alberti wrote the first treatise relating the laws of optics to art, the *De pictura* (Florence, 1435), that the centric ray reached its most moral dimension. Quite taken by Dante's notion that one could detect a sinner by looking him straight in the eye, Alberti refashioned the centric ray so that it came to stand for the only ray that was pure in the sight of God: those rays striking the eye obliquely were now deemed impure, and subject to the variable laws of a sinful world. Only the centric ray, the "prince of rays," would enable one to perceive the very soul of a person; the shortest distance between two points also being the most Christian.[59]

When single-point, linear perspective arrived in the West during the fifteenth century, it did so with these moralizing tendencies firmly ensconced in its geometric rendering of the visible world. Early proponents of linear perspective saw in its mathematical uniformity not only an ideal reflection of the harmonious order of the cosmos, but also the perfect tool for the re-creation of that order here on earth. Thus, not only was perspective seen as imputing a moral certitude to the domain of painting, but it also suggested that appropriately proportioned buildings, and in particular centrally planned churches, would have an expressive significance and practical consequence transcending mere structural form.[60] Thus, the geometrically planned church represented more than just an aesthetic ideal rendered in stone and mortar; it was, quite literally, the physical manifestation of the cosmic order in the earthly realm. In this regard, the notion of the morally superior centric ray proved particularly captivating to Renaissance architects. We find in the Florentine church of San Lorenzo, for instance, the subordination of all structural and architectural details to a central axis of vision, bisecting the church from nave to apse at the level of the observer's eye (figure 3.8). Standing at the foot of the church, all the cornice levels, architraves, and flagstones seem to converge, like the orthogonals of a perspective picture, on a central "vanishing point": the centric ray of vision directing all eyes to the spiritual center of the church—the high altar.[61]

With regard to the pictorial arts, single-point perspective likewise carried with it the significance of this moralized geometry, transforming painting into an intellectual exercise involving not only the craft-based skills of the technician, but also an understanding of the ideal world of God obtained through direct observation. Maintaining a conviction that "the beauties of the arts … correspond to a moral and spiritual equilibrium of human existence," Alberti claimed that painting should not merely be pleasing to the eye but, more importantly, should be instructing and edifying to the mind. Linear perspective, he asserted, would enable artists to enhance the moral, allegorical, and mystical message of the Scriptures, or the lives of the saints, precisely because of its implicit geometry.[62] Alberti's treatise was in many ways aimed at providing artists with the techniques to construct a plausible and unified stage setting within which painted figures could be placed, appearing rich in the divine quality of grace.[63] It is for this reason that *istoria* would come to hold the privileged position it did in the hierarchy of painting: essentially, history painting was perceived as a means for the improvement of society; enhancing the didactic nature of the Scriptures by presenting before the eyes a harmonious vision of the Word of God.

During the fifteenth century, then, artists increasingly began to depict their subject matter in the gridded confines of the geometric space produced

**3.8**

Carlo Brogi (1850–1925), San Lorenzo, Florence
(interior), photo around 1900. The interior of Filippo
Brunelleschi's church of San Lorenzo sees all
orthogonals directing the gaze to a specific point—
the place of the altar. Interestingly enough, the
effect works the other way around: directing the
gaze to the "feet of Christ," the church portal.

by Albertian perspective as a means of edifying the mind and transforming the everyday lives of pious Christians. So complete were the changes wrought by linear perspective in the visual rendering of the world that by the mid- to late sixteenth century the oblique and "additive" viewpoints of medieval art had entirely vanished.[64] What one found instead was the physical organization of pictorial space so that the predominant plane (that is, the background facing) of the composition became aligned, almost without exception, parallel to the painted surface of the picture. The effect of this melding of interior pictorial plane and painted surface was that the latter came to been seen as a "window" onto the painted world, which, because of its implicit geometry, behaved visually according to the rules of our own world.[65] Thus, through the mediating frame of the painting, there was established a continuum and flow between the painted world on the one hand, and the world of the artist on the other; the space existing on one side of the picture plane was seen to be an exact mirror of the other.

This mirror-like effect of perspective was enhanced by the existence of the central visual axis that bisected the picture plane at right angles, from the viewing point to the vanishing point; something that perspective was set up to facilitate in the first place. Alberti was quick to seize upon the didactic potential of this, suggesting that artists would be wise to follow the dictates of the "prince of rays" by placing the vanishing point of this "window onto the painted world" at the center of their compositions. As a result, the perpendicular axis of vision (the line of sight from viewer to vanishing point) would trace the very vector of the centric ray itself, thereby magnifying the moral force and didactic nature of the work.[66]

Viewed discursively, this central visual axis of linear perspective was, of course, productive of further effects, due precisely to the perceived mirror-like quality of its visual apparatus. Two of these effects warrant our attention.

The first relates to the ability of the linear perspective to position and distribute viewing bodies in space: the geometric nature of perspective necessitates that the vanishing point of the "painted world" has a mathematically equivalent viewing point, equidistant from the "window" of the painted surface set along the central viewing axis. As we have already seen with the illusionistic ceiling in the church of Sant'Ignazio in Rome, this viewing point was often rigidly prescribed. Yet even when it was not, the success of linear perspective's ability to align bodies perpendicular to viewed surfaces can be seen in most forms of modern architecture, whose linear geometries are invariably built to facilitate "a view," whether it be of pictures (the museum), people (the prison), or commodities (the department store). In many ways preempting the visual technologies that would come to underpin Foucault's disciplinary power, what

**3.9**

Woodcut from Hieronymus Rodler and Johann II
of Bavaria, *Eyn schön nützlich büchlein und
underweisung der kunst des Messens mit dem
Zirckel* (Nürnberg, 1531). Image: Department
of Special Collections, University of Wisconsin—
Madison Libraries.

the central visual axis of linear perspective allowed, then, was the reflection of the geometric order of the "painted world" back through the "window" of the picture plane, to be mapped onto the world of the artist. With linear perspective, the body of the viewer came to be subjected to the same laws of distribution as the figural compositions of art itself: objects, including the body of the viewer, were laid out along a "line of sight," a continuum of distance from body to infinity.

Concerning the ubiquity of this geometric rendering of the world through the apparatus of perspective, we find in the second book of Alberti's *De pictura* a chilling sign of things to come with regard to the disciplinary effects of the visual. In his efforts to provide artists with a ready technique for the construction of perspective pictures, Alberti conceived of the instrument of the *velo*: the gridlike mesh or veil of fine thread suspended over an aperture or a window used to assist, quite literally, in "squaring" the world (figure 3.9). Conceived as more than just a mechanical technique for transferring scale drawings to a surface ready to be painted, the *velo* would act as a means by which artists could develop an intuitive sense of proportion; Alberti exhorting artists that they must learn to see the world in terms of perspective's gridlike confines.[67] Once again, in preemption of the spate of visual technologies of the eighteenth and nineteenth centuries that so captivated Foucault's imagination, the *velo* can be seen as a means for organizing the visible world itself into a geometric composition. Further to this, perhaps even more than Foucault's panopticon, the training effect of Alberti's *velo* alerts us to how vision itself will become a "mode of work" under modernity.

The second discursive consequence of the central visual axis of perspective is ontological in nature. In his description of perspective, Norman Bryson alludes to the reversibility of the vanishing point with regard to the position and gaze of the viewer:

> something is looking at my looking: a gaze … whose vista I can imagine only by reversing my own, by inverting the perspective before me, and by imagining my own gaze as the new, palindromic point of disappearance on the horizon.[68]

The linear nature of the visual axis enables the infinite point of the horizon to be reflected back through the mirrored apparatus of perspective to present to the viewer an image of the self as a visible, objectified, and measurable unit distributed in space. As Bryson suggests, "in an age of religious witness … [perspective] solidifies a form which will provide the viewing subject with the first of its 'objectified' identities."[69] Not only did linear perspective present to an individuated viewer a world to be grasped as a picture, this very process of

individuation was itself tightly enmeshed in the apparatus of a gaze cast and returned: by the reflection of the infinite point of the horizon onto the very being of the viewer.

·····

We are now in a position to reflect upon the events that took place at the abbey of Tegernsee. In effect, what Nicholas of Cusa conducted was an early demonstration not only of perspective's ability to present an idealized representation of the pictorial world, but also its ability to fashion the world outside the picture into the image of a geometric construction. The scene we were witness to at Tegernsee can be looked upon as if it were a picture, both in the mind of its mathematician author, and in our minds in the retelling. Unfolding in the imaginary space of the mind's eye, the arrangement and movement of monks about the all-seer image vacillates between being both object and subject of a pictorial construction—an effect central to the Cusan method of "seeding" a notion of the infinite in its participants (which includes us, on the other side of this picture, as it were). The spatial narrative of lines of sight distributing bodies in space about the surface of a picture, behind which a being of infinite visual gazes resides, is itself the world of the painted picture; that is, it is the perspective construction of a picture. It is us, the (modern) reader of the *De icona*, who stands gazing from the other side of the "window" of the painted image in this scene; gazing in upon a picture of a room where monks gaze back in astonishment at our ability to "picture" them.

The all-seer is thus the perfect metaphor and "window" that allows this vacillation between picture and reality. It is, in effect, the gaze of Norman Bryson looking forward to the infinite of the vanishing point, which in turn gazes back, "seeding" its infinite nature in the being of the observer by propelling them to that infinite nature of being. Here is produced the first inklings of the modern individuated subject. Unfettered from the ontological hierarchy of beings, the observing subject has "pictured" the world and, in doing so, has captured the nature of the vanishing point, standing replete with infinite potentiality with regard to other beings.

That we cannot be sure that monks performed the experiment that Nicholas of Cusa set before them is beside the point; it does not place the Cusan method back in the realm of textual discourse as opposed to the spatial narrative of perceptual discourse. Rather, we find in the simple greeting that accompanied the *De icona* ("Here, then, dearest brothers, are the explanations I promised you ...") the suggestion that the monks needed to walk about the image; needed Nicholas of Cusa's "human path" to divine things. Unlike us moderns, for whom geometry is a property "innate" to the eye, the monks of the abbey at Tegernsee were yet to be able to grasp the world as a picture.

## Cartographic Desire: Mapping and the Erasure of Space

Of Exactitude in Science:

In that Empire, the craft of Cartography attained such Perfection that the Map of a Single province covered the space of an entire City, and the Map of the Empire itself an Entire Province. In the course of Time, these Extensive maps were found somewhat wanting, and so the College of Cartographers evolved a Map of the Empire that was the same Scale as the Empire and that coincided with it point for point. Less attentive to the Study of Cartography, successive Generations came to judge a map of such Magnitude cumbersome, and, not without Irreverence, they abandoned it to the Rigours of sun and Rain. In the western Deserts, tattered Fragments of the Map are still to be found, sheltering an occasional Beast or beggar; in the whole Nation, no other relic is left of the Discipline of Geography.

J. A. Suarez Miranda, *Travels of Praiseworthy Men*, 1658

Jorge Luis Borges, "On Exactitude in Science," from *A Universal History of Infamy* [70]

As an allegory of Empire, the charm of Borges's "Of Exactitude in Science" lies in the suggestion that modern cartographic maps may in fact have a more vital link to the land they are said to represent than our popular conceptions of them afford. With its bright swathes of color abruptly marking one territory from another, a modern map summons to the mind childlike images of soldiers emblazoned in uniforms of red and blue facing off against each other over an arbitrary line in the sand. Red to the south, blue to the north: the colored territories and their corresponding uniforms mark modern maps as little more than the pictorial rendition of the imperial fantasy of absolute territorial sovereignty. Previously lorded over by colonial administrators, explorers, and the captains of the lucrative spice trade alike, the modern cartographic map, with its once ominous and defiant blank spaces now filled in, seems to remain with us today, as a distant reminder of an age of exploration and conquest. Like failed icons of imperial domination, all that remains of the map's pictorial power is its utilitarian ability to direct us from one place to another.

Yet as Baudrillard has suggested, lurking within Borges's tale of the perfect cartographic reproduction of territorial space is the specter that the relationship between map and territory may in fact be reversed: "if we were to revive the fable today," Baudrillard suggests, "it would be the territory whose shreds are slowly rotting across the map." [71] At a time when the very notion of territorial sovereignty is as staunchly defended as it is much maligned, the idea that the map may actually engender territory opens cartography up to the suggestion that maps may be viewed discursively, that is, as part of the modern armature of spatial practices that organize and arrange bodies in space, define certain

ways of knowing, and are productive of certain subject effects. More than just a mere pictorial rendition of otherwise concrete and "real" power relations between territorialized political entities, then, the modern map can be seen as an uncompromising technology for the production and maintenance of such territorial definitions of space. In short, cartography constitutes the primary mode for a modern rendering of the "world picture." This, in effect, becomes our point of departure for a framing of maps as spatial practices.

·····

Like the previously examined disciplines of museology and anatomy, the history of cartography has, until quite recently, been seen exclusively as the steady unfolding of ever more accurate and refined techniques for the collection, collation, and projection of mathematically precise coordinates onto a two-dimensional surface. Further to this, it is the very composition of the modern map out of these geometrically defined spatial coordinates that has been taken as the guarantor of its scientific neutrality. In fact, maps are often viewed as emblematic of scientific knowledge for this very reason; just as scientific theories are regularly taken to be inherently maplike.[72] Thus, on the one hand, maps have come to define science as progressive, cumulative, objective, and continually evolving in their accuracy, while, on the other, we can talk of cognitive maps, language maps, body maps, mapping the genome, mapping desire, and even the discursive mapping of the cultural landscape. The underlying paradigms scientists are said to follow are taken to function much like a map, charting where research is to go and how it is to proceed.[73] Perceived, then, as an asexual, apolitical, and nonracial utilitarian tool for "getting around," the modern map, and in particular the obdurate and binding logic of the cartographic grid, has been taken to represent the spatial order of the world in its most exact and reliable form; free from the vagaries of both ideology and culture.

However, in recent years this view of maps has come under increased scrutiny by an ever-widening circle of authors following in the footsteps of the late J. B. Harley. Harley's repeated calls from within the discipline of geography for a more discursive approach to cartographic practices, although somewhat limited in scope, did garner much support; the initial thrust of this early critical attention was directed primarily toward the omissions and obfuscations of the supposed scientific accuracy and transparency of the modern map. In this regard the development of modern cartographic practices from the seventeenth century onward were taken to be intrinsically linked to the development of the nation-state: the cartographic map spoke of various political silences in the service of the state; its homogenized representations of space assisted in the acquisition of power and the maintenance of the status quo.[74] As Harley himself described the study of cartography: "Instead of just the transparency of

clarity we can discover the pregnancy of the opaque. To fact we can add myth, and instead of innocence we may expect duplicity."[75]

Accompanying these efforts to redress the silences of state-sanctioned cartography was the recognition that the geometric relationships of the modern map were, in fact, but one way of "validly" representing spatial understandings. The effect of this concession was that the history of Western cartography became open to an historiography (potentially) free of the crippling effects of the teleological projections that had characterized it for decades.[76] The Roman route map, the medieval sacred map, and the seafaring portolan charts of the Renaissance now all enjoyed an autonomy previously denied them.[77] In many ways, then, the significant achievement of this early interest in the history of cartography was a new, more inclusive definition of what a map entailed: "Maps are graphic representations that facilitate a spatial understanding of things, concepts, conditions, processes, or events in the human world."[78] Gone were the specific references to scientific cartography; gone were references to the surface of the earth as their only guide.

In more recent years, a number of scholars from disciplines outside of geography, as diverse as literary criticism, new historicism, and postcolonial studies, have started to cast a critical eye at the history of cartography. The majority of these authors are primarily concerned with the wider effect this dominance of Western definitions of "geometric space" had on the encounter between Europe and its Others. According to Walter Mignolo, for instance, the establishment of the cartographic grid as the only "true" and "accurate" way of representing territorial space stripped Amerindian spatial rationalizations of their traditional authority; the resulting deterritorialization was an integral part of the European colonization of the Americas.[79] In this regard, most authors would be inclined to agree with Mignolo's sentiments when he suggests: "The memory that might have survived among Amerindians of territoriality as a way of governing, defining social relationships, and organizing populations, had to negotiate the new reality ... of having their space emptied or negated."[80]

In a similar vein, Thongchai Winichakul's account of Siamese nationhood is a tale of the displacement of local conceptions of territorial sovereignty by a new European political geography that defined such sovereignty in terms of rigid borders where none had previously existed.[81] Prior to the British imperial presence at the court of Siam, sovereignty was expressed through a series of overlapping vassal states paying fealty to multiple overlords; these states were essentially "nonbounded" insofar as whole geographical regions often constituted their limits, and even then, such "territories" were never prohibitive of movement or settlement.[82] This, of course, stood in sharp contrast to the

straight geometrically defined border*lines* the British and French imperial forces were so keen to have the Siamese court define itself by.[83]

These two illustrations show the way in which the history of cartography has become something of a testing ground for authors wishing to expound upon the numerous silences and erasures of modern scientific discourse, be they concerned with indigenous spatial practices, or the elaboration of either the racial or gendered nature of mapping.[84] In this regard, cartography is not only still taken to enjoy a vital link to scientific practice, but it also marks such scholarship as treading, essentially, in the footsteps of Harley's call for a deconstructed understanding of cartography.

· · · · ·

There are two aspects of this historiographical narrative that strike me as being of particular relevance to our present task of understanding the notion of the world rendered as a picture. The first of these concerns the now general consensus that the geometric coordinates of the modern map can no longer be seen as a guarantor of the scientific "neutrality" of cartography. The claim that such maps are asexual, nonradicalized, and apolitical depictions of space has now all but been deemed inherently false. The second observation concerns the manner in which those engaged in redressing these imbalances go about their task: through the elaboration of precisely those things which have been excluded from the map (race, gender, politics). In many ways we can characterize these authors as being engaged in efforts to put these excluded things "back in the picture," as it were. What I wish to suggest, however, is that taken together, both of these observations point toward a fundamental misrecognition of the discursive function of modern scientific maps, particularly with regard to their part in the generation of definitions of space. Betraying our reluctance to abandon the notion that science may yet be rid of the knowledge/power relationships of discourse, the allure of an inclusive cartography leads us further and further away from the very *raison d'être* of scientific mapping.

The first thing that must be said regarding the trend of criticizing cartography for its obfuscations, and then offering up those spatial narratives erased by the homogeneity of the cartographic grid in an act akin to "filling in the blanks," is that this approach skirts dangerously close to replicating the kinds of binary logic that the history of cartography so readily employed with its pre- and post-scientific definitions. The pervading logic of this approach is one of a fixed relationship, or confrontation, between a unified European cartographic understanding of space and its incommensurable *and unchanging* Others. While this is certainly an improvement on the modern/primitive divide that the history of cartography once so overtly traded in, there is, nonetheless, something of the logic of the museum project at work here; not just in the essentialized categories of Europe and its unchanging Others, but also in the

preservationist mentality that underpins the desire to include non-European spatial knowledges within the discourses of cartography in the first place.

Ricardo Padrón has laid much the same charge against Walter Mignolo's framing of Amerindian territorial representations stripped of their traditional authority by the coming of a unified European scientific cartography.[85] What is interesting about Padrón's analysis, however, is that he seeks to correct Mignolo by dispensing with this binary and replacing it, instead, with a ternary: the suggestion being that the persistence of linear way-finding (or portolan) sea charts well into the nineteenth century represents an alternative spatial understanding, *within European conceptions* of space, to the planar projections of the cartographic grid. Padrón makes a strong claim that it was actually these way-finding maps that were the stock in trade of explorers and navigators; thereby calling for a more nuanced understanding of the European spatial imaginations that helped facilitate conquest.[86] Undoubtedly Padrón is correct, yet this does not mean that his arguments are concerned with anything more than "filling in the blanks."

However, I must admit that it is not so much this act of "filling in the blanks," or the kinds of scholarship that are produced by it, that concerns me. Rather, it is the persistence of the underlying belief that there can, in fact, be an inclusive scientific cartography in the first place. Although it is nowhere near as overt a statement of the "science versus ideology" trope, of which Harley's "willful" silences of cartography-in-the-service-of-the-state was an example, the allure of an inclusive cartography persists with us today as a myth of discourse. To subscribe to this notion is to posit a belief in the extradiscursive nature of knowledge production; it is an attempt to "save" science from itself in that it is to deny the *discursive* function of geometrically defined maps as tools, *not* for the generation of definitions of space, *but for their erasure*. The very point of a modern cartographic map—that is, what makes a map "scientific" in the first place—is its ability to subsume any number of heterogeneous understandings of lived and experienced space within a rationalized grid of "sameness." In this regard, cartography takes its place among those other techniques of the Enlightenment for the flattening-out of the heterogeneity of Renaissance knowledge associations, and the locking-down of things with what they signify in binary relationships, both of which we encountered as characteristics of early scientific knowledge production in our discussion of the scientific natural history collection. In the case of cartography, this flattening-out of the heterogeneity of space is in many ways quite a literal one: gone are the multiple viewpoints and horizontal narrative elements of the topographical map, to be replaced instead by the fixed and singular vantage point of a detached and scientific view, upon a world laid out for inspection.

What I am proposing, then, is not that something "goes wrong" in the collection or assemblage of different contemporary understandings of space that erases their vital connection to the lived spatial practices from which they were derived; nor even that the act of mapping is itself a "social" process, and therefore open to the vagaries of both ideology and human error. Rather, what I am suggesting is that the geometrically defined cartographic map is an instrument for the homogenization of spatial practices, which operates *at the level of discourse*. It is the map as a thoroughly rational, scientific, discursive technology that has enabled and enacted precisely the very depoliticization, the deracialization, the desexing and the denarrativizing of space that so many contemporary authors have railed against. What we must now address is the manner in which cartography has achieved this end.

## Mapping and the Colonization of Space

The net result of the greater accuracy of triangulation, of its greater congruence with the land, of its greater degree of control, and of its use in measuring the figure of the earth is that triangulation is held to offer the potential perfection of the map's relationship with the territory mapped. ... The "technological fix" offered by triangulation has served to intensify the Enlightenment's "cartographic illusion" of the "mimetic map."

Matthew H. Edney, *Mapping an Empire*, 1997

Had she not been thwarted by the rebellious Goths, Rome might have turned all of Europe into one vast sheet of graph paper.

Samuel Y. Edgerton, 1987

In an interview with Michel Foucault, Paul Rabinow is in the midst of inquiring into Foucault's consistent use of vivid spatial metaphors to describe certain structures of thought in *The Order of Things*. Rabinow asks Foucault whether he considers the actual plan or schematic of a building to be the same form of discourse as a hierarchical pyramid that describes the spatial relationships between people. In response Foucault proffers the following:

> There is the model of the military camp, where the military hierarchy is to be read in the ground itself, by the place occupied by the tents and the buildings reserved for each rank. It reproduces precisely through architecture a pyramid of power; but this is an exceptional example, as is everything military—privileged in society and of extreme simplicity.[87]

When Rabinow reiterates the infrequency of such correlations, Foucault acerbically remarks in agreement: "Fortunately for human imagination, things are a little more complicated than that."[88]

.....

In *The Practice of Everyday Life*, Michel de Certeau presents us with the critical means of understanding how modernity went about naturalizing an optically based, geometric space as the fundamental epistemological category of its age; that is, how modernity came to order everything as either a "proper" location, or as an object bound to such a location for the "view" of knowing subjects. What separates de Certeau's account from other authors' descriptions of the spatial practices of modernity is his ability to place the formation of these practices firmly within a discursive understanding of space. In many ways a more nuanced conception of space than Foucault's arsenal of disciplinary technologies, de Certeau's account allows us to avoid the kinds of extradiscursive logic characteristic of much of the literature on cartography. As we have already seen, this literature would have architecture, art, and mapping left to the vagaries of the will of individuals. For de Certeau, however, such disciplines, in their ability to form and represent narrativized versions of space, are inextricably entwined with the very power structures of modernity itself. Furthermore, where de Certeau's account truly differs from most is in his fundamentally ontological understanding of the spatial ordering of modernity, which is to say that for de Certeau it is precisely with the spatial practices of architecture, art, and cartography that modern subject effects are produced. This is an understanding that will serve us well in our present task of unpacking the cartographic rendering of the world.

In a similar way to Henri Lefebvre's notion that space is not merely a receptacle waiting to be filled (there is no "natural" or empty space; it is something always produced), de Certeau characterizes space in terms of the discursive "operations" that constitute it.[89] Yet unlike Lefebvre, for whom the constitution of this space is primarily a matter of its habitation/appropriation, for de Certeau it is more the result of its *narration*: the discursive operations that produce space are something akin to a "spatial story."[90] In this regard, de Certeau draws a distinction between "place" and "space": a place is the order in which elements are distributed in relationships of coexistence; a space occurs when a "proper" place is situated, oriented, and temporalized, that is say, when it is *narrated*. The kinds of "operations" that enact such narrations of place can be as simple as just "walking in the city." Thus for de Certeau, the proper *place* of a geometrically planned street is transformed into a *space* by the everyday movements of pedestrians. In this way, space essentially comes to be seen as a *practiced* place.[91] Yet an important distinction here for de Certeau is that the operations that do this "performing" are not fixed in the direction of their narration: space and place refer to two different determinations in stories between which there are passages back and forth, so that stories or narratives carry out the labor that constantly transforms places into spaces and back again.[92]

**3.10**

T-O *mappamundi* from *Etymologiae* of Isidore of
Seville. In its most basic form the T-O *mappamundi*
is depicted as a circle bisected by a cross,
dividing the world into the three continents. Asia
(the location of Paradise) is almost always aligned
to the top. Larger *mappaemundi* would allow
for the inclusion of all manner of narrative forms.
See figure 3.12.

For de Certeau, corresponding to these two ways of organizing and narrating space are two ways of representing it: the map and the itinerary. The first is the geometrical arrangement of *places* in relative distances from one another; the second a narration of actions (a journey) marked out by the citation of places that result from, or authorize, that journey. The first we are familiar with only insofar as we encounter them in their capacity as icons of the "proper ordering of the world," either in geography textbooks or in the official state-sanctioned representations of sovereign territoriality. The second is something more akin to the descriptive sketch map we would give a friend desiring to find their way to our place of work or home ("Go halfway up the hill with the tree-lined street; turn left at the service station; then turn right at the house with the yellow picket fence," et cetera). The itinerary is, itself, a visualization of a spatial narrative.

Nearly all maps from antiquity through to the Middle Ages took the form of the itinerary, unfolding in this manner as a spatial story. Essentially, such itineraries consisted of a rectilinear series of place names marked with distances to be traveled, environs to be traversed, people or animals to be encountered, and places to camp or stay along the way. Whether designed for the pilgrim visiting sacred sites, the sea captain plying a profitable trade route, or the lost soldier needing to find their way back to the garrison, each itinerary was drawn strictly for a limited purpose, with one class of user in mind.[93]

The most significant exception to this compositional rule would have to be the ecclesiastical *mappamundi* (literally "cloth of the world"). Commonly referred to as "T-O" maps—a simple yet expressive conflation of descriptive nomenclature (*Orbis Terrarum*) and compositional form (a circle bisected with a cross)—the medieval *mappamundi*, although an early world map, nonetheless retained the narrativized form of other itineraries of the day.[94] A common feature of most well-equipped monasteries and churches, such maps were characterized by a general profusion of textual and narrative embellishments in the form of wild men, mythical creatures, fabled cities, and biblical events. Regarded much like an open-framed history book where all manner of moral, theological, zoological, and anthropological knowledge could be expressed, the medieval *mappaemundi* have come to be seen as detailed documents of the Christian conceptualization of Creation; their use being tied to an elaboration of scriptural narrative.[95]

In many ways the itinerary possesses all of the discursive features of other textually based medieval forms of knowledge production; the kinds that we saw dominating the anatomical descriptions of the human body before the arrival of the autonomous, visually based discourses that would come to underpin Vesalius's *De fabrica* and similar texts.[96] Yet as de Certeau points out,

from the middle of the fifteenth century the strictly maplike elements of these spatial stories start to disentangle themselves from the itineraries that were the condition of their possibility, reducing the signs of their own creation to mere "figurations." Pushed to the margins, then, the sailing ships and the sea monsters so prevalent in Renaissance cartography come to mark, like fragments of a story, all that is left of the operations that once authorized the construction of the map. By the beginning of the nineteenth century, however, this process of marginalization would be all but complete, the map having fully erased all traces of the conditions of its production. As de Certeau puts it: "the map gradually wins out over these figures; it colonizes space; it eliminates little by little the pictorial figurations of the practices that produce it."[97] Not that this is to suggest that modern maps came to represent an absence of spatial practices; rather that they were constituted as "the 'proper' places in which to *exhibit the products* of knowledge, form[ing] tables of *legible* results."[98]

Although he does not mention Foucault by name here, it is clear that de Certeau's description of the steady eradication of the narrative elements from the modern map is part of the wider homogenizing effect that would have its roots in the visual discourses of the Renaissance, but truly achieve its discursive endpoint only with Foucault's Enlightenment *episteme*: that period when knowledge production had fully come to be defined by a series of "scientific" discourses prioritizing specific observational techniques. During the Renaissance, then, the cartographer joined ranks with the natural historian (of chapter 1) and the Vesalian anatomist (of chapter 2) as heralds of an age of visual "exploration"; an age that would supplant the demonstrative, textual traditions of the Middle Ages. Thus in each of their realms (geography, natural history, and anatomy), "discovery" would come to define what it meant to be scientific. By the end of the seventeenth century this new scientific "vision" of exploration would be coupled with an "enlightened" rationality, and in the realm of cartography, the mapmaker would become the agent of the spatial narrative's near-complete erasure. As Walter Ong eloquently conceives of it: "The ancient oral world knew few 'explorers,' though it did know many itinerants, travelers, voyagers, adventurers and pilgrims."[99]

Yet rather than seeing these closures and erasures for what they were, Enlightenment knowledge would proclaim them to be productive of hitherto *unseen* revelations, hailing the truth effects of the "visual" as of paramount importance to a "proper" ordering of the world. And the way this ordering would proceed, so Foucault reminds us, is precisely through the visual structuring of that world: the summoning forth of a cellular grid of optical technologies, like the panopticon, for the production of subjects known not only through the constancy of their being seen, but also through their ability *to see*. In this regard, the cartographic map would come to be more than just the ally of Foucault's

modern disciplinary technologies; in effect it would come to precede them through the inscription of its geometric grid of normalized relationships onto the very landscape itself. It is here that the charm of Borges's tale of the perfect cartographic representation comes to the fore. What de Certeau's narrativized understanding of space enables us to suggest is that rather than being merely the site where the colonization of space is reflected and recorded in pictorial form, the cartographic map, with its ability to *precede* territory, is actually a key technology for this very colonization. And the map achieves this end through the production of a lived space made in its own image. In this regard, Foucault's acerbic remark concerning the extreme simplicity of the military was somewhat misplaced: as we will shortly see, the simplicity of the military is all but matched by that of cartography.

·····

In 1401, a mere two decades before Brunelleschi was to complete his first demonstration of linear perspective at the baptistery doors in Florence, a group of Florentine intellectuals and businessmen formed a "seminar group" for the study of Greek under the tutelage of the gifted Byzantine scholar Manuel Chrysoloras. With Chrysoloras's personal supply of texts rapidly exhausted by the group's keen interest, he and papal secretary Jacopo d'Angiolo traveled to Constantinople to secure more manuscripts. On their return trip to Florence, however, disaster struck: their ship ran aground off the coast of Naples. To their great fortune, both men narrowly avoided drowning and were able to recover a handful of texts from the wreckage of the ship before returning to Florence. One of those texts was Ptolemy's world atlas.[100]

This "rediscovery" (as scholars of the Renaissance are so fond of describing such events) of Ptolemy's second-century *Cosmographia* has been declared the single most important event in overhauling the medieval understanding of the world. For our purposes it is enough to suggest that along with Brunelleschi and Alberti's treatises on single-point linear perspective, Ptolemy's *Cosmographia* became part of a growing number of textual sources that would form the discursive backbone of a Renaissance reordering of space, from the narrative-rich understandings of the medieval world to a homogenized, rational, and scientific understanding of modern spatial relationships.

In this regard, it was not so much Ptolemy's geographical knowledge *per se* that was to prove so captivating to Renaissance intellectuals, but rather his system of mapping the earth's surface; a system that—most importantly—allowed for corrections.[101] Within the eight books of the *Cosmographia*, Ptolemy presented three different methods for the mathematical projection of a spherical globe onto a plane surface using gridlike techniques. Among the maps that accompanied Ptolemy's text were two complete *mappaemundi* constructed

using these techniques, and although they depicted fewer details of the known world than most contemporary equivalents, what was of particular interest about them was their presentation of the known world as but a fragment of the entire surface of a globe. In effect, what Ptolemy had presented the reader with was a method for reducing the heterogeneity of the world's surface to a geometrical uniformity in the mind's eye. And particularly in the case of Ptolemy's third method of projection, this eye was a fixed and static eye, with exactly the same properties as the viewing point of a perspective picture. As Edgerton suggests: "This indeed is the first recorded instance of anybody—scientist or artist—giving instructions on how to make a picture based on a projection from a single point representing the eye of an individual human beholder."[102]

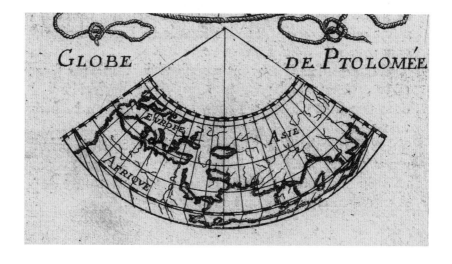

**3.11**

Seventeenth-century reconstruction of a Ptolemaic map. Alain Manesson Mallet, *Description de l'Univers* (Paris: Chez Denis Thierry, 1683), plate 67. Image: author's collection.

Like the perspective grid of Renaissance artists, then, Ptolemy's cartographic grid imposed an immediate mathematical unity on what it depicted; the most far-flung places could now be conceived of in terms of a series of fixed relationships and proportionate distances. At precisely the time when new information was becoming available concerning the "outside" world, the Ptolemaic grid gave Europe a perfectly expandable cartographic tool for the collection, collation, and correction of geographical knowledge.[103] Thus, in many ways, the cartographic grid came to enable a new discourse of the "Other": no longer that which was despised from within (the Jew, the pauper, et cetera), the "Other" could now be projected as something that lay "beyond." At the same time, although nothing was known of it, *terra incognita* would now be susceptible to the same rational, qualitative measurement as the inhabited world. The cartographic grid provided not only the means by which the Renaissance could visualize the "Other" in terms of a new discourse, but also the means of inscribing this difference in terms of an economy of the same: a series of geometrically defined places.

. . . . .

As various authors have pointed out, the logic of the cartographic grid as a means of normalizing the heterogeneity of space through the erasure of its defining spatial practices did not occur overnight. The persistence of the itinerary as a means of representing and conceiving of space persisted right throughout the Renaissance and was truly overcome only by the geometric certainty of the cartographic grid, as the Enlightenment finally gave way to a modern colonial world order in the nineteenth century. This much is attested to by the story of the failed efforts of the Spanish to construct a master template map during the sixteenth century. Known as the *Padrón Real*, this map was designed to record, in one place, the extent of Iberian travel and conquest throughout the New World. From its very inception the *Padrón Real* was plagued by inconsistencies produced by the differential nature of the maps and charts used to assemble it. Various efforts had been employed to regulate the old nautical traditions including the standardization of instruments, the training and licensing of captains, and the commissioning of new tables for calculating distances, latitudes, and the sun's declination.[104] However, the key to the *Padrón Real*'s failure lay not so much in the unsolved problem of how to record knowledge of the relationship between space and time (longitude), but rather in the persistence of the itinerary, in the form of the portolan chart, as a practical understanding of lived space.[105]

In 1577, Juan López de Velasco, in an effort to correct seventy years of inconsistent information, sent out instructions to local officials in the Spanish colonies of the New World to observe the lunar eclipses on 26 September (1577) and 15 September (1578) so that he could attempt to calculate the actual

distances of each colony from Europe. Along with these instructions López sent out detailed questionnaires aimed at garnering accurate territorial knowledge, and requested that officials commission maps of their cities and the surrounding landscape. What López received in return was a series of hybrid maps that took the general form of the requested plane projections, but were detailed with local narrative or indigenous understandings of territorial jurisdiction. López was incapable of assembling the *Padrón Real* from the spatial stories he received: each map resisted his desire to affix it to the logic of the grid.[106] In short, the homogenized conception of space that the Spanish tried to impose across their territorial possessions ultimately proved too hard to maintain—thwarted by the persistence of everyday narrations of space. However, this was something that would last only as long as the territory continued to precede the map, and as Borges's tale warns us, this would eventually be challenged by Enlightenment science. What the story of Spain's failed efforts to homogenize the spatial practices of the New World colonies shows us, then, is the manner in which cartography increasingly came to take place within the "contact zone" of the colonial encounter; revealing cartography's simultaneous need for indigenous knowledges, at the same time as desiring their eradication.

Numerous historical examples present themselves as relevant in this regard, though few are as apt as the cartographic missions following in the wake of the so-called "Great Trigonometrical Survey" of India in the nineteenth century. Seen as one of "the most glorious monuments to British rule in the east," the trigonometric surveys were not only thoroughly dependent upon both local assistance and geographical knowledge, but also sent a powerful statement to the bordering territories of Turkestan, Tibet, and Afghanistan regarding British intentions in the region.[107] Upon the survey's completion near the end of the nineteenth century, British cartographers turned their eyes and instruments north toward these independent regions, but found themselves repeatedly thwarted and actively repelled by officials and local inhabitants alike. While the British altruistically spoke of striving toward the "forbidden frontiers" of the "neutral zones," the inhabitants of these regions saw little to convince them that such ventures were anything but a preliminary to open invasion.[108]

The fact that indigenous groups resisted colonial efforts to map the surfaces of their territorial holdings in this manner speaks of their understanding that mapping was not the neutral affair the British claimed it to be; or perhaps we should say it speaks of their understanding that it was *precisely* the neutral affair the British claimed it to be: that is, the scientific neutralization or homogenization of spatial practices. Betraying its historical roots in Enlightenment rationality, modern cartography operates within this "contact zone" of coloni-

zation through a process somewhat akin to textual translation, taking indigenous spatial practices and territorial knowledge claims and "translating" them into the rational language of cartographic coordinates.[109] In this regard, we could read the mapping of spatial narratives in much the same way that Niranjana characterizes the discourses of textual translation as a strategy of containment. Deployed across a number of discourses, translation remains for Niranjana "a significant technology of colonial domination."[110] Given de Certeau's characterization of the map as a pictorial recording of spatial *narratives*, this move would be easy enough to sustain, thereby enabling us to situate cartography as part of the armature of Said's Orientalist discourses, at the same time as opening up the study of cartography to the more immediate concerns of postcolonial analysis. The fact that few authors have attempted to situate cartography in this manner (Walter Mignolo being a rare exception) reveals the continuing influence of postcolonialism's discursive roots in literary criticism, while it highlights the persistent view that maps are merely utilitarian tools, things of science or pictorial fancies—in short, maps are deemed just too obvious to warrant such analysis.

While the study of cartography as the "history of spatial translation" is thus one area of scholarship in need of more critical attention, it is also clearly one beyond the scope of my present concerns. What I would prefer to maintain our interest in is the way in which cartography operates both epistemologically and ontologically as the "pictorialization" of modernity; by which I mean: the way in which cartography comes to precede the cellular grid of modern disciplinary technologies by rendering the world as a picture. I wish to characterize this process with reference to the somewhat irreverent assertion by Steve Woolgar and Bruno Latour that the epistemological privilege of scientific knowledge resides not in any special technique or unique methodology, but rather in its quite mundane bureaucratization of knowledge production.[111] Conducting what the authors describe as an "anthropology" of the scientific laboratory, Woolgar and Latour discovered that the primary endeavor most scientists found themselves engaged in was the collection, collation, and production of "inscriptions"—tabulations, labels, graphs, and markings. Latour would take these observations to his wider study of *Science in Action*, where he would suggest that scientific achievement is predicated upon making these inscriptions speak to the world beyond the confines of the laboratory.[112] The novelty of this characterization of science truly comes to the fore, however, with Latour's suggestion that in order to "act at a distance" in this fashion, it is the outside world and not the inscription that must be transformed: "calculations on paper can apply to the world outside only if the outside world is itself another piece of paper in the same format."[113] Applied to the realm of cartography, the logic of

Latour's suggestion is immediately obvious: we do not normally compare what is written on a roadmap to the landscape itself; rather, we compare what is written on the map with the landmarks, the signs, the arrows, and the names that have been inscribed on the land itself. The scientific place map is "useful" only insofar as what we read it against has been transformed into a further inscription; cartography is both the impetus and the means of effecting such a transformation.[114]

Viewed in this manner, cartography, we can now suggest, provided Europe not only with a perfectly expandable matrix that allowed for a discourse of the "Other" through the projection of a uniformity over that which had hitherto remained unknown, but also with both the impetus and the means of inscribing this "Other" in an economy of the same. Not something merely confined to the drawing rooms of European trading companies and colonial administrators, cartography was indeed a way of *representing* space, but more importantly, it was a way of *producing* space (as all modern representations do). In this regard, cartography needs to be seen as a set of discursive practices for the production of a normalized grid of spatial associations. It is the imposition and inscription on the very land itself of specific power relationships in the form of geometrically defined "proper places," within which bodies can be both distributed and ordered in relationships of coexistence. Cartography is thus inherently "colonial" insofar as it necessitates the implementation of its own pictorial structuring of the world.

Possessed of a demiurgic quality to transform the world into the likeness of its own image, what remains to be seen is the subject of this "image"; and here there could be no better guide to the discursive function of modern cartography than the mystic theology of the fifteenth-century mathematician-bishop Nicholas of Cusa. For it is in the infinite qualities of the "all-seer" image that the vital spirit of cartography resides: a spirit whose essence can in no way be confined or contained by the decorative borders framing it. Spilling its geometric rendering of the world out from the picture plane, the image that is created by cartography is none other than the modern observing subject standing before the world presented as a view; the panoptic god of Michel Foucault being the name we can put to this face.

## Modernity in Ascension: The World Picture Mourning the Celestial

The totalizing eye imagined by the painters of earlier times lives on in our achievements. The same scopic drive haunts users of architectural productions by materializing today the utopia that yesterday was only imagined.

Michel de Certeau, *The Practice of Everyday Life*, 1988

In the haste of those enchanted by postmodernism's suggestion that the valorization of the "marginal space" and the "oppositional tactic" will deliver the promise of both "agency" and "resistance" squarely within reach of the individual, Michel de Certeau's "spatial practices" are often celebrated as the panacea to the perceived crushing discursive effects of Foucault's disciplinary power. In particular, de Certeau's spatial narration of "walking in the city" has been taken as the tactic *par excellence* of a willful resistance to the normalizing effect of surveillance: so often we find it lauded as the theoretical guarantor of an extra-discursive, individuated form of modern, urban "agency."[115] However, to proceed in such a manner is to proceed uncritically on two counts. Not only does the persisting allure of "resistance" tend to deny the productive nature of Foucauldian discourse in the first place, but also (and more importantly for our purposes) de Certeau's spatial practices, while critical of the totalizing effects of Foucault's panoptic techniques, were clearly meant as an elaboration, not a refutation, of the Foucauldian rendition of disciplinary power.[116]

For those authors wishing to enlist de Certeau to the task of loosening the discursive stranglehold this disciplinary power is seen to have over modern subject formation, the most common reference point would have to be his story of gazing down from the 110th floor of the World Trade Center. Although its mythologized narrative of Icarus soaring above the labyrinthian devices of Daedalus now carries with it an aura of prescience, it is to de Certeau's description of this vantage point above the city's grasp that most authors turn. For this description has come to represent that aspect of the panoptic impulse deemed most in need of redress: the ability of the "voyeur-god" to transform the world into a text before its own eyes. The grounds on which this struggle is to be fought, we are told, lie somewhere below the threshold at which this panoptic visibility begins: down there with the practitioners of the city tracing an urban text through the act of walking. Buoyed by de Certeau's use of phrases like "These practitioners make use of spaces that cannot be seen," one could almost be forgiven for picturing an urban grid seething with agents/authors conducting dissenting acts against the omnipotence of the panoptic eye, de Certeau at their head.[117]

However, to my mind, this reading does de Certeau an injustice. In suggesting that his narrative set atop the World Trade Center is a rallying cry against the position of the panoptic god is to read only half the text.[118] As is so often the case with de Certeau's writings, we find that there is a less corporeal view of things to be had here. The suggestion of what this narrative of resistance misses out on can be found in the following question posed by de Certeau:

To what erotics of knowledge does the ecstasy of reading such a cosmos belong? Having taken a voluptuous pleasure in it, I wonder what is the source of this pleasure of "seeing the whole," of looking down on, totalizing the most immoderate of human texts.[119]

For de Certeau, the narrative of the World Trade Center is concerned not so much with raising a god so that it may be torn down, but rather with inquiring into the desire *to create that god*, the desire to see the city as a mobile and endlessly gridded text, and to inquire as to the sensual pleasure derived from such a "vision"; questions which, ultimately, will lead us back to the notion of the world picture.

What I wish to do in this final section, then, is to tie together the two parts of this chapter: the first regarding the nascent conception of the world grasped as a picture through representation; the second, the modern production of a homogenized grid of disciplinary technologies through the discourses of cartography. Clearly, the two are discursively related. Not only does the projection of a cartographic grid share the same architectural structure as the geometric space produced by single-point linear perspective, but also, as the pictorial "abstractions" of such spatial practices, both the cartographic map and the perspective picture share a similar epistemological status as "representations"; the only real structural difference between the two being related to the position of the viewer for whom their picture of the world is presented. As we saw with Nicholas of Cusa's "all-seer" image, the geometry of the perspective picture was conceived as a "window onto a world," locking the viewer to a fixed vantage point perpendicular to the picture plane by the central visual axis defined and traced by the "prince of rays." Yet what we witnessed with the formation of cartographic perspective was an ever-increasing vertical elevation of this fixed viewing point, from the somewhat oblique angle of the Renaissance topographical map to the bird's-eye view of modern cartography. Both perspectives were constructed for the vantage point of a spectator, though one was an embodied and (very) corporeal viewer (being quite literally brought to their knees on the floor of a church), while the other was a somewhat disembodied viewer, looking upon the world as if from "nowhere."

It is to these two vantage points that I now wish to turn in discussion of the final achievement of the world grasped as a picture: the summoning forth of a modern observing subject before a world laid out as a view. Whether it is de Certeau atop the World Trade Center, the fairgoer gazing down from Eiffel's tower, or the cartographer squaring up the city for their topographical view, there is something else at work behind the erasures of Enlightenment science and the homogenizing gestures of modern disciplinary technologies that marks

subjectivity with a desire not to defile the vision of the panoptic god but, rather, to revitalize it: something which, we will ultimately find, is little more than the blind search for a modern "vision" capable of bringing the body to its knees.

.....

Serving as an altarpiece in the thirteenth-century Benedictine nunnery of the same name, the Ebstorf *mappamundi* represents one of the clearest expressions of the medieval relationship between the microcosmic and macrocosmic realms: the map of the known world being depicted here as coterminous with the body of Christ (figure 3.12). Reproducing the standard orientation of medieval T-O maps, the Ebstorf *mappamundi* shows the figure of Christ with its head to the east (the location of the earthly paradise of Eden); the feet of Christ standing at the Pillars of Hercules (the westernmost extremity of the Mediterranean); while at the center of the world, the city of Jerusalem represents, quite literally, the heart of Christendom. What the medieval viewer was presented with, then, was the worldly embodiment of the Christian ideal of transubstantiation. Body and world conjoined, the Ebstorf *mappamundi* reminds us that the medieval world was devoid of the object/subject divide that so thoroughly characterized Enlightenment subjectivity; the map of the earth being as complete as the earth itself.[120] Thus any talk of the "accuracy" of this map was completely dependent upon the wholeness of the body of Christ; its rivers, mountains, and oceans corresponding to the bodily contours of the Messiah himself. This notion of the map's "embodiment," therefore, not only allows us to discard the positivism of modern understandings of geographical accuracy, but also enables us to comprehend the medieval lack of correlation between mapmaking on the one hand, and the idea of "exploration" on the other: to sail through the Pillars of Hercules was, quite literally, to abandon the body of Christ, and hence salvation.

Yet the "embodiment" of this map was not merely confined to its transubstantive relationship between an earthly world and heavenly body; that is, the Ebstorf *mappamundi* was not merely a "depiction" of medieval cosmology. Rather, like most representations that we have looked at during this chapter, the "embodiment" of the map was also reflected in, or inscribed upon, the viewing subjects for whom this map was designed. The sheer size (3.58 by 3.56 meters) and profusion of the scriptural and narrative details of the Ebstof *mappamundi* necessitated an embodied viewer both spatially mobile and temporally placed—the meaning of the map could not be reduced to a single graspable "view." Unlike the static and timeless viewer created by linear perspective, the Ebstorf *mappamundi* required its viewer to interpret its textual details in a bodily fashion: through the immersion of one's self within the details of the map, interpreting its narrations of Scripture and Christian lore

**3.12**

Gervase of Tilbury, *Ebstorf Mappamundi*, ca. 1339.
Reproduction. Original made for the convent at
Ebstorf, near Lüneburg. Once housed in the Museum
des Historischen Vereins für Niedersachsen,
Hanover. Destroyed in 1943.

through bodily movement. In this manner, the movements and actions of the viewer's body come to trace and narrate the very meaning of the mysteries of transubstantiation at the same time as "acknowledging the spatio-temporal continuum of God's domain contained within and depicted by the map."[121]

The Ebstorf *mappamundi* thus presented to its viewer a *sacred* depiction of the world; a depiction that inculcated the viewer into the mysteries of transubstantiation by revealing to them a series of embodied "visions" of the world made whole through the death and resurrection of Christ. In much the same way that the collection of reliquaries, rarities, and beautiful objects in the abbey church of Saint-Denis enabled Abbot Suger (of chapter 1) to be "thrown" into pious communion with God, so too the altarpiece *mappamundi* would assume its place within the ideally proportioned church at Ebstorf as a means of producing certain subject effects: its embodied nature allowing us to define subjectivity in an age of wonderment as being mobile, temporal, textual, and experiential.

· · · · ·

If we view the spatial narratives of the city practitioner tracing his or her daily itineraries through the act of "walking in the city" not, as some authors would have it, as a willful act of resistance to the totalizing "cellular grid" of panoptic practices mapped from above, but rather as the "micro-techniques" which de Certeau intended them to be (that is, the near-forgotten discursive actions which exist alongside the panoptic impulse to map the city), then what we find underpinning subjectivity in an age of disciplinary power is something more akin to a dialectic of "embodiment."[122] To read resistance into de Certeau's spatial practices is to lock his analysis into a binary between two modern spatial embodiments: one summoned into being by the productive effects of the cellular grid, defining subjects by the constancy of their being seen (corporeal yet transparent); the other defiantly cutting across this grid, with unseen narratives and itineraries (corporeal and opaque). Yet what de Certeau's narrative from the 110th floor of the World Trade Center tells us, in fact, is that modern subjectivity is kept in productive tension between these two embodiments through the projection of a third: the *disembodied*, fixed vantage point of the panoptic god. Constituted not merely by the proper places of disciplinary power, nor even through their everyday narrations, the modern, individuated subject is summoned into discourse by the oscillation between being the object of the panoptic god's omnipotent gaze, and the desire to possess that gaze.

We can see glimmers of this at work in Tony Bennett's addendum to Foucault's remarks concerning the development of the carceral archipelago during the eighteenth and nineteenth centuries. In response to Foucault's claim that a new demand was placed on architecture that it must be built not

only to be seen (the ostentation of the princely palace) but also to "permit an internal, articulated and detailed control—to render visible those who are inside it," Bennett counters with the suggestion that the so-called "exhibitionary complex" (the museum and the exposition hall) posed the further demand that everyone should see, and not just be seen.[123] In this regard, Bennett suggests that within the confines of the exhibitionary complex relationships between space and vision were organized not merely so that observers would have a clear view of objects on display, but so that they would become the objects of each other's inspection; the fairgoer interchangeably being the object and subject of a policing gaze.[124]

However, what I am suggesting is something quite removed from the disciplinary effects of Bennett's shifting crowd of fairgoers on the midways and boulevards of the universal expositions. In that instance, the individuated and atomized subject of the modern exhibitionary complex was one among many; undifferentiated in its "embodiment." What I am referring to, by contrast, is the modern desire to create and occupy the privileged and fixed position of the very panoptic god itself; that celestial and disembodied viewing point with the infinite potential of perspective's *geometric* divinity—the vanishing point. It is thus the desire to picture and totalize the world as a view, and the ability to alienate vision from the body so that it may access the uniform knowledge of the grid of disciplinary power, that I wish to call our attention to. And by "desire" I am not merely referring to an individuated extradiscursive "will," but rather to the ontologically productive condition of modernity, which sees the formation of the modern subject as being tied to the effects of the cellular grid of disciplinary power both as the *embodied* object of vision and as the *disembodied* source of that vision. Moreover, we can go so far as to suggest that it is the tension maintained between these two modern "embodiments" that constitutes the modern subject as both individuated and knowing, yet also disciplined and controlled—two otherwise seemingly incongruous symptoms of Foucault's concept of it.

It is precisely at this point that the discursive effects of the world picture become apparent. Although Heidegger claimed that the hallmark of modern subjectivity was the ability to grasp the world as a picture, and that this did not entail a "painting" or "pictorialization" of the world, I have been arguing that much like the ability of Foucault's disciplinary technologies to be productive of certain subject effects, the technologies of perspective and cartography should be seen as achieving similar ends, *precisely* because they did present a "pictorialization" of the world. The modern subject, the being at the center of all beings, is brought into discourse because of its ability to "picture" itself, through the "embodying" techniques of representation, as the infinitely potential "point"

(of light, of grace, of being) of the perspective picture's elusive vanishing point. Reflected back through the architecture of perspective's geometric rendering of the world, the modern subject is constituted as the single point of knowing and being that was once reserved for God. Hence the epistemological and ontological scandal of homogenizing gestures of Enlightenment science: by locking the relationship of knowledge and things to the binary differences of scientific classification, humankind was elevated to the position of gods.

Previously I suggested that it was the uncontrollable way in which the geometry of the map spilled out from its frame to colonize the land itself that marked cartography as a technology for the erasure of spatial narratives (thereby laying the ground, as it were, for Foucault's cellular grid of disciplinary technologies). Yet we can also say that it was the visual architecture of this perspectival grid that would ensure that modern subjects were summoned forth, not only as the beneficiaries of a "knowingness," but also as being in possession of a *disembodied* vision produced by a world ordered as a view. This, in effect, is the basis of Timothy Mitchell's narrative of European travelers and explorers in Egypt constantly seeking a vantage point from which to view the city. Unaccustomed to a world not rendered as a "view," the European traveler to the East sought to re-create the world in the image of a gridded perspective picture; something the exhibition had led them to believe the world was actually structured like.[125]

Simon Ryan has suggested much the same of the need for European explorers to find a "commanding view" of the landscape from which to take their bearings: "The explorative gaze ... becomes a microform of the divine gaze, hence it must always be directed from above."[126] Thus as we saw, with its development from the narrativized landscapes of the Renaissance, the viewing position of the modern map gets higher and higher until it reaches the point of being of a view from nowhere; the geometrically defined gaze it finally comes to imply is suggestive of something akin to a modern out-of-body experience.[127] In this regard, whatever else can be said of the modern cartographic map, it also reveals a devotional quality. Like the medieval *retablo* that once hung in churches as a votive offering in the form of a picture or painting (usually in gratitude for deliverance from distress), the modern cartographic map beckons us to venerate it as a modern means of celestial commune.[128]

Thus the technologies of picturing the world that are constitutive of the modern subject operate above all by situating "the being at the center of all beings" as a disembodied and celestial subject. It is here that our present discussion joins with our previous discussion of the subject effects of Renaissance collection. As we saw in that instance, a modern individuated subject was summoned forth in the closeted confines of the curiosity cabinet, usurping the privileged knowing position that had previously been occupied by God.

Likewise, in this instance we see the same modern subject being formed through the spatializing practices of the visual; picturing a world laid out for the view of a celestial gaze once enjoyed by God alone.

．．．．．

If we return to de Certeau's view atop the World Trade Center, residing in the architectural achievements of modernity may well be the realization of the totalizing eye that painters of an earlier time could only image. But something is missing: something that was there in Pozzo's illusionistic ceiling but absent from the view atop the Eiffel Tower. It is something that can be seen in the Ebstorf *mappamundi*, but is absent from the cartographic map: the wonderment of the sacred that could bring subjects to their knees. Try as they might to proffer the category of "man" as a substitute for the knowing position and omniscient vision of God, the mechanical contrivances of Enlightenment science do not quite capture that essence of being that was able to "throw" Abbot Suger or Nicholas of Cusa into communion with the sacred. The homogenized knowledges and transparent spaces created by Enlightenment science would demand a veneration of their own, and would certainly bring many subjects to their knees through their disciplinary technologies. But for the most part, these technologies would come to appear as little more than an act of mourning for the ability of the sacred to transfix through art and architecture, and propel the subject into divine commune.

## Postscript: The Maze of Linear Discourse

Easy substitutes for more exacting devotion were found in many ways. The introduction of the Stations of the Cross is ascribed to this cause, the devout following in the footsteps of the Saviour in His last sufferings, being accounted equivalent to visiting the holy places; and somewhat similarly, the maze, or labyrinth, is said to have been pressed into the service of religion … being reckoned as a simple substitute for a longer pilgrimage.

George Tyack, *Ecclesiastical Curiosities*, 1899

Inlaid in the tiled floor and occupying the entire width of the nave of the cathedral of Notre-Dame de Chartres is one of the last surviving examples of those somewhat baffling symbols of medieval artistry, the Christian church labyrinth (figure 3.13). Baffling in that an ancient pagan symbol could hold such a prominent position within the harmonic order of the Gothic cathedral's structural components. Baffling also, in that by the beginning of the eighteenth century the church labyrinth had all but lost this discursive certainty; most falling prey to the hired pickaxes of frustrated church officials who claimed that their existence merely attracted children and idlers whose incessant wanderings disrupted the divine offices.[129]

**3.13**

The labyrinth, cathedral of Notre-Dame de Chartres.
Schematic showing individual floor tiles. Courtesy
of Jeff Saward/<www.labyrinthos.net>.

In our previous discussion of the dominant discursive formations of the Middle Ages and the Renaissance it was suggested that in a system of knowledge production prioritizing the existence of resemblances and sympathies between significant structural forms and experience effects, virtually every element and detail within the geometrically planned and appropriately proportioned Gothic cathedral would impart some form of expressive significance to a higher principle or order. This is exactly what Edward Trollope, suffragan bishop of Nottingham, was referring to in 1858 when he remarked: "Perhaps the most surprising fact connected to the mythological labyrinth is its acceptance by Christians, and its adoption by the Church into a higher significance than it originally bore."[130] However, whereas we know the general nature of the harmonious order to which each compositional element of the Gothic cathedral aspired, we cannot necessarily be so sure about Trollope's "higher significance" underpinning the nature of the church labyrinth: no reference to the function of the church labyrinth exists prior to these nineteenth-century speculations.

That the church labyrinth became unmoored from the harmonic order which continued to bind the other elements of the Gothic cathedral as a site of religious experience in this fashion has, of course, guaranteed it a certain romantic allure and fascination among academics and "idle wanderers" alike keen to decipher its original meaning and function. Of the manifold solutions proffered toward this end, by far the most popular would have to be that these giant circuitous pathways offered the pious who were too sick, too weak, too young, or too old an alternative to the arduous task of pilgrimage to Jerusalem. Nigel Pennick continues this historical supposition thus:

> Originally small, carved into walls they came into their own when laid into the pavement of a church interior where it is suggested that they were used by the devout, who crawled around on their hands and knees as the spiritual equivalent of a pilgrimage to Jerusalem.[131]

It has also been suggested that if the various parts of the medieval church denote the crucified body of Christ, then the position of church labyrinths at the base of the nave would correspond to the feet of Christ, thereby indicating a sense of travel, spiritual or otherwise: the word "nave" derives from *navis* (ship), thus taken to symbolize the journey that the Christian must make in order to achieve salvation: the Heavenly Jerusalem.[132] It is for this very reason that church labyrinths have often been referred to as *Chemins de Jérusalem*.

This explanation that the church labyrinth represents the pathway to the Heavenly Jerusalem also serves to explain the Christian appropriation of an otherwise wholly pagan symbol. Thus it is suggested that within much late

ancient and medieval literature, a commonplace allegorical association existed between the myth of Theseus entering the labyrinth of the Minotaur and the story of Christ's passage through the maze of the underworld. The fourth-century theologian Gregory of Nyssa, for instance (whom we encountered in chapter 1 warning us of the follies of curiosity), saw in the labyrinth the perfect metaphor for the state of perpetual death from which only Christ could save humankind:

> Reflect: so is the labyrinth of life inextricable for man if he does not follow the path that led Him who once entered outside. This labyrinth symbolizes the inextricable prison of death, where unhappy mankind was once imprisoned.[133]

To follow in the footsteps of Christ as he navigated the maze of the underworld was to trace the sure and straight path of Christianity, a path through the earthly temptations of this world leading to the Heavenly City of Jerusalem. Here again the notion of Christian salvation is associated with the figure of the labyrinth.

This explanation of the church labyrinth as a spiritual equivalent to actual pilgrimage certainly accords with our (somewhat romantic) image of the more robust forms of Christian aestheticism. Yet I wish to suggest that, in light of our previous discussion of the discursive underpinnings of medieval notions of geometric harmony, there is a much simpler way of characterizing the symbolism of the church labyrinth; one which is there in the very structural composition of its linear form.

Almost without exception, the mazes of medieval art, including the church labyrinth, were unicursal in structure, consisting of a single twisting path that formed the most circuitous route conceivable within their circular confines (see figure 3.12). This lay in sharp contrast to the idea of the maze derived from medieval literature as a series of confounding choices between pathways characterized by the frustration of blind alleyways and multiple dead-ends.[134] Structurally, then, the church labyrinth was explicably teleological. If the maze depicted in medieval literature represented a symbol of continual choice, then the unicursal path of the labyrinth was governed by the single decision to enter or not; this initial choice abrogating all future decisions. This being so, the key to "solving" a unicursal labyrinth lay not so much in wise decision making, but merely in the virtue of persistence—persistence necessarily revealing the goal of the labyrinth: its center.[135]

The medieval church labyrinth was also diagrammatic in presentation, always depicted as if viewed from above. Any potential confusion arising from the labyrinth's winding pathway would thus always be allayed by the assurance that order and symmetry dominated its structure. In this way, the labyrinth

shared a common structural composition with the medieval T-O maps, both labyrinth and map appearing as a circle bisected by the cross (see figures 3.10 and 3.11), with the holy city of Jerusalem at their center.[136]

It would seem, then, that whether we ascribe the construction of the church labyrinth to the same impulse that saw the re-creation of the true Stations of the Cross in European holy sites (the labyrinth as substitute for pilgrimage), or merely as a symbolic reminder of the arduous but sure path of the Christian way of life, a number of structural considerations accompany, and are communicated through, the use of a unicursal labyrinth design. First and foremost among them would have to be the Christian West's faith in the organizing principle of the vector: the surest way to salvation was to follow the straight and narrow path of Christ throughout life. Alberti's "prince of rays" returns here, in the guise of a geometry of salvation: the most Christian path being equated with the straight line of faith.

· · · · ·

The trenches are a labyrinth, I have already lost myself repeatedly …
you can't get out of them and walk about the country or see anything
at all but two mouldy walls on each side of you.

Major Frank Isherwood, letter to his wife, December 1914

Commencing on 31 July 1917 and lasting ten days, the preparatory barrage of the Third Battle of Ypres saw some four and a half million shells explode—nearly ten thousand pounds of shell on every linear yard of front.[137] This ceaseless pounding of the earth disinterred bodies as rapidly and as brutally as it reinterred them, leaving no recognizable trace of landscape in its wake. Crouched, awaiting that fateful call to "go over the top," the infantry soldier inhabited a labyrinthian world of mud and bodies, shattered nerves, and cruel disfigurements; while the clutching fumes of chlorine gas, the fevered waves of typhus, and the hallucinations and tremors of shell shock lay close at hand. If a soldier was to even make it over the trench wall, all that was left for him to face was an unseen enemy and the barrenness of "no-man's-land."

If it can be said that in the first decades of the twentieth century the logic of the war machine shifted from the destruction of the body and its protective devices to the disintegration of the very condition of human habitation, then it could also be said that the soldier of war briefly found parry to this onslaught by retreating into the very thickness of the landscape itself.[138] Likewise, if it could be said that the trench of World War I represented the ultimate expression of an unwavering adherence to the organizing principle of the vector, then it must also be said that in its much-maligned immobility, the trench also represented the ultimate "pathology" of the Western faith in the straight line.

In the midst of this "war to end all wars," Gustave Le Bon remarked that the ability of modern warfare to reduce all qualities of the land to rubble and debris had cast the permanent character of human personality in doubt.[139] Le Bon noted that up till then, the human personality's alleged fixity had relied upon the permanence of the natural environment, but with the constant disintegration of landscape during the war various psychological disorders were making themselves known in otherwise stable personalities. One of these disorders could best be described as a "topographical amnesia."

For someone denied a point of reference by which to stabilize vision, topographical amnesia produced an unmooring of the perceptual field, in not dissimilar ways to the "incomplete awakening" that affects some people on fast railway transport.[140] With vision reeling out of phase in this manner, all the infantry soldier could do to stabilize a world devoid of reference points was to take solace in the artificial sighting line of the rifle. The sighting line, then, had already served the soldier well in removing a degree of responsibility from the act of killing: desire being identified with the path or flight of a bullet toward an imagined encounter with an unseen enemy—"Mon désir est là sur quoi je tire."[141] But now, to stare down the barrel of one's rifle was an act of vision aimed at restoring that which war had so easily striped away: in French the "line of sight"—*ligne de fuite*—means, quite literally, "line of faith."

# Conclusion

As long as the temporary burial of the corpse lasts, the deceased
continues to belong more or less exclusively to the world he
has just left. ... During the whole of this period the deceased is looked
upon as having not yet completely ended his earthly existence ...
in its present distress it remembers all the wrongs it has suffered
during its life and seeks revenge ... it may return of its own initiative
through necessity or through malice, and its untimely appearance
spreads terror.

Robert Hertz, *Death and the Right Hand*, 1906

I pause in the midst of an operation being performed under spinal
anesthesia to observe the face of my patient, to speak a word or
two of reassurance. I peer above the screen separat-ing his head from
his abdomen, in which I am most deeply employed. He is not asleep,
but rather stares upward, his attention riveted, a look of terrible
discovery, of wonder upon his face. Watch him. He is violating a taboo.
I follow his gaze upward, and see in the great operating lamp
suspended above his belly the reflection of his viscera. There is the
liver, dark and turgid above, there the loops of his bowel winding
slow, there his blood runs extravagantly. It is that which he sees and
studies with so much horror and fascination. Something primordial
in him has been aroused—a fright, a longing. I feel it, too, and quickly
bend above his open body to shield it from view. How dare he look
within the Ark! Cover his eyes! But it is too late; he has already seen;
that which no man should; he has trespassed. And I am no longer a
surgeon, but a hierophant who must do magic to ward off the
punishment of the angry gods.

Richard Selzer, *Mortal Lessons: Notes on the Art of Surgery*, 1976

## Scientific "Visions" of the Living Body

There is no dead matter, lifelessness is only a disguise behind which
hide unknown forms of life.

Bruno Schultz's father, "The Street of Crocodiles," 1998[1]

It is inevitable that at some point, every person engaged in an academic pursuit is called upon to give an account of what it is that they are presently engaged in, particularly when it concerns the act of writing. On this occasion I was in the back seat of a parked car with three other occupants whiling away a bit of time before being required to take our seats for the evening's diversion. On request, I tentatively proffered an unrehearsed argument regarding anatomical science and what I saw, and still see, as its intimate epistemological relationship to the dead body. More importantly, I was in the midst of stressing how this relationship had come to mark Western medicine (as opposed to some non-Western medicines) as a discourse concerned with the dead, rather than the living, body. I say "tentatively" proffering my argument, for sitting next to me was a very silent marine biologist, a mollusk expert, to be more precise. Forging ahead with my claim, I suggested that such is the marking of medical discourse in this fashion that when we walk into a doctor's surgery it is our *dead* body that is presented before them, not our vital and living body: the probing anatomical gaze of medical science being one characterized almost solely by its pathologizing nature.

Having satisfied, on one level or another, the initial question asked of me by the passenger in the front seat, I took the opportunity to inquire as to the polite but disapproving noises made by my companion. Of the numerous helpful reminders I subsequently received, one particular response is worth the retelling. It was a seasoned, professional observation regarding the very act of professional scientific observation. It was succinct, effective, and hit its mark. Paraphrased, it went something like this: "I'm sorry, David, I don't think any doctor would agree with you. I know, for one, that when a specimen is in front of me, I imagine it as alive, it is a living body that I see and to which my observations are directed."

It was a claim that, at the time, I had no ability to refute. Yet it was only later that I realized it was also a claim that I had no need to refute, as what, in fact, had just been presented to me was precisely the point of the matter: that modern science is possessed of a gaze that allows its practitioners to envisage (or, should I say, have visions of) the dead-as-living. The visual depiction of animated corpses may well have receded from anatomical illustrations since the time of Vesalius's *De fabrica*, but in many ways the scientific "vision" of seeing dead matter live again has not only been preserved as a mode of research within the so-called life sciences, it has also been preserved as the very cornerstone of scientific knowledge production. What was once an artistically rendered, early mapping of the anatomical structure of the dead body—the tortured and broken perpetually "living" body of Vesalius's *écorché*—has faded from the

pages of anatomical atlases, spreading out into the very discursive structures of scientific practice itself, as an innate, prescient scientific "vision."

One need only wander through the natural history section of a modern museum to see this in effect: row upon row of cabinets, brimming with stuffed animals in lifelike poses, stand forlornly as the modern equivalent to the awe-inspiring reliquaries of an age of wonderment. Although these near-sacred taxonomic collections allow scientific practitioners to "envisage" broken bodies as if rich in life, the power of the living saint, the *praesentia* behind each bodily fragment in the medieval church, seems to stand in sharp contrast to the emptiness of so many violated, once-living bodies in the modern museum. Pausing before such a macabre collection certainly produces an awe of its own, but this modern scientific awe is clothed in the pallor of death: the fanlike arrangement of bodies in display cabinets charting imperceptible variations in color, or size, or function, startling the viewer with the meticulousness of this trade in the dead. The effect is that one cannot help but ask: of all the means available to modern science for "knowing" an animal, why is it that we have been so ready to turn to dead bodies in our account of the living?

The banality of the obvious utilitarian response to this question stands as such an affront to those marginalized or non-Western peoples that have also suffered the effects of the so-called "transparent" scientific cataloging and collection of bodies that we need not consider it worthy of elaboration. Rather, what we find underpinning this scientific "vision" of dead-matter-made-living is a particular desire to animate, which in itself prompts yet another question: could the ability to see a broken and tortured body—a body that has borne the full brunt of either retributive justice or the harvesting act of scientific collection—as a complete, whole and living body, have achieved its epistemological privilege in Western science were it not for the existence of the perfect exemplar to which this science could aspire? And this perfect exemplar is, of course, the Christian notion of the resurrection of the flesh. Marked within the very discursive structures of modern observational science seems to be an irresolvable ambivalence: on the one hand there is the desire to homogenize the difference of knowledge production through the one-to-one subject-object relationships of scientific classification; yet on the other, there is the constant failure of these efforts to fully erase the heterogeneous from knowledge production.

If there is a postscript to my anecdote from the back seat of the car, then it would be there in the somewhat fitting fact that once the required amount of time had passed in conversation, we all got out of the car, crossed the road, and entered a church ... to listen to hymns sung to this very exemplary act of bodily animation.

# Monuments and Masks: Visions of a Modern Sacred

Can you imagine the pain, the dull imprisoned suffering,
hewn into the matter of that dummy which does not
know why it must be what it is, why it must remain in that
forcibly imposed form which is no more than a parody?

..................................................................................................................

Bruno Schultz's father, "The Street of Crocodiles," 1998

The trench warfare of the First World War produced a disproportionate number of facial injuries, as it was often the face that bore the brunt of flying debris and ricocheting shrapnel, or even unseen bullets propelling fragments of one's own helmet through the face. Four years of this entrenched war left its scars on tens of thousands, these scars made all the more horrendous for being impossible to hide. Clothing and gloves could cover some body wounds, a crutch or prosthesis mitigate others, but without a nose or a jaw or the skin that covers them, one can really only speculate as to the fate of many of these returned servicemen. As the British surgeon Sir Arbuthnot Lane noted, their families may love them and their country may honor them, but "the race is only human, and people who look as some of these creatures look haven't much a chance."[2]

Returning war wounded proved a particular problem for the British Home Front desperate to spare its civilian population the horrors of war; a problem which could in no way be fully redressed by surgery alone. Although advancing rapidly because of the war, the techniques of the newly conceived "plastic" surgery were highly experimental and often brutal, leaving many soldiers little better off for the additional hardships endured on the surgeon's table. So medical science came to meet with that other great innovation of this war, camouflage, to produce a method of masking this living face of death. Sculptors and painters collaborated with doctors in the construction of copper and silver alloy facemasks that a soldier would wear while surgery slowly attempted to repair the wounds underneath.[3] Painted in the likeness of prewar photographs, the faces of unfortunate soldiers were literally "struck in silver"; permanently captured in strangely immobile, youthful smiles that belied the pain of a broken body beneath.

If it can be suggested that it is the broken object that bespeaks of life, then in a curious inversion of Taussig's notion of defacement, the "hemorrhaging of presence" that these disfigured faces represented was to be repaired by making mannequins of men, "stoning" them as monuments to a war whose most enduring achievements would be found in camouflage and masking.

.....

In a war where the traditional military compulsion to advance across the surface of the land had come grinding to a halt as spatial progress gave way to a policy

of endurance and attrition, the trench precipitated the advent of a new type of military logistic: the mastery of perceptual fields rather than territorial ones.[4] The battle for the sky, for instance, was less a battle of arms than a battle of sight. In this regard the logistics of military perception would see the supply of visual imagery as being as vital as any supply of arms or ammunition: at the height of the war, the French were developing anything up to ten thousand photographs of the front each night.[5] In response to this immense and overwhelming scopic regime of watchers and interpreters of visual imagery, an army of artists and sculptors were deployed from civilian ranks to shield troops from the mechanized gaze of reconnaissance and sighting devices through the use of various techniques of camouflage: runways were painted as if already bombed, papier-mâché dummies attracted the bullets otherwise destined for able bodies, netting obscured gun emplacements, hollow metal trees allowed snipers to survey "no-man's-land," while movable canvas hoardings were placed on top of trenches painted to represent damaged roads and craterous fields. Whether it was the English speaking of "dazzling," the Germans of *die Tarnung* (masking and screening), the Americans of "protective coloration," or the French of "the art bordering on the miraculous," the catch-cry of camouflage was that it was more important to be unseen or invisible than it was to be protected or invincible.[6]

In many ways war camouflage was symptomatic of a newly conceived visual self-consciousness that characterized modernism's ambivalence toward the possibilities of vision.[7] The war, itself, was very much a war of illusion and disillusionment; and by disillusionment I am not so much referring to the much-vaunted betrayal of the romantic values of honor and glory, but rather the realization of the extreme limitations of embodied vision. *Trompe l'œil* had once characterized baroque vision as playful, sensual, and transfiguring; now such illusion was a thing of nightmares, a pathology of the visual, a "disease of the eyes whose sole cure, it seemed, was the sense one could make from high above through lenses more reliable than the naked eye."[8] More than merely a means of protecting soldiers from the probing gaze of a series of "disembodied" visual techniques, camouflage had a tendency to reproduce the very fragile, "embodied" visual experiences of troops at the front. Double vision, disorientation, fragmentation, displacement, disruption, and vertigo were as much symptoms of the shell-shocked soldier as they were the tactics of *camoufleur*; war trauma and *trompe l'œil* being one of a piece.[9]

In this regard we must see camouflage not merely, as traditional historians would have it, as the logical and rational response to the technological developments of the modern war machine, but rather as a particular modern manifestation of those discourses of the visual whose genealogies we have been tracing throughout this book. And just as our investigation of those genealogies

**4.1**

Horace Nicholls, Ministry of Information official
photographer, the development of plastic surgery
during the First World War: the work of Francis
Derwent Wood, Third London General Hospital,
Wandsworth. Image: Photograph Archive, Imperial
War Museum, London.

has primarily been centered upon modernity's continued, though incomplete, efforts to expunge the heterogeneous from its discursive folds, so too we may read, in these early modern concerns with the limits of embodied vision, an unsettled and ambivalent response to the disenchantment of industrial modernity. Thus, although a faith in the transfiguring ability of an embodied "vision" gave way, under its repeated assault in the factories, museums, fairgrounds, and battlefields of modernity, to a new faith in the mechanical contrivances of the disembodied optical devices of the panoptic god, in something like camouflage we can see a striking ambivalence at work. At the very moment when the disembodied gaze of the panoptic god was being called upon to save its battered subjects from the ravishes of a mechanized war, the optic that modernity summoned in response was one that conjured with the very state of human embodiment.

Camouflage, which was, after all, most commonly deemed a form of mimicry derived from the "protective coloration" of various animal species, can be seen as an effort to "embody" or capture that elusiveness of vision whose ethereal nature underpinned the transformations, the transfigurations, and the transubstantiations of an age of visual piety; an age of wonderment.[10] "Dazzling," "mimicry," "obliterative gradation," and "the art bordering on the miraculous": these were the names of a modern technique of "embodied vision," acting upon the flesh to make the body recede through its control, discipline, and even torture. Like the Christian flagellant elevating the soul by bringing the vulnerable physicality of the body painfully to the fore, the embodying techniques of war camouflage acted like contemporary substitutes for the dazzling and obliterative techniques of spiritual communion, marking the body as a site of pious vision precisely through its transformation in, through, and by the visual. In the case of the amnesic, tremulous body of the shell-shocked soldier, though, this modern embodiment of a once pious vision lay in a mirroring of the pathological limits of bodily vision.

· · · · ·

If we view the "re-facement" or masking of the war-wounded soldier as an instance of camouflage's more "embodied" nature, then we can find the ultimate extension of this "embodying" logic in the modern war memorial. At the front, the First World War soldier inhabited a world of corpses, but in the case of the Home Front, the perceived need to spare the British civilian population the horrors of this war led to the mourning of a corpseless dead; next to no British soldier being returned home for burial.[11] Not only did this "corpselessness" deny returning servicemen their very sense of home, it forced civilian modernists to summon forth the presence of these absent bodies through the architecture of the cenotaph; that monument to the persistence of a modern mimetic magic.

CONCLUSION

**4.2**

Unknown artist, *Camouflaged soldier standing
before building camouflaged to resemble
trees, Company F, 24th Engineers, American
University, Washington D.C. November 14, 1917.*

CONCLUSION

The Cenotaph, Whitehall, London

**4.3**

Unknown artist, *The Cenotaph, Whitehall,
London*. Image: Author's collection.

In fact, it would be possible to suggest that one of the most powerful markers of modern political territoriality occurs at the slippery interface between the body and the statue. The ease with which the dead body gives way to its politically embodied (or perhaps we should say "entombed") state of arrested decay in the form of the statue, and the way in which such monuments can in turn be animated as political actors, is a modern magic without parallel. Vladislav Todorov, for instance, suggests that the mummy of Lenin stood at the center of communism as the primal Party nucleus of power. Like a giant gnomon casting its shadow across the land, "it remained to stake out the territory where Stalin's Party imperialism was to expand."[12] In this regard, the embalmed monument that was the once-living body of Lenin animated the politics of communism: the mummy being the greatest communist.

Following this logic, we might also suggest that those soon-to-be monuments that are the unknown corpses buried in the mass graves and killing grounds of modernity saturate the landscape with a political value and potentiality that situate both corpses and monuments at the forefront of modern ethnic and state politics; both being instances of a politics that "works" through a conjuration of the dead. We saw this "political animation" wielded to great effect in the conflict marking the bloody dismemberment of the former Yugoslavia. In that instance, a war that commenced with the exhumation of unknown bodies from the mass graves of the Second World War unleashed a revolutionary vanguard of the dead to carve out territorial borders with their freshly dug graves.[13]

The repatriation and reburial of lost soldiers, or at the very least the conjuration of those bodies through architectural means, represents but one of the incursions of the heterogeneous into the homogenized landscape of modern scientific rationality that this book has paved the way to addressing. Despite assertions made by modern medical and legal discourse regarding the instantaneity of death, clearly death is experienced by the living as a state of transition; a state of transition which it is the duty of the living to help complete. To bury, to mark the grave, and to reclaim the bodies of war dead as a "properly dead person," that is, "giving that body a social integrity as a dead member of the society of the living," is clearly strong at work in the memorializations and ritual life of modernity.[14] In a modern war dominated by the economic rationalism of scarcity (of arms and ammunition), something is at work that speaks of the heterogeneity of modern rationality when Serbian soldiers unload full cartridges of machine-gun fire into the unmarked mass graves of Croat soldiers lest those bodies return to fight again.[15] Likewise, the modern West's continued use of camouflaged uniforms to mark the bodies of soldiers persists, in spite of the almost completely disembodied nature of modern virtual warfare.

Like talismanic relics to the embodied visual elusiveness of baroque *trompe l'œil*, the camouflaged uniform remains as a modern war curiosity, marking the persistence of modernity's heterogeneous relationship to the dead body.

## Conclusion

He stood behind her, pointing over her shoulder. Beneath the data strips, or tickers, there were fixed digits marking the time in the major cities of the world. He knew what she was thinking. Never mind the speed that makes it hard to follow what passes before the eye. The speed is not the point. Never mind the urgent, endless replenishment, the way the data dissolves at one end of the series just as it takes shape at the other. This is the point, the thrust, the future. We are not witnessing the flow of information so much as pure spectacle, or information made sacred, virtually unreadable. The small monitors of office, home and car become a kind of idolatry here, where crowds might gather in astonishment.

Don DeLillo, *Cosmopolis*, 2003

This book has attempted to undertake a specific "archaeology" of modern scientific knowledge formation with a particular eye on the privileged position of vision, both epistemologically and ontologically, in the modern West. Toward this end, a series of genealogies (of collections, bodies, and spaces) has been traced in an effort to illuminate the dual nature of modern scientific rationality which proceeds through simultaneous acts of revelation and concealment: that is, for every illuminating knowledge statement made, there is a resultant erasure, suppression, or containment that accompanies it. Because of this, it has been suggested that the scientific knowledge formations of the West have ingrained within their very structure a curious ambivalence. Proceeding through an idiosyncratic collection of discursive curiosities has allowed this ambivalence to be revealed as being predicated upon the active and systematic "desire" to erase all elements of what I have been calling the heterogeneous from scientific knowledge formations, while such heterogeneity persists and lingers on within the very structures *from which such rationalism was struck.*

Throughout the book I have continually stressed the importance of viewing, tracing, and exploring this ambivalent "desire" (as I have been calling it) as a function of discourse. Not something to be left to the vagaries of an individuated, ahistorical, humanist "will," this "desire," I have been suggesting, operates at the level of discourse. Like an active political campaign, Enlightenment rationality openly sought rupture with a previous medieval rendering of knowledge as textual; a rendering which marked all knowledge as being derived from that most quintessential of texts, the Scriptures. Effecting this rupture, Enlightenment rationality would raise a uniform, visualized form of knowl-

edge, prioritizing direct one-to-one relationships between objects presented to knowing and observing subjects who were, in turn, pressed into the service of observers by a world now rendered as a "view" to be grasped. Gone was the sophistication of multiple subject-object relationships based on resemblances and sympathies that had once given wonder, enchantment, and curiosity free rein; replaced instead by the flat, visually based tables of scientific classification.

It has also been stressed that one cannot view such epistemological shifts without considering their equivalent ontological function. For what we have found in this shift to a regime of visualized knowledge production has been the attendant story of the summoning forth of a modern, individuated, homogenized, and disciplined subject. From within the discursive sites of the cabinet, the anatomy theater, and the vantage point, we have seen how scientific rationality sought to expunge the heterogeneous by offering up the category of "man" (and it was a gendered "man") as the being at the center of all beings. In attempting to do so, however, it merely managed to rearrange the medieval hierarchy of being that was the text of creation, by placing "man" at its pinnacle as the knowing, naming, and seeing subject, rather than destroying it. In aspiring to possess the knowledge of Edenic wisdom, the Renaissance scholar was, in effect, aspiring to replace Adam/Christ as the new ascendant being. In the process, the structures of that sacred hierarchy of being lived on as a repressed blueprint for the relationship between knowledge production and subject formation; one which is seldom, if ever, acknowledged, but also one which can never be fully expunged from the supposedly transparent surfaces of modernity. In this regard, the curiosities we have traced in this book speak of nothing so much as the persistence of a metanarrative of ascendency: where something is propelled into nothing, so that it may become everything.

In exposing the ambivalent relationship between Enlightenment rationality and the heterogeneity it so desperately, but ultimately unsuccessfully, sought to expunge, this book has suggested that if we probe traditional histories of science genealogically then we find evidence of the repeated incursions of this heterogeneity; incursions that scientific historiography has, itself, also sought to disarm. In most of these instances, such incursions are the result of a disjuncture between the transparency of scientific rationality and the shadowy presence of this repressed legacy of a system of knowing and being that gave rise to a divine, miraculous, and sacred "order of things" now deemed irrational and superstitious. Thus we saw, with Descartes as his witness, the eminent anatomist Dr. Nicolaas Tulp putting his hand to the broken body of a petty thief, searching, as it were, for the location of that one thing now lost—somewhere between the discursive point of the scaffold and the martyr's grave—which would animate scientific knowledge claims. Likewise, we saw this dead

matter gathered together in the vast storehouses we call the modern museum and arranged in systematized, visualized, and categorized hierarchies in an act reminiscent of Adam naming the creatures of Eden by reading the "sign" inscribed in their very being. Such modern "collections," however, have all but lost their ability to create and renew the world as they had once done.

A productive manner in which we can characterize this ambivalence underpinning Enlightenment scientific rationality is through the medieval and Renaissance practices of restitution: those recuperative acts aimed at healing the rifts produced through various iconoclastic ventures of a not-so-distant past. In this regard we can see precisely how the contents of the ravished curiosity cabinet found their way into the modern museum as the basis of a newly conceived scientific taxonomy, without recourse to a teleological narrative of collection's evolution from irrational cabinet of oddities to rational cabinet of science. Like the construction of Britain's manor houses and civic halls from the stonework salvaged from Henry VIII's dissolution of the monasteries, the constant efforts by Enlightenment rationality to expunge the heterogeneous from its transparent surfaces was matched by various recuperative moves which betray the persistence of this heterogeneity within the very structures of Enlightenment understanding. It is for this reason that I have characterized such ambivalences, when they have shown themselves, in terms of a discursive act of mourning: mourning the power that vision once had to transfigure and "throw" the subject into communion with the sacred.

·····

If the aim of any specific "archaeology" is to illuminate how further research should proceed, then with regard to the persistence of the heterogeneous within the discursive folds of modernity, what this book has shown is that the elusive notion of a so-called "modern sacred" need not be sought in the innumerable, often indistinguishable stories of modern Christian miracles (the Rainbow Madonna of chapter 1 being but one case among many). Such narratives are invariably proffered in a bid to ascertain whether *organized religion* "still has it," though in many ways to proceed in such a fashion is to miss the point. Likewise, at the other end of the spectrum we could also suggest that searching for a modern sacred need not necessarily proceed through the kinds of analogous substitutions that would declare something like shopping as "the new religion": a "communion of consumption," as it were. Although this is an increasingly popular method by which certain cultural historians are making sense of a supposedly disenchanted modernity, such analogous characterizations achieve little more than stripping away the very thing that separates the heterogeneous from the normalized composition of homogeneous society in the first place, thereby somewhat defeating the point.

This book has suggested that the further study of the heterogeneous should proceed from an understanding of the ambivalent discursive structures of post-Enlightenment, scientific rationality itself; for it is within the very folds of these discourses that a repressed heterogeneity already resides. Thus, as we have seen, it is to the cabinets of scientific collection and the oracle-like visions they engender that we should turn to find a continuing belief in the sanctity of violated flesh and the modern means of demiurgic animation.

In this regard, the work of the Comaroffs is an illuminating instance of how such study might proceed.[16] Their ability to see, in the recent turn to occult means for the procurement of capital in the Southern African post-colony, the fundamentally millenarian underpinnings of *Western* capitalism represents a similar point of departure to my own, insofar as their suggestion is that the "magic" we ascribe to the non-West as "irrational" is, in fact, ingrained in the discursive structures of post-Enlightenment thought. When we witness the everyday interactions of our "others" with the illusive structures of capitalism, the magical allure of "making money from nothing" is taken as pure irrationality. The point for the Comaroffs, however, is that in a system of capital, to turn from the tangibility of production toward the ephemerality of arbitrage, to yield wealth without labor and value without visible effect, is to invoke "new magic for new times." From the preternatural profits of possessing someone else's name (their chimerical "domain name") to the shadowy hand that has always guided economic rationalism, the Comaroffs show us a magic of modern capital that can in no way be transferred to our "others": the magic of capital being a Western magic.

This book, on the other hand, has been more concerned with establishing the groundwork for the study of the heterogeneity of modernity, though such heterogeneity need not manifest itself in a sense of "otherness" or in radical difference; far from it, in fact. Thus, unlike the Comaroffs, we need *not* turn to the margins, the post-colony, to the "strange tales" of modernity, as our starting point: not to UFO sightings in Armenia, mass radio hypnotism in Russia, or even the trade in body parts in Southern America. Rather, this book has directed our attention to the less overtly "vengeful incursions of the heterogeneous" (to paraphrase Bataille) which manifest themselves in the very structures of Western knowledge production and subject formation. We can see it in our commonplace memorializations of lost loved ones, and in our subsequent defacements of such monuments; in our veneration of the image, and the mapping of that image onto the body; in the exalted place assumed by the machine which augurs signs of disease, and our relief that such sight might be claimed "noninvasive"; and in the day-to-day work of street artists whose anamorphic play would have us slip through the cracks in the pavement. But most of all,

we can see it in the interplay, the weave, and the constant realignment of all of these things; the furtive glances, the fleeting visions and far-flung curiosities of modernity.

The work which remains to be done, then, is to discover how, once identified, these hidden and repressed ways of knowing and being may come again to invigorate our understandings of the world, and how we may put on hold the instincts of our of rational ways to drive us on to encase the heterogeneous in stone.

# NOTES

## Introduction

1. Georges Bataille, "The Psychological Structure of Fascism," in *Visions of Excess: Selected Writings, 1927–1939* (Minneapolis: University of Minnesota Press, 1985).

2. Ibid., 141.

3. Martin Heidegger, *Being and Time*, trans. John Macquarrie and Edward Robinson (New York: Harper & Row, 1962). For a discussion of Heidegger's general metaphysic of knowledge, see Rüdiger Safranski, *Martin Heidegger: Between Good and Evil*, trans. Ewald Osers (Cambridge: Harvard University Press, 1998). For Husserl's phenomenology of perception, see Edmund Husserl, "Ideas Pertaining to Pure Phenomenology," in *General Introduction to a Pure Phenomenology* (The Hague: M. Nijhoff, 1982), especially sections 41 and 43.

4. Katherine Verdery, *The Political Lives of Dead Bodies: Reburial and Postsocialist Change* (New York: Columbia University Press, 1999), 5.

5. The three primary texts in question being Michel de Certeau, *Heterologies: Discourse on the Other*, trans. Brian Massumi (Manchester: Manchester University Press, 1996); Michel Foucault, *The Order of Things: An Archaeology of the Human Sciences*, trans. Alan Sheridan-Smith (New York: Vintage Books, 1994); and Michel Foucault, *The Archaeology of Knowledge*, trans. A. M. Sheridan-Smith (London: Routledge, 2002).

6. De Certeau, *Heterologies*, 179.

7. Hillel Schwartz, *The Culture of the Copy: Striking Likenesses, Unreasonable Facsimiles* (New York: Zone Books, 1996), 11.

8. Walter Benjamin, "Paris—Capital of the Nineteenth Century," in *Charles Baudelaire: A Lyric Poet in the Era of High Capitalism* (London: Verso, 1997), 159.

## Chapter 1

1. Walter Benjamin, "Unpacking My Library," in *Illuminations*, ed. Hannah Arendt (Glasgow: Fontana/Collins, 1977), 60.

2. Ibid.

3. Ibid., 61.

4. Ibid.

5. Ibid., 67.

6. Susan Stewart, *On Longing: Narratives of the Miniature, the Gigantic, the Souvenir, the Collection* (Durham: Duke University Press, 1994), 152.

7. Ibid.

8. Bruce Robertson and Mark Meadow, "Microcosms: Objects of Knowledge," *AI and Society* 14 (2000): 223.

9. Ibid.

10. Robertson and Meadow, "Microcosms: Objects of Knowledge," <http://microcosms. ihc.ucsb.edu/intro.html>. Date *first* accessed: 7 January 2006. Almost as if to illustrate the very point and purpose of this book, when returning recently to this website with editorial due diligence firmly in mind, the promise of the Internet to function as an unfettered storehouse of knowledge was proved illusory: "Forbidden. You don't have permission to access." But in a book attempting (among other things) to restore the epistemological validity of the fragment to our notions of what should constitute "proper" modes of knowledge creation, many of the items and historical artifacts we will encounter no longer exist. But just as the destruction of the thirteenth-century Ebstorf *mappamundi*, or the nineteenth-century Galerie des Machines, does not militate against them being objects of contemplation, so too with this most contemporary of losses, erasure should not deter us. In fact, this absence, if anything, is revealing precisely of how far the "monumentalization" of our present academic ventures can go. It is for this reason that I let these references stand, and seek to pursue their remaining traces.

11. Ibid.

12. Ibid.

13. Robertson and Meadow, "Microcosms: Objects of Knowledge," 226.

14. Ibid.

15. Bruce Robertson and Mark Meadow, "The Pangolin-and-Pinecone Effect," <http:// vv.arts.ucla.edu/publications/lectures/98-99/microcosms/essays/001.html>. Date *last* accessed: 9 June 2010.

16. Ibid.

17. Robertson and Meadow, "Microcosms: Objects of Knowledge," 227.

18. Ibid., 228. I am intentionally not fleshing out the background, nature, or composition of Quiccheberg's *Inscriptiones*, as they, along with Camillo's *theatrum mundi*, will be dealt with in further detail shortly. At this moment I merely wish to let the "Microcosms" narrative play its course.

19. Ibid.

20. The veritable "industry" of critical literature concerning the nineteenth-century museum project is as variable in quality as it is vast in scope; too vast to survey here. Of the less essentialist or positivist approaches to this discipline, the influence of new historicism (with its proclivity for "micro-histories" of colorful, yet often obscure, individual collectors) has been felt far more than the influence of critical or discourse theory. Often proceeding from the margins of museology rather from within its folds, the literature that I have employed throughout this chapter represents what I consider to be productive alternatives to the otherwise straight narratives of museology. Although Tony Bennett's *The Birth of the Museum: History, Theory, Politics* (London: Routledge, 1995) remains an invaluable critical history from within the folds of museum studies for its

encyclopedic playfulness Hillel Schwartz's *The Culture of the Copy: Striking Likenesses, Unreasonable Facsimiles* (New York: Zone Books, 1996) is suggestive of alternative approaches to issues central to, but strangely omitted from, museology. Of particular note is the way Schwartz's bibliographic and archival flair seems to activate otherwise seemingly improbable associations, bringing to life disparate material in a manner not dissimilar to early modern natural histories with their penchant for allegory and similitude.

21. This scholarly disdain for baroque art was, for the most part, an attribute of English-speaking academic scholarship right throughout the nineteenth century and continuing into the early twentieth. Heinrich Wölfflin's *Renaissance and Baroque* (1888) is considered to be the first theorization of the baroque, which until that time had been seen as a corrupt, diseased, and impudent form of art. However, it was not until the 1940s that authors such as Rudolf Wittkower were to retrieve baroque art fully from its languishing state in the canon of art history (Robert Harbison, *Reflections on Baroque* [London: Reaktion Books, 2000], 217–220). In both Germany and Italy, in particular, such prejudices were nowhere near as prevalent, and to this day the great bulk of scholarly work on the curiosity cabinets comes from these two regions, though generally it remains untranslated into English. It is for this reason that the essays in Oliver Impey and Arthur MacGregor's *The Origins of Museum: The Cabinets of Curiosities in Sixteenth- and Seventeenth-Century Europe* (Oxford: Clarendon Press, 1985) enjoy such continuing popularity, in spite of the positivistic tenor of most of the entries.

22. Although not the place for such an excursion, one would not have to confine this observation to the realm of museum studies alone. Popular fiction has appropriated this very same marker of "curiosity cabinet as embodied and collected uncanniness" with great vigor: from historical fiction to New York murder mystery, the curiosity cabinet seems to have captured a certain popular (and decidedly "dark") imagination. Two recent examples would be Douglas Preston and Lincoln Child, *The Cabinet of Curiosities* (New York: Warner Books, 2002), and Catherine Czerkawska, *The Curiosity Cabinet* (Edinburgh: Polygon, 2005). We can see the general tenor of this popular appropriation most clearly in the first of these two titles, which equates the curiosity cabinet with a serial killer's "collection" of victims' bodies.

23. The number of museums projecting the structural composition of the curiosity cabinets onto the Internet is too large to list here. Two significant projects of this type are the Metropolitan Museum's "Collecting for the Kunstkammer," <http://www.metmuseum.org/toah/hd/kuns/hd_kuns.htm> and the Walker Art Center's "Wonderwalker a Global Online Wunderkammer," <http://209.32.200.23/gallery9/wunderkammer/>.

24. The Getty Museum, "Devices of Wonder," <http://www.getty.edu/art/exhibitions/devices/html/>. I say *young* virtual visitor, as the "new museum" seems to have all but given up on its pedagogic aims and claims of a century ago, appealing instead to the fancies and fantasies of a youthful audience through the prioritization of the strange, distant, and bizarre qualities of its material objects, increasingly framed, as they are, by the near-Tantric catchphrase of "interaction."

25. Jeanne Bornstein, Meg Maher, and Holland Goss, *The Public's Treasures: A Cabinet of Curiosities Brochure* (New York: New York Public Library, 2002), 4.

26. Any number of instances of the overt statement of this narrative could be cited here; one will probably suffice: "The modern museum effectively dates from the Renaissance. ... Even at that time, however, one can already see the dual role of museums: to exhibit objects and to provide a working collection for scholars." Paul Whitehead, *The British Museum (Natural History)* (London: Scala, 1981), 7.

27. The Getty Museum, "Devices of Wonder."

28. Bornstein, Maher, and Goss, *The Public's Treasures*, 4.

29. Robertson and Meadow, "Microcosms: Objects of Knowledge," 226.

30. Robertson and Meadow, "Microcosms: Objects of Knowledge."

31. Krzysztof Pomian, *Collectors and Curiosities: Paris and Venice, 1500–1800*, trans. Elizabeth Wiles-Portier (Cambridge: Polity Press, 1990).

32. David Murray, *Museums: Their History and Their Use*, vol. 1 (Glasgow: James MacLehose and Sons, Publishers to the University, 1904), 41.

33. Ibid., 40.

34. Ibid., 12.

35. Of course there is a simple logic behind this: particularly in the Protestant North, most church reliquaries were seized and broken down; their constituent parts ended up in princely and royal collections, and later still in museums, and the relics themselves were invariably thrown away as mere dross. In reference to Thomas Cromwell's "visitations" of English religious houses at the behest of Henry VIII to eradicate all traces of "the abomination of idolatry," Richard Altick suggests: "it was these settings [reliquaries], rather than the relics themselves, which led to their being sent up to the Tower of London, the national collection point." The logic in operation here is the logic of the treasure hoard. See Richard Altick, *The Shows of London* (Cambridge, Mass.: Harvard University Press, 1978), 6. A curious inversion of this can be seen in the prolonged disregard Anglo-American art history had for the study of reliquaries as objects of art. That the gem-encrusted silver plate work of the cranial reliquary of Saint Yrieix in the Metropolitan Museum of Art, New York, was removed from its wooden core, so that the latter could be put on display as a fine example of Gothic sculpture, speaks not only of the disdain for "minor arts" of metalsmithing, but also of the ambivalent relationship modern museums have with the "preciousness" of much of their material collections. The silverwork in this instance was seen as too gauche or too associated with mere "treasure" to be the object of serious art-historical contemplation. See Barbara Drake Boehm, "Body-Part Reliquaries: The State of Research," *GESTA* 36, no. 1 (1997): 11.

36. Altick, *The Shows of London*, 5.

37. The following account of the Christian cult of the saints is, for the most part, taken from Peter Brown's seminal text *The Cult of the Saints: Its Rise and Function in Latin Christianity* (Chicago: University of Chicago Press, 1982). I am aware that the literature of late antiquity is vast, yet I am not concerned with exploring the cult of the saints for its own sake, nor am I particularly interested in testing the veracity of Brown's thesis against those of other authors. Essentially, I merely wish to provide an indication of the extent to which the cult of the saints underpinned the medieval collection

of specific liturgical and sacramental objects, and how these objects then functioned within a regime of wonderment that lifted people up into communion with the sacred.

38. Brown's characterization of the bodies of saints or martyrs as "very special dead" stems from their ability to rise above the facts of death: "They died in a special way; they lay in the grave in a special way; this fact was shown by the manner in which all that was delightful and most alive in late antique life could be thought of as concentrated in their tombs and even in the detached fragments of their dead bodies." Ibid., 70.

39. Quoted in Ernst Kitzinger, "The Cult of Images in the Age before Iconoclasm," *Dumbarton Oaks Papers* 8 (1954): 116. What is most significant here, in Gregory of Nyssa's words, is the tactile nature of visually beholding a relic, which speaks of nothing so much as the mimetic qualities of the overriding medieval metaphysic of representation; a metaphysic I am in the midst of describing as a regime of wonderment.

40. With regard to the *praesentia* of contact relics, the following story of the shrine to St. Peter in Rome, as related by the sixth-century Bishop Gregory of Tours, is suitably illuminating of their production:

> Whoever wishes to pray there must unlock the gates which encircle the spot, pass to where he is above the grave and, opening a little window, push his head through and there make the supplication that he needs.

Alternatively, pilgrims could lower small pieces of cloth, *brandea*, down into the tomb: "drawing them up heavy with the blessing of Saint Peter" (Brown, *The Cult of the Saints*, 87).

41. Daston and Park, for instance, note the way that the abbots of Saint-Denis would periodically sell off parts of the abbey's collection in order to "weather famines, ransom vassals, buy off foreign occupiers, or defray their own expenses." Lorraine Daston and Katherine Park, *Wonders and the Order of Nature, 1150–1750* (New York: Zone Books, 1990), 74. The point here, though, is that a unicorn horn might fetch enough money to ransom a vassal, precisely because it circulated within a *magical* economy first and foremost.

42. For a fascinating discussion of how the various alterations and extensions during the twelfth century to the cathedral at Canterbury were predicated upon the direct need to accommodate the various sacred objects of the cult of Becket, see Millard F. Hearn, "Canterbury Cathedral and the Cult of Becket," *Art Bulletin* 74, no. 1 (1994).

43. Stephen Bann, "Shrines, Curiosities and the Rhetoric of Display," in Lynne Cooke and Peter Wollen, eds., *Visual Display: Culture beyond Appearances* (Seattle: Bay Press, 1995), 21. Bann's description of the "demonstration" derives from the contemporary (albeit somewhat skeptical) account offered by Erasmus in his *Colloquies*, published in 1526. In a further curious conflation of church and theater, it should be noted that we will encounter the practice of demonstration with the aid of a *radius* again. In chapter 2, the *radius* will be the instrument by which textual authority will be demonstrated upon the splayed and opened bodies dissected within the early anatomy theaters of Europe.

44. I am aware that a relic is not a reliquary, is not a marvel, is not a window, is not a church. Yet the impulse to diligence, to separate them out neatly and expound upon

their differences, is one I am attempting to resist at every turn. It is how these objects circulated collectively within an economy geared toward largely singular ends—the generation of wonder—that interests me here. And isn't it the point that in many ways the relic *is* the reliquary, *is* the marvel, *is* the window, *is* the church? It is in the movement of sympathies and resonances that often we catch glimpses of the heterogeneous.

45. Erwin Panofsky, *Abbot Suger on the Abbey Church of St.-Denis and Its Art Treasures* (Princeton: Princeton University Press, 1979), 73–81. For a catalog of extant treasures, see Bibliothèque Nationale, *Le Trésor de Saint-Denis: Musée du Louvre, Paris, 12 mars–17 juin 1991* (Paris: Bibliothèque Nationale, Réunion des Musées Nationaux, 1991). For the mythic origins of many of the Saint-Denis marvels, see Murray, *Museums*, 3.

46. I will return in chapter 3 to the theory of ideal proportion as it pertained to a shift from the "technology" of perspective as a tool for the production of certain "pious" subjectivities to a "technology" for their normalization in the guise of scientific cartography. For now it is more important to stress the relationship between light and color, which saw beauty manifest in the *splendor* of brilliant and unadulterated colors. However, unlike the theory of ideal proportion, which existed as a more or less discrete theoretical position independent of its practices and experiences, medieval writings on light and color had much less consistency to them. This is not so much the product of poor modern scholarship unable to adequately re-present a medieval "theory" of light and color, but rather an indication of the experiential, not theoretical, nature of medieval light and color in the first place: color was a "lived," everyday experience, being both sensual and tactile (quite literally, as we will see). My own protracted frustration with the at times seemingly contradictory material on medieval light and color has, in the end, proved remarkably instructive insofar as the understanding that was eluding me was the realization that medieval experiences of light and color were just that: experiences and not theories. Further to this, my frustrations represented precisely that encounter with a different *Order of Things*, the study of which formed the generative logic of this very book. Upon realizing this, the tack I subsequently took with this material was not to attempt to reconcile conflicting accounts, but rather to select the words of a particular medieval person as my guide: Abbot Suger was my choice. Where I do make general theoretical claims regarding the state of "perception" in the Middle Ages (as in the note immediately following this one), I have allowed myself to be guided by the "collection" of ideas assembled by Umberto Eco in *Art and Beauty in the Middle Ages*, trans. Hugh Bredin (New Haven: Yale University Press, 1986).

47. In general, it could be said that color was deemed visually pleasing when the inner light of things and beings coincided: luminosity being the equivalent to the light of the soul, which projected out from the body through the gaze. Medieval notions of visions suggested that light (or, more accurately, *lumen*) literally emanated from the eyes: perception resulted when this light struck objects and resonated with their color or their own luminosity. This explains the prevalence within both medieval art and everyday culture for brilliant displays of primary colors: it was the colorful object that shone most forcefully, and hence was most pleasing. Likewise, the translucent object was prized for its ability to magnify, and make *splendid*, the light of color as well as the invisible light of God's sacredness, hence the prevalence and popularity of gems, rainbows, and stained-glass windows. St. Thomas's third category of beauty (after integrity and symmetry) was clarity: "all things which have a lustrous

(i.e. transparent) color are regarded as beautiful," cited in W. S. Heckscher, "Relics of Pagan Antiquity in Mediaeval Settings," *Journal of the Warburg Institute* 1, no. 3 (1938): 212. For a comprehensive treatment of the subject see Eco, *Art and Beauty in the Middle Ages*, 68–69. There are two aspects of the medieval aesthetics of light and color that I find particularly interesting. First, visual perception was not uncoupled from the other senses; the aesthetics of light and color were never far away from the aesthetics of music and harmony. And second, unlike with modern theories of perception, the implication of the notion of *lux* and *lumen* was that objects in the physical or metaphysical world could not exist independently of vision.

48. Eco, *Art and Beauty in the Middle Ages*, 14.

49. Ibid., 16.

50. Stephen Bann, "Shrines, Gardens, Utopias," *New Literary History* 25, no. 4 (1994): 831.

51. Norman Bryson, *Word and Image: French Painting of the Ancien Régime* (New York: Cambridge University Press, 1981), 3. I am, of course misrepresenting Bryson here. For Bryson, the stained-glass window conspires toward an enunciation of the Word (of Scripture) rather than of light, or even the image. However, I feel this interpretation tells us as much about Bryson's own preferred area (and era) of art history as about the function of so many light-bearing/light-transmitting vessels that formed an integral part of the physical structure of the Gothic cathedrals, as well as their collections. In this regard I tend to agree more with Stephen Bann in his efforts to let the qualities of the window speak of the transmutation of light and the production of "pure visibility." See also Bann, "Shrines, Gardens, Utopias."

52. Virginia C. Raguin, *Stained Glass: From Its Origins to the Present* (New York: Harry Abrams, 2003), 14.

53. Murray, *Museums*, 11.

54. Cited in Panofsky, *Abbot Suger*, 55.

55. Bann, "Shrines, Gardens, Utopias," 20.

56. I am referring here, of course, to Foucault's notion of Sovereign power; the type of power that is manifest through spectacular displays of bodily destruction, glorification, and stagecraft. The nature of this form of power and that of modern disciplinary power will be followed up in greater detail in chapters 2 and 3.

57. Manuel A. Vásquez and Marie F. Marquardt, "Globalizing the Rainbow Madonna: Old Time Religion in the Modern Age," *Theory, Culture and Society* 17, no. 4 (2000): 120.

58. *Miami Herald*, 27 June 1997, cited at The Witches' Voice Inc., "Arianhrod? Dianna? Mary? What Do You See?," <http://www.witchvox.com/media/mary_shrine.html>59. Jane Baker, *Share International*, June 1997, cited in ibid.

60. James Randi, "Busted Miracle," Swift online newsletter of the JREF, <http://www.randi.org/jr/031204busted.html>. Along with his newsletter *Swift*, James Randi has a permanent standing offer of one million dollars for anyone who can "demonstrate any psychic, supernatural or paranormal ability of any kind under mutually agreed upon scientific conditions." And in a curious inversion of standard persecution narratives, the Foundation offers assistance in the form of a legal defense fund to people being at-

tacked "as a result of their investigations and criticism of people who make paranormal claims."

61. Ibid.

62. Ibid.

63. Bauman's words act as a welcome tonic to the kind of academic treatment that the Rainbow Madonna has occasioned. Vásquez and Marquardt rehearse the explanation of "the global creation of the local," suggesting that in an age of post-modern capital and "globalized" definitions of time and space, the Virgin of Clearwater represents the way that "local religious practices" (whatever they might be) are manifest through global circuits of communication. What is noteworthy about this approach is just how much it seems to miss the point, any point! With its utility-laden, social science language clearly originating from within, and taking sustenance from, the domain of those transparent rationalities of post-Enlightenment thought, Bauman is absolutely correct when he suggests that this logic is like "a pass-key meant to unlock the gates to all present and future mysteries." Zygmunt Bauman, *Globalization: The Human Consequences* (New York: Columbia University Press, 1998), 1.

64. I will explore the properties of transgression's "animating" qualities more fully in chapter 2, with a discussion of medical anatomy's efforts to animate corpses through their defacement.

65. I am aware of the essentializing pitfalls of any recourse to historical "ages" or "spirits"; however, such recourse is largely unavoidable in a genealogical approach to the history of collection, though there are a few things that need stressing. First, Michel Foucault's *The Order of Things: An Archaeology of the Human Sciences*, trans. Alan Sheridan-Smith (New York: Vintage Books, 1994) is my primary point of departure in this regard: any reference to a classical or Renaissance *episteme* is a direct engagement with his work. Second, my own reference to a spirit or age of curiosity is a reference not merely to an historical "era," but rather to a series of discursive formations that linked together certain ways of representing, visualizing, and producing knowledge through collection. For this reason the term "regime" will usually be employed to help resolve any ambiguity. Third, the relationship between this regime of curiosity and Foucault's so-called *epistemes* is not a direct one. Although the regime of curiosity takes sustenance from the Renaissance *episteme*'s "metaphysic of representation" (which will be elaborated upon shortly), the regime of curiosity was not quite the totalizing discourse that an *episteme* claims to be, nor was it merely confined to the sixteenth century. Rather, as many of my examples will suggest, the spirit of curiosity extended well into the Enlightenment, or what Foucault describes as the "classical" age of the seventeenth and eighteenth centuries. Finally, and perhaps most importantly, it needs to be stressed that when dealing with the broad historical brushstrokes of Foucault's *epistemes*, exact times, places, and dates will never neatly match up. What is of importance in Foucault's analysis (and, by extension, my own) is the epistemological shifts that occur and the order in which they occur: that curiosity was a latecomer to the Russian court, for instance, speaks more of Russia's political isolation before the time of Peter the Great than it does of the failure of Foucault's idea of the Renaissance *episteme*. In this instance, what is important to note is that regardless of the dates, the Renaissance episteme was followed by a classical one.

66. Quoted in Oleg Neverov, "'His Majesty's Cabinet' and Peter I's Kunstkammer," in Impey and MacGregor, eds., *The Origins of Museums*, 55.

67. Although there were slight differences between the Northern European princely *Kunstkammern* and the British, French, and Italian cabinet of curiosities (as will become apparent throughout my discussion of them), at the level of discourse, these terms, essentially, are interchangeable. A central tenet of this chapter is the suggestion that the history of museums needs to move beyond the art-historical commonplace of "provenance." Tracing the "lives" of individual objects as they pass from one form of collection to the next has the tendency to conflate various historical manifestations of collection. If we focus instead on the discourses of collection, we come to see how the same object can take on very different meanings depending on the form of collection it inhabits; meaning is not something intrinsic to objects, but rather is produced from the discourses that nourish and nurture them.

68. Quoted in Neverov, "'His Majesty's Cabinet' and Peter I's Kunstkammer," 55.

69. Joy Kenseth, "A World in One Closet Shut," in Kenseth, ed., *The Age of the Marvelous* (Hanover: Hood Museum of Art, Dartmouth College, 1991), 90. See also Anthony Anemone, "The Monsters of Peter the Great: The Culture of the St. Petersburg Kunstkamera in the Eighteenth Century," *Slavic and East European Journal* 44, no. 4 (2000): 593.

70. For an elaboration of the Enlightenment encyclopedic project, particularly with regard to the ensuing problem of the need for a universal language to complement and transmit a universal knowledge, see Umberto Eco, *The Search for the Perfect Language*, trans. James Fentress (London: Fontana Press, 1997).

71. Paula Findlen, "The Museum: Its Classical Etymology and Renaissance Genealogy," *Journal of the History of Collections* 1, no. 1 (1989): 68. I will return to the discursive roots of curiosity's claim to universal knowledge and what this meant for the construction of a "knowing" subjectivity in the section entitled "The Renewal of Worlds." For now I merely wish to flag these ideas so that we can move on to an understanding of curiosity as an epistemologically discrete category which would come to be actively challenged by the flat tables of difference of the Enlightenment *episteme*.

72. Both dictionary entries are reproduced in Pomian, *Collectors and Curiosities*, 54–58. With reference to my earlier note regarding the elusiveness of categories such as the Renaissance *episteme*, these two dictionary entries are a case in point. According to dates alone, both are firmly entrenched within Foucault's classical *episteme*, yet clearly only one of them displays the characteristics Foucault suggests were endemic of that age. That these two illustrations point to the end of the seventeenth century rather than the beginning of that century as being the time of this shift in "the order of things" is of little importance compared to the occurrence of this shift itself. Speculation as to whether Furetière's dictionary represents a new form of ordering knowledge, but with old content, becomes somewhat of a moot point to a genealogical exercise. What matters is the presence and veracity of the disjuncture between a regime that nurtured curiosity, on the one hand, and a regime that heralded its demise, on the other.

73. For an elaboration of the epistemological underpinnings of the knowledge claims of the classical age, see Foucault, *The Order of Things*, 50–76.

74. Eilean Hooper-Greenhill, *Museums and the Shaping of Knowledge* (New York: Routledge, 1992), 84.

75. Outside of this museological project, the "spirit" of curiosity has, at various times, been said to inhabit the general demeanor of scientific inquiry, the constitution of the nineteenth-century anthropologist/explorer, or more recently the indomitable will of the modern liberal individual. However, these represent little more than a nominal call to a half-articulated notion of inquisitiveness (the final instance of the liberal individual seems dubious even on this front). What separates present museological forays into the realm of the curious from these other calls to the spirit of curiosity is its concerted effort to appropriate an historical sense of curiosity as a discourse of representation / knowledge production. At the heart of the "Microcosms" project, for instance, was an effort (however flawed) to occupy the discursive structures of the Renaissance *episteme* or, to use their words, to explore "the habits of mind that would have been employed by a visitor to such a cabinet." Robertson and Meadow, "Microcosms: Objects of Knowledge," 228.

76. Far from being an obscure instance of the type of historiographical recuperation I am referring to, Olmi's work is the lead article in the much-celebrated volume *The Origins of the Museum*, edited by Oliver Impey and Arthur MacGregor who, incidentally, are the chief editors of the *Journal of the History of Collections*. Both publications are considered standards for museum studies scholarship.

77. Giuseppe Olmi, "Science-Honour-Metaphor: Italian Cabinets of the Sixteenth and Seventeenth Centuries," in Impey and MacGregor, *The Origins of Museums*, 8–9. The terms *naturalia* and *artificialia* represented the twin binding categories of all curiosity cabinets. That these categories were inextricably entwined is suggested by the priority accorded to ancient sculpture: part fossil, part work of art, sculpture signified nothing so much as the sympathetic resemblances between natural objects formed by the hand of God, and the same objects wrought by humans. In this way, collection was the ultimate expression of a humanist understanding of creation. For this Renaissance hierarchy of materials, see Horst Bredekamp, *The Lure of Antiquity and the Cult of the Machine: The Kunstkammer and the Evolution of Nature, Art and Technology*, trans. Allison Brown (Princeton: Markus Weiner Publishers, 1995), 11–19. The point I wish to make here is that given the *raison d'être* of Renaissance collection, a predominance of natural curiosities in a cabinet does not make a natural history museum. It merely indicates a different set of signs from which the collector is attempting, essentially, the same task as any other cabinet owner: the assemblage of the Book of the World.

78. Olmi, "Science-Honour-Metaphor," 8.

79. Walter Ong, *Orality and Literacy: The Technologizing of the Word* (London: Methuen, 1982), 9.

80. F. H. Taylor, quoted in Hooper-Greenhill, *Museums and the Shaping of Knowledge*, 79.

81. Niels von Holst, *Creators, Collectors and Connoisseurs: The Anatomy of Artistic Taste from Antiquity to the Present Day* (London: Thames and Hudson, 1967), 104.

82. Ibid.

83. Thomas Kaufmann, "Remarks on the Collections of Rudolf II: The Kunstkammer as a Form of Representation," *Art Journal* 38, no. 1 (1978): 22.

84. Pomian, *Collectors and Curiosities*, 59.

85. Isidore of Seville, quoted in ibid.

86. Quoted in ibid., 76.

87. Quoted in Foucault, *The Order of Things*, 32.

88. Findlen, "The Museum," 61.

89. An indication of how widespread the specific influences of these particular fragments of ancient sculpture were can be seen in the frequency and diversity of their direct quotation: from the Promethean figures of Michelangelo's Sistine ceiling to the visceral anatomies of Andreas Vesalius's anatomical atlas, the *De fabrica*, the Belvedere fragments had an unprecedented influence on the development of Renaissance art.

90. Kenseth, "A World in One Closet Shut," 84.

91. The disciplines I have listed here are all ones which, to varying degrees, will be encountered throughout the course of this book: the revival of anatomical investigation of the inner recesses of the human body, and its association with new modes of visualizing that body, form the basis of chapter 2; the colonization of a narrativized and lived "space" by a technology of cartographic "place" is the focus of chapter 3.

92. Findlen, "The Museum," 62.

93. Anthony Alan Shelton, "Cabinets of Transgression: Renaissance Collections and the Incorporation of the New World," in John Elsner and Roger Cardinal, eds., *The Cultures of Collecting* (Cambridge, Mass.: Harvard University Press, 1994), 179.

94. S. K. Heninger Jr., *The Cosmographical Glass: Renaissance Diagrams of the Universe* (San Marino: Huntington Library Press, 2004), 144. I am aware of the potentially alarming speed with which I am moving through complex notions like Renaissance cosmology. My intention, however, is not to explicate each of these sizeable categories, but rather to get a sense of how the regime of curiosity was composed of a plethora of different discursive associations which culminated in the necessity of collection as an expression of divine celebration and temporal enlightenment (the two never being far apart).

95. Hooper-Greenhill, *Museums and the Shaping of Knowledge*, 68.

96. Johann Daniel Major, quoted in Bredekamp, *The Lure of Antiquity*, 40.

97. Johann Daniel Major, quoted in ibid.

98. Kenseth, "A World in One Closet Shut," 86.

99. Foucault, *The Order of Things*, 36.

100. Ibid., 17.

101. Foucault elaborates upon four related notions of similitude: *convenientia, aemulatio, analogy*, and *sympathy*. *Convenientia* represented the relationship between two things that come close enough to one another to be in juxtaposition such that they resemble each other: body and soul being the quintessential "convenience." *Aemulatio* functioned as a form of *convenientia* freed from the proximity of place, so that things or beings may resemble each other as if reflected in a mirror from afar: the human face is a reflection of the sky; the eyes are a mirror of the stars. *Analogy* was a complex interrelatedness between *convenientia* and *aemulatio*: like the latter, it made

possible the marvelous confrontation of resemblances across space, but like the former it spoke of adjacencies, of bonds and joins. Thus, the relationship of proximity between the stars and the sky could be reflected in the relationship of proximity between a plant and the earth, or between the skin mole and the face of which they are a secret mark. *Sympathy* represented the free play of resemblances, the generative power that drives the root of the plant toward the stream of underground water; the mobility of attraction that allows the sunflower to turn its radiant surface to face and follow the curving path of the sun's rays of light; it is what makes fire strive from the earth toward the air of the heavens, thereby losing its dryness and combining with humidity to become that air itself. The power of sympathy was matched by its opposite in *antipathy*, maintaining an isolation between things, preventing their assimilation and being responsible for why some things may grow, yet others may change and die. Ibid., 18–25.

102. Paracelsus, quoted in ibid., 26.

103. Ibid.

104. Ibid., 29.

105. Foucault, *The Order of Things*, 32.

106. Ibid., 36. For an elaboration of the narrative of the transparency of Adam's act of naming and the subsequent state of *confusio linguarum* following the fall, see also Eco, *The Search for the Perfect Language*, 7–24.

107. Foucault, *The Order of Things*, 33.

108. William B. Ashworth Jr., "Emblematic Natural History of the Renaissance," in Nick Jardine, Jim Secord, and Emma Spray, eds., *The Cultures of Natural History* (Cambridge: Cambridge University Press, 1997), 34.

109. Foucault, *The Order of Things*, 39.

110. Ashworth, "Emblematic Natural History of the Renaissance," 19.

111. Foucault, "The Order of Things," 40.

112. Stewart, *On Longing*, 152.

113. Lorraine Daston and Katherine Park, "Unnatural Conceptions: The Study of Monsters in Sixteenth- and Seventeenth-Century France and England," *Past and Present* 92 (1981): 25.

114. Georges Bataille, "The Deviations of Nature," in *Visions of Excess: Selected Writings, 1927–1939* (Minneapolis: University of Minnesota Press, 1985), 55.

115. Shelton, "Cabinets of Transgression," 185.

116. Bredekamp, *The Lure of Antiquity*, 67. I am aware that, as a *living* curiosity, Foma represents somewhat of an ambivalent example. As I suggested above, although inhabiting a cabinet that for the most part (in spite of its late formation of 1697–1699) functioned within the epistemological discourses of the age of curiosity, Foma's presence in Peter's *Kunstkammer* marks the beginning of a shift to an Enlightenment age of fixed signs. Foma's service to Peter's *Kunstkammer* in both life and death seems to resonate particularly well with the binary of malaise and seduction of Bataille's modern pathological deformity. The point I wish to make concerns the general epistemological weight of the monstrous and anomalous object, not the specifics of Foma's case. If time

permitted, the specifics of Foma's imprisonment in Peter's *Kunstkammer* would be elaborated upon in terms of the inference I am making here that it was the age of fixed signs and medical pathology that gave birth to the "freak" as the shadowy underbelly of the scientific attraction and repulsion to the deformed product of nature, something that exists with us today in the fascinating horror that deformity carries with it. It is with the advent of the eighteenth century that the monstrous loses its reverential quality, becoming instead "a low, bumptious form of pleasure." Patrick Mauriès, *Cabinets of Curiosity* (London: Thames and Hudson, 2002), 86.

Peter's *Kunstkammer* is of further interest as it alerts us to the culturally specific nature of many of the practices underpinning the collector's "spirit" in an age of curiosity. Unlike in Western Europe, where the incorruptibility of flesh was taken as the surest sign of saintliness, in Orthodox and Slavic folklore the refusal of a corpse to rot was most often associated with heresy, witchcraft, and vampirism. With his proclivity for keeping anatomical specimens (both living monsters and preserved bodies/parts), Peter's collecting habits marked the St. Petersburg *Kunstkammer* not as a showcase of the new secular arts and sciences, but as a place the local inhabitants might fear and shun as the devil's work. See Anemone, "The Monsters of Peter the Great," 588–589.

117. Hooper-Greenhill, *Museums and the Shaping of Knowledge*, 79.

118. Ibid., 60.

119. Benvenuto Cellini, quoted in Bredekamp, *The Lure of Antiquity*, 1.

120. Benvenuto Cellini, quoted in ibid., 2.

121. Benvenuto Cellini, quoted in ibid.

122. Kaufmann, "Remarks on the Collections of Rudolf II," 23. For an account of the position of the alchemical and occult arts in Rudolf's court, see chapter 6 in R. J. W. Evans, *Rudolf II and His World: A Study in Intellectual History 1576–1612* (New York: Oxford University Press, 1984).

123. Foucault, *The Order of Things*, 32.

124. My use of the term "magic" and the form that I am suggesting it took in the curiosity cabinets is borrowed directly from modern opponents of the cabinets, like Neils von Holst. What is interesting in this regard is that some magical associations seem worthy of modern critical attention, while others do not. For instance, the magic of scale—*synecdoche*, allowing a part to stand in for the whole—does not seem to disturb the modern critic half as much as the idea of *prescience* or foresight, which was nothing more than an interpretation of how this magic of scale "worked." This is due, no doubt, to the fact that the microcosmic collection of the macrocosm remained alive and well in the modern museum project. Of course other "forms" of magic could be discussed here, for instance the magic of mimesis; the magic that allowed the image of an icon to "stand in" for the saint or martyr depicted upon it—something endemic to the age of wonderment. However, for the purposes of viewing the magical associations underpinning the regime of curiosity, I will restrict my discussion to the *prescience* that accompanied the synecdochical relationship of microcosm and macrocosm (mimesis being related to the later more than the former; the latter being deemed less dangerous a magic). It would be interesting to chart why one form of magic (prescience) has attracted modern condemnation, while the other (which I am calling synecdoche) has not. Perhaps it is in the "predictive" nature of scientific transparency that we would find our answer.

125. We can see this same distinction at work in modern art-historical understandings of the power of iconic mimesis. Mimesis is invariably relegated to the status of "other" even when it is (improperly) displaced to a "primitive" past. Thus not only is the mimetic faculty almost never accorded a place in modern systems of representation; it is often excluded as "tolerated other" from accounts of the past as well. A sign of imminent change in this regard is the recent work of W. J. T. Mitchell in *What Do Pictures Want? The Lives and Loves of Images* (Chicago: University of Chicago Press, 2005). Mitchell's anthropomorphizing of the image in asking "what is it that *they* want?" has the type of playfulness that would see mimesis come alive as one of a number of modern magics of the image, not *tolerated* by modern ways of seeing, but as *the* modern way of seeing.

126. Von Holst, *Creators, Collectors and Connoisseurs*, 104.

127. I appreciate that in characterizing the magic of the curiosity cabinets in terms of a Foucauldian understanding of the hermeneutics and semiology of the sign I am running the risk of replicating exactly what modern critics of the curiosity cabinet (not to mention those museological exercises like "Microcosms" which began our discussion of collection) have consistently done: deny that certain *je ne sais quoi* that makes magic or the sacred what it is: heterogeneous. I have two things to say to this. First I must say, as someone employing Foucault: in some ways, isn't this precisely the point? If one cannot be exterior to power and discourse, then to hope to occupy a different "Order of Things" brings with it the scent of that modern utopia of "authenticity"; of the "authentic native," the "authentic subject position," et cetera. Call them what you will—signs, marks, or signatures (all three were used by contemporaries of the curiosity cabinets)—the difficulty is in imagining, let alone occupying, an "Order of Things" where the sign is not in a one-to-one relationship to what it signifies. Perhaps magic *is* simple. Perhaps it is about hermeneutics and semiology: haven't these very terms become somewhat talismanic themselves in a modern era? The second point I wish to make is, in many ways, the ultimate thesis of this present work: that, try as it might, the flat language of transparent rationality cannot fully expunge the heterogeneous from within its folds; the heterogeneous having a way of constantly erupting through the homogenized surfaces of modern rationality. Of course this is something that will be elaborated upon later; for now it is enough to suggest, as I did in the Introduction, that my use of narrative fragments represents one of the ways in which I am attempting to write about the heterogeneous while still allowing it the room to work its charms. And with regard to the act of collection, those charms are most evident in the renewal of worlds affected by collection's "unpacking."

128. Quiccheberg's "classification system" consisted of five classes or groups, each with ten or eleven *inscriptions* in them. The "Borgesque" incongruity between these *inscriptions* prevents a general elaboration of them, as coins are placed with foreign textiles, and animal skeletons are placed with dyes and paints. Likewise I see no particular need to list his *Inscriptiones* in full, as the incessant search for modern order in Renaissance forms of collection is precisely the task I have been critical of in contemporary museology. Further to this, it is not in Quiccheberg's descriptions that I find worth, which is in itself a form of museological criticism.

129. Elizabeth Hajos, "References to Giulio Camillo in Samuel Quiccheberg's 'Inscriptiones vel Tituli Theatri Amplissimi,'" *Bibliothèque d'humanisme et Renaissance* 25

(1963): 208. See also Lorenz Seelig, "The Munich Kunstkammer, 1565–1807," in Impey and MacGregor, *The Origin of Museums*, 87.

130. For more details of the "art of memory," see Hooper-Greenhill, *Museums and the Shaping of Knowledge*, 91–96; and Frances Amelia Yates, *The Art of Memory* (London: Routledge and Kegan Paul, 1966), 130–159.

131. Vigilius Zuichemus, quoted in Yates, *The Art of Memory*, 132.

132. Hooper-Greenhill, *Museums and the Shaping of Knowledge*, 100.

133. Mauriès, *Cabinets of Curiosity*, 34.

134. Bredekamp, *The Lure of Antiquity*, 39.

135. Ibid., 49.

136. Hooper-Greenhill, *Museums and the Shaping of Knowledge*, 60.

137. Mauriès, *Cabinets of Curiosity*, 119.

138. Daston and Park, "Unnatural Conceptions," 43.

139. Bredekamp, *The Lure of Antiquity*, 69.

140. Quoted in Hooper-Greenhill, *Museums and the Shaping of Knowledge*, 39.

## Chapter 2

1. Paul Turnbull, "Outlawed Subjects: The Procurement and Scientific Uses of Australian Aboriginal Heads, ca. 1803–1835," *Eighteenth Century Life* 22, no. 1 (1998): 166.

2. Ibid.

3. Jay Maeder, "Raiders of the Lost Conk," *US News and World Report* 8 (1997): 14. From the title of this piece it should come as no surprise that most media coverage of Colbung's visit to the UK was overtly racist in character, constantly trivializing the importance of repatriation to both Yagan's ancestors and his living descendants. In a strange, yet increasingly familiar, convergence of modern reportage and colonial paternalism, the ever-so-easily detected racism of years gone by is constantly being mirrored in, or mimicked by, today's press when it comes to issues of indigeneity. Adam Shoemaker has pointed out how the mix of "journalistic excess with patronizing put-down" that characterized Maeder's article was conspicuously absent from another article in the same paper on the work of International War Crimes inspectors in seeking out mass grave sites in the former Yugoslavia. It would seem that the correct and proper handling of some people's dead holds far more political import than others. Adam Shoemaker, "Authenticity: Globalisation and Indigenous Culture" (unpublished manuscript, 2004).

4. It would seem that Dale never found a buyer for Yagan's head and instead donated it to the Liverpool Royal Institution fairly soon after he received it back from Pettigrew. In 1894 the Institution's collections were dispersed, and the head of Yagan found its way into the collection of the Liverpool City Museum. It is not known whether the head was ever placed on display at either institution.

5. Cited in Jay Maeder, "The Long and Winding Road," *New York Daily News*, 4 September 1997.

6. For introductory, and fairly apologetically conservative, remarks on the issue of the repatriation of indigenous remains, see chapters 7, 8, and 9 of Moira Simpson, *Making Representations: Museums in the Post-Colonial Era* (London: Routledge, 2001). There is something disturbing and potentially trivializing about the surprisingly common use of puns and word plays in section or chapter headings used by many authors when discussing matters of repatriation. It would not be wildly overstating the point to suggest that there is little difference between such academically sanctioned titles and more wince-inducing journalistic excesses like Maeder's "Raiders of the Lost Conk" cited above. "Bones of Contention" or "Spirited Away" may appear harmless enough and in accord with the present academic penchant for witty and clever chapter headings, but surely when it comes to matters of someone else's dead, wit should be left as the exclusive domain of those whose dead it is! What makes "Bones of Contention" appear so suitable is precisely its ability, as a title, to slip seamlessly to something like "I've got a bone to pick with you," which immediately summons to mind a whole array of puns and word plays based on racist fantasies about the primitive Other, like "pointing the bone." The existence of this shared cultural archive of representations of the Other has led many indigenous leaders and authors to the claim that those calls to keep human remains in museums for scientific purposes are nothing short of a continuation of colonial methods for the subjugation and governance of indigenous peoples.

7. Any number of examples would suffice here. For instance, in 1971 an archaeological dig was disrupted in Minneapolis. An Indian skeleton had been discovered at the edge of a white pioneer cemetery, which was being relocated because of the construction of a highway. The remains of the white pioneers were promptly reburied, while the remains of the Indian were taken for further study. See ibid., 180.

8. The following account leading up till Yagan's death in 1833 is taken from Turnbull, "Outlawed Subjects," 160.

9. Ibid., 163.

10. Ibid., 166.

11. Barbara Kirshenblatt-Gimblett, "Objects of Ethnography," in Ivan Karp and Steven Lavine, eds., *Exhibiting Cultures: The Poetics and Politics of Museum Display* (Washington: Smithsonian Institution Press, 1991), 398.

12. Sander Gilman's account and analysis of Saartjie Baartman's life and her subsequent dissection by George Cuvier remains the most compelling of its kind: Sander Gilman, "Black Bodies, White Bodies: Toward an Iconography of Female Sexuality in Late-Nineteenth Century Art, Medicine and Literature," *Critical Inquiry* 12 (1985).

13. C. Fforde, "English Collections of Human Remains: An Introduction," *World Archaeological Bulletin* 6 (1992): 22.

14. Quoted in Charles D. O'Malley, *Andreas Vesalius of Brussels 1514–1564* (Berkeley: University of California Press, 1964), 64.

15. Like most histories that appeal to a "Renaissance" of thought somewhere in their heritage, the history of anatomical knowledge in the Christian West can best be described as "reclamative," insofar as the study of anatomy was lost to Europe for nearly a thousand years before its eventual revival during the fifteenth century. According to this patrilineal narrative of loss and return, the study of anatomy had been in serious

decline since the incorporation of Alexandria into the Roman Empire in AD 30, due to the Roman prohibition against the mutilation of the dead. With the death of Hellenic philosopher and physician Galen in AD 199, all serious study of anatomy in the West ceased. In a moment of bitter ambivalence for those who subscribe to this narrative, all textual knowledge of the Ancients might have been lost to Europe forever upon the fall of Alexandria to the Arabs in 642, were it not for the translation of these texts into Syriac and Arabic. All Greek medical knowledge became the sole preserve of the (condescendingly so-called) "Arabic commentators"who, so this Eurocentric narrative goes, made scant few advances upon Galen's anatomical knowledge due to the Islamic prohibition against dissection. Latin translations of these Arabic "commentaries" began to trickle into Europe during the late Middle Ages through the Muslim-influenced South. It was not until the fall of Constantinople in 1453, with the subsequent influx of Greek scholars and texts into Europe, however, that the first translations of Galen's texts from the original Greek were made available. Anatomy returned to the great medical schools of Paris, Padua, and Bologna in the form of a textually based Galenic lore, and would remain as such until Vesalius reinvigorated its practice in the sixteenth century. For a more detailed account of this narrative, see Jonathon Sawday, *The Body Emblazoned: Dissection and the Human Body in Renaissance Culture* (London: Routledge, 1995), 39–41. It should be obvious that the near-millenarian nature of this narrative is highly teleological in its characterization of knowledge (anatomy is the cumulative understanding of the structure of the human body), as well as highly Eurocentric in the place it accords to Arabic learning. To relegate Arabic medicine to the category of "interim custodians" or "trustees" of an otherwise unbroken European tradition that was to flower once again, after it had been liberated by physical conquest, tells us more about our own desire "to establish authority, precedent and certainty" than anything else. Sawday, *The Body Emblazoned*, 39.

16. O'Malley, *Andreas Vesalius of Brussels*, 1. Perhaps the simplest indication of the veracity of this narrative is the almost universal description of anatomy in two discrete eras: pre- and post-Vesalian.

17. Ibid. There are numerous suggestions as to the origin of this taboo restricting the dissection of the body: from Roman funerary practices, to St. Augustine's admonitions in the seventh century against disturbing the house of the soul (Glen Harcourt, "Andreas Vesalius and the Anatomy of Antique Sculpture," *Representations* 17 [1987]: 37), to Pope Boniface VIII's papal bull of 1300 prohibiting the boiling of the body for easy transportation (Elizabeth Brown, "Death and the Human Body in the Later Middle Ages: The Legislation of Boniface VIII on the Division of the Corpse," *Viator* 12 [1981]: 221–270) and the simple argument that there has always been something anthropologically risky about the cutting open of a cadaver and the delay to its burial that this would bring (Andrea Carlino, *Books of the Body: Anatomical Ritual and Renaissance Learning*, trans. John Tedeschi and Anne Tedeschi [Chicago: University of Chicago Press, 1999], 5–6). The historical specificity of these prohibitions is rarely, if ever, considered. The teleological nature of most histories of science would rather see Ancient Roman practices of handling the dead as equivalent to, and interchangeable with, fourteenth-century papal decree. Again, the unpacking of such narrative is a task largely ancillary to my present concerns.

18. Carlino, *Books of the Body*, 1.

19. Ancient manuscripts were "instruments of recitation," designed to be read aloud. Visual adornment existed only insofar as it assisted in this task. Humanist texts allowed for illustrative frontispieces to lend *cachet* to a publication, but it was not until Vesalius's *De fabrica* that such resistance to elucidative illustrations showed the first signs of being overcome. William Heckscher, *Rembrandt's Anatomy of Dr. Nicolaas Tulp: An Iconographical Study* (New York: New York University Press, 1958), 62.

20. Andreas Vesalius quoted in O'Malley, *Andreas Vesalius of Brussels*, 355–356.

21. After receiving church sanction, the rector of the university would grant a permit to the professor of practical medicine (surgery) to procure a cadaver from the appropriate city authorities at the professor's (and his students') expense. The subject of the anatomy was invariably a recently executed criminal whose place of birth, the statutes of 1442 onward clearly stipulate, must have been at least thirty miles from Bologna. The subsequent demonstration of the anatomy could be attended by up to twenty students for a male corpse, or thirty for a female corpse; the maximum number of lessons any student could attend throughout their degree being three (two male, one female). Monies were also set aside by the professor (again with the help of students) for equipment, the venue, and for the recital of prayers in a nearby chapel for the souls of those dissected. These details are taken from Giovanna Ferrari, "Public Anatomy Lessons and the Carnival: The Anatomy Theatre of Bologna," *Past and Present* 117 (1989): 51, 53–54.

22. Heckscher, *Rembrandt's Anatomy*, 46. As we will see shortly, Heckscher's description will, over the course of the sixteenth and seventeenth centuries, become more than just an apt one; it will become quite a literal one. By the middle of the seventeenth century the public anatomies would be open to a more general, lay audience, while their conduct would come to be associated not only with the season of carnival, but also with the carnivalesque associations with sacrifice and atonement.

23. Carlino, *Books of the Body*, 11.

24. Harcourt, "The Anatomy of Antique Sculpture," 36.

25. Jonathon Sawday, "The Fate of Marsyas: Dissecting the Renaissance Body," in Lucy Gent and Nigel Llewellyn, eds., *Renaissance Bodies: The Human Figure in English Culture c. 1540–1660* (London: Reaktion Books, 1990), 48.

26. Luke Wilson, "William Harvey's Prelectiones: The Performance of the Body in the Renaissance Theatre of Anatomy," *Representations* 17 (1987): 64. Extant statutes from the University of Padua dating from 1465 give us a clear indication as to the role of the *ostensor* in this regard: "The rector and the *consilari* are to depute ... one of the *doctores ordinarii*, either of practice, or of theory, who will explain the aforesaid text line by line, and what he has explained according to text and letter, let him demonstrate by visual testimony, and verify in the cadaver itself." Quoted in Andrew Cunningham, *The Anatomical Renaissance: The Resurrection of the Anatomical Projects of the Ancients* (Aldershot: Scolar Press, 1999), 44.

27. Andreas Vesalius, Preface to the *De fabrica*, quoted in O'Malley, *Andreas Vesalius of Brussels*, 356.

28. Vesalius, Preface to the *De fabrica*, quoted in ibid. With such contemporary criticism of the practice of anatomy, one can almost empathize with modern historians of

science who are so nonplussed by the practical and "scientific" worth of these demonstrations. Since they were conducted with the professor so far away from the cadaver, and the barber so ignorant of proceedings, what chance was there of discrepancies between text and body being discovered? As one author states it: "from a strictly scientific point of view they led practically nowhere" (Heckscher, *Rembrandt's Anatomy*, 46). Yet this is positivism, to be sure: that direct observation of a corpse did not produce corrections to Galen's anatomical knowledge (based as it was for the most part on dissections of apes) and that this scene typified anatomy for over two hundred and fifty years cannot, and should not, be dismissed essentially as a dead-end. For the object of these anatomy lessons was not the cumulative accretion of knowledge (in itself a decidedly teleological and modern notion) but rather the *demonstration* of anatomical knowledge, that is, the verification of the authority of the Ancients.

29. H. Jansen, "Titian's Laocoon Caricature and the Vesalius-Galenist Controversy," *Art Bulletin* 28 (1946): 50.

30. Wilson, "William Harvey's Prelectiones," 68, 70.

31. Andreas Vesalius quoted in O'Malley, *Andreas Vesalius of Brussels*, 356–357.

32. Heckscher, *Rembrandt's Anatomy*, 52. Although *Fabrica* is the standard abbreviation used in the literature, for this book the more grammatically accurate *De fabrica* will be used.

33. Sylvius quoted in ibid., 63.

34. The "riot" of Renaissance geographical and cartographic metaphors, of which my own is illustrative, will be discussed and eventually critically recuperated in chapter 3.

35. There is one exception to this general rule of naming, or rather, sometimes one: "Occasionally a supernumerary or accessory bone called *vesalium pedis* (Vesalius's bone) appears near the base of the fifth metatarsal." Keith Moore, *Clinically Oriented Anatomy*, 2nd ed. (Baltimore: Williams and Wilkins, 1985), 473.

36. Original Dutch manuscript entry: "Adriaan adriaansz anders genaamt het Kindt. Was kokermaamer geboren tot leijden in hollant int 28 Jaar is voor sijn moetwil met de koorde gestraft an. 1632 den 31 Januarij bij die vant gilt ontleet." Thanks to M. J. Martin for the translation.

37. Michel Foucault, "The Life of Infamous Men," in *Michel Foucault: Power, Truth, Strategy*, ed. Meaghan Morris and Paul Patton (Sydney: Feral Press, 1979), 77.

38. Ibid., 79.

39. Ibid., 80.

40. Ibid., 84.

41. Michel Foucault, *Discipline and Punish: The Birth of the Prison*, trans. Alan Sheridan (New York: Vintage Books, 1979), 191.

42. Ibid.

43. Pierre Bourdieu, "The Biographical Illusion," *Actes de la recherche* 62, no. 3 (1986): 69–72.

44. Michel Foucault, "What Is an Author?," in *The Foucault Reader*, ed. Paul Rabinow (London: Parthenon Books, 1984).

45. We can see this clearly at play in the preface to the "Body Worlds" exhibition catalog, where individual triumph over the taboo of viewing the dead is celebrated as not only liberating but somehow constitutive of good Being: "For each visitor, this was ultimately a personal victory. They had overcome the taboos that surround human corpses. They were able to look at these specimens quietly and with interest in anatomical details. ... This transition from expecting revulsion to looking at specimens freely and uninhibitedly amounts to a personal break with these taboos. Many visitors to KÖRPERWELTEN have spoken about this and thus encouraged family and friends and acquaintances to have the same experience." Wilhelm Kriz, foreword to *Prof. Gunther von Hagens' Bodyworlds: The Anatomical Exhibition of Real Human Bodies: Catalogue on the Exhibition* (Heidelberg: Institut für Plastination, 2002), 6.

46. There has always been something oracle-like in the ability of the eye so trained to augur disease and malignancy in the smudges and smears of X-ray film. To this we may add the sheer weightiness of more contemporary medical imaging technologies. The monolithic nature of CAT scan and MRI machines only enhances the magical vision they perform: their sentinel-like nature transforming hospital rooms and corridors into places bordering on hallowed; the depth of their penetrations ensuring that beings are inculcated into a life reduced to traces in a file from a time before birth itself.

47. Foucault's description of the "examination" in *Discipline and Punish* (188) coincides with his description of the military "review" of Louis XIV and focuses, for the most part, on its more disciplinary effects. But as with most of Foucault's descriptions of power, one cannot be too rigid with the epistemological shifts that he traces. It is often precisely in the lingering of supposedly "outdated" modes of power that we get a hint of how different discursive formations can radically change the meaning of a particular practice (like the collections of the previous chapter) as they produce radically jarring effects. Essentially, it is my aim with this section to trace the persistence of more "sovereign" modes of identification, even within the dominant "disciplinary" discursive manifestations of power that arose during the seventeenth century.

48. The roll call is actually a later addition to the panel. Originally the folio sheet held by Hartman Hartmansz depicted an anatomical illustration of a hand, the significance of which will be discussed below. For a detailed examination of the condition of, and additions to, the canvas, including the additional figure on the far left, see William Schupbach, *The Paradox of Rembrandt's "Anatomy of Dr. Tulp"* (London: Wellcome Institute for the History of Medicine, 1982).

49. Heckscher, *Rembrandt's Anatomy*, 26. If the year 1543 is retrospectively seen as one of great portent for the history of science (the year of publication of both Vesalius's *De fabrica* and Copernicus's *De revolutionibus*), then 31 January 1632 stands equally as another: René Descartes is believed to have been in the audience at Dr. Tulp's dissection.

50. Sawday, "The Fate of Marsyas," 114.

51. Ferrari, "Public Anatomy Lessons," 83. The sale of tickets to public anatomies predates the sale of tickets to other theatrical performances, and anatomy theaters were most likely the first purpose-built theaters of their kind; often hosting operas or musical dramas when not staging public exercises in anatomy. The earliest plan for a permanent anatomical theater dates from 1493, while the first amphitheater backdrop used on a Renaissance stage dates from 1533. See Ferrari, "Public Anatomy Lessons," 87. See also Heckscher, *Rembrandt's Anatomy*, 32, 135 n 59.

52. Sawday, "The Fate of Marsyas," 135.

53. According to Foucault, the public execution served a juridico-political function in that it was conceived as a ceremony to restore or reconstitute a momentarily injured sovereign, through a display of the dissymmetry of force brought to bear upon the body of the criminal. With a mimetic quality reminiscent of the icon, to break the law was to touch the very person of the sovereign, and it is this sovereign which in turn marks the body of the criminal in a pageant of excess. Breaking and displaying that body in an emphatic exercise of physical strength functioned to affirm the power of the sovereign and the superiority of that power. Foucault, *Discipline and Punish*, 48–49.

54. See in particular ibid., 3–6.

55. Sawday, "The Fate of Marsyas," 116.

56. Heckscher, *Rembrandt's Anatomy*, 105.

57. Katherine Park, "The Criminal and the Saintly Body: Autopsy and Dissection in Renaissance Italy," *Renaissance Quarterly* 47, no. 1 (1994): 20.

58. Contemporary commentary quoted in Ferrari, "Public Anatomy Lessons," 88.

59. Rembrandt has depicted a most unorthodox initial act of dissection. Since the early fourteenth century, there had existed a strict order in which anatomists proceeded through the body: from the abdomen, through to the chest, to the head, and finally to the extremities. This order was initially thought to have been predicated upon the rate that flesh would naturally corrupt; it is now believed that it was in fact predicated upon a hierarchy of the location of the soul within the body: the dissection proceeding from the nutritive (the liver), to the spiritual (the heart), to the animal (the brain). See Cunningham, *The Anatomical Renaissance*, 52. That Rembrandt would depict the anatomy as commencing with the extremities tends to indicate that a specific reading of the canvas was envisaged in this regard.

60. Francis Barker, "Into the Vault," in *The Tremulous Private Body: Essays on Subjection* (Ann Arbor: University of Michigan Press, 1995), 66.

61. Ibid.

62. Ferrari, "Public Anatomy Lessons," 60.

63. Foucault, *Discipline and Punish*, 188.

64. Carlino, *Books of the Body*, 5. Although Carlino is merely using the term "excess" to connote "knowledge that pertain[s] to a discipline that pursue[s] its objectives regardless of clinical benefit," thereby suggesting a degree of superfluousness which carries with it the hint of modern utilitarian science, I will return to this notion of "excess" shortly to critically recuperate it. For what we are dealing with here is a knowledge that, throughout its history and to the present day, has been associated with a sensual revelry of and in the flesh.

65. Wilson, "William Harvey's Prelectiones," 62.

66. Ibid.

67. Carlino, *Books of the Body*, 11.

68. Sawday, "The Fate of Marsyas," 118.

69. Wilson, "William Harvey's Prelectiones," 88.

70. Sawday, "The Fate of Marsyas," 123.

71. Baldasar Heseler quoted in Sawday, *The Body Emblazoned*, 131–132.

72. Wilson, "William Harvey's Prelectiones," 63.

73. Ibid., 79.

74. Sawday, "The Fate of Marsyas," 127.

75. William M. Ivans Jr., "What about the 'Fabrica' of Vesalius?" in Archibald Malloch, ed., *Three Vesalian Essays to Accompany the "Icones Anatomicae" of 1934* (New York: Macmillan, 1952), 91.

76. Sawday, "The Fate of Marsyas," 123.

77. Ibid., 126.

78. Barker, "Into the Vault," 68.

79. Ferrari, "Public Anatomy Lessons," 58.

80. Ibid., 68–69.

81. An obvious reason for presenting anatomical information not as it would be found on a dissecting table, but as it would be found in a living body, has to do with the construction of a normative description of the body that is to be utilized by surgeons upon the living. Knowledge is structured, and hence represented, with an eye to its deployment in the medical examination where the physician is face to face with a living body. As I have just suggested, however, the regime of complicity that characterizes the medical gaze is such that this mapping of the normative description onto the living body marks it as part of the armature of disciplinary power; producing docile, recordable, deployable, hence "known" subjects/patients.

82. Sawday, "The Fate of Marsyas," 117.

83. Harcourt, "The Anatomy of Antique Sculpture," 42.

84. I will pursue this line of argument more fully in chapter 3, where cartography serves as an entry point into discussions concerning the relationship between ways of seeing and modes of representation, and certain "technologies of power" that distribute and arrange bodies in space. In this way, vision, representation, and knowledge structures tend to circulate as "assemblages."

85. Essentially this is a paraphrasing of Harcourt when he states: "The point here is simply that a single representational tactic may be at once programmatically scientific and practically evasive" (Harcourt, "The Anatomy of Antique Sculpture," 42). However, where Harcourt tends to write from the perspective of "authorial intent" (hence it is a "representational *tactic*"), I wish to follow this otherwise suggestive claim through its more discursive possibilities; something that is absent from all literature on this matter.

86. Leonardo da Vinci, quoted in Sawday, *The Body Emblazoned*, 111.

87. Leonardo da Vinci, quoted in ibid.

88. Ferrari, "Public Anatomy Lessons," 42.

89. Ibid.

90. Heckscher, *Rembrandt's Anatomy*, 28.

91. Ferrari, "Public Anatomy Lessons," 99.

92. Ibid.

93. Mikhail Bakhtin, *Rabelais and His World*, trans. Helene Iswolsky (Bloomington: Indiana University Press, 1984), 40.

94. One of the few authors to have commented on this association between carnival and anatomy is Andrea Carlino. What is interesting about his account, however, is the way this association has been configured, essentially, as an opportunistic one: "Even if dissection was to be considered a transgressive and profane act, it was tolerated because it took place at a time when every form of subversion and inversion was concealed under the guise of performance." Carlino, *Books of the Body*, 81. The inference here is that, apart from a shared sense of "transgressiveness," carnival and anatomy were essentially two unrelated enterprises. This, I wish to suggest, was not the case: the association is a much more vital connection based on sacrifice and atonement.

95. For most authors the answer is deemed so obvious that the question is not worthy of being asked in the first place. Yet even if we only begrudgingly acknowledge that late Renaissance culture was structured with all manner of symbolic and religious associations, then surely the utilitarian answer "because they were there"—because they were already condemned, were not to be buried on hallowed ground, and so forth—seems woefully inadequate. Why seek answers from corrupt bodies? Yes, the discursive links to the scaffold were close, but we cannot see anatomy as merely another tool of retributive justice—as I have already pointed out: the figure of Dr. Tulp is the agent of a retributive justice, yet he is also the procurer of surgical information. There remains, then, the need to answer the question: why criminal bodies? And it is through a notion of carnival that an answer presents itself.

96. Barker, "Into the Vault," 66.

97. Ferrari, "Public Anatomy Lessons," 100.

98. Suggestive of this connection between anatomy, sacrifice, and feasting, Bakhtin's Rabelais, who was praised on at least one occasion for his skill as an anatomist, describes victims of torture in a language bordering on the anatomic and the gastronomic. See Bakhtin, *Rabelais and His World*, 354–367. It should also be noted that Bakhtin's *grotesque* body has striking similarities to the anatomized body, with its openness and connection to the generation of living matter.

99. Edgar Wind, "The Criminal-God," *Journal of the Warburg Institute* 1, no. 3 (1938). The following account of the criminal-god is taken exclusively from Wind's article. Frazer's somewhat different take on the matter in his essay on the *Scapegoat* (volume 9 of *The Golden Bough*) will not be employed here. This is because I am less concerned with testing the veracity of Wind's claims than I am with employing the narrative of the criminal-god as a motif to be read alongside another such notion, the criminal-saint, in order to explore the possibility of the continuance of certain elements of the sacred within the discourses of science.

100. Ibid., 243.

101. Ibid., 244.

102. Ibid.

103. Heckscher, *Rembrandt's Anatomy*, 84.

104. Ibid., 87. Justice pictures developed in the second half of the fifteenth century in the Netherlands. Depicting scenes of the tortures and punishments described in the myths of the Ancients, these moralizing panels served as contemporary commentaries or warnings regarding crimes committed and virtues rewarded.

105. Ibid., 88.

106. Ibid., 87.

107. Samuel Y. Edgerton Jr., *Pictures and Punishment: Art and Criminal Prosecution During the Florentine Renaissance* (Ithaca: Cornell University Press, 1985), 217. Other authors have been keen to draw an iconographical connection between Becerra's *écorché* and the Ovidian myth of Apollo flaying Marsyas. Pictorial renditions of the brutal bodily destruction of the satyr who dared to challenge a god to a contest of skill became decidedly popular during the sixteenth and seventeenth centuries (along with any number of other tales from the *Metamorphoses*). Vesalius's *De fabrica* has a representation of the myth in the prominent historiated letter "V," elevating the myth in the process (at least in the eyes of modern commentators) to the level of a general motif for the profession of anatomy itself. What is interesting in this regard is the aptness in this association precisely because of the brutal, retributive nature of Ovid's tale. See Sawday, "The Fate of Marsyas," 111–113.

108. Art historians have been most active in their efforts to delineate a clear connection between Becerra's *écorché* and Michelangelo's *Last Judgment*. It is not particularly difficult: Becerra was a student of Giorgio Vasari, who was a student of Michelangelo; Valverde (whose atlas Becerra was illustrating) was a student of Realdo Colombo, who was Michelangelo's collaborator and personal physician. It seems likely, therefore, that Becerra would have seen Michelangelo's controversial work in the Sistine Chapel (Edgerton, *Pictures and Punishment*, 217–219, n 52).

109. Heckscher, *Rembrandt's Anatomy*, 87, emphasis added.

110. Edgerton, *Pictures and Punishment*, 172–173.

111. The confraternities of the Catholic South were officially sanctioned organizations of laypeople tending to the needs and comfort of condemned criminals in return for "spiritual reward." Recently discovered manuals of conduct of the Confraternity of San Giovanni Decollato suggest that the comforter's words should address the following three prime concerns of the condemned: first, an assurance that their condemnation would not stain the reputation of their family; second, offering hope that a repentant and contrite soul would be given a place in Paradise; and third, the guarantee that the confraternity would attend to the body's proper burial. It is interesting to note that the confraternities were responsible for the "loan" of bodies to the universities for their anatomies. They were delivered under the cover of night; fees would be paid for the use of the body, for prayers to be said for its soul, and for its return and burial after the dissection. For further details of the work of the confraternities, see Carlino, *Books of the Body*, 99–115. Although the *tavolette* were a strictly Catholic invention, we can see, in the justice panels of the Protestant North, similar equations being drawn between the choice of execution technique and the crime committed.

112. Edgerton, *Pictures and Punishment*, 131.

113. Park, "The Criminal and the Saintly Body," 23.

114. Edgerton, *Pictures and Punishment*, 135.

115. Apart from the partition of the body for purposes of beatification and subsequent veneration, there existed a not unrelated practice of the dispersal of the remains of the nobility for burial purposes. Promulgated in 1300, the bull of Boniface VIII against the partition and dispersal of the body was aimed at the practice of nobles, and in particular the English monarchy, whose penchant for such practices was based on the popular belief that the dead would derive satisfaction from such an arrangement. For more details, see Brown, "The Legislation of Boniface VIII on the Division of the Corpse."

116. Sawday, *The Body Emblazoned*, 99.

117. Account of Sr. Francesca of Filigno, quoted in Park, "The Criminal and the Saintly Body," 2.

118. Sawday, *The Body Emblazoned*, 100.

119. Ferrari, "Public Anatomy Lessons," 101; David Murray, *Museums: Their History and Their Use*, vol. 1 (Glasgow: James MacLehose and Sons, Publishers to the University, 1904), 57, 56.

120. Peter Linebaugh, "The Tyburn Riot against the Surgeons," in Douglas Hay, ed., *Albion's Fatal Tree* (London: Pantheon Books, 1975), 109.

121. See chapter head for Vasari's full description of the deed.

122. Park, "The Criminal and the Saintly Body," 26.

123. The public nature of these moralizing collections (as opposed to the largely private princely collections) has led at least one modern author to make the assertion that these anatomy theaters represent the first truly public museums. There is nothing in this hastily made suggestion that would discredit the general argument of my first chapter regarding Renaissance discourses of collection and display being completely dissimilar to the modern museum. The reference in question is Heckscher, *Rembrandt's Anatomy*, 97–98.

124. Schupbach has identified two discrete meanings behind the motto *Nosce te ipsum*: the first being the somewhat pessimistic tradition of the medieval *memento mori*, referring to the mortality of the flesh; the second being related to the underlying principle of the curiosity cabinet (*cognitio Dei*), referring to the divinity of the flesh. The dual meaning of this phrase indicates that anatomy was at once a moralizing lesson concerned with the frailty or transience of human life, as well as a search for the traces and fragments of God's creation in that most perfect of creations: the microcosm of humankind.

125. Heckscher, *Rembrandt's Anatomy*, 99.

126. Ibid., 164 n 79.

127. Ibid., 105.

128. For further details of this narrative, see Sawday, *The Body Emblazoned*, 66–78.

129. Harcourt, "The Anatomy of Antique Sculpture," 30.

130. Jansen, "Titian's Laocoon Caricature and the Vesalius-Galenist Controversy," 51.

131. Harcourt, "The Anatomy of Antique Sculpture," 29.

132. Foucault, *Discipline and Punish*, 47.

133. Robert Musil, "Monuments," in *Posthumous Papers of a Living Author* (Colombia: Eridanos Press, 1987), 62.

134. Michael Taussig, *Defacement: Public Secrecy and the Labor of the Negative* (Stanford: Stanford University Press, 1999), 43.

135. Ibid., 52.

136. Ibid., 1, 32.

137. Ibid., 1, 52.

138. Peter Stewart, "The Destruction of Statues in Late Antiquity," in Richard Miles, ed., *Constructing Identities in Late Antiquity* (London: Routledge, 1999), 162.

## Chapter 3

1. Rudolf Wittkower, *Art and Architecture in Italy 1600–1750* (Suffolk: Penguin, 1990), 139–140.

2. Martin Kemp, "Perspective and Meaning: Illusion, Allusion and Collusion," in Andrew Harrison, ed., *Philosophy and the Visual Arts: Seeing and Abstracting* (Boston: Riedel, 1987), 256.

3. I wish to leave the details of geometric perspective for later, and even then I do not wish to dwell excessively on the history of the Western "discovery" of perspective, but to say that Filippo Brunelleschi was the first artist to conduct a perspective "experiment" (which was a demonstration of the principle of the vanishing point) on the steps of the Duomo in Florence in 1425—nor do I wish to dwell on the mechanics of single-point perspective, which, like art-historical theories regarding color or naturalism, have a tendency to be overly turgid. As it is my ultimate desire to explore perspective in terms of it being a discursively structured mode of rendering the world to the view of particular (though not necessarily fixed) subjectivities, all I require of the reader is the most rudimentary understanding of the optics of perspective: that linear perspective renders the illusion of depth by depicting all compositional orthogonals as converging upon a single point (often in relation to a horizon) known as a vanishing point, thereby forming a receding grid within which compositional elements may be placed; and that if this vanishing point were reflected back through the picture plane, as if it were a mirror, then it would have a mathematically equidistant corollary in the so-called viewing point. Innumerable sources exist for both the history and the mathematics of perspective; however, for its use of contemporary Renaissance treatises and its conciseness in both these matters, see Samuel Y. Edgerton Jr., *The Renaissance Rediscovery of Linear Perspective* (New York: Basic Books, 1975). For an accessible account of the mathematics of perspective as it pertains to the visual arts, see Martin Kemp, "The Science of Art: Optical Themes in Western Art from Brunelleschi to Seurat" (New Haven: Yale University Press, 1992), 342–345.

4. Maurice Henri Pirenne, *Optics, Painting and Photography* (London: Cambridge University Press, 1970), 84.

5. A *velo* or "veil" was a device for transferring scale drawings, often associated with a window-like aperture across which was suspended a grid of fine woven thread. Jonathan Crary has suggested that the "interiority" of image production associated with the camera obscura stands as a perfect metaphor for the late Renaissance production of an individuated, observing subject (Jonathan Crary, *Techniques of the Observer: On Vision and Modernity in the Nineteenth Century* [Cambridge, Mass.: MIT Press, 1994], 22–66). While I do not wish to refute the aptness of this association, it is the *velo* that, I wish to suggest, should be seen as the quintessence of Renaissance ocular technologies insofar as its gridlike structure represented nothing short of the dominant mode of visualizing and capturing a "world picture"; something that, according to Heidegger, underpins and precedes the formulation of such a subject position. I will return to the implications of this statement shortly; for now I merely wish to flag a wider association between Western single-point perspective and the means for organizing the visible world as a geometric composition, structured on an evenly spaced grid.

6. Published in two volumes (1693 and 1700), the *Perspectiva pictorum et architectorum* went through fifteen editions before 1800. Although not as seminal a work as Leon Battista Alberti's *De pictura* (1435), which was the first treatise to explain the merits of linear perspective for artistic composition and enjoyed steady republication right up till 1970, Pozzo's literary work clearly was as influential as his *quadratura* was controversial.

7. Andrea Pozzo, quoted in Kemp, "The Science of Art," 139.

8. Andrea Pozzo, quoted in ibid.

9. It also gives us an indication as to why baroque art proved so unpopular with nineteenth- and early-twentieth-century art historians: this was an art that subordinated intellectual and literary associations to sensual and physical responses. The supposed "playfulness" of baroque art that raised the ire of a century's worth of art critics can be seen here to be a certain kind of self-consciousness (something usually reserved for modern art), in that baroque art expressly sought to manipulate its own modes of production to affect its viewer's physicality with regard to the painting/sculpture proper.

10. Walter Benjamin quoted in Susan Buck-Morss, *The Dialectics of Seeing: Walter Benjamin and the Arcades Project* (Cambridge, Mass.: MIT Press, 1993), 130–131.

11. Rosalind H. Williams, *Dream Worlds: Mass Consumption in Late Nineteenth-Century France* (Berkeley: University of California Press, 1991), 59.

12. Walter Benjamin, "Paris—Capital of the Nineteenth Century," in *Charles Baudelaire: A Lyric Poet in the Era of High Capitalism* (London: Verso, 1997), 165.

13. Michael B. Miller, *The Bon Marché: Bourgeois Culture and the Department Store, 1869–1920* (Princeton: Princeton University Press, 1981), 42.

14. John W. Stamper, "The Galerie des Machines of the 1889 Paris World's Fair," *Technology and Culture* 30, no. 2 (1989).

15. Williams, *Dream Worlds*, 84–85.

16. Benjamin, "Paris—Capital of the Nineteenth Century," 165.

17. Zeynip Çelik, *Displaying the Orient: Architecture of Islam at Nineteenth-Century World's Fairs* (Berkeley: University of California Press, 1992), 72.

18. It is not my intention to leave the vantage point of Eiffel's tower to provide an exhaustive description of exhibition practices as they happened "on the ground," nor even a critique of the various imperial and sexual metanarratives that underpinned them: such "legwork" has been exhaustively conducted by numerous other authors. Rather, my intention is to deploy the expositions as a device for opening up an analysis of modern spatial practices, in much the same way that Timothy Mitchell deploys them to open up issues of representation. Hence the significance of my narrativized view from atop the Eiffel Tower, which I am presenting as a kind of de Certeauian "spatial story" (the meaning of which will be explained later).

Regarding the "legwork" conducted by others, it should be noted that almost without exception this wealth of material is descriptive in nature (postcolonial theory being a conspicuous absence) and generally concerned either with "representations of race" (Annie Coombes, *Reinventing Africa: Museums, Material Culture and Popular Imagination* [New Haven: Yale University Press, 1994], esp. 187–216) or "the commodification of cultures" (Meg Armstrong, "A Jumble of Foreignness: The Sublime Musayums of Nineteenth-Century Fairs and Expositions," *Cultural Critique* 23 [1992–1993]). Two (partial) exceptions to this rule would be Tony Bennett's (somewhat overly) Foucauldian analysis of the "Exhibitionary Complex" (Tony Bennett, *The Birth of the Museum: History, Theory, Politics* [London: Routledge, 1995]) and Curtis Hinsley's underdeveloped allusions to *flânerie* (Curtis M. Hinsley, "Strolling through the Colonies," in Michael P. Steinberg, ed., *Walter Benjamin and the Demands of History* [Ithaca: Cornell University Press, 1996]). For a specific analysis of the gendered nature of exposition practice, see Zeynep Çelik and Leila Kinney, "Ethnography and Exhibitionism at the Expositions Universelles," *Assemblage* 13 (1990).

19. Charles Garnier quoted in Çelik, *Displaying the Orient*, 72. The tradition of portraying subject peoples in pavilions that were themselves summaries of cultures would become a mainstay of expositions for years to come. An indication of the imbricated nature of this vision of scientific transparency and commodity consumption can be seen in the ethnographic "experiments" of Franz Boas at the Chicago world's fair of 1893. Before a white sheet in a facsimile village, Boas recorded his observations of the ceremonial dances of a group of Kwakiutl Indians from Fort Rupert, British Columbia. In many instances Boas urged his Kwakiutl performers to reproduce rituals that they had ceased to practice; Boas, it would seem, was equally struck by the idea of "truth, truer than true." These proceedings were carefully recorded by photographer John Grabill, and were subsequently sold as souvenir postcards to curious fairgoers. See Curtis M. Hinsley, "The World as Marketplace: Commodification of the Exotic at the World's Columbian Exposition, Chicago, 1893," in Ivan Karp and Steven Lavine, eds., *Exhibiting Cultures: The Poetics and Politics of Museum Display* (Washington: Smithsonian Institution Press, 1991), 350.

20. Charles Garnier quoted in Çelik, *Displaying the Orient*, 70–71.

21. Jean-Claude Vigato, "The Architecture of the Colonial Exhibitions in France," *Daedalus* 19 (1986): 28.

22. Timothy Mitchell, *Colonising Egypt* (Berkeley: University of California Press, 1991), 6.

23. Jean Baudrillard, "The Orders of Simulacra," in *Simulations* (New York: Semiotext(e),

1983), 87. A potential point of confusion arises in Baudrillard's use of terminology here, as he has a tendency to alternate between a conception of baroque art being discursively allied to a Renaissance *episteme*, and being a characteristic of the Enlightenment's "classical" *episteme*. However, this is easily enough resolved: as we saw in chapter 1, baroque art commences at the turn of the seventeenth century, and can thereby be seen as flourishing at precisely that moment when a Renaissance "Order of Things" is about to give way to the homogenizing influences of the Enlightenment. Baudrillard's own example of stucco as the homogenizing substance *par excellence* is intended to illustrate an early instance whereby something we normally associate with the Renaissance begins to acquire the discursive qualities of the coming Enlightenment. In my brief rendition of Baudrillard's "order of simulations" I have, therefore, taken the liberty of using the phrase "early classical" rather than "late Renaissance" to avoid such confusion. This is an important distinction given Baudrillard's use of the term "counterfeit," which, when discussing Renaissance art, should not be confused with a notion of the "fake." As we saw in chapter 1, the notion of the fake was epistemologically vacuous in an age where signs were not locked into binary relationships with signifiers. This, however, is precisely what is happening with Baudrillard's metaphysic of stucco: its homogenizing tendencies are actually a mark of the Enlightenment's locking-down of signs into the flat tables of difference of an emerging scientific discourse. It is with the Enlightenment that the notion of the fake takes on its scandalous qualities. With regard to Renaissance art, "imitation" (of divine creation), therefore, is a more fitting term than "counterfeiting."

24. Michael Gane, *Baudrillard's Bestiary: Baudrillard and Culture* (London: Routledge, 1991), 95.

25. Baudrillard, "The Orders of Simulacra," 88–89.

26. Benjamin, "Paris—Capital of the Nineteenth Century," 161.

27. Ibid., 162.

28. Mitchell, *Colonising Egypt*, 8.

29. Thomas Markus, *Buildings and Power: Freedom and Control in the Origin of Modern Building Types* (London: Routledge, 1991), 215. In the case of the 1889 Parisian diorama this feature was not included, quite probably because it was deemed superfluous in the face of Eiffel's tower.

30. Mitchell, *Colonising Egypt*, 9–10.

31. For details of the painting's provenance, see Robert Koch, *Joachim Patinir* (Princeton: Princeton University Press, 1968), 32.

32. It seems quite remarkable to the modern observer that, as an independent genre, landscape painting did not exist before the sixteenth century. Prior to this time, if landscape elements were included in paintings then it was merely as a stage setting for the more sanctified themes of history painting (*istoria*). When landscape did begin to emerge from the background of history painting, it did so primarily within a group of Flemish artists, Joachim Patinir being first among them.

33. Walter S. Gibson, *Mirror of the Earth: The World Landscape in Sixteenth-Century Flemish Painting* (Princeton: Princeton University Press, 1989), 5.

34. Ibid., 8.

35. Reindert L. Falkenburg, *Joachim Patinir: Landscape as an Image of the Pilgrimage of Life*, trans. Michael Hoyle (Philadelphia: John Benjamins Publishing Company, 1988), 66.

36. Gibson, *Mirror of the Earth*, 6.

37. For instance, although the fastidious "Alpine studies" of early Germanic Renaissance artists like Albrecht Dürer could not be considered an autonomous landscape genre in themselves (as they were more akin to an encyclopedic census of local flora and fauna), art history would find in the majestic battle scenes of Albrecht Altdorfer a worthy heir to this tradition of nature studies; one that would see Dürer as the antecedent, and Altdorfer as the direct descendant, of a "naturalistic" portrayal of landscape views. See Keith Moxey, "A New Look at Netherlandish Landscape and Still-Life Painting," *Arts in Virginia* 26, no. 2 (1986): 22. The problem with the *Weltlandschaft* was that this neat teleology of landscape's progression could not be so easily charted. It was, in effect, an aesthetic with seemingly little or no artistic precedent.

38. Ernst Gombrich, "The Renaissance Theory of Art and the Rise of Landscape," in *Norm and Form* (London: Phaidon, 1966), 108–110.

39. In his desire to read Patinir's landscapes as a metaphor for the "Pilgrimage of Life," Falkenburg, for instance, takes the didactic motifs of Bosch (torture wheels, pagan images, ruined bridges, and highway bandits) and transposes them to his description of Patinir's paintings to suggest that the landscape elements of Patinir's paintings also represent a "world in sin" (Falkenburg, *The Pilgrimage of Life*, 67–69). The tenuous nature of this argument is of little concern to us here. What should be noted, however, is the extent to which Falkenburg is prepared to go in seeing Bosch as an "influence" on Patinir's iconography. This lies in sharp contrast to his lack of discussion regarding the nature and meaning of Patinir's use of the *Weltlandschaft* aesthetic.

40. Charles Talbot, "Topography as Landscape in Early Printed Books," in Sandra Hindman, ed., *The Early Illustrated Book: Essays in Honor of Lessing J. Rosenwald* (Washington: Library of Congress, 1982), 113.

41. This was certainly the impression the publishers of the *Civitates* wanted to cultivate. In the editor's introduction, Braun cited the following list of professions his book was aimed at satisfying (quoted in Lucia Nutti, "The Perspective Plan in the Sixteenth Century," *Art Bulletin* 74, no. 1 [1994]: 107):

> the traveler in search of a guide for the places he is going to visit; the merchant keen to find out about commercial sites and trading customs; the military man eager to become familiar with the defense system of his immanent objectives; the citizen hungry for deeper knowledge of his own country; and finally the scholar wishing for a round-the-world trip, while comfortably ensconced in his chair, and free of the costs and risks of a real journey.

Although it is easily dismissed as mere self-promotion, two things can be taken from this passage: first, the idea that viewing a precise topographical study was deemed equivalent to standing before the city itself (as in the case of the so-called "military man" sizing up a city's defenses); and second the related notion that images may serve as a vicarious form of travel. The latter, in particular, has obvious modern resonances

with certain aspects of the tourism and publishing industries. In light of our previous discussion concerning the power of images in an age of wonderment, it is interesting to note the ways in which such adherence to an understanding of the power of images during the Renaissance can be dismissed as naïve magic by modern commentators, yet our own modern calls to the transparent accuracy of scientific imaging systems, or for that matter, capitalism's ability to effect its own forms of vicarious travel through desire and imagery, are completely overlooked.

42. Isaac Massa's story is taken from Johannes Keuning, "Isaac Massa, 1586–43," *Imago Mundi* 10 (1953): 66–67.

43. As a final indication of both the "prized" nature of these topographical studies and their perceived utility, especially in matters of political espionage, we turn once again to the publishers of the *Civitates*, Braun and Hogenberg. They claimed that they included prominent figures in the foreground of their topographical views just in case one of their volumes fell into the hands of the Turks—the inference being that the presence of figural depictions would render the view unusable in matters of warfare (Svetlana Alpers, "The Mapping Impulse in Dutch Art," in David Woodward, ed., *Art and Cartography* [Chicago: University of Chicago Press, 1982], 67).

44. This, of course, is a direct reference to Michel de Certeau's notion of a "spatial practice"; one of the "micro-techniques" of everyday engagement with the normative spatial strategies of contemporary discourse. Although I will return to this in greater detail shortly, I raise de Certeau at this point to acknowledge my debt to his notion that it is the everyday "lived" narrations of a city that transform place into space. In many ways this present section on the world landscape represents my effort to prefigure de Certeau's comments on space and place: Patinir's *Weltlandschaft* represents that historical moment when map and landscape were still very much fused.

45. As an aside, we are also now in a position to respond to Gombrich's narrative regarding the rise of landscape as an independent genre being the result of a desire to provide the pictorial equivalent of a theoretical ideal inherited from the Ancients. While the Renaissance rediscovery of pastoral poetry may, indeed, have helped landscape to assert itself in the face of the dominance of history painting in Italy, Patinir's *Weltlandschaft* points to a decidedly cartographic tradition of depicting the politicized nature of territorial *Landschaft*. In this regard, it is interesting to reflect upon Dürer's oft-quoted opinion of Patinir as "the good landscape painter." Although it is usually taken to mean that Patinir was the first landscape artist in the modern sense of the word, it is equally interesting to entertain the possibility that Dürer was referring to the word's original meaning as a politicized topography.

46. Nicholas of Cusa quoted in Michel de Certeau, "The Gaze of Nicholas of Cusa," *Diacritics* 17, no. 3 (1987): 2.

47. The Cusan method of the *De icona* is premised on participants being witness to an "absolute" in the form of a "point of view," unfettering their being from the ontologically hierarchical cosmos that defined Christian Creation. Such witnessing is at once singular, total, and irreplaceable, hence replete with infinite potentiality with regard to other beings. This, de Certeau speculates, is an early mystical rendition of the modern individual (ibid., 6).

48. Nicholas of Cusa quoted in ibid., 11.

49. Nicholas of Cusa quoted in ibid.

50. Here, yet again, is an instance of the epistemological certainty of the copy during the Renaissance. Nicholas of Cusa lists a handful of images that he has seen with the "all-seer" quality, including a painting of St. Veronica in his own chapel at Koblenz. He makes little mention of the image that he sends to the abbey at Tegernsee but for the following: "So that you should lack for nothing in an exercise that requires the perceptible figure that was at my disposal, I am sending you a painting that shows that figure of an all-seer, which I call the icon of God" (ibid.). What is interesting is that there is no question, here, that Nicholas of Cusa can employ a copyist to repaint his "all-seer" icon, and its attributes will remain intact. The language is most revealing in this regard: he is sending "a painting that shows that figure of an all-seer." The logical inference is that the figure "exists" or "resides" within his icon; in sending a copy of it he sends with it its ability to see all.

51. Nicholas of Cusa quoted in ibid., 12.

52. Nicholas of Cusa quoted in ibid.

53. Ibid., 14.

54. Ibid., 18.

55. Edgerton, *The Renaissance Rediscovery of Linear Perspective*, 16.

56. These arguments bring us back to the medieval theories of light discussed in chapter 1, as it was light, in the form of lux, which was the means through which the divine grace of God was propagated, and it was light that came to be regarded as an intimate manifestation of God's rational presence in nature's design. Hence the importance to Renaissance theologians of studying the ways in which light was seen to reflect, refract, and transmit—all three being seen as issues of spiritual importance. See Kemp, "The Science of Art," 26.

57. Interestingly enough, apart from the Alexandrian Greek Ptolemy, one of the first exponents of the centric ray theorem was the Hellenic physician Galen, whose anatomical studies (as we saw in chapter 2) dominated knowledge of the body for a thousand years.

58. Edgerton, *The Renaissance Rediscovery of Linear Perspective*, 69.

59. Samuel Y. Edgerton Jr., "Florentine Interest in Ptolemaic Cartography as Background for Renaissance Painting, Architecture, and the Discovery of America," *Architectural Forum* 56 (1976): 178.

60. Paul Hirst, *Foucault and Architecture* (Sydney: Local Consumption, 1984), 8.

61. The influence of the moralizing geometry of linear perspective on the Renaissance built environment was in no way limited to its ideally proportioned, centrally planned churches. Yet clearly it also constitutes a book unto itself. Although it is somewhat subsidiary to our present narrative regarding the technologies employed for picturing the world, it is not without its relevance, as we will see when discussion turns to the technology of cartographic mapping which, I wish to claim, works above all through its ability to transform landscape itself into the image of the map. However, at this point I merely wish to touch on two aspects of Renaissance architecture that are relevant to our more immediate concerns; the first regarding modern narratives of disciplinary technologies, the second, a recapitulation of the epistemic nature of discourse.

In the writings of Leon Battista Alberti and Leonardo da Vinci we can find the curious preemption of the nineteenth century's wholesale leveling of city blocks in the colonial cities of Cairo and Calcutta, and the implementation of Haussmannesque boulevards to open these cities up to a controlling gaze. Transposing the moralizing influence of the centric ray theorem to town planning, both authors suggested that straight and wide avenues radiating from a centralized piazza, with either gates or bastions capping each axis, would serve to infuse a city with divine grace and raise the moral level of the inhabitants. What is otherwise seen as the "functionality" of the nineteenth-century colonial practice is hereby preempted as "spiritually functional" (Martha Pollak, *Military Architecture: Cartography and the Early Modern European City* [Chicago: Newberry Library, 1991], xx). For a discussion of the leveling of Cairo as part of a strategy for the disciplining and control of its inhabitants, see Mitchell, *Colonising Egypt*, 63–65. For the way similar techniques were deployed in European cities as part of a strategy to educate and make docile the working classes, see Bennett, *The Birth of the Museum*, 17–24. What strikes me about this literature on the modern disciplinary effects of town planning, whether at home or abroad, is how far removed its discussion is from notions of the sacred. Particularly in the case of the disciplining of the working classes through an attempt to raise their moral fiber in the mechanics' institutes and museums of the nineteenth century, it is as if it is the sacred, not the working classes themselves, which is being disciplined.

The extent to which Renaissance architectural discourse was underpinned by a moralized geometry of ideal and harmonious proportions can be clearly seen in the otherwise secular domains of architecture; military architecture being a case in point. The Renaissance preoccupation with perspective and magnificence surfaced in the form of the bastion trace, a pentagonally shaped fortification, which was at once aesthetic, moral, and designed to inspire awe among the citizens of the cities it protected. Most standard military histories refute the claim that a form of fortification deemed so practical well into the nineteenth century could have anything to do with symbolism (John Hale, *Renaissance Fortification: Art or Engineering* [London: Thames and Hudson, 1977], 46). Yet for architects working with a Renaissance *episteme*, the practicality of such a design would be no accident, but rather a function of the harmony and intrinsic superiority of certain forms (Hirst, *Foucault and Architecture*, 13). Both of these examples also help to illustrate the ease with which the visual regime underpinning the Cusan method slipped between the purely esoteric and the concrete: perspective being at once mathematical, theological, and practical. These examples also help to reinforce the idea that perspective operated at the level of discourse, and was seen very much as a tool for the transformation of people's very being.

62. Edgerton, *The Renaissance Rediscovery of Linear Perspective*, 30.

63. Ibid., 24, 30.

64. It is the complete lack of an artificial spatial recession, like single-point perspective, that has led to medieval art being labeled naïve. In medieval art, depth is suggested by overlaying compositional elements on top of one another, while compositional forms are generally rendered as if seen from different angles or viewpoints concurrently (buildings often showing three sides to the viewer). This lack of spatial homogeneity is quite telling for our present discussion, as what the medieval artist is displaying in rendering the world in this fashion is not a naïveté on their part, but rather a more subjectified

way of viewing the world: it is as if the artist is absorbed within the world he or she is attempting to represent, rather than taking the detached viewpoint of the perspective painter. This will become particularly relevant shortly, when discussion moves to the de Certeauian notion of narrative through movement: the spatial practice.

65. John Shearman, *Only Connect: Art and the Spectator in the Italian Renaissance* (Princeton: Princeton University Press, 1992), 67.

66. Edgerton, "Florentine Interest in Ptolemaic Cartography," 278.

67. Edgerton, *The Renaissance Rediscovery of Linear Perspective*, 119.

68. Norman Bryson, *Vision and Painting: The Logic of the Gaze* (New Haven: Yale University Press, 1983), 106.

69. Ibid., 107.

70. Jorge Luis Borges and Aldolfo Bioy Casares, *A Universal History of Infamy*, trans. Norman Thomas di Giovanni (Harmondsworth: Penguin, 1984), 131.

71. Baudrillard, "The Orders of Simulacra," 2.

72. David Turnbull, *Masons, Tricksters and Cartographers: Comparative Studies in the Sociology of Scientific and Indigenous Knowledge* (Singapore: Harwood Academic Publishers, 2000), 92.

73. Ibid. The pervasiveness of the cartographic metaphor beyond geographical understanding, to include our very conception of how knowledge is both structured and ordered, has led Denis Wood to suggest that one of the prime characteristics of Western modernity is its "map-immersed" nature (Denis Wood, *The Power of Maps* [New York: Guilford Press, 1992], 34–38). In contrast to this, Turnbull has suggested that the relationship between cartography and scientific knowledge goes beyond mere metaphor, arguing instead that there is an especially powerful symbiotic and symbolic synergy between them (Turnbull, *Masons, Tricksters and Cartographers*, 95).

74. John Brian Harley, "Silences and Secrecies: The Hidden Agenda of Cartography in Early Modern Europe," *Imago Mundi* 40 (1988).

75. John Brian Harley, "Deconstructing the Map," *Cartographica* 26, no. 2 (1989): 8. Although he invokes the names of both Derrida and Foucault, unfortunately a generally uncritical reading of both authors plagued Harley's early writings. For instance, to speak of the hidden political agendas of the association between cartography and the nation-state is to evoke a concept of power (and subjectivity) at odds with a discursive reading of maps. As we have already seen from our discussion of Foucault's *Life of Infamous Men*, if the author is conceived as a function of discourse, then texts must be examined independently of the people who write them. In the case of maps, to subscribe to a notion of either deliberate or subconscious censorship (Harley, "Silences and Secrecies," 57), or even to posit a division between internal and external conceptions of power exercised by or through cartography (Harley, "Deconstructing the Map," 12), is to invest in a concept of power as a "commodity," and a notion that subjects may be external to power—both of which Foucault would refute. In her critical evaluation of Harley's work, Barbara Belyea puts it thus: "If there is no subtext, no internal/external distinction, if the subject is a part of the discourse rather than a force 'behind' it, then there can be no 'mask,' no 'veil' behind which the map functions, no 'hidden agendas' by

which 'human agents' exercise 'duplicity.'" (Barbara Belyea, "Images of Power: Derrida/ Foucault/Harley," *Cartographica* 29, no. 2 [1992]: 3.)

76. An indication of just how long these teleological understandings of cartography persisted can be seen in any number of examples; the following will suffice as an illustration: "Mapmaking as a form of decorative art belongs to the informal, prescientific phase of cartography. When cartographers had neither the geographical knowledge nor the cartographic skill to make accurate maps, fancy and artistry had free range." (Ronald Rees, "Historical Links between Cartography and Art," *Geographical Review* 70, no. 1 [1980]: 62.)

77. Clearly it is not my intention to engage in any kind of extensive survey of the history of cartography. Rather, I merely wish to briefly sketch the general tenor of these early historiographical efforts, as we will shortly find that the more recent and critical forays into this domain have, in many ways, been shaped (much to their detriment) by the trajectories of these earlier concerns to "fill in the blanks," as it were, of the history of cartography.

78. John Brian Harley and David Woodward, eds., *The History of Cartography*, vol. 1, *Cartography in Prehistoric, Ancient, and Medieval Europe and the Mediterranean* (Chicago: University of Chicago Press, 1987), xvi.

79. Walter D. Mignolo, *The Darker Side of the Renaissance: Literacy, Territoriality, and Colonization* (Ann Arbor: University of Michigan Press, 1995), 259–313.

80. Ibid., 260.

81. Thongchai Winichakul, "Siam Mapped: Making of Thai Nationhood," *Ecologist* 26, no. 5 (1996).

82. Ibid., 220–221.

83. What is noteworthy about this particular encounter between these different conceptions of territorial space is the appropriation, around 1880, of European techniques of mapping by the Siamese court, as a means of countering French incursions into the region. As Thongchai suggests: "They [the Siamese] came to believe that modern geography was the only language the West would hear; in particular, they considered that only a modern map would counter French claims to the areas along the Mekong river which Siam wanted for itself. To define their margins for exclusive sovereignty, the French and the Siamese fought with both force and maps" (ibid., 222).

84. For an excellent analysis of the division that existed between a masculine conception of reading abstract cartographies and its feminized counterpart of looking at landscape paintings, see Eileen Reeves, "Reading Maps," *Word and Image* 9, no. 1 (1993). For a more general account of both the racial and gendered aspects of cartography, see Karen Piper, *Cartographic Fictions: Maps, Race and Identity* (New Brunswick: Rutgers University Press, 2002).

85. Ricardo Padrón, "Mapping Plus Ultra: Cartography, Space and Hispanic Modernity," *Representations* 79 (2002): 44.

86. Ibid.

87. Michel Foucault, "Space, Knowledge, and Power: Interview with Paul Rabinow," in *The Foucault Reader*, ed. Paul Rabinow (Harmondsworth: Penguin, 1986), 254.

88. Ibid., 255.

89. Henri Lefebvre, *The Production of Space*, trans. Donald Nicholson-Smith (Oxford: Blackwell, 1991).

90. Michel de Certeau, *The Practice of Everyday Life*, trans. Steven Rendall (Berkeley: University of California Press, 1988), 115–117.

91. Ibid., 117.

92. Ibid., 118. I will elaborate upon this movement later, as it relates to de Certeau's dialectic of "strategies" and "tactics": the discursive operators that situate both space and place within a wider critique of Foucault's disciplinary power.

93. Paul D. A. Harvey, *Medieval Maps* (London: British Library, 1991), 7. One of the oldest surviving and most famous itinerary maps of this kind is the Tabula Peutingeriana. Depicting fourth-century Europe (from West Britain to East India, North Africa to the reaches of Scandinavia) the dimensions of the Peutinger map give us an indication of just how far from the spatial associations of the modern map these itineraries were. Rolled out, the map is nearly seven meters in length, yet only thirty centimeters in width; its function of depicting major travel routes throughout Europe clearly required only a rectilinear marking of roadways converging on Rome. See O. A. W. Dilke, "Itineraries and Geographical Maps in the Early and Late Roman Empire," in Harley and Woodward, eds., *The History of Cartography*, vol. 1.

94. For a comprehensive study of the compositional form of the medieval *mappamundi*, as well as an effort to locate its spatial and historical conceptualizations of the world with a broader "theology," see Evelyn Edson, *Mapping Time and Space: How Medieval Mapmakers Viewed Their World* (London: British Library, 1997), esp. 145–163.

95. David Woodward, "Reality, Symbolism, Time, and Space in Medieval World Maps," *Annals of the Association of American Geographers* 74, no. 4 (1985): 511.

96. David Turnbull has openly questioned the notion of a cartographic "revolution," rightly pointing out that the idea that geometric cartography suddenly came to dominate Western spatial imaginations from the middle of the sixteenth century onward is an historical fancy; the product of modern historians writing over the persistence of other spatial depictions like the seafaring portolan chart (Turnbull, *Masons, Tricksters and Cartographers*, 101–105). Turnbull suggests that cartography would remain the exclusive concern of intellectuals until a means was devised to enable this particular form of spatial imagination to be "useful" as a tool of management and control, something that did not really happen until the General Ordnance Surveys of the nineteenth century enabled the standardization of previously separate local knowledge and practices. Although this is a cogent argument, de Certeau enables us to suggest (in much the same way that Foucault allowed us in the previous two chapters) that this supposedly "revolutionary" shift should in fact be sought in the epistemological certainty of the image as an "independent" product of direct observation rather than as an aid to, and an outcome of, an essentially textual "reading" of the narrative acts behind itinerary images. In a similar way to the images of Giulio Camillo's "memory theater," then, the graphic representations of medieval itinerary maps, and in particular the ecclesiastic *mappamundi*, would function textually—much like mnemonic devices for the elaboration of Scripture. With the coming of the Renaissance *episteme*, however, this textually based knowledge system

would give way to the scopic realm of Vesalius, and, we may now add, the cartographer: images would come to be seen, as Isaac Massa would put it, as "placing before the eyes something truer than truth itself."

97. De Certeau, *The Practice of Everyday Life*, 121.

98. Ibid.

99. Walter Ong, *Orality and Literacy: The Technologizing of the Word* (London: Methuen, 1982), 73.

100. Edgerton, "Florentine Interest in Ptolemaic Cartography," 278.

101. Edgerton, *The Renaissance Rediscovery of Linear Perspective*, 98.

102. Ibid., 104. A debate has raged within the ranks of art historians and historians of cartography alike as to whether Ptolemy's third method of cartographic projection was in fact an instance of the linear perspective enunciated by Renaissance artists, like Alberti. This is precisely the kind of art- historical and history-of-science commonplace that we have witnessed at work on numerous occasions already. Yet, although the search for a causal link between these two renditions of the perspectival grid would normally be of little concern to a discursive approach, from within this debate an interesting distinction is drawn that is worth mentioning; one regarding the viewpoints for whom these grids were constructed. Svetlana Alpers, in disagreeing with the general stance of Edgerton, suggests that "Although the grid Ptolemy proposed ... share[s] the mathematical uniformity of the Renaissance perspective grid, [it] do[es] not share the positioned viewer, the frame, and the definition of the picture as a window through which an external viewer looks. ... The projection is, one might say, a view from nowhere" (Alpers, "The Mapping Impulse in Dutch Art," 71). What Alpers is referring to here is the distinction between the embodied view that Albertian perspective presupposes and the somewhat disembodied view of a map. I will return to the significance of this shift in viewpoint (and its corresponding point of view) with regard to Foucault's panoptic gaze in the final section of this chapter. For now, however, it is enough to suggest that whether strictly embodied or not, what we are referring to with the Ptolemaic grid is a geometrical rendering of the world to the view of a particular external gaze.

103. Edgerton, *The Renaissance Rediscovery of Linear Perspective*, 114.

104. Turnbull, *Masons, Tricksters and Cartographers*, 105–113.

105. The portolan chart, with its dense array of coastal toponyms inviting the eye to trace itineraries across its surface, functioned through a technique of way-finding: locating a destination point along a linear projection of coastline, aligning the ship so that it will trace the straightest path between these two coastal points, and setting sail. During the Middle Ages such techniques would be exclusively coast-bound, the navigator tracing the path of coastal features and toponyms with both eye and vessel, allowing the spatiality of the voyage to proceed along a line of well-traversed names. However, during the Renaissance the skill of navigators in the art of "dead reckoning"— the art of estimating speed and distance—would enable the projection of such itinerary lines without the citations of proper place that would normally constitute the beginning and end points of a journey: "At once, then, the [portolan]chart [comes to] figure the spaciousness of the sea as well as its reduction to a network of itineraries" (Padrón, "Mapping Plus Ultra," 52). Of course it must be acknowledged that the ability

to conceptualize an itinerary with no proper-place citations was, itself, a function of a cartographic understanding of space. Thus we can suggest that, much like de Certeau's description of the sixteenth-century map with the depiction of ships and sea monsters being pushed to the margins as all that remains of the spatial itineraries that authorized the production of the map, at the time of the *Padrón Real* map and itinerary are still very much entwined. As Ricardo Padrón puts it: "As a highly rationalized cartographic product that retains its connection with way-finding, as a map that figures space in and through that serve to experience and construct it, the [portolan] chart seems to internalize that opposition between plane and line, and to place the two in a creative tension" (Padrón, "Mapping Plus Ultra," 54).

106. Turnbull, *Masons, Tricksters and Cartographers*, 110.

107. Piper, *Cartographic Fictions*, 41–42. For a detailed history of the trigonometric surveys of India, particularly with regard to cartography's role in the production of a rationalized space of Imperial rule, see Matthew Edney, *Mapping an Empire: The Geographical Construction of British India, 1765–1843* (Chicago: University of Chicago Press, 1997), esp. 236–261. For a critical evaluation of the ensuing technological organization of India that was to follow in the wake of such cartographic spatial rationalizations with the forging of irrigation and manufacturing networks, railways, telegraphs, and so forth, see Gyan Prakash, *Another Reason: Science and the Imagination of Modern India* (Princeton: Princeton University Press, 1999), esp. 159–201.

108. Piper, *Cartographic Fictions*, 43. The British solution to this impasse was one with similar political overtones to the story of Isaac Massa and his efforts to procure a map of Moscow during the sixteenth century. In what were known as the Pundit Expeditions, Britain would send native Hindus into Tibet incognito to record latitudinal coordinates for collection and collation once their missions were complete. Taught merely to take measured recordings, not to construct or even carry anything that resembled a map, for fear that they might fabricate results, the pundits were essentially viewed as threats to the very maps they were creating. Piper reads this historical narrative and the desire for cartographic representations of the so-called "neutral zones" largely in terms of British racial fears and efforts to neutralize them: cartography being seen here, essentially, as "a white language" (Piper, *Cartographic Fictions*, 12–13, 49). In posing this historical narrative in this manner, Piper focuses on cartography as a means of eliminating racial identity (the pundits are denied their rightful claims to the authorship of these maps). Furthermore, Piper tends to read the British need for indigenous "informants" primarily in terms of their ability to carry out the physical labor or "legwork" of cartography. While I do not wish to deny these claims, Piper's approach has a tendency to miss that aspect of cartographic practice that operates at the level of discourse, as expressed in the fears of those inhabitants of these so-called "neutral zones" who regarded cartography as a means of territorial conquest: the European appropriation of actual indigenous spatial narratives for their own mapping exercises.

109. See in particular Bruno Latour's account of cartography as action at a distance, wherein he expressly states (with a degree of condescension) that cartography relies on the translation of indigenous knowledge into "inscriptions" to be taken away to "centers of calculation": "The implicit geography of the natives is made explicit by the geographers; the local knowledge of the savages becomes the universal knowledge of the cartographers; the fuzzy, approximate and ungrounded beliefs of the locals are turned

into a precise, certain and justified knowledge" (Bruno Latour, *Science in Action: How to Follow Scientists and Engineers through Society* [Milton Keynes: Open University Press, 1987], 216; original emphasis).

110. Tejaswini Niranjana, *Siting Translation: History, Post-Structuralism, and the Colonial Context* (Berkeley: University of California Press, 1992), 21. Of particular interest to our present discussion is Niranjana's stress on the ontological capacities of translation to summon forth into discourse a romantic, primitivized "native" awaiting the civilizing influence of the West.

111. Bruno Latour and Steve Woolgar, *Laboratory Life: The Construction of Scientific Facts* (Oxford: Princeton University Press, 1986).

112. Latour, *Science in Action*, 215–236.

113. Ibid., 251.

114. See also Simon Ryan, *The Cartographic Eye: How Explorers Saw Australia* (Hong Kong: Cambridge University Press, 1996), esp. 101–127. Ryan makes a similar claim that as explorers increasingly valorized the verticality of maps over the horizontality of the land, this encouraged "the construction of the land as a system of signs" (Ryan, *The Cartographic Eye*, 121).

115. The inordinate number of references to de Certeau's "spatial practices" as extradiscursive resistances (that is, resistance with a capital R) can be found in sources as diverse as Cultural Studies readers, urban geography texts, and performance art handbooks. These obvious references aside, a measure of the allure of this reading of de Certeau's "spatial practices" is evident in the otherwise important critical work of Ian Buchanan, who places the interaction of de Certeau's modern subject with the spatial formations of modernity in direct opposition to Jameson's somewhat Foucauldian notion that space is the discursive precondition for the constitution of modern subjectivities. The effect of this is that de Certeau's spatial practices come to be seen as oppositional to the discourses of the panoptic impulse. See Ian Buchanan, "Heterophenomenology, or De Certeau's Theory of Space," *Social Semiotics* 6, no. 1 (1996): 111–132.

116. One need only read the essay "The Laugh of Michel Foucault" to get an inkling of de Certeau's engagement with Foucault both professionally and personally. As de Certeau recalls the occasion when Foucault responded to the question of how he would categorize his own work with: "No, no, I'm not where you are lying in wait for me, but over here, laughing at you," the reader can almost make out the glimmer of pride in his eyes. Yet what I find fascinating about this essay is the uncanny resemblance between Foucault's response on that occasion and de Certeau's own approach to Foucauldian discourse: "do you think that I would keep so persistently to my task, if I were not preparing ... a labyrinth into which I can venture, in which I can move my discourse, opening up underground passages, forcing it to go far from itself, finding overhangs that reduce and deform its itinerary, in which I can lose myself [?]" In many ways, this labyrinth of winding and sheltering passageways is a beautiful illustration of how de Certeau sees his own "spatial practices" in action. As a collection of "procedures" or "micro-techniques" enmeshed within the folds of disciplinary power, the spatial practice operates, above all, by traversing the normalized disciplinary grid, criss-crossing it with unseen itineraries, thereby providing us with a more nuanced understanding of the modern "disciplined" subject. See Michel de Certeau, "The Laugh of Michel

Foucault," in *Heterologies: Discourse on the Other* (Manchester: Manchester University Press, 1996).

117. De Certeau, *The Practice of Everyday Life*, 93.

118. On numerous occasions de Certeau stresses that the poem which each body traces upon the surface of the city in its daily movements is not only largely illegible to the panoptic eye, but also blind unto itself: "It is as though the practices organizing a bustling city were characterized by their blindness" (ibid.). What is suggested by this is that the willful author/agent other writers would have de Certeau's city practitioner be is actually more akin to the Foucauldian subject as a product of discourse; both authors largely reject the notion of extradiscursive subjectivities.

119. De Certeau, *The Practice of Everyday Life*, 92.

120. Ken Hillis, "The Power of Disembodied Imagination: Perspective's Role in Cartography," *Cartographica* 31, no. 3 (1994): 4.

121. Ibid.

122. This dialectic is, of course, already expressed in de Certeau's use of the terms "strategies" and "tactics," which in turn correspond to the two related organizations of space discussed above: the proper "place" and the narrativized "space." While it is suggestive of the kind of binary relationship between state-sanctioned discipline and resisting individual that I am in the midst of critiquing, de Certeau's characterization of them actually accords with a conception of power in a constant state of flux: the strategic field of discursive operations being constantly traversed by the tactical, only to be incorporated back into the fold, invigorating those discourses in the process. What I am attempting to suggest is that corresponding to de Certeau's understandings of the micro-techniques that operate within the folds of Foucauldian disciplinary power are different subject "embodiments." Particularly because of the way disciplinary power tends to bring subjects into discourse through a crushing corporeality (as we saw with the discourses of medical anatomy in chapter 2), we tend to forget the existence of other modern subject embodiments, or rather, we tend to read even the micro-techniques of discourse in terms of strictly corporeal embodiments. I am trying to suggest that in the need to place the body back into conceptions and theorizations of space, we need to acknowledge the body's less than bodily desires.

123. Michel Foucault, *Discipline and Punish: The Birth of the Prison*, trans. Alan Sheridan (New York: Vintage Books, 1979), 172.

124. Bennett, *The Birth of the Museum*, 48, 68.

125. Mitchell, *Colonising Egypt*, 28–33. At this point I should differentiate my argument from Mitchell's rendition of the "world as exhibition." In much the same way as I have argued that the "pictorialization" of the world preceded, or quite literally laid the ground for, Foucault's cellular grid of disciplinary technologies by either inscribing power structures into the very ground itself or spilling a geometrically based visual ordering of the world out from the picture plane, I would argue the same in Mitchell's case. Although this is not expressly acknowledged, Mitchell's "world as exhibition" is a reconfiguration of Heidegger's world picture. But in reducing a modern ordering of the world to a (very) Foucauldian understanding of the exhibitionary complex (one that precedes Tony Bennett's coining of the phrase), a disjuncture is produced between

the ontological effects of Mitchell's modern "reality effect" of the exhibition and the nature of the view from atop the pyramids. For Mitchell, the desire to acquire this view is subsumed within the need to find the "real" Orient that exhibition suggested was to be found "out there." But this has little to do with the actual privilege of such an elevated vantage point. What I am suggesting is that in staying closer to Heidegger's original concept of a world picture (albeit a more inclusive one than Heidegger would have it), we return meaning (an ontological meaning) to the position atop the pyramids. In short, what Mitchell's search for a "reality effect" is actually referring to is the search for a distinction between the geometry of the world behind the picture plane of the perspectival construction, and the now innate geometry of the world that has spilled out of the frame to colonize space on this side of the picture: the world picture preceding the exhibition. It is here that our previous spatial narrative atop the Eiffel Tower assumes its full significance: residing in the architectural achievements of modernity is the mechanical realization of the totalizing eye that painters of an earlier time could only image (to paraphrase de Certeau).

126. Ryan, *The Cartographic Eye*, 93.

127. Hillis, "Perspective's Role in Cartography," 7.

128. Wood, *The Power of Maps*, 66.

129. In fact, as early as 1654, Canon Jean-Baptiste Souchet saw in the labyrinth at Chartres nothing more than "a foolish amusement whereby those with little to do waste time twisting and turning" (Jean Villette, "L'énigme du labyrinthe de la cathédrale, Cathedral of Notre-Dame de Chartres," undated pamphlet, 5). In the vicinity of Chartres alone, labyrinths were destroyed at Auxerre in 1690, Sens in 1768, Reims in 1778, Arras in 1795, and Amiens in 1825; these dates tend to indicate that the function of the church labyrinth was all but lost to the more "enlightened" age of the eighteenth century. It is believed that only twenty-three churches remain in Europe with an original pavement labyrinth, most of them in Britain and France (John James, "The Mystery of the Great Labyrinth, Chartres Cathedral," *Studies in Comparative Religion* 11, no. 2 [1977]: 93). In recent years, however, the romantic appeal of the church labyrinth has brought about a resurgence of such designs not only in church imagery (particularly in the asphalt playgrounds of church schools), but also in a host of non-Christian settings paralleling the resurgence of interest in pre-Christian religious beliefs in the West.

130. Nigel Pennick, *Mazes and Labyrinths* (London: Robert Hale, 1990), 134.

131. Ibid., 112.

132. J. O. Ward, "Alexandria and Its Medieval Legacy: The Book, the Monk and the Rose," in Roy Macleod, ed., *The Library of Alexandria: Centre of Learning in the Ancient World* (London: I. B. Tauris, 2000), 172.

133. Gregory of Nyssa cited in Penelope Reed Doob, *The Idea of the Labyrinth from Classical Antiquity through the Middle Ages* (Ithaca: Cornell University Press, 1993), 73–74.

134. Ibid., 102.

135. Ibid., 50.

136. Purely as an aside, note also with the labyrinth at Chartres the shape of the central

"goal," the figure of the rose, which can be found in the rose windows for which this cathedral is so famed; see James, "The Mystery of the Great Labyrinth," 95–96. Clearly the labyrinth was initially constructed as one element among others in the harmonic order of the cathedral, making its "dropping out" of discourse all the more interesting. Although these are not necessarily grounds from which to mount a critique of Foucault's at times unwieldy notion of the *episteme* (the dates seem to coincide with the coming of the Enlightenment), if time permitted, a study of such slippages within the discursive fold would be a challenging exercise, potentially productive of a less cumbersome way of characterizing such shifts. In many ways the curiosity cabinets of chapter 1 represented the potential for an "in-between" space of discourse with their continuance well into the age of the Enlightenment. The closest Foucault comes to a disruption of his own notion of the *episteme* is with the idea of the heterotopia.

137. Paul Fussell, *The Great War and Modern Memory* (London: Oxford University Press, 1979), 16. See also Hillel Schwartz, *The Culture of the Copy: Striking Likenesses, Unreasonable Facsimiles* (New York: Zone Books, 1996), 187.

138. Paul Virilio, *Bunker Archaeology*, trans. George Collins (New York: Princeton Architectural Press, 1994), 12, 38.

139. Paul Virilio, *The Vision Machine*, trans. Julie Rose (London: British Film Institute, 1994), 12.

140. Virilio suggests that the model for topographical amnesia lay in the so-called Elpenor's Syndrome, where sufferers would display normal automatic motor functions in waking up in an unfamiliar place, but be unaware of their environment. A fortuitous disorder for Virilio's general thesis regarding the optical speed of modernity being both one of its defining features as well as one of its most productive in terms of new subject effects, Elpenor's Syndrome (named after a hero from the *Odyssey* who fell from the roof of Circe's temple) was made famous by the death of the French President Deschanel, who fell from a train at the turn of the twentieth century.

141. Paul Virilio, *War and Cinema: The Logistics of Perception*, trans. Patrick Camiller (New York: Verso, 1989), 14.

## Conclusion

1. Bruno Schultz, "The Street of Crocodiles," in *The Collected Works of Bruno Schultz*, ed. Jerzy Ficowski (London: Picador, 1988).

2. Arbuthnot Lane quoted in Elizabeth Haiken, *Venus Envy: A History of Cosmetic Surgery* (Baltimore: Johns Hopkins University Press, 1997), 31.

3. The two most well known of such artists were Francis Derwent Wood, whose Masks for Facial Disfigurement Department in the Third London General Hospital was euphemistically called the "tin noses shop," and the American sculptor Anna Coleman Ladd working for the Red Cross and the Bureau for the Reduction of the Mutilated in France in Paris. For the former, see Caroline Alexander, "Faces of War," *Smithsonian Magazine* 2007. For the latter, see Sharon Romm and Judith Zacher, "Anna Coleman Ladd: Maker of Masks for the Facially Wounded," *Plastic and Reconstructive Surgery* 70, no. 1 (1982).

4. See in particular Paul Virilio, *War and Cinema: The Logistics of Perception*, trans. Patrick Camiller (New York: Verso, 1989).

5. Hillel Schwartz, *The Culture of the Copy: Striking Likenesses, Unreasonable Facsimiles* (New York: Zone Books, 1996), 189.

6. Ibid., 190.

7. We can see this ambivalence at work in the designs of a generation of so-called "Impressionist" architects returning from the war. Seen largely as a briefly lived "emotional" reaction to the horrors of trench warfare, the Impressionists' use of glass stood in sharp contrast to the modernist tendency toward the sheer and unadorned surfaces of mass-produced "industrial" architecture. Whereas glass would become the ultimate modernist building material due to its ability to reveal structure and volume as the dominant function of building design, to the group of war-ravaged Impressionists, the use of glass would tend to be more polarized. On the one hand the fantastical glass sky-cities of Bruno Taut appear as utopian "visions" of glass's democratizing transparency; yet on the other, the alien and nightmarish visions of Hermann Finsterlin's designs, with their curved and opaque surfaces bristling with needles and spines of glass, mark two ends of an Impressionist response to the possibilities and limitations of vision in an age of industrial disenchantment. For an excellent introduction to the architecture of postwar Impressionism, particularly as it pertains to the experiences of trench warfare, see Allyson Booth, *Postcards from the Trenches: Negotiating the Space between Modernism and the First World War* (New York: Oxford University Press, 1996), esp. 125–169.

8. Schwartz, *The Culture of the Copy*, 190.

9. Ibid., 188.

10. As an aside, Abbott Handerson Thayer, the American naturalist/artist most often accredited with the advancement of modern techniques of war camouflage, developed his notion of evolutionary protective coloration, interestingly enough for our purposes, through the characteristically scientific pursuit of collection: "The beauty of birds' patterns, etc. simply thrills me and my immense color progress and decorator progress is greatly due to this passion in me and the hundreds of hours spent in looking at my birds' skins" (quoted in ibid., 174). From the embodied nature of avian coloration to the dazzling and "ruptive" effects of war camouflage, we can witness a kind of modernist animism at work, projecting the protective spirit of these collected bird carcasses onto the uniforms of soldiers and weapons of war so that they may remain invisible to the mechanical eye of sighting devices. Similarly we can see something of a scientific theriomorphism in Thayer's own artistic predilection for portraying winged angels with resplendently feathered bird wings, which, by his own admission, were inspired by his collection of bird skins. In the figure of Thayer, then, we can see the conflation of a number of modern "magics" at work behind the "left-handed" science of camouflage. For an account of Thayer's camouflage that extends the reach of its masking to included issues of nineteenth-century American social ostentation, see Alexander Nemerov, "Vanishing Americans: Abbott Thayer, Theodore Roosevelt and the Attraction of Camouflage," *American Art* 11, no. 2 (1997).

11. Booth, *Postcards from the Trenches*, 22.

12. Vladislav Todorov, *Red Square, Black Square: Organon for Revolutionary Imagination* (Albany: State University of New York Press, 1995), 94–95.

13. Katherine Verdery, *The Political Lives of Dead Bodies: Reburial and Postsocialist Change* (New York: Columbia University Press, 1999), 102.

14. István Rév, "Parallel Autopsies," *Representations* 49 (1995).

15. Verdery, *The Political Lives of Dead Bodies*, 108.

16. See in particular Jean and John Comaroff, "Occult Economies and the Violence of Abstraction: Notes from the South African Postcolony," *American Ethnologist* 62, no. 2 (1999). And more recently, Jean and John Comaroff, "Alien-Nation: Zombies, Immigration and Millennial Capitalism," *South Atlantic Quarterly* 101, no. 4 (2002).

# BIBLIOGRAPHY

Alexander, Caroline. "Faces of War." *Smithsonian Magazine*, 2007.

Alpers, Svetlana. "The Mapping Impulse in Dutch Art." In David Woodward, ed., *Art and Cartography*. Chicago: University of Chicago Press, 1982.

Altick, Richard. *The Shows of London*. Cambridge, Mass.: Harvard University Press, 1978.

Anemone, Anthony. "The Monsters of Peter the Great: The Culture of the St. Petersburg Kunstkamera in the Eighteenth Century." *Slavic and East European Journal* 44 (4) (2000): 583–602.

Armstrong, Meg. "A Jumble of Foreignness: The Sublime Musayums of Nineteenth-Century Fairs and Expositions." *Cultural Critique* 23 (1992–1993): 199–211.

Ashworth, William B., Jr. "Emblematic Natural History of the Renaissance." In Nick Jardine, Jim Secord, and Emma Spray, eds., *The Cultures of Natural History*. Cambridge: Cambridge University Press, 1997.

Bakhtin, Mikhail. *Rabelais and His World*. Trans. Helene Iswolsky. Bloomington: Indiana University Press, 1984.

Bann, Stephen. "Shrines, Curiosities and the Rhetoric of Display." In Lynne Cooke and Peter Wollen, eds., *Visual Display: Culture Beyond Appearances*. Seattle: Bay Press, 1995.

Bann, Stephen. "Shrines, Gardens, Utopias." *New Literary History* 25 (4) (1994): 825–837.

Barker, Francis. "Into the Vault." In *The Tremulous Private Body: Essays on Subjection*. Ann Arbor: University of Michigan Press, 1995.

Bataille, Georges. "The Deviations of Nature." In *Visions of Excess: Selected Writings, 1927–1939*. Minneapolis: University of Minnesota Press, 1985.

Bataille, Georges. "The Psychological Structure of Fascism." In *Visions of Excess: Selected Writings, 1927–1939*. Minneapolis: University of Minnesota Press, 1985.

Baudrillard, Jean. "The Orders of Simulacra." In *Simulations*. New York: Semiotext(e), 1983.

Bauman, Zygmunt. *Globalization: The Human Consequences*. New York: Columbia University Press, 1998.

Belyea, Barbara. "Images of Power: Derrida/ Foucault/ Harley." *Cartographica* 29 (2) (1992): 1–9.

Benjamin, Walter. "Paris—Capital of the Nineteenth Century." In *Charles Baudelaire: A Lyric Poet in the Era of High Capitalism*. London: Verso, 1997.

Benjamin, Walter. "Unpacking My Library." In *Illuminations*, ed. Hannah Arendt. Glasgow: Fontana/Collins, 1977.

Bennett, Tony. *The Birth of the Museum: History, Theory, Politics*. London: Routledge, 1995.

Bibliothèque Nationale. *Le Trésor de Saint-Denis: Musée du Louvre, Paris, 12 mars– 17 juin 1991*. Paris: Bibliothèque Nationale, Réunion des Musées Nationaux, 1991.

Booth, Allyson. *Postcards from the Trenches: Negotiating the Space between Modernism and the First World War*. New York: Oxford University Press, 1996.

Borges, Jorge Luis, and Aldolfo Bioy Casares. *A Universal History of Infamy*. Trans. Norman Thomas di Giovanni. Harmondsworth: Penguin, 1984.

Bornstein, Jeanne, Meg Maher, and Holland Goss. *The Public's Treasures: A Cabinet of Curiosities Brochure*. New York: New York Public Library, 2002.

Bourdieu, Pierre. "The Biographical Illusion." *Actes de la recherche* 62 (3) (1986): 69–72.

Bredekamp, Horst. *The Lure of Antiquity and the Cult of the Machine: The Kunstkammer and the Evolution of Nature, Art and Technology*. Trans. Allison Brown. Princeton: Markus Weiner Publishers, 1995.

Brown, Elizabeth. "Death and the Human Body in the Later Middle Ages: The Legislation of Boniface VIII on the Division of the Corpse." *Viator* 12 (1981): 221–270.

Brown, Peter. *The Cult of the Saints: Its Rise and Function in Latin Christianity*. Chicago: University of Chicago Press, 1982.

Bryson, Norman. *Vision and Painting: The Logic of the Gaze*. New Haven: Yale University Press, 1983.

Bryson, Norman. *Word and Image: French Painting of the Ancien Régime*. New York: Cambridge University Press, 1981.

Buchanan, Ian. "Heterophenomenology, or De Certeau's Theory of Space." *Social Semiotics* 6 (1) (1996): 111–132.

Buck-Morss, Susan. *The Dialectics of Seeing: Walter Benjamin and the Arcades Project*. Cambridge, Mass.: MIT Press, 1993.

Carlino, Andrea. *Books of the Body: Anatomical Ritual and Renaissance Learning*. Trans. John Tedeschi and Anne Tedeschi. Chicago: University of Chicago Press, 1999.

Çelik, Zeynip. *Displaying the Orient: Architecture of Islam at Nineteenth-Century World's Fairs*. Berkeley: University of California Press, 1992.

Çelik, Zeynep, and Leila Kinney. "Ethnography and Exhibitionism at the Expositions Universelles." *Assemblage* 13 (1990): 34–59.

Comaroff, Jean, and John Comaroff. "Alien-Nation: Zombies, Immigration and Millennial Capitalism." *South Atlantic Quarterly* 101 (4) (2002): 779–805.

Comaroff, Jean, and John Comaroff. "Occult Economies and the Violence of Abstraction: Notes from the South African Postcolony." *American Ethnologist* 62 (2) (1999): 279–309.

Coombes, Annie. *Reinventing Africa: Museums, Material Culture and Popular Imagination*. New Haven: Yale University Press, 1994.

Crary, Jonathan. *Techniques of the Observer: On Vision and Modernity in the Nineteenth Century*. Cambridge, Mass.: MIT Press, 1994.

Cunningham, Andrew. *The Anatomical Renaissance: The Resurrection of the Anatomical Projects of the Ancients*. Aldershot: Scolar Press, 1999.

Czerkawska, Catherine. *The Curiosity Cabinet*. Edinburgh: Polygon, 2005.

Daston, Lorraine, and Katherine Park. "Unnatural Conceptions: The Study of Monsters in Sixteenth- and Seventeenth-Century France and England." *Past and Present* 92 (1981): 20–54.

Daston, Lorraine, and Katherine Park. *Wonders and the Order of Nature, 1150–1750*. New York: Zone Books, 1990.

De Certeau, Michel. "The Gaze of Nicholas of Cusa." *Diacritics* 17 (3) (1987): 2–38.

De Certeau, Michel. *Heterologies: Discourse on the Other*. Trans. Brian Massumi. Manchester: Manchester University Press, 1996.

De Certeau, Michel. "The Laugh of Michel Foucault." In *Heterologies: Discourse on the Other*. Manchester: Manchester University Press, 1996.

De Certeau, Michel. *The Practice of Everyday Life*. Trans. Steven Rendall. Berkeley: University of California Press, 1988.

DeLillo, Don. *Cosmopolis*. London: Picador, 2003.

Dilke, O. A. W. "Itineraries and Geographical Maps in the Early and Late Roman Empire." In J. Brian Harley and David Woodward, eds., *Cartography in Prehistoric, Ancient, and Medieval Europe and the Mediterranean*, vol. 1 of *The History of Cartography*. Chicago: University of Chicago Press, 1987.

Doob, Penelope Reed. *The Idea of the Labyrinth from Classical Antiquity through the Middle Ages*. Ithaca: Cornell University Press, 1993.

Drake, Barbara Boehm. "Body-Part Reliquaries: The State of Research." *GESTA* 36 (1) (1997): 8–19.

Eco, Umberto. *Art and Beauty in the Middle Ages*. Trans. Hugh Bredin. New Haven: Yale University Press, 1986.

Eco, Umberto. *The Search for the Perfect Language*. Trans. James Fentress. London: Fontana Press, 1997.

Edgerton, Samuel Y., Jr. "Florentine Interest in Ptolemaic Cartography as Background for Renaissance Painting, Architecture, and the Discovery of America." *Architectural Forum* 56 (1976): 275–292.

Edgerton, Samuel Y., Jr. *Pictures and Punishment: Art and Criminal Prosecution during the Florentine Renaissance*. Ithaca: Cornell University Press, 1985.

Edgerton, Samuel Y, Jr. *The Renaissance Rediscovery of Linear Perspective*. New York: Basic Books, 1975.

Edney, Matthew. *Mapping an Empire: The Geographical Construction of British India, 1765–1843*. Chicago: University of Chicago Press, 1997.

Edson, Evelyn. *Mapping Time and Space: How Medieval Mapmakers Viewed Their World*. London: British Library, 1997.

Evans, R. J. W. *Rudolf II and His World: A Study in Intellectual History 1576–1612*. New York: Oxford University Press, 1984.

Falkenburg, Reindert L. *Joachim Patinir: Landscape as an Image of the Pilgrimage of Life*. Trans. Michael Hoyle. Philadelphia: John Benjamins, 1988.

Ferrari, Giovanna. "Public Anatomy Lessons and the Carnival: The Anatomy Theatre of Bologna." *Past and Present* 117 (1989): 50–106.

Fforde, C. "English Collections of Human Remains: An Introduction." *World Archaeological Bulletin* 6 (1992): 1–24.

Findlen, Paula. "The Museum: Its Classical Etymology and Renaissance Genealogy." *Journal of the History of Collections* 1 (1) (1989): 59–78.

Foucault, Michel. *The Archaeology of Knowledge*. Trans. A. M. Sheridan-Smith. London: Routledge, 2002.

Foucault, Michel. *Discipline and Punish: The Birth of the Prison*. Trans. Alan Sheridan. New York: Vintage Books, 1979.

Foucault, Michel. "The Life of Infamous Men." In *Michel Foucault: Power, Truth, Strategy*, ed. Meaghan Morris and Paul Patton. Sydney: Feral Press, 1979.

Foucault, Michel. *The Order of Things: An Archaeology of the Human Sciences*. Trans. Alan Sheridan-Smith. New York: Vintage Books, 1994.

Foucault, Michel. "Space, Knowledge, and Power: Interview with Paul Rabinow."

In *The Foucault Reader*, ed. Paul Rabinow. Harmondsworth: Penguin, 1986.

Foucault, Michel. "What Is an Author?" In *The Foucault Reader*, ed. Paul Rabinow. London: Parthenon Books, 1984.

Fussell, Paul. *The Great War and Modern Memory*. London: Oxford University Press, 1979.

Gane, Michael. *Baudrillard's Bestiary: Baudrillard and Culture*. London: Routledge, 1991.

Getty Museum. "Devices of Wonder." <http://www.getty.edu/art/exhibitions/devices/html/>.

Gibson, Walter S. *Mirror of the Earth: The World Landscape in Sixteenth-Century Flemish Painting*. Princeton: Princeton University Press, 1989.

Gilman, Sander. "Black Bodies, White Bodies: Toward an Iconography of Female Sexuality in Late-Nineteenth Century Art, Medicine and Literature." *Critical Inquiry* 12 (1985): 204–242.

Gombrich, Ernst. "The Renaissance Theory of Art and the Rise of Landscape." In *Norm and Form*. London: Phaidon, 1966.

Haiken, Elizabeth. *Venus Envy: A History of Cosmetic Surgery*. Baltimore: Johns Hopkins University Press, 1997.

Hajos, Elizabeth. "References to Giulio Camillo in Samuel Quiccheberg's 'Inscriptiones Vel Tituli Theatri Amplissimi.'" *Bibliothèque d'Humanisme et Renaissance* 25 (1963): 207–211.

Hale, John. *Renaissance Fortification: Art or Engineering*. London: Thames and Hudson, 1977.

Harbison, Robert. *Reflections on Baroque*. London: Reaktion Books, 2000.

Harcourt, Glen. "Andreas Vesalius and the Anatomy of Antique Sculpture." *Representations* 17 (1987): 28–61.

Harley, John Brian. "Deconstructing the Map." *Cartographica* 26 (2) (1989): 1–20.

Harley, John Brian. "Silences and Secrecies: The Hidden Agenda of Cartography in Early Modern Europe." *Imago Mundi* 40 (1988): 57–76.

Harley, John Brian, and David Woodward, eds. *Cartography in Prehistoric, Ancient, and Medieval Europe and the Mediterranean*. Vol. 1 of *The History of Cartography*. Chicago: University of Chicago Press, 1987.

Harvey, Paul D. A. *Medieval Maps*. London: British Library, 1991.

Hearn, Millard F. "Canterbury Cathedral and the Cult of Becket." *Art Bulletin* 74 (1) (1994): 19–52.

Heckscher, William S. "Relics of Pagan Antiquity in Mediaeval Settings." *Journal of the Warburg Institute* 1 (3) (1938): 204–220.

Heckscher, William S. *Rembrandt's Anatomy of Dr. Nicolaas Tulp: An Iconographical Study*. New York: New York University Press, 1958.

Heidegger, Martin. "The Age of the World Picture." In *Off the Beaten Track*. Cambridge: Cambridge University Press, 2002.

Heidegger, Martin. *Being and Time*. Trans. John Macquarrie and Edward Robinson. New York: Harper and Row, 1962.

Heninger, S. K. H., Jr. *The Cosmographical Glass: Renaissance Diagrams of the Universe*. San Marino: Huntington Library Press, 2004.

Hertz, Robert. *Death and the Right Hand*. Trans. Claudia Needham and Rodney Needham. London: Cohen and West, 1960.

Hillis, Ken. "The Power of Disembodied Imagination: Perspective's Role in Cartography." *Cartographica* 31 (3) (1994): 1–17.

Hinsley, Curtis M. "Strolling through the Colonies." In Michael P. Steinberg, ed., *Walter Benjamin and the Demands of History*. Ithaca: Cornell University Press, 1996.

Hinsley, Curtis M. "The World as Marketplace: Commodificiation of the Exotic at the World's Columbian Exposition, Chicago, 1893." In Ivan Karp and Steven Lavine, eds., *Exhibiting Cultures: The Poetics and Politics of Museum Display*. Washington: Smithsonian Institution Press, 1991.

Hirst, Paul. *Foucault and Architecture*. Occasional Papers. Sydney: Local Consumption, 1984.

Hooper-Greenhill, Eilean. *Museums and the Shaping of Knowledge*. New York: Routledge, 1992.

Husserl, Edmund. "Ideas Pertaining to Pure Phenomenology." In *General Introduction to a Pure Phenomenology*. The Hague: M. Nijhoff, 1982.

Impey, Oliver, and Arthur MacGregor. *The Origins of Museum: The Cabinets of Curiosities in Sixteenth- and Seventeenth-Century Europe*. Oxford: Clarendon Press, 1985.

Ivans, William M., Jr. "What About the 'Fabrica' of Vesalius?" In Archibald Malloch, ed., *Three Vesalian Essays to Accompany the 'Icones Anatomicae' of 1934*. New York: Macmillan, 1952.

James, John. "The Mystery of the Great Labyrinth, Chartres Cathedral." *Studies in Comparative Religion* 11 (2) (1977): 92–115.

Jansen, H. "Titian's Laocoon Caricature and the Vesalius-Galenist Controversy." *Art Bulletin* 28 (1946): 49–53.

Kaufmann, Thomas. "Remarks on the Collections of Rudolf II: The Kunstkammer as a Form of Representation." *Art Journal* 38 (1) (1978): 22–28.

Kemp, Martin. "Perspective and Meaning: Illusion, Allusion and Collusion." In Andrew Harrison, ed., *Philosophy and the Visual Arts: Seeing and Abstracting*. Boston: Riedel, 1987.

Kemp, Martin. *The Science of Art: Optical Themes in Western Art from Brunelleschi to Seurat*. New Haven: Yale University Press, 1992.

Kenseth, Joy. "A World in One Closet Shut." In Joy Kenseth, ed., *The Age of the Marvellous*. Hanover: Hood Museum of Art, Dartmouth College, 1991.

Keuning, Johannes. "Isaac Massa, 1586–43." *Imago Mundi* 10 (1953): 65–79.

Kirshenblatt-Gimblett, Barbara. "Objects of Ethnography." In Ivan Karp and Steven Lavine, eds., *Exhibiting Cultures: The Poetics and Politics of Museum Display*. Washington: Smithsonian Institution Press, 1991.

Kitzinger, Ernst. "The Cult of Images in the Age before Iconoclasm." *Dumbarton Oaks Papers* 8 (1954): 83–150.

Koch, Robert. *Joachim Patinir*. Princeton: Princeton University Press, 1968.

Kriz, Wilhelm. "Foreword." In *Prof. Gunther von Hagens' Bodyworlds: The Anatomical Exhibition of Real Human Bodies: Catalogue on the Exhibition*. Heidelberg: Institut für Plastination, 2002.

Latour, Bruno. *Science in Action: How to Follow Scientists and Engineers through Society*. Milton Keynes: Open University Press, 1987.

Latour, Bruno, and Steve Woolgar. *Laboratory Life: The Construction of Scientific Facts*. Princeton: Princeton University Press, 1986.

Lefebvre, Henri. *The Production of Space*. Trans. Donald Nicholson-Smith. Oxford: Blackwell, 1991.

Linebaugh, Peter. "The Tyburn Riot against the Surgeons." In Douglas Hay, ed., *Albion's Fatal Tree*. London: Pantheon Books, 1975.

Maeder, Jay. "The Long and Winding Road." *New York Daily News*, 4 September 1997.

Maeder, Jay. "Raiders of the Lost Conk." *U.S. News and World Report* (1997): 8.

Markus, Thomas. *Buildings and Power: Freedom and Control in the Origin of Modern Building Types*. London: Routledge, 1991.

Mauriès, Patrick. *Cabinets of Curiosity*. London: Thames and Hudson, 2002.

Metropolitan Museum. "Collecting for the Kunstkammer." <http://www.metmuseum.org/toah/hd/kuns/hd_kuns.htm>.

Mignolo, Walter D. *The Darker Side of the Renaissance: Literacy, Territoriality, and Colonization*. Ann Arbor: University of Michigan Press, 1995.

Miller, Michael B. *The Bon Marché: Bourgeois Culture and the Department Store, 1869–1920*. Princeton: Princeton University Press, 1981.

Mitchell, Timothy. *Colonising Egypt*. Berkeley: University of California Press, 1991.

Mitchell, W. J. T. *What Do Pictures Want? The Lives and Loves of Images*. Chicago: University of Chicago Press, 2005.

Moore, Keith. *Clinically Oriented Anatomy*. 2nd ed. Baltimore: Williams and Wilkins, 1985.

Moxey, Keith. "A New Look at Netherlandish Landscape and Still-Life Painting." *Arts in Virginia* 26 (2) (1986): 18–31.

Murray, David. *Museums: Their History and Their Use*. Vol. 1. Glasgow: James MacLehose and Sons, Publishers to the University, 1904.

Musil, Robert. "Monuments." In *Posthumous Papers of a Living Author*. Hygiene, Colo.: Eridanos Press, 1987.

Nemerov, Alexander. "Vanishing Americans: Abbott Thayer, Theodore Roosevelt and the Attraction of Camouflage." *American Art* 11 (2) (1997): 50–81.

Neverov, Oleg. "'His Majesty's Cabinet' and Peter I's Kunstkammer." In Oliver Impey and Arthur MacGregor, eds., *The Origins of Museums: The Cabinets of Curiosities in Sixteenth- and Seventeenth-Century Europe*. Oxford: Clarendon Press, 1985.

Niranjana, Tejaswini. *Siting Translation: History, Post-Structuralism, and the Colonial Context*. Berkeley: University of California Press, 1992.

Nutti, Lucia. "The Perspective Plan in the Sixteenth-Century." *Art Bulletin* 74 (1) (1994): 105–128.

O'Malley, Charles D. *Andreas Vesalius of Brussels 1514–1564*. Berkeley: University of California Press, 1964.

Olmi, Giuseppe. "Science-Honour-Metaphor: Italian Cabinets of the Sixteenth and Seventeenth Centuries." In Oliver Impey and Arthur MacGregor, eds., *The Origins of Museums: The Cabinets of Curiosities in Sixteenth- and Seventeenth-Century Europe*. Oxford: Clarendon Press, 1985.

Ong, Walter. *Orality and Literacy: The Technologizing of the Word*. London: Methuen, 1982.

Padrón, Ricardo. "Mapping Plus Ultra: Cartography, Space and Hispanic Modernity." *Representations* 79 (2002): 28–60.

Panofsky, Erwin. *Abbot Suger on the Abbey Church of St.-Denis and Its Art Treasures*. Princeton: Princeton University Press, 1979.

Park, Katherine. "The Criminal and the Saintly Body: Autopsy and Dissection in Renaissance Italy." *Renaissance Quarterly* 47 (1) (1994): 1–33.

Pennick, Nigel. *Mazes and Labyrinths*. London: Robert Hale, 1990.

Piper, Karen. *Cartographic Fictions: Maps, Race and Identity*. New Brunswick: Rutgers University Press, 2002.

Pirenne, Maurice Henri. *Optics, Painting and Photography*. London: Cambridge University Press, 1970.

Pollak, Martha. *Military Architecture: Cartography and the Early Modern European City*. Chicago: Newberry Library, 1991.

Pomian, Krzysztof. *Collectors and Curiosities: Paris and Venice, 1500–1800*. Trans. Elizabeth Wiles-Portier. Cambridge: Polity Press, 1990.

Prakash, Gyan. *Another Reason: Science and the Imagination of Modern India*. Princeton: Princeton University Press, 1999.

Preston, Douglas, and Lincoln Child. *The Cabinet of Curiosities*. New York: Warner Books, 2002.

Raguin, Virginia C. *Stained Glass: From Its Origins to the Present*. New York: Harry Abrams, 2003.

Randi, James. "Busted Miracle." Swift online newsletter of the JREF, <http://www.randi.org/jr/031204busted.html>.

Rees, Ronald. "Historical Links between Cartography and Art." *Geographical Review* 70 (1) (1980): 60–78.

Reeves, Eileen. "Reading Maps." *Word and Image* 9 (1) (1993): 51–65.

Rév, István. "Parallel Autopsies." *Representations* 49 (1995): 15–39.

Robertson, Bruce, and Mark Meadow. "Microcosms: Objects of Knowledge." *AI and Society* 14 (2000): 223–229.

Robertson, Bruce, and Mark Meadow. "Microcosms: Objects of Knowledge." <http://microcosms.ihc.ucsb.edu/intro.html>.

Robertson, Bruce, and Mark Meadow. "The Pangolin-and-Pinecone Effect." <http://vv.arts.ucla.edu/publications/lectures/98-99/microcosms/essays/001.html>.

Romm, Sharon, and Judith Zacher. "Anna Coleman Ladd: Maker of Masks for the Facially Wounded." *Plastic and Reconstructive Surgery* 70 (1) (1982): 104–111.

Ryan, Simon. *The Cartographic Eye: How Explorers Saw Australia*. Cambridge: Cambridge University Press, 1996.

Safranski, Rüdiger. *Martin Heidegger: Between Good and Evil*. Trans. Ewald Osers. Cambridge, Mass.: Harvard University Press, 1998.

Sawday, Jonathon. *The Body Emblazoned: Dissection and the Human Body in Renaissance Culture*. London: Routledge, 1995.

Sawday, Jonathon. "The Fate of Marsyas: Dissecting the Renaissance Body." In Lucy Gent and Nigel Llewellyn, eds., *Renaissance Bodies: The Human Figure in English Culture c. 1540–1660*. London: Reaktion Books, 1990.

Schultz, Bruno. "The Street of Crocodiles." In *The Collected Works of Bruno Schultz*, ed. Jerzy Ficowski. London: Picador, 1988.

Schupbach, William. *The Paradox of Rembrandt's "Anatomy of Dr. Tulp."* London: Wellcome Institute for the History of Medicine, 1982.

Schwartz, Hillel. *The Culture of the Copy: Striking Likenesses, Unreasonable Facsimiles*. New York: Zone Books, 1996.

Seelig, Lorenz. "The Munich Kunstkammer, 1565–1807." In Oliver Impey and Arthur MacGregor, eds., *The Origin of Museums: The Cabinets of Curiosities in Sixteenth- and Seventeenth-Century Europe*. Oxford: Clarendon Press, 1985.

Shearman, John. *Only Connect: Art and the Spectator in the Italian Renaissance*. Princeton: Princeton University Press, 1992.

Shelton, Anthony Alan. "Cabinets of Transgression: Renaissance Collections and the Incorporation of the New World." In John Elsner and Roger Cardinal, eds., *The Cultures of Collecting*. Cambridge, Mass.: Harvard University Press, 1994.

Shoemaker, Adam. "Authenticity: Globalisation and Indigenous Culture." Unpublished manuscript, 2004.

Simpson, Moira. *Making Representations: Museums in the Post-Colonial Era*. London: Routledge, 2001.

Stamper, John W. "The Galerie des Machines of the 1889 Paris World's Fair." *Technology and Culture* 30 (2) (1989): 330–353.

Stewart, Peter. "The Destruction of Statues in Late Antiquity." In Richard Miles, ed., *Constructing Identities in Late Antiquity*. London: Routledge, 1999.

Stewart, Susan. *On Longing: Narratives of the Miniature, the Gigantic, the Souvenir, the Collection*. Durham: Duke University Press, 1994.

Talbot, Charles. "Topography as Landscape in Early Printed Books." In Sandra Hindman, ed., *The Early Illustrated Book: Essays in Honor of Lessing J. Rosenwald*. Washington: Library of Congress, 1982.

Taussig, Michael. *Defacement: Public Secrecy and the Labor of the Negative*. Stanford: Stanford University Press, 1999.

Todorov, Vladislav. *Red Square, Black Square: Organon for Revolutionary Imagination*. Albany: State University of New York Press, 1995.

Turnbull, David. *Masons, Tricksters and Cartographers: Comparative Studies in the Sociology of Scientific and Indigenous Knowledge*. Singapore: Harwood Academic Publishers, 2000.

Turnbull, Paul. "Outlawed Subjects: The Procurement and Scientific Uses of Australian Aboriginal Heads, ca. 1803–1835." *Eighteenth Century Life* 22 (1) (1998): 156–171.

Vásquez, Manuel A., and Marie F. Marquardt. "Globalizing the Rainbow Madonna: Old Time Religion in the Modern Age." *Theory, Culture and Society* 17 (4) (2000): 119–143.

Verdery, Katherine. *The Political Lives of Dead Bodies: Reburial and Postsocialist Change.* New York: Columbia University Press, 1999.

Vigato, Jean-Claude. "The Architecture of the Colonial Exhibitions in France." *Daedalus* 19 (1986): 24–37.

Villette, Jean. "L'énigme du labyrinthe de la cathédrale, Cathedral of Notre-Dame de Chartres." Undated pamphlet.

Virilio, Paul. *Bunker Archaeology.* Trans. George Collins. New York: Princeton Architectural Press, 1994.

Virilio, Paul. *The Vision Machine.* Trans. Julie Rose. London: British Film Institute, 1994.

Virilio, Paul. *War and Cinema: The Logistics of Perception.* Trans. Patrick Camiller. London: Verso, 1989.

von Holst, Niels. *Creators, Collectors and Connoisseurs: The Anatomy of Artistic Taste from Antiquity to the Present Day.* London: Thames and Hudson, 1967.

Walker Art Center. "Wonderwalker a Global Online Wunderkammer." <http://209.32.200.23/gallery9/wunderkammer/>.

Ward, J. O. "Alexandria and Its Medieval Legacy: The Book, the Monk and the Rose." In Roy Macleod, ed., *The Library of Alexandria: Centre of Learning in the Ancient World.* London: I. B. Tauris, 2000.

Whitehead, Paul. *The British Museum (Natural History).* London: Scala, 1981.

Williams, Rosalind H. *Dream Worlds: Mass Consumption in Late Nineteenth-Century France.* Berkeley: University of California Press, 1991.

Wilson, Luke. "William Harvey's Prelectiones: The Performance of the Body in the Renaissance Theatre of Anatomy." *Representations* 17 (1987): 62–95.

Wind, Edgar. "The Criminal-God." *Journal of the Warburg Institute* 1 (3) (1938): 243–245.

Winichakul, Thongchai. "Siam Mapped: Making of Thai Nationhood." *Ecologist* 26 (5) (1996): 215–227.

Witches' Voice Inc. "Arianhrod? Dianna? Mary? What Do You See?" <http://www.witchvox.com/media/mary_shrine.html>.

Wittkower, Rudolf. *Art and Architecture in Italy 1600–1750*. Suffolk: Penguin, 1990.

Wood, Denis. *The Power of Maps*. New York: Guilford Press, 1992.

Woodward, David. "Reality, Symbolism, Time, and Space in Medieval World Maps." *Annals of the Association of American Geographers* 74 (4) (1985): 510–521.

Yates, Frances Amelia. *The Art of Memory*. London: Routledge and Kegan Paul, 1966.

# INDEX

Mourning, 62, 128, 162, 190
Murray, David, 15, 55, 109
Museology, 13, 32, 46, 148
Museum, 9–14, 32–34, 59–60, 150, 179, 190, 195n20
Musil, Robert, 105, 108

Natural history, 37, 40, 179
*Naturalia. See Artificialia* and *naturalia*
New York Public Library, 11
Nicholas of Cusa, 138–140, 146, 162, 164, 171
  *De visione Dei, sive De icona* (1453), 138, 146
Niranjana, Tejaswini, 161
Noongar, 56, 58–59, 110
Notre-Dame de Chartres, 171

Olmi, Giuseppe, 32, 41
O'Malley, Charles D., 63
Ong, Walter, 156
Optics, 140

Padrón, Ricardo, 151
Palissy, Bernard, 51
Panoptic god, 162–163, 168, 184
Panopticon, 137, 145, 163
Patinir, Joachim, 129, 132–133, 137
  *Landscape with St. Jerome* (1516–1517), 129–133, 135
Pennick, Nigel, 173
Perspective, 113, 117, 126, 139, 140–141, 143–146, 157–158, 162, 164–165, 169–170, 218n3
  vanishing point, 113, 139, 141, 143, 169
  viewing point, 113, 117, 139, 143
Peter the Great (tsar), 28–29, 43–44, 53, 204n116
Pettigrew, Thomas, 56–57, 60
Philip II (king of Spain), 129
Philosophy, 51–52
Phrenology, 60
Piety
  medieval, 19
  visual, 117, 128, 138–142, 184

Place and space, 136, 153
Plastic surgery, 180
Pliny the Elder (Gaius Plinius Secundus), 37, 41
Postcolonial theory, xiv, 149–150, 161, 191
Power
  disciplinary, 69–71, 75–76, 83, 89, 100, 137, 143, 153, 157, 161, 163–164, 168–169, 171, 212n47
  sovereign, 71, 74–76, 92, 100, 105, 108
Pozzo, Andrea, 112–113, 117, 126, 137, 171
  *Perspectiva pictorum et architectorum* (1693), 113
*Praesentia*, 17, 24, 46, 48, 54, 108, 179, 197n40
Ptolemy (Claudius Ptolemaeus), 157–159
  *Cosmographia*, 157–158

Queen of Sheba, 19
Quiccheberg, Samuel, 9, 12, 43, 49
  *Inscriptiones vel tituli theatri amplissimi* (1565), 9, 49, 206n128

*Radius*, 18, 65, 80
Rainbow Madonna, 24–25, 27, 190, 200n60
Randi, James, 25, 199n60
Rationality, xiv, xviii, 14, 25, 27, 31–32, 40, 47, 54, 76, 90, 137, 152, 156, 188, 190–191
  characteristics of, xvi, 31, 188
Relics, 15–17, 18, 23, 109, 197n44
Reliquaries, 16, 18, 21, 179, 196n35
Rembrandt Harmensz van Rijn, 70–73, 75, 97
  *The Anatomy Lesson of Dr. Nicolaas Tulp* (1632), 70–73, 75–76, 87, 94, 104
Renaissance
  *episteme*, 28, 35, 36, 38, 40–42, 47–48
  ordering and hierarchy, 11, 29, 31, 33, 46, 51, 159
Repatriation, 57–58, 187, 208n6
Representation, 18, 35, 36, 64, 67, 70, 76–77, 87–89, 97, 102, 108, 123, 126, 139, 164